# Orléans Embrace

with

## The Secret Gardens
## of the Vieux Carré

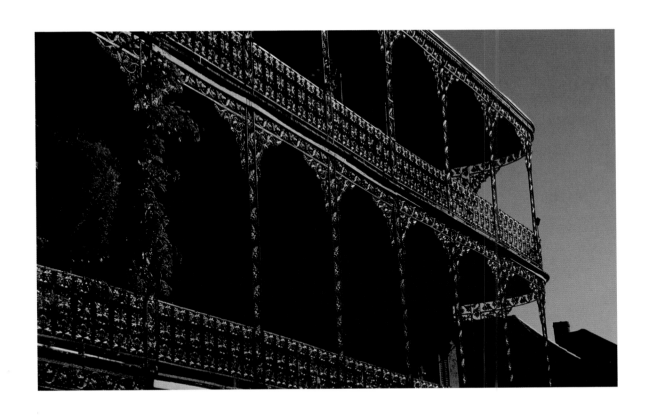

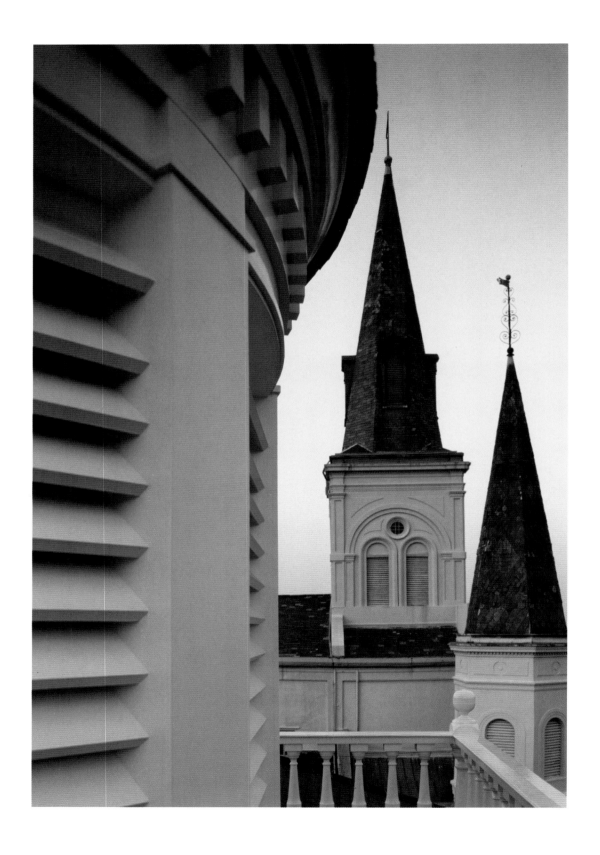

# Reviews
## Celebrity & Literary
## Comments

"An enchanting peek inside the elusively secret
and mysterious parts of the indomitable French Quarter.
This is the real Vieux Carré rarely glimpsed by outsiders."
FRANCIS FORD COPPOLA

"Sumptuously photographed, this book presents the esoteric and efflorescent
truth of the Vieux Carré and why there is no other place like it in the world."
NICOLAS CAGE

"The Vieux Carré was my window to the tropics before there ever was a
Margaritaville song or restaurant. It was the place for all us children of the
coast, who were lucky enough to see the gardens, smell the gumbo and hear
the music that spoke of a larger and more interesting world beyond the path
of Highway 90. I have been lucky enough to see many views of many places
that are called paradise, but my first view was a banana tree in a Vieux Carré
garden. I can remember that view nearly 50 years later as if it were yesterday.
In a world filled with many storms and much uncertainty, the Vieux Carré
was, still is and will hopefully always be a shelter from the storms."
JIMMY BUFFETT

"What a visual palette. Wow! — This is truly the New Orleans I love."
EMERIL LAGASSE

"This lovely work is a touching journey; it takes us deep behind closed doors
and locked gates into the ancient soul and stillness of the French Quarter."
LENNY KRAVITZ

"In the great tradition of Irish writers TJ Fisher gives us the soul of the Quarter and puts New Orleans in our arms before and after Katrina. New Orleans is so blessed."
DANNY O'FLAHERTY, Celtic balladeer

"This is simply the best book that has been written about the enchanted gardens of the Vieux Carré."
JOE DESALVO, owner,
Faulkner House Books

"Roy F. Guste, Jr., scion of an old Creole family, is among the initiated who know the lush tropical gardens of the French Quarter intimately from a lifetime of invitations for café au lait in the morning or tea laced with mint late afternoons or, perhaps a stronger aperitif after dark. With the familiarity of a lover, he brings to life the secret beauties of this neighborhood to those who have only glimpsed their voluptuous glory through the iron lace of garden gates. A must for those who treasure New Orleans."
ROSEMARY JAMES, Co-Founder,
The Pirate's Alley Faulkner Society

"An ideal testament to the extraordinary beauty hidden inside the patios and courtyards of the French Quarter...a view that is unique, treasured and desired."
E. RALPH LUPIN, M.D., Chairman,
Vieux Carré Commission

"We who live in the French Quarter enjoy sharing our treasures with the world. This book brings you behind the walls and gates and reveals our most charming secrets."
NATHAN CHAPMAN, President,
Vieux Carré Property Owners, Residents and Associates

"My life, my love and my soul are buried in the Vieux Carré."
DORIAN BENNETT

"Few realize the visual excitement hidden behind French Quarter doors. Beyond the traffic and tourists, at the end of narrow brick paths, vines grow and fountains flow, uninterrupted for more than 150 years. These living masterpieces are a unique part of New Orleans and American culture."
GEORGE RODRIGUE, artist

"This magnificently realized work reminds us that the beauty of our great city lies not only in what the eyes capture, but in what the heart feels. New Orleans has a secret soul."
HARRY ANDERSON

"This stunning book reveals the beauty and romance of New Orleans and returns me to my childhood. It's a treasure and makes the perfect gift."
PATRICIA CLARKSON

"Living in the Vieux Carré trumps all other neighborhood experiences. The Quarter constantly astonishes, and this book reveals many of its delicious secrets."
TAYLOR HACKFORD & HELEN MIRREN

"An intimate look at the city Tennessee Williams called his spiritual home — the nooks and crannies of its heart and the beautiful intricacies of its endearing and enduring soul."
KARISSA KARY, Associate Director,
The Tennessee Williams/New Orleans Literary Festival

"This book captures the haunting beauty of these Edenic gardens like no other I have read about the Vieux Carré. I am glad that we have this book to remind us of their fragile beauty and to embolden us to do something about their eventual return."
JAMES H. MEREDITH, President,
Ernest Hemingway Foundation and Society

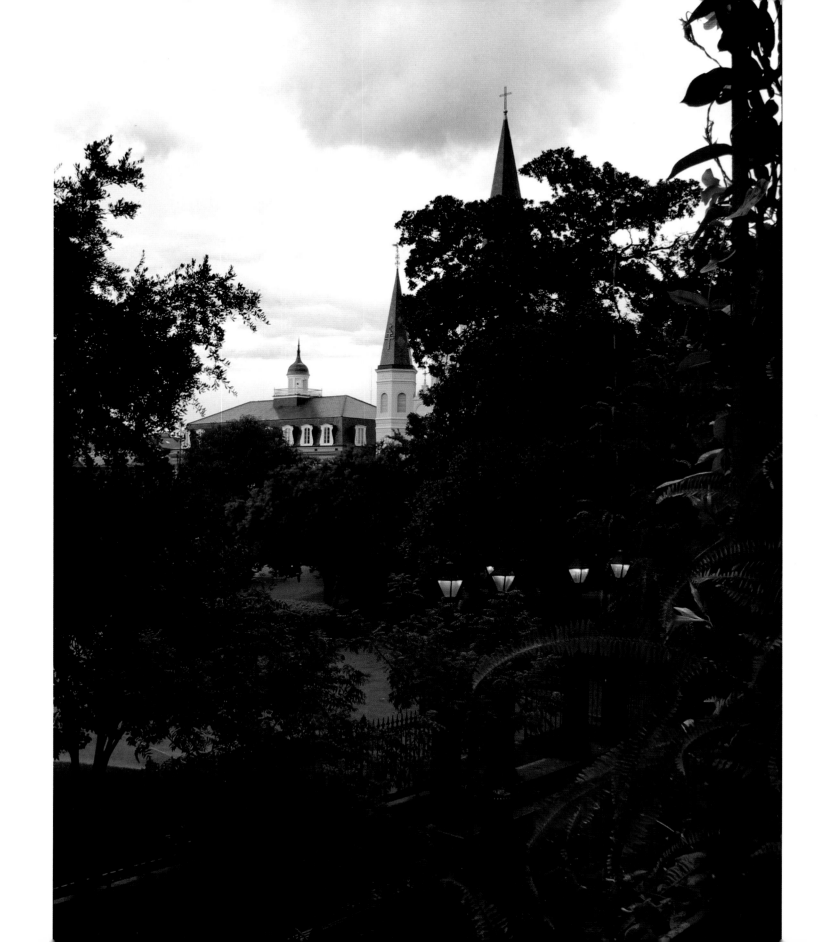

# Orléans Embrace

with

# The Secret Gardens
of the Vieux Carré

TJ Fisher

Roy F. Guste, Jr.

Louis Sahuc Photo Works

Morgana Press
New Orleans

First edition

**Library of Congress Cataloging-in-Publication Data**
Fisher, TJ.
    Orléans embrace; with The secret gardens of the Vieux Carré / TJ Fisher, Roy F. Guste, Jr.;
Louis Sahuc, photo works. — 1st ed.
    p. cm.
ISBN-13: 978-0-9773514-7-3
ISBN-10: 0-9773514-7-5
    1. New Orleans (La.) — Social life and customs. 2. New Orleans (La.) — History. 3. New Orleans (La.) —
Pictorial works. 4. Historic buildings — Louisiana — New Orleans — Pictorial works. 5. Architecture —
Louisiana — New Orleans — Pictorial works. 6. New Orleans (La.) — Buildings, structures, etc. — Pictorial works.
7. Vieux Carré (New Orleans, La.) — Social life and customs. 8. Vieux Carré (New Orleans, La.) — Pictorial
works. 9. Gardens — Louisiana — New Orleans. 10. Gardens — Louisiana — New Orleans — Pictorial works.
I. Guste, Roy F. Secret gardens of the Vieux Carré. II. Title. III. Title: Secret gardens of the Vieux Carré.
F379.N55F57 2006
712'.60976335 — dc22
                                          2005057697

10  9  8  7  6  5  4  3  2  1

Cover and book design: Jedd Haas
Editor: Ron Kenner

Little, Brown & Company first published *The Secret Gardens of the Vieux Carré: The Historic French Quarter of New
Orleans* in 1993; (inset) original covers by Steve Snider and design by Mary Reilly.

The *States-Item* newspaper first published Lafcadio Hearn's *Creole Sketches: The Glamour of New Orleans* in 1878 and
*A Creole Courtyard* in 1879.

Printed in China by Imago

Published by Morgana Press, LLC
1034 Royal Street, New Orleans, LA 70116
www.morganapress.com

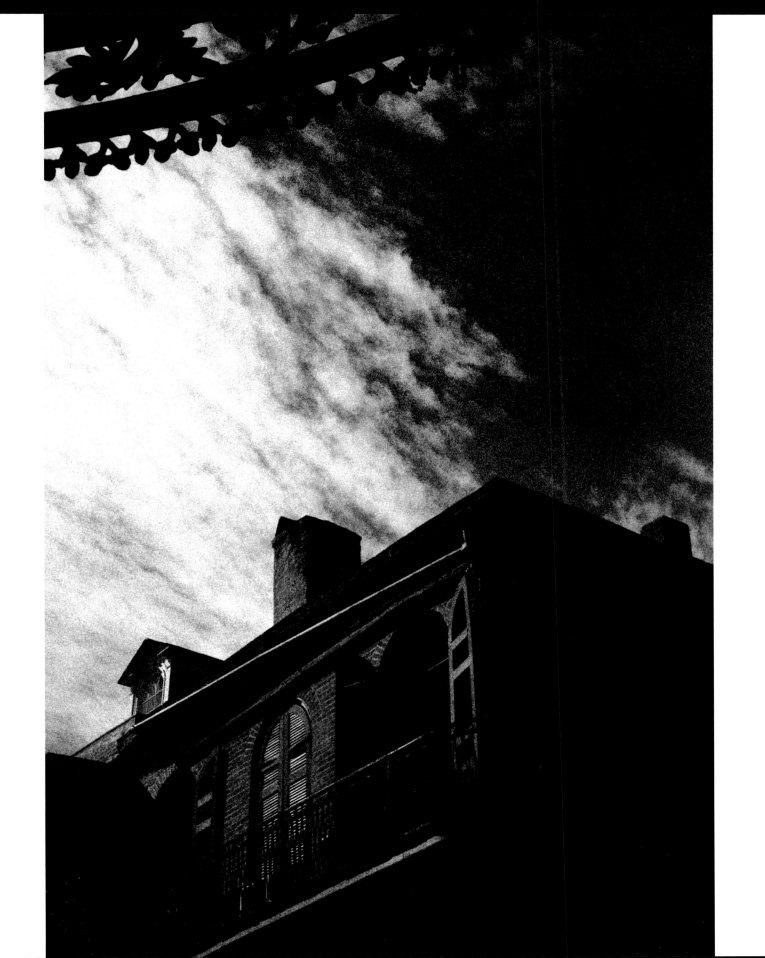

# Acknowledgments

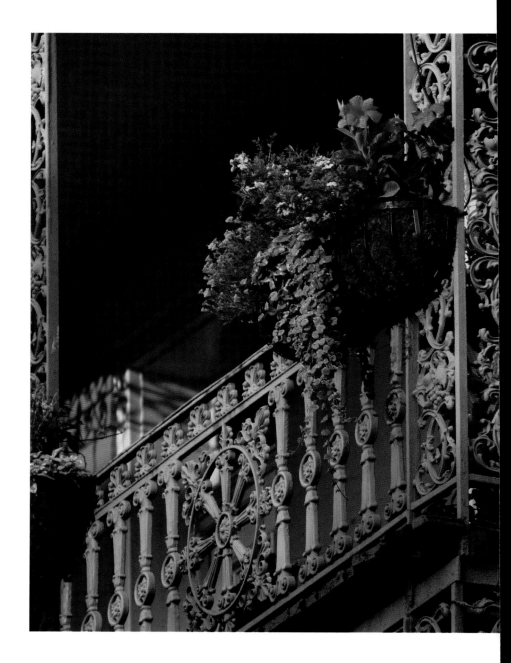

The following individuals were instrumental in helping to bring this post-Katrina compilation vision to fruition: Don and Jackie Eisenberg; Bill and Nancy Broadhurst; Joe and Becky Jaeger; Bubby Valentino; Matthew and Dianne Harris; John Ordoyne; Ricardo L. Fraga; Teddi Lawrence; Kevin and Lenora Tusa; Irene Singletary; Frank and Rhoda Schachter; Otis Biggs; Paul Jacobson, M.D.; Donald and Marilyn Geddes; Tom Puckett; Chris Smith; Jessica Keet; Drs. Steven and Karen Lesser; John Williams, AIA; Jim Caridi; the Williams Research Center of the Historic New Orleans Collection; and the untold others who affected and contributed to the realization of this work.

A special acknowledgment and recognition goes to the American Library Association — New Orleans' first post-Katrina conference, June of 2006.

To the rescuers who risked their lives to save people and pets from the devastation of floodwaters; to the caring people worldwide who have contributed to the welfare, relief and recovery of New Orleans; to those committed to the rebuilding and preservation of our unique city and culture — thank you.

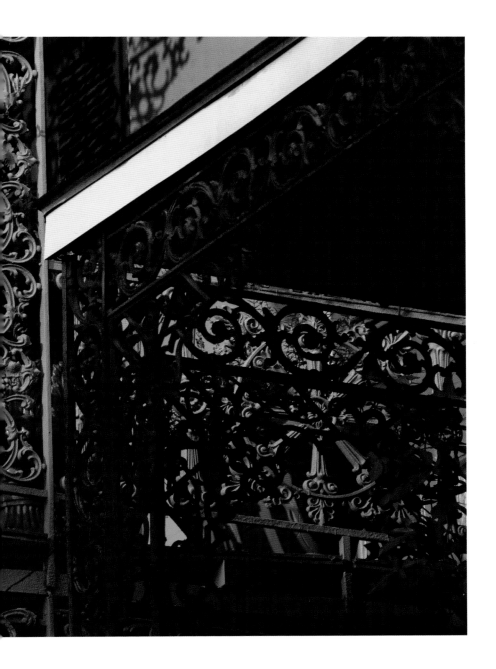

# Dedication

*Orléans Embrace*, along with the resurrection of *The Secret Gardens*, is dedicated to the memory and the stories of the people and the history of New Orleans — past, present and future — in particular to the beloved families, friends, pets, homes and dreams ravished and forever lost to Katrina, as well as to that which has survived reborn; to the celebration of triumph over sorrow, the defeat of dark days; and to my husband, the one whom I loved long before I ever knew him and who rescued me from peril. Although we shall miss what is gone and is no more, the unyielding fingerprints of time that lie heavy upon our hearts, we hold fast to what we have left, in the here and now. Our laughter shall overcome our tears.

TJ Fisher

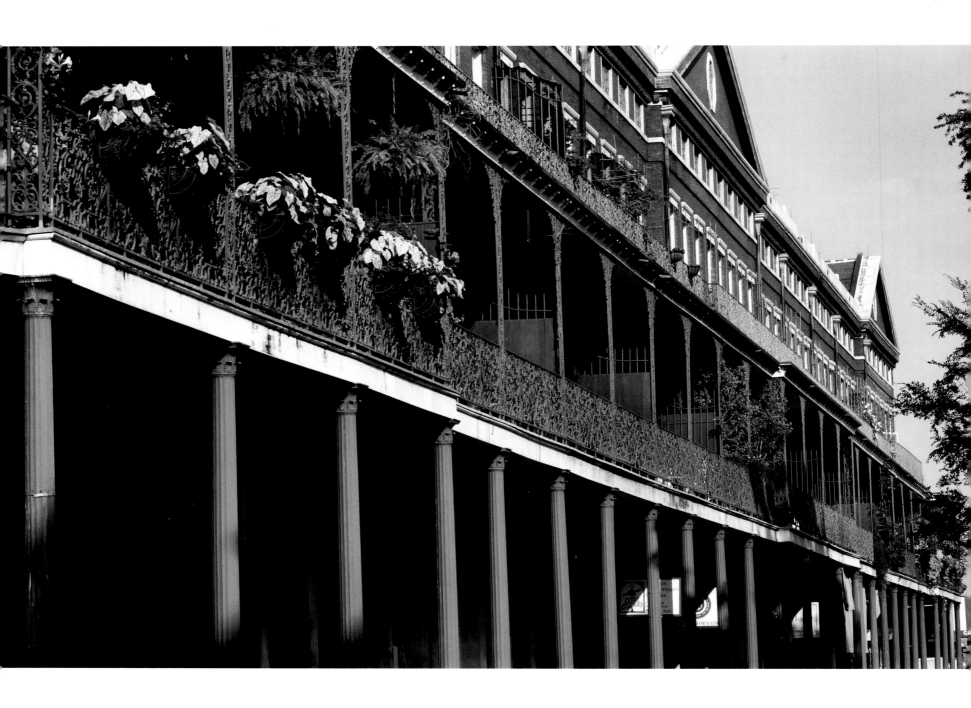

# Contents

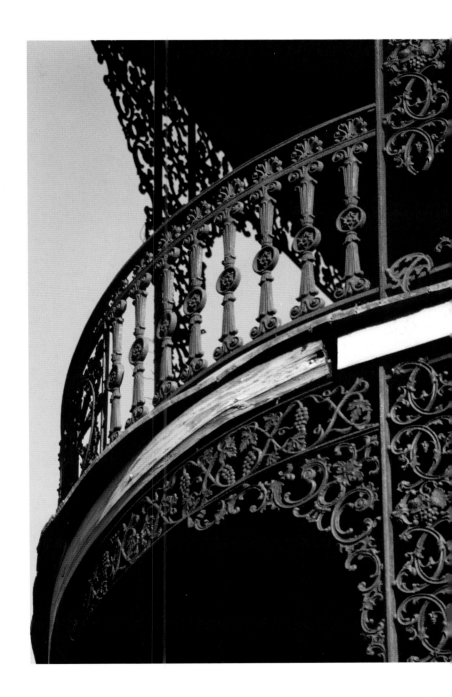

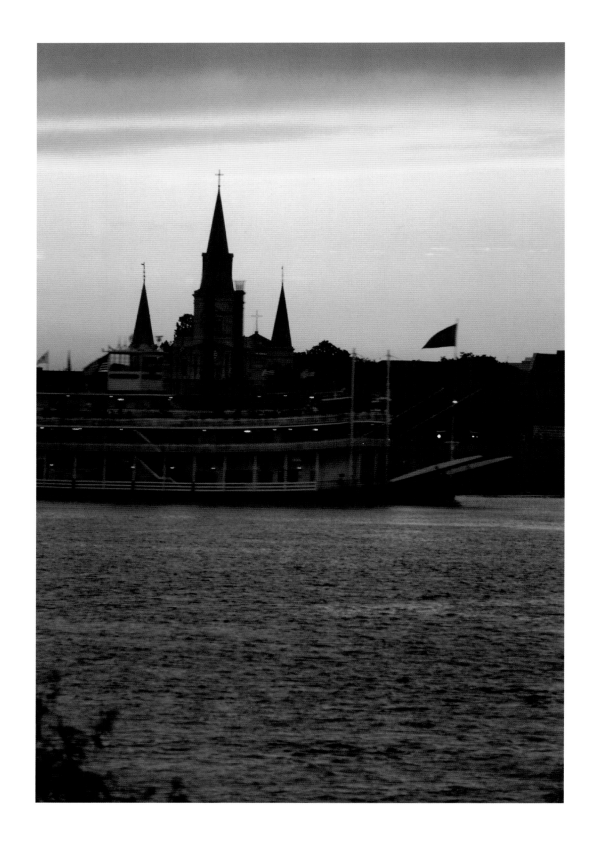

# New Orleans

1878

*"The season has come at last when strangers may visit us without fear, and experience with unalloyed pleasure the first delicious impression of the most beautiful and picturesque old city in North America. For in this season is the glamour of New Orleans strongest upon those whom she attracts to her from less hospitable climates, and fascinates by her nights of magical moonlight, and her days of dreamy languors and perfumes. There are few who can visit her for the first time without delight; and few who can ever leave her without regret; and none who can forget her strange charm when they have once felt its influence. To a native of the bleaker Northern clime — if he have any poetical sense of the beautiful in nature, any love of bright verdure and luxuriance of landscape — the approach to the city by river must be in itself something indescribably pleasant. The white steamer gliding through an unfamiliar world of blue and green — blue above and blue below, with a long strip of low green land alone to break the ethereal azure; the waving cane; the ever-green fringe of groves weird with moss; the tepid breezes and golden sunlight — all deepening in their charm as the city is neared, make the voyage seem beautiful as though one were sailing to some far-off glimmering Eden, into the garden of Paradise itself. And then, the first impression of the old Creole city slumbering under the glorious sun; of its quaint houses; its shaded streets; its suggestions of a hundred years ago; its contrasts of agreeable color; its streets rëechoing the tongues of many nations; its general look of somnolent contentment; its verdant antiquity; its venerable memorials and monuments; its eccentricities of architecture; its tropical gardens; its picturesque surprises; its warm atmosphere, drowsy perhaps with the perfume of orange flowers, and thrilled with the fantastic music of mocking-birds — cannot ever be wholly forgotten."*

Lafcadio Hearn
(1850–1904)

# Part One

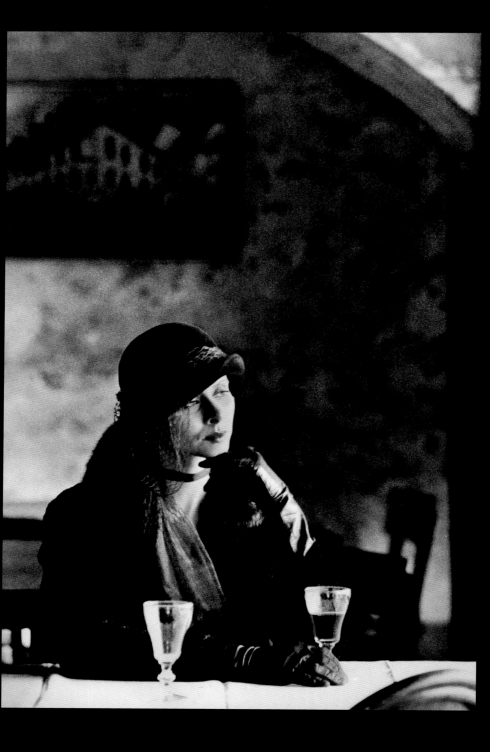

# Orléans Embrace

TJ Fisher

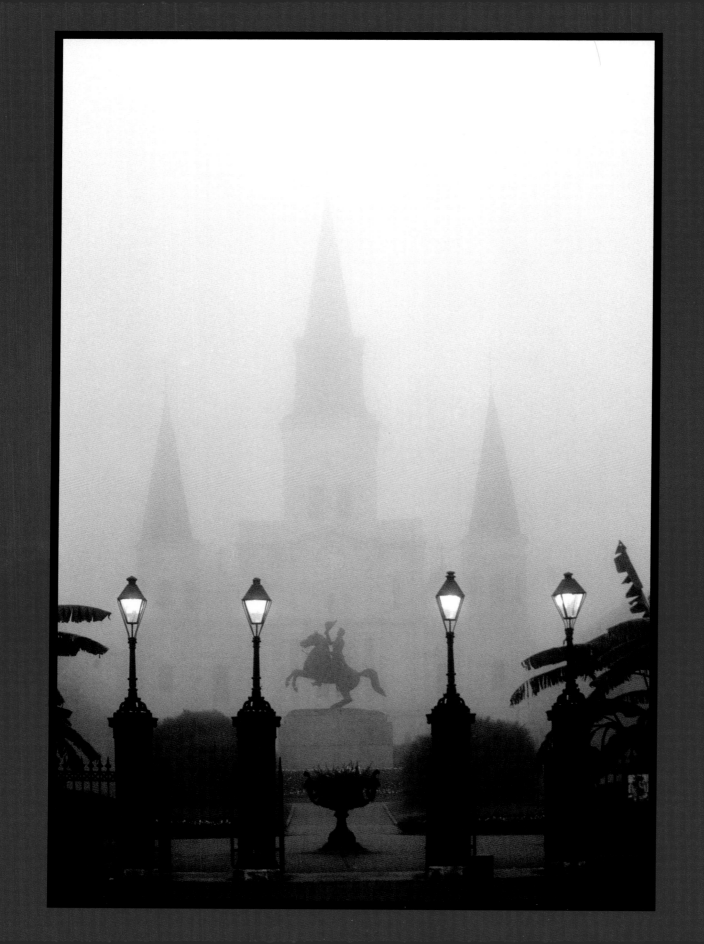

# Preserving New Orleans

## L'Histoire

Katrina changed everything. Life here is different, every face altered. Yet we feel and sense the landscape not only in its hurricane-leveled, sodden depressions but — perhaps even more so now in the strangely comforting depths of our shared history. Even in the worst hit areas, not all is dissipated. Dense intricate attachments burrow too deep to underestimate or overlook. This is no featureless town to be rubbed off the map and cast aside. Here the band plays on.

Our kindred colors speak to the values of justice, faith and power; to curious combinations of passion, openness, irreverence and loyalty, to the values of individuality, sharing and compassion. Not least, we still enjoy the sounds of music and respond to succulent foods, to the magnificent flowering gardens, to the elements of grace and dreamy escape, and to the languid Southern charm typical of faded days gone by.

As the band plays on, the music celebrates the most curious mix of people imaginable and we appreciate that special tolerance of the Big Easy that had to be, with all its problems and sometimes because of its problems, to make the city what it was and to produce the spirit as it prevails. You can take the people out of the city, but you can't take the soul — that remains here.

Admittedly not all is solid ground; and much has been swept away. Yet we take hold. The human heart digs into the past as an anchor, a guidepost and foothold threaded into the future as we traverse life by retracing the timeworn, rutted grooves of others; we proceed from the ingrained footsteps of those who came before us.

Although not born in New Orleans, I dwell here by choice, not only before but also after Katrina. Along with those who have strolled the streets and built memories here I remain smitten by the power and pull of her essence, more so than by any other city. Something in the sultry soil and air here compels people and speaks to them deeply.

The rich interplay of tradition and culture looped with tragedies webs people together with a permanent bond. Mindful of the decisions we face, the architecture of yesterday is the mooring of our hopes, dreams and consciousness, all from which we learn and grow. An earlier day, possessing the power to sway thoughts, to incite and rekindle emotions, pushes us along. We zigzag onward but our history remains unforgettable; the collective joys, ashes and sackcloth that prove we left a mark on time.

For those without a connection, history is meaningless and soon forgotten. But for others, even in sadness, it is priceless. It maintains our distinct values, culture, pride and self-preservation. We are never severed from pieces of the past because history chases us. It is our catalyst, muse and inspiration; all that we are. Perhaps that is why we have a special passion to preserve aged, weather-battered cities.

When recasting a reflection of what tomorrow might look like, the salvation of New Orleans becomes an unmistakable proclamation and reminder of our legacy. Of the sacraments and sacrifices of life; of our liturgies, too, regardless of religion or lack thereof. A punished, flood-filled landscape does not mean a perished spirit; here the comeback spirit lives, lit from within, not to be snuffed out.

We struggle with the aftermath of the worst natural disaster ever to decimate U.S. soil, but we refuse to be squashed, or shamed, by happenstance. Surpassing the sadness of loving a crippled city there is an overriding sharpness of strength and connectedness, an interwoven ribbon of classic satire and humor that calms us while we work hard from the inside out to unearth a promise for the future.

If we treat our past as insignificant, if we do not rebuild and rise up from the ashes of what has been cruelly taken from us, then who are we? What do we have left? New Orleanians realize that yesterday cannot be blotted out, merely covered up and left

behind. A man who forgets his past and allows the flame of the things he loves to be extinguished has no future.

New Orleans and its strategic location at the mouth of the Mississippi River not only gave America its very soul but also kept it alive and beating. This is not a city from which we decamp. Great adversity runs parallel with great dreams and calamity invariably leaves a large handprint on tomorrow. Yet a faint heart cannot conquer misfortune; and the strong do not run or cower from catastrophe no matter how dire or dismal the situation. The refusal to accept defeat is the genesis and solidifying mortise of the foundation upon which our country was built. This is real life unscripted.

Here, in New Orleans, forces beyond our control have led us to a new place. Another notable Great American Tragedy for the history books, yet we persevere and move on. As if through

a dream unbroken, our plight propels us. Decades and more from now our tale will be repeated as the defining chapter of a great city; with the future of New Orleans and of the nation etched by how we pick ourselves up — or not — and by how we recover from cataclysm.

With an outpouring of passion, we wrestle with wretched windstorm seasons of calamities unexpected and chain reactions unforeseen. A storm-torn city submerged beneath an implosion of floodwaters does not overnight cease to be home. The hallowed halls, walls, crypts and cityscape of my New Orleans also encompass other people's New Orleans: their homes, lives and loves. Home is not someplace easily surrendered.

A city immersed in ethos, mythos and pathos, New Orleans is well vested in the extraordinary. Its people long accustomed to overcoming hardship, this is a venerable town that played a

predominant role in the settlement and development of our nation. Louisiana was the eighteenth state to join the Union, with New Orleans built on the fundamental premise that gumption, guts and gumbo go together as one.

Of course we are shaken and nurse doubts about the future. We are only human, with normal mortal apprehensions. But we pull ourselves together because we must. Charged with emotion, we believe in the ultimate power and evidence of hope and things unseen; we believe that nothing is greater than the force of the human spirit. The willfulness of man, the inheritance of our forefathers, the quest for dreams unfulfilled, shape and mold our world. The end is where we begin as we search for our holy grail regardless of where it might lie swamped in concealing mire. Our roots define us. No quicksand can swallow what is rooted in our hearts. A season in perdition does not erase our kindred resolve.

New Orleanians realize that all goodbyes are false and fleeting. A part of us remains embedded in the walls and there are no true farewells. The lingering legacy, history and tradition that spring from this city are conjoined, and incredibly compelling. This earth cannot be moved. Great nations rebound and rebuild.

In Louisiana, the steadfastness of our customs, ceremonies, rituals and rites of passage push us forward.

Stubborn practices inexorably linked to our city's one-of-a-kind culture ensure an outlandish colorfulness, soulful and distinct, in an increasingly wan world of diminished character. Nothing stops the observance of Carnival. Nothing prevents dedication to krewes. Nothing cancels Mardi Gras.

Old traditions continue. New ones start. Fantasy floats roll past. "Hey, mister, throw me something," children cry out to costumed paraders, echoing their parents and ancestors. In reply, necklaces of colored beads are tossed; arms arch skyward, grabbing throws and the circle is complete, the culture unbroken.

Ritualized customs and established occasions have enriched and grounded humanity since primitive mankind. The mores of prehistoric tribes and clans formed civilization. As society searches through the ages for meaning and significance, symbols of mythology and legend, rarely recognized, remain imprinted in the fabric of daily life.

The colorful heritage of New Orleans is often misunderstood; it defines and assembles people with a sense of unity and belonging. Even in trying times. This is a place emotionally tied to the formality of tradition. Fiercely clinging to the slightest hint or semblance of something beloved, the familiar, handed down through the years, cements the existence of life, sharply defining a pattern of hope and the possibility of a tomorrow. The perpetual marvel of New Orleans is the reaffirmation of pomp and pageantry, an impressive spectacle of meaningful events uninterrupted even in the face of overwhelming disaster. Somehow we get by.

The preoccupation with the cause and order of things here spans the centuries — regardless of civil unrest, strife, pestilence and suppression. This is a segment of the rebuilding process. Our celebrations help soothe the pain of living by proving that life does in fact go on. Without exception. No matter what. Here we "get it," as most do, even if certain fringes do not. There is no mystery in a fundamental belief system that understands

that everyone needs an occasional breather from the real world, a time-out from crushing burdens that prey on the mind and weigh on the soul. This is rudimentary knowledge. Laughter can lighten a heavy heart's oppressive load. To put this philosophy in a prized Zulu parade coconut shell, it is therapeutic to put realism on hold. Briefly.

Ceremonial jubilee, the redundant song of the universe, reunites communities with a shared memory and helps man transcend suffering. Long after memory-invoking rituals end, we are fortified with an onrush of renewed strength. The feeling of resuscitation lingers. We turn the corner to recovery.

Mardi Gras and Lent come and go with the calendar. No one can stop time from marching on, but New Orleans parades with rollicking saints. The rites handed down by our ancestors unify, motivate and uplift an entire community. A basin of tears makes for a lowland of laughter, since the more we laugh the less we cry. The ability to disassemble and imitate our own wide sweep of foibles, shortcomings and failures bolsters our ability to dust off the silt and reconstruct our lives.

The Crescent City has long cherished the escapades of flitting glitter as good cheer for the conscience. Impressionism combats despair, mocking ill-fortune and pointing fingers at decried devils. The Shrove "Fat" Tuesday revelry of airbrushed denial and delusion helps this damaged city cope. A momentary dream world of parody creates the momentum for remembrance and renewal.

Regalement does not diminish penitence, remorse or regret. On the contrary, all solemnizations and glorifications are revered and experienced even more deeply here; a throwback to earlier days. We are thankful for our mighty, tireless, unsung, faceless heroes; an approach to life's ongoing trials and tribulations that redeems and restores us.

What is treasured is forever on the tightropes here in New Orleans. We live life on the edge, knowing we are not always in charge of our own destiny. In quieter moments we acknowledge that there is no everlasting season under the sun, no door where an obituary wreath has not hung. We respect that every tomb tells a tale and that the whispers of the past lead the way to the future. One who is immune to joy feels no anguish; a heart that cannot feel anguish is a heart that cannot know joy.

Throughout the swamping torrents and storms of recent days, those proud to call New Orleans home hold fast to spunk seasoned with wry wit. Tethered by a shared ancestral strength

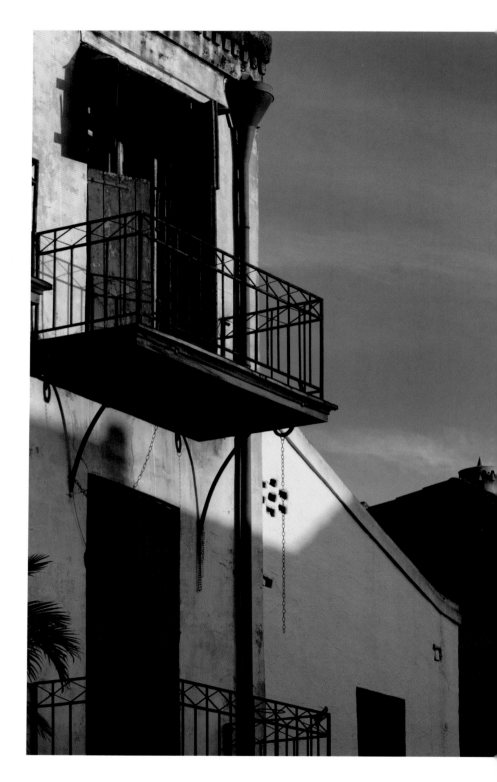

of purpose and pride, the weight of what anchors us lies here, pulling us back to the land we love best. Circumstance will not crush our resolve. Neither will condemnation. We have iron will and courage on our side. Our ancestors conquered hell and high water. We can, too. Whether local by birth or osmosis, we are a strain of people who do not give up easily. This is the shared sentiment of those who love New Orleans.

Here in this hurricane-lashed region, prone to merciless storm strikes and Army Corps of Engineers floodwalls and levees, the ceaseless incandescent circle of life continues. Although our town is badly scarred, the empowerment of raw determination feeds fortitude. People aim to save what uniquely characterizes the culture and spirit of New Orleans. Even a world overturned and dismantled by the dark loss and gloom of retreated floodwaters is greeted by reemerging fragrant flowers and newfound rejoicing. In a traumatized city gashed and defaced with telltale brown watermarks, we retrench and make headway. Heritage is understood rather than obscured. Nobody is left unmarred. Everyone has lost so much. All are seriously impacted. Yet familial ties, friendships, relationships strengthen and come close, closer still.

Although crucified by a grisly baptism of flood, the Earth, buried beneath surging storm waters, keeps revolving and so do we. In the backwash of grimness and gladness, blooms burst forth from all soils, bringing cause for celebration. Lovers wed. Babies arrive. Bouquets appear. And so we start afresh. Quicksilver dreams roll past. Nightmares come and go. Bereavement subdues. The sun and moon arrive and then depart. Storms collide. Seasons change. So many things vanish and yet our perennials flourish. Crops are replanted. Soil turned. Cities rebuilt. And hope for tomorrow, the resilience of faith and healing, returns.

Tourism is New Orleans' biggest business. In this storm-tossed city now confronting a monumental rebuilding process, a city struggling to regain its footing, the thin, silver lining is that the historic parts of town most frequented by visitors are mainly unaffected by Katrina and the ensuing floods.

Clusters of acclaimed hotels, restaurants, shops, tourist sites and attractions are undamaged or already repaired. The city's old-time scenic beauty is still lush.

Of course, there is far more to this after-tragedy story. Clear of the rosier parts of the picture we all wish to see, the town is rife with tremendous hurt and upheaval, which cannot be slighted.

We separate the two realities, but they are in fact enmeshed. As school children's voices rise again in the French Quarter, and as tourists and conventioneers slowly make their way back into the city, for the majority of locals, the scars of a post-traumatic Katrina struggle still dominate life.

For the disenchanted inhabitants of the hardest-hit areas, doleful melodrama and desperation frame each day. A panorama of still-ravaged areas, homes and businesses that marinated for weeks in floodwaters remain turned upside down and inside out, awaiting a reconstruction program. The abandonment is unnerving.

From the air one cannot see that much of New Orleans is a hollow floodscape of moldy-shell buildings. Deserted. Nobody lives in these houses anymore. They are uninhabitable. Katrina-driven storm surges destroyed more historic homes than any event in U.S. history. With the rampage of water gone, the mossy muck dried to silt, the scourge of destruction remains, largely untouched. The void is relentless. Hulking. It is painful to witness such desolate neighborhoods encased in choking refuse piled up unmitigated for longer than the mind can equate or fathom.

The littered landscape of demolished homes, crumpled businesses and abandoned vehicles plastered in grime cuts deep into the core of our being. Locals bear the brunt of what is unbearable and insurmountable. But we persevere and soldier on even though eighty percent of our city was underwater. The apocalyptic sight of New Orleans consumed beneath a festering lagoon of floodwaters is something others might choose to forget, or ignore, but we cannot. We will not. How could we?

As the ubiquitous cameras and sound bites revealed, a fallen New Orleans claimed countless lives and swallowed property indiscriminately. With complete disregard, the doomsday storm and its after-effects smashed across all real or imagined demarcation lines of race, creed, color, religion, gender, social, historic and socioeconomic boundaries. Here we find the scattered swill, sediment, scraps and leavings of our lives. The residue of lives shattered is hard to scrape up. Nobody has been left unscathed. No barrier unbreached. No one commands an exclusive claim on the unholy mess and ramifications of such a disaster.

We stumble along hundreds of square miles of broken all-American byways and roads, paths that recede and disappear before us — precious homes and entire neighborhoods forever gone, our beloved friends and families exiled. In such turmoil we sink to our knees, yet do not remain submerged. No, not at

all. Staggering amid the sunken debris and wreckage of what was our life, we arouse a dream that seems within grasp and, as New Orleans has done before, we rise again.

Today is the first day and night in which the world begins again, rising slowly in the shadow of majestic old oak trees face down, of a town trampled. For the most part we are weary, many uprooted, but we have another chance to outshine the wrongs, to ride the painted carousel, to seize the brass ring, laugh, sing, dance in the streets, and embrace our secret gardens. Beyond the numbing grind of reclaiming vanished places there rests another chance to brave whatever hurt bogs us down and to breathe in life's ambrosia, to celebrate life. We rub away the tears and start anew with the resolve of a constant gardener.

Many areas of the Crescent City — vital neighborhoods brimming with personality, stardust and cinders — swiftly dissipated, slipped through our fingers and floated away. Slivers of hearts snapped off adrift as well. Never to be located. Yet, remarkably, the city's historic district remains. The entire Gulf Coast region has been painfully stripped bare and tossed into the abyss but the ancient site from which Greater New Orleans sprang was spared, this time around, the malice of heaven and hell.

As before, this section of the city has known a lion's share of serendipity and good fortune, calamity and contretemps. This bedrock dowager of New Orleans' history remains the surviving wellspring of hopes and dreams of days and men gone past. A birthplace town within a town, so practiced in the art of evolution and deception that it is the place where what is planted within us takes hold and flourishes.

This fragile flawed fortress stands poised, built beyond the grasp of reality and boundaries. A vision of brick and mortar, myth and magic, here the present is culled from earlier chapters. Haunting memories hang heavy in the air and the shadows of ancient mysteries draw close. I am speaking of the French Quarter: "America's Most Interesting City."

This place will steal your heart, as she did mine, and not give it back. Since I am among those she long ago absorbed, I call her the Vieux Carré. Sometimes she is simply the Quarter. Whatever name you choose, she will not leave you unmoved. Her storied streets and gardens are ageless; the past never far away, she is the current coinage of the gold of time.

In an impermanent world of constant change, man gathers strength and sense of purpose from history, fables, fairy tales and romance. For nearly three hundred years we've chronicled the potent secrets, daunting beauty and curious charms of this fractured and imperfect place. Here you see, feel and know the unseen. The dust of the ancients lingers. Rules of realism are torn into confetti.

An island of beauty balanced atop an ill-fated horizon, her existence has always been perilous at best. The enticing enchantress at the bend of the river rises up out of the mist born of the soaked earth just above sea level to impart a bittersweet lullaby. She sings a siren song, the muse's music. It is a lover's wail, of many lives, many voices. She is scarred, withering and faded, yet her glory and spirit are indomitable.

Always a source of imagination and intrigue, the imperfections lining French Quarter thresholds make the district all the more interesting and intoxicating. The Vieux Carré lies thick in the fabrications of history and heresy, embalmed with clotted calcifications and mythologies. Her secrets beat heavy in our heads.

Like a slumbering guardian bell tower standing staunch and regal, submersed in history and suffused with intrigue, she is cloaked in the vestiges of days gone by. Never far removed from the eve of destruction, always courting doom, the French Quarter sits precariously perched at a fragmented crossroads symbolizing all that is, was and never will be; all that we are and are not.

Louisianian and American ancestry besiege and inundate us. The perimeters and interiors of our world-famous Jackson Square, St. Louis Cathedral, and Cabildo and Presbytére museums domicile more distinct hums, insinuations and encasements of history that unwrap before us than other entire cities combined.

The Old Square known as the French Quarter drips with authenticity, eccentricity and humidity, packing more diversions and charms for the senses into its block-by-block grid than any U.S. city.

Within the surreal world that is the Vieux Carré, people of similar sensibilities and logics of the heart revel in supping slowly from the fountain of time. Reminiscent of another era, cognizant of a complicated history, it is a city with a potent hold on those who fancy the past. Unlike anywhere else in America, only capricious New Orleans embraces the gracious, odd splendor of life come to a standstill. Embroiled in fading decay and crackled shadows, the Quarter allows us to traipse backward. We step deep into a morass of myth-filled majesty. This firmament envelops us. No place burns brighter than in the artistry of creative thought.

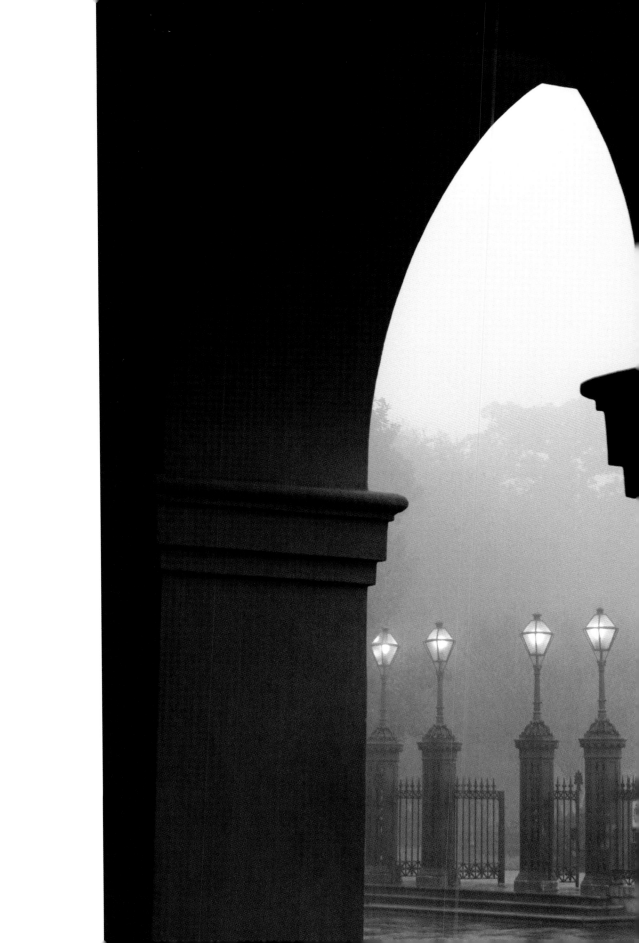

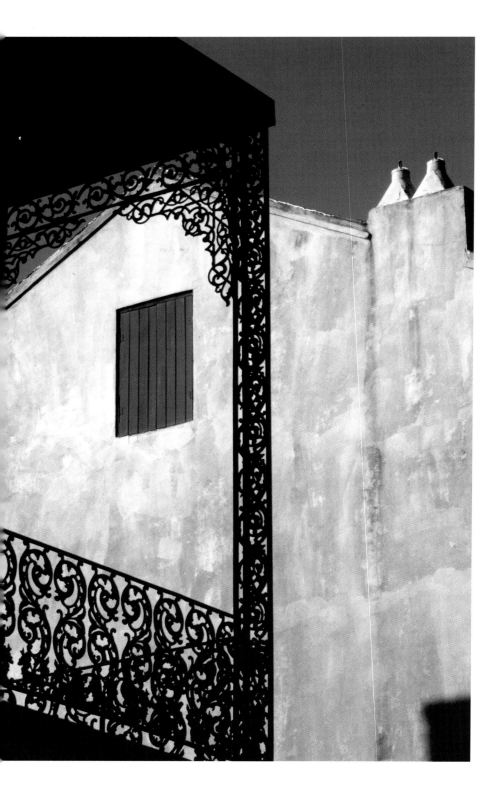

As one of the oldest communities in America, the grand Vieux Carré has always boasted a distinctive identity and character, a culture all its own. A place of secret stories to behold, the cradle and tomb of sorrow and loss, pleasure and joy, it is a living memoir. Today, as in yesteryear, this is the heart and soul of New Orleans. Her fabled fantasia of spellbinding streets and gardens is home to generations of legend and lore.

This is where it began, where the French colonial fortress known as *la Nouvelle-Orléans* was settled in 1718. The French Quarter has withstood the thunderclaps of history and tragedy, the transgressions of man and nature. This genuine imagery speaks from the innards of old New Orleans. Hidden behind her streetscape edifices lies a treasure map of romantic gardens, forever flowering. These courtyards are saturated in remnants and relics of bygone eras, pieces of many lives departed. The Quarter's cloistered spaces are the rendezvous points of many mysteries, the mystifications of forever and a day as you feel the prickly shards of something ancient yet very much alive.

This is no ordinary place. This uncanny city of vignettes challenges our expectations and assumptions about everything. She fuses the past and present, known and unknowns into something that impels our deepest emotions. Her story has been told in song and written word many times over, and few can avoid falling captive to the lure of her alchemistic odd beauty.

The secret gardens of the Vieux Carré remain scenes that rest and revive the soul, offering refuge and solace from the outside world for hundreds of years. All who pass through these hideaway gardens glide through a looking glass encrusted with so many memories. Watchful fallen angels with faces framed in statuary preside majestically over the moment. Triumph is marked over sorrow.

The Vieux Carré, the official grande dame of all masquerades old and new, is a confounding and jarring juxtaposition; a multidimensional character of stunning hybrid ancestry. Having already crisscrossed the line into a half-mythical place, her aging specter can never be put into a deep sleep or eerie silence. She wears the fine mist of another world. Some discoveries go beyond our powers of reason but the heart inescapably knows how to understand what it cannot comprehend. This is that type of city.

We love most what we have lost or nearly lost, what vanishes now and what is long vanished. Perhaps this explains why we

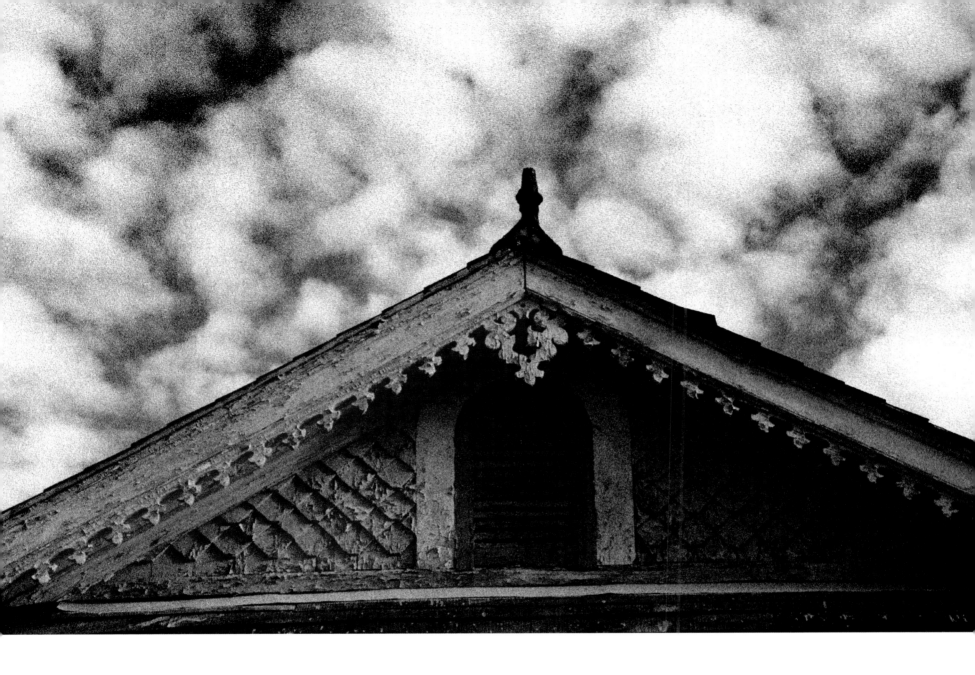

obsessively search out and exhume the ghosts imprinted here. All seek secret souvenirs of people, places, things, loves lost. Here in the Quarter, jewel-like shadows and images swarm upon us. Imagination rules.

Shrouded in perpetual afterlight, the Vieux Carré exudes the mystique of an ageless temptress. A complex siren who does not surrender her secrets easily, here is a locale of history and intrigue where the outside world briefly fades and melts. Yet she is real. Many things are dimming yet still ravishingly beautiful in eternal twilight, and we are drawn to these broken places. Here we catch glimpses and vestiges of all that has preceded us. The dusky symphony that is the Vieux Carré overtakes us and we do not object. She assaults our senses, swirls our sentiments, affects our sight, and we feel it. We know the passage of time alters memories, yet here in the Vieux Carré memories alter the passage of time; those who have experienced this odd phenomenon know it to be true.

A memoir of fate and the unfolding of what remains is rarely written sweetly, yet this elusive place transcends the current tragedy, blurring the distinction between fact and fiction. Despite

floods, fires, plagues, insects, abandonment, neglect and erosion, her voice, as it has for ages, beckons us.

Those who know the Quarter will concur that to arrive here is to step from time into the timelessness that gallivants in a patinaed world of verdigris and varnish.

Throughout the centuries, writers struggle endlessly to capture the cadre of colorful characters who come and go here. Those who pirouette across the stage of the French Quarter reenact recurring scenes that regularly recede and advance as in a long stage run. Traditional units of measure do not exist here. Neither do rules of reason. Whether you are an eyewitness to a particular era or not is irrelevant. Her ethereal beauty is so unique that it can never be sundered into extinction nor razed into mere rubble. Absolutely not. Herein lies an impossible never-never-land town well suited to many lives and lifetimes.

Deep behind her crumbly walls, behind obscuring foliage and garden gates, lie winsome places that murmur to us, helping to unravel life's delicate intricacies. What is gnarled is authentic. The spirit of the French Quarter shall never die. The soul of the city will never pass away. She is the avowed spiritual home to people of all ages and nationalities. Few wish to see through the romantic shroud we choose to spread over yesterday; the cruel tattoo of time is best kept softly draped.

For those who promenade arm-in-arm with tradition, no forward march of modern development or elixir can extinguish the lingering beauty of the Vieux Carré's broken smile or rich heritage — no water, wind, rain, decay or wrecking ball can override the powerful hold she has over us.

But Katrina came close. The beast banged hard on doors. She peered into windows, danced on rooftops, hopscotched

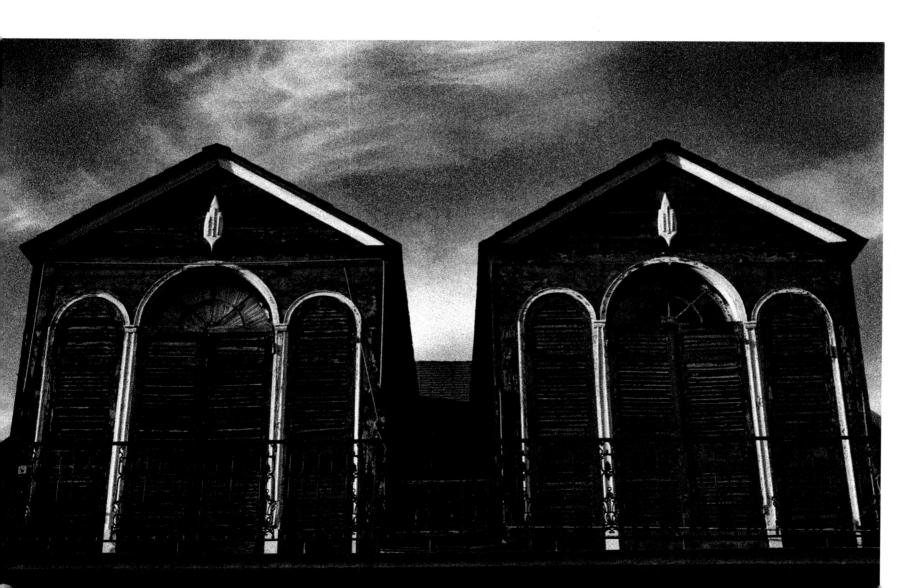

across courtyards. But mostly, in the Quarter, she did not enter. As the world watched in horror, the fetid floodwaters ringed and devoured most of modern-day New Orleans, literally drowning an American city. The harrowing and nightmarish memories of Katrina's landfall remain, stuck in our heads and in plain visible sight. For areas ingurgitated by raging waters that sank rooftops, the fallout was fatal, like a Pompeii or Atlantis plunged into oblivion. Yet our Creole Queen remains. The town I call the muse of the Mississippi River, royal cousin of the Cajuns, seraph of all the surrounding lands and bayous, was not consumed. The crown jewel of the South was not toppled. In the manner of a mythological tale, the tiny Vieux Carré dueled and jousted with forces beyond her. She got lucky, luckier than most of Orleans Parish and other adjacent communities.

More than an over-the-rainbow land of Carnival season — beads, feathers and masking — the Vieux Carré is the talebearer and torchbearer of many things we feel to the marrow of our bones. How do we identify or speak of one's longing to embrace something larger than the visceral present? Something felt yet not grasped. The French Quarter is our *flambeau* in the dark, our bellwether.

Directly attached to the coattails of Katrina came the most devastating and costliest civil engineering disaster in our country's history. The physical and human casualties are incalculable. The damage inflicted is tangible but also intangible; we are forced to regroup and reexamine the meaning of what our life here is about.

In addition to the far-reaching effects and complications of this great human disaster, the consequences of Katrina also represent the greatest cultural disaster our country has ever encountered. Centuries-old slates of history were scoured from record, entire communities wiped out.

In a transient world of darkness and light, much of New Orleans has descended into purgatory. Just outside and beyond the unflooded high-ground portions of our city, areas that themselves were barely damaged, lay endless ribbons of interconnected fundamental neighborhoods where citizens of this community live, work and raise their children. This crescent webbing of our city is unimaginably maimed, gutted and demolished, the surrounding parishes a mud-caked wasteland. Multigenerational scores of residents, banished and wandering, wait in hope for a brighter tomorrow and the promise of a

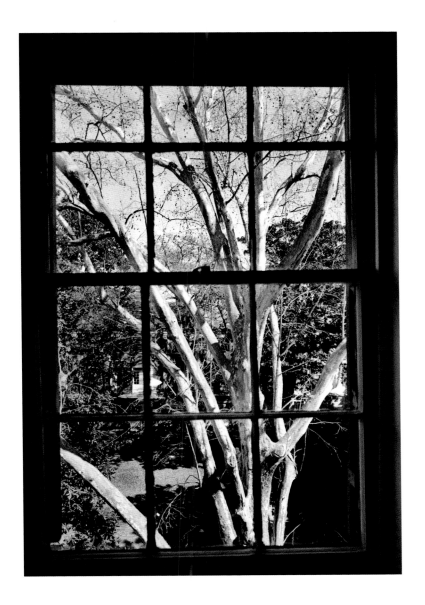

homecoming that may not come anytime soon, if ever. The unprecedented scale of devastation is beyond horrific.

New Orleans is an intimate city of close friends and relatives, an age-old place of intense ancestral ties and relationships. To see a shredded city splayed apart and undone is not only disillusioning, it's mind numbing; the breadth of damage humbling and inescapable. The hideous vision of what is ripped, mangled and torn slices deep into the soul. No great American city should be left lying spread out as a mutilated carcass with bits of people's lives strewn clear across the horizon.

Yet amid the desolation and darkness, astride the brink of the precipice, just beyond the sad shambles and shattered ruins the Vieux Carré remains — intact. A gilded cloud of guilt accompanies survival here. A responsibility, too. She wears that victory wrap like a weighted tattered cape curled around her shriveled shoulders. The banner is obsequious and cloying, beautiful but pensive. As bleak uncertainties lurk near at hand, the heaviness of her allegorical mantle cannot be dismissed or forgotten, ever. She is an evocation of yesterday, a metaphor of today, a warning and promise for tomorrow. The Quarter sketches an outline and effigy of a world that was — all the more priceless in recall.

Backed-up storm waters left behind a catastrophic reservoir of bottomless grief and unspeakable loss, yet the Vieux Carré lives on, the most precious antique treasure we've managed to salvage. To watch the death knell and funeral cortege of a city we love is not easy. Our hearts are perforated, some ruptured. Yet you do not walk away from a love affair, or from communion. We keep our vows and commitments.

Although a monstrously grotesque truth blankets much of New Orleans, here in the Quarter there is an opportunity to break loose from the pall of melancholy. We are still able to dream, to revel in a vulnerable and fragile paradise regained. With the Quarter's imperishable soul and otherworldly charm, she summons an invitation to savor the magic that lives on in our memories.

If the sounds, shouts and whispers of the Vieux Carré were to suddenly fall silent and cry out no more, the world would mourn the loss of what is irreplaceable. The promise would disappear, a curtain would drop across a vast stage; how defeated, sad and ruined we would be.

The Quarter has always been a figurative place, a frame of mind, a watchtower that permits us to transcend the physical and form a new point of view. Her roots expose stories that ensnare us mind and body. She bears the ancient fruit of New Orleans, and more. Love her or not, she shakes loose a thousand human emotions; she translates stone and stucco into the spirit of man.

For now, no onslaught of nature's unbridled fury, no wrath of wind or cruel decay, no coterie of marauding demons has succeeded in darkening the Quarter's ambient light. She continues to stave off the destruction of Mother Nature while surviving the miscarriage and missteps of man. Thus the Vieux Carré did not meet her Waterloo. Her lure and lull persist. Beyond the vale of tears there is life. Birds sing, gardens bloom, laughter rings.

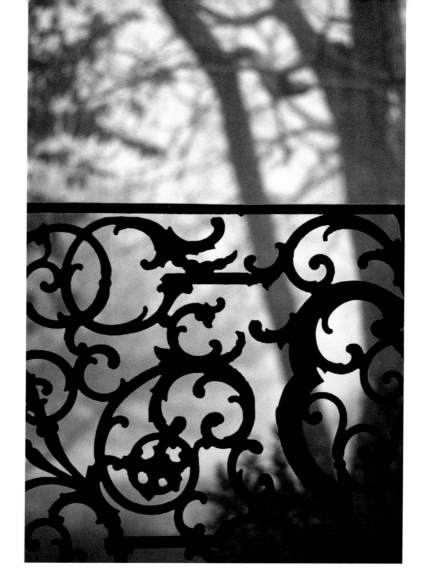

Beauty flourishes here. They come from near and far to bask in her afterglow. The Quarter is a cocoon of relief and hope.

A quintessential muse to a sometimes absurd and tragic society, she holds the pearls of social and aesthetic wisdom. The enigmatic Vieux Carré manifests the strong and solemn, the joyful and resilient, the surviving and indestructible spirit that sustains New Orleans and her people. She understands struggle, has seen her share of hard times. With her broken shutters closed tight, she has weathered the eye of the storm in many incantations. The signature centerpiece of the entire city, she stores the memories of what is departed. Collective joy lingers here. Yet all is not well even in the French Quarter. Do not be fooled or misled. She is a speck in a sea of sorrow where all walls crumble and fall tragically unless we move to save them.

The man-made floodgates and levees failed and betrayed New Orleans, but we must not.

The French Quarter sits amid tragedy and morbidity, hugging the bordering abyss of an indiscriminate netherworld. So much history has been swept away. Ruthless watery jaws nearly swallowed an entire city yet did not flood the Quarter's ancient buildings nor deaden her spirit. The district survived by the mere division of an angel's hair, for the macabre ruination lapped up to her edges. Purgatory is now her next-door neighbor. Into the lion's mouth she did not go; this time she did not perish. She was not pulverized, yet nothing can stand alone as an island in the middle of a deluge and emerge unchanged. The Vieux Carré has been carried to a new place, to another epoch. The Vieux Carré intimates and ushers in the arrival of so many epiphanies that she mystifies and demystifies us evenly, and we find ourselves coddled and mollified by this wounded songbird calling to us as if through the mist.

The Quarter reminds us that we all pursue the past. It stalks us. As we smother in life's riptides and somehow resurface for air, we come full circle, snagged once more by the historical undertow. Indeed, we all long to slide backward to see, hear, feel and touch that remembrance of things gone by. Reborn, the Vieux Carré is a place of tradition made all the more appealing with an air of genteel decay, of lost moments set in brick. Who among us has not craved to recapture and hold onto a moment already passed? Something inexplicable deep inside makes us yearn to relive what is departed. We cannot forget what was, nor do we wish to. Our stream of consciousness keeps close tabs on finished moments, forever pursuing the sunset in which they dwell. The condensation and soot of what is no longer present adheres to us. We hobnob and partner-up with it daily. The procession of the past provides new building blocks. Time immemorial indents and defines our present, foretelling the future.

All who loved the Vieux Carré before Katrina love her now; perhaps more so. Where the flood brought torment and left little behind, the Quarter allows us to saunter along on a sentimental sojourn with what is lost. The district stands as a realm between two worlds, clutching the embers of another era; the ashes boundless, uncounted. Our heads and hearts are twin lockboxes where we stockpile private fragments, true or illusory, of hidden lost loves and remembrances.

Peering through the two-way mirror of time, all is rewritten, commingled as we see, dream and imagine it. The blueprints of history give us strength, courage and conviction to move ahead. In a surreal post-Katrina world the Vieux Carré is a beacon in the ancient mist, a lighthouse in the darkness. And so we come back to the starting point, to begin again.

Moths and termites are drawn to swarm this damp streetlamp city, and so are we. This is a resilient place of warm people who embrace *joie de vivre*.

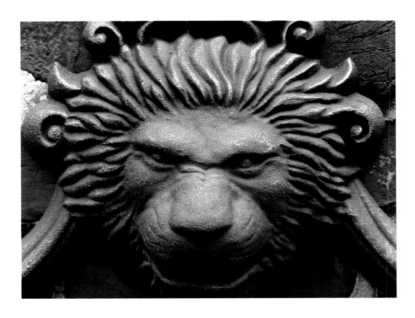

Haloed in a crown of legacies and glories, the Quarter is approached with awe and sentiment. Her influence endures never to be expunged from memory. The layers of myth that spring from this place flow like moon tides; the tales that leave here eventually come home, borne back into this physical place of seeping bricks. The Quarter propagates myth and myth makes the Quarter, each begetting the other.

Do you know what it means to dream of New Orleans? Within the Old Square, everything coexists and parades toe-to-toe in a jester's charade, a half-imaginary twirling merry-go-round ride. Forever shall the spirits of many dance here. Where the circle stops, nobody knows. What is real? What is make-believe? Who can say with absolute authority? The mind is full of false memories. A fantasia of sequences takes us inside ourselves and we remember. Like a wind chime of haunting echoes, a calliope shrills a strange cadence in the clandestine distance, chimes shrieking out a ghostly greeting. A steam paddlewheel boat joins in seconding the phantasmal melody with a guttural foghorn's grunt; squalling pigeons alight steeples, spires pierce the sky, church bells clash and clang warningly, tolling for all in the wake of shadows as a cavalcade of hooves go clippity-clomping across cobblestones. The lush madcap clatter continues. Life goes on. Enfolded and emboldened with rapt beauty, history and culture. A bracing aura prevails here; more than an ode to human suffering and loss it is the commitment to survival, the ability to thrive and go forward.

What is entwined in eternity and our own psyche cannot be obliterated. Amid heartache there is laughter, jubilation and celebration, even in the graveyards, whether at the cusp of General Beauregard or General Honoré striking a command post. Contained within the sagging buildings and beguiling gardens of this odd Eden are recollections, in every one of us, of the parade of pageantry and parables that have passed on uninterrupted for hundreds of years.

A panoramic mood of mystery and enchantment, not realism, is what we hunger for to give us hope and resolve. In the same inexplicable way that some things exceed words, the Vieux Carré is a cerebral city of the head and thus particularly potent and immortal; a place that walks with us. Here the law of probability is reversed and torqued. Without question, the Vieux Carré is a purveyor of images that talk to the heart. Our emotions are magnified, projected upon her weathered landscape. This place of tattered elegance secretes legend and lore as

mythmakers line the streets. We shall never let the Vieux Carré slip away into the umbrage of night unnoticed. She is our magnet of cure and optimism helping to unsnarl the complicated strands of life; even more so in disaster's wake.

Thank you for purchasing this book, a trilogy compilation of post- and pre-Katrina assembled thoughts, pictures, words and memories gathered over time, shared through collective eyes and voices. We are in essence an embodiment dedicated to be the witnesses, documenters and biographers of her fate.

Memorable photography and folklore chronicle and confide truths and mysteries, complex and inscrutable. This voice continues when ours vanishes. The world and time may fall away, but our love for the Vieux Carré lingers and remains even when we are gone.

To behold and be taken in by the French Quarter's strange beauty and sublimeness is to become her lookout and watchtower, as she is ours. Her worth rules stoic and supreme, not to be excelled, for she pronounces an ennobled majesty, a spirit within, crumbled yet visible. By the time you finish this book, perhaps you, too, from something you see, read or feel deep inside, will be inspired to help save not only New Orleans, but also the old queen of the river, the Vieux Carré and her historic buildings, a crux of time and a marker of history. And perhaps, not least, save something of the soul of America.

Our low-lying city was founded on water. The Mississippi River, Lake Pontchartrain, Lake Borgne, Lake Maurepas, Breton Sound, canals, tributaries and the coastal wetlands fan out around us, setting our outer edges and boundaries, with the Gulf of Mexico not far away. Water virtually rings us on all sides, forming a crescent-shaped isle. The waters brought the "Isle of New Orleans" to life, and then nourished that life, shaping our town's characteristic temperament and cultural expressions.

Nowadays, open waters are increasing while threatened cypress swamps and marshes erode and recede at an accelerated rate. Pre-Katrina, it was public knowledge that, as saltwaters intruded, Louisiana wetlands were in rapid demise, with an area the size of a football field washing away every thirty-five minutes. This is actual physical loss. Marshlands are the most important buffer required by New Orleans and Louisiana, an essential value that can no longer be ignored.

We hold onto our world, our way of life. To arrive or depart New Orleans by ground, one must cross a bridge. The

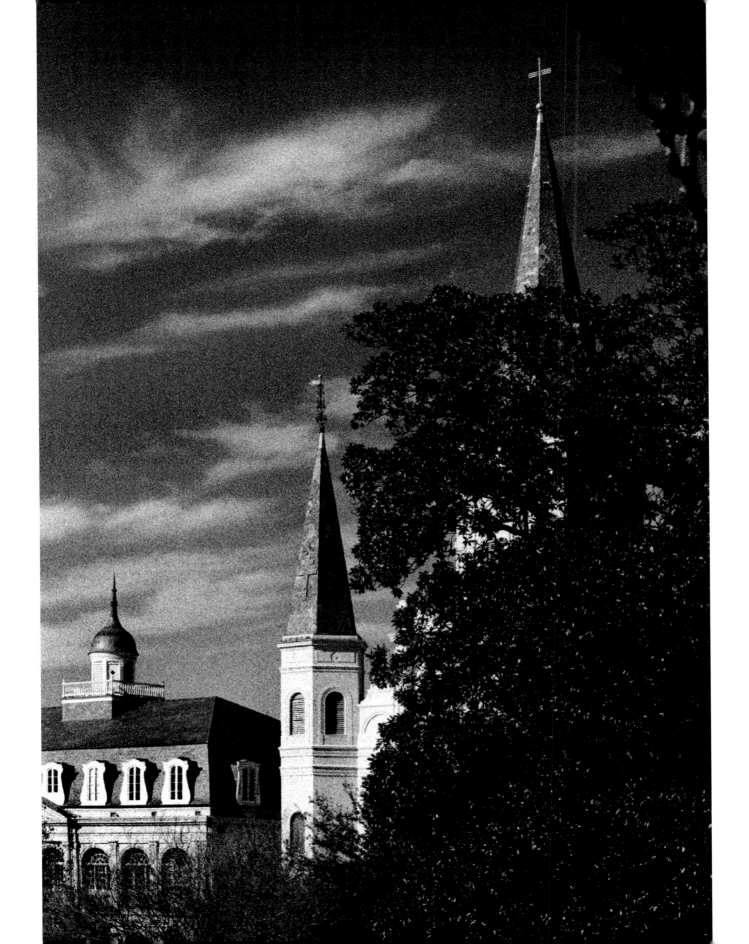

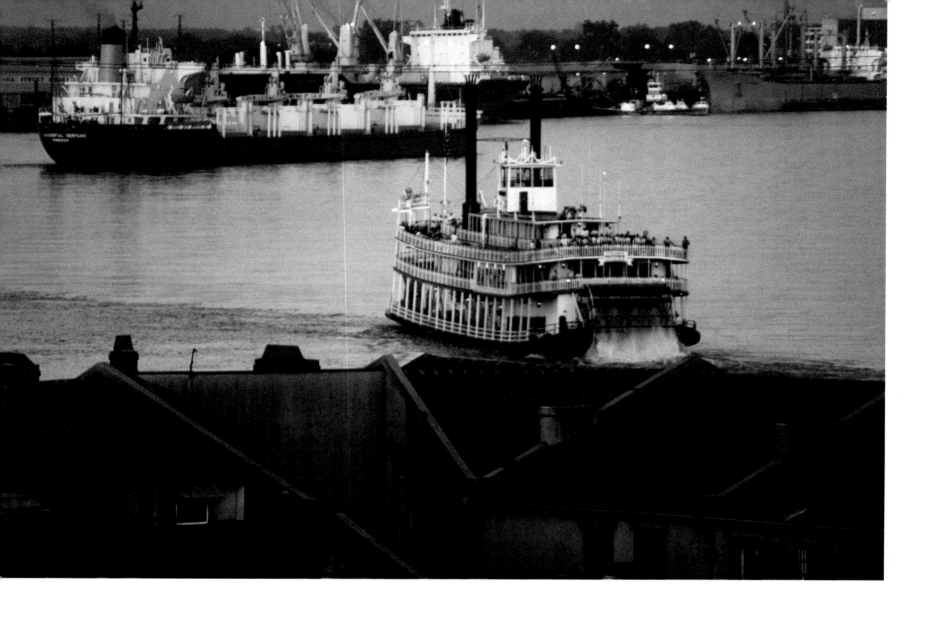

French once called us *le flottant,* the floating land. To this day, we possess the laid-back languor, dreaminess, spirit and lifestyle of a tropical port-of-call locale. Sadly, a dual high price and many risks are incurred along with the pleasures and benefits of a waterside existence, sometimes culminating in an eventual day of dark reckoning.

The waters that surround us and make our city into a virtual island have brought centuries of fair tidings and good fortunes; those very same waters have cursed, covered and taken away much of what we hold dear and never intended to let go of; one more reminder of how life and the earth are only lent to us for a short while, with no blessings, vows or pledges. Thus, with the clear simplicity of seeing beauty everywhere, we crystallize the moment borne here in New Orleans. Perhaps, all the more aware subconsciously that time is limited, that is why the town is underpinned with creative outpourings.

All publisher profits from this special commemorative edition book will be donated to the preservation of the Vieux Carré. This idiomatic name is native to New Orleans, a place where French words are not necessarily articulated the Gallic way. Local pronunciation is different. Vieux Carré ("view kah-ray") means Old Square. It is a title spoken in tones of respect and deference, similar to how one addresses royalty or a dear grandmama. In life, often it is our grandparents who teach us the most, and we feel that generational wisdom here.

The Quarter's authentic stamp of originality and flair cannot be found elsewhere.

A petite yet dense storybook city of only thirteen-by-six blocks, the Quarter is small in size but magnificent in the scope of significance, history and stature. A one-square-mile place of international prestige and global prominence, her essence and influence wraps through the ages. Your contribution will help sustain and preserve this landmark that cannot be replaced. The Vieux Carré district embodies New Orleans' and America's earliest historic identity.

The mainstay of this multilayered compilation is the revival of the emotively beautiful *The Secret Gardens*. A classic work first published in 1993, the original writings and photography have remained unavailable to readers and fans for more than a decade. Now there is new life.

The return of Roy F. Guste, Jr.'s classic edition, *The Secret Gardens*, is a timely postscript and tribute to the Vieux Carré, thankfully, not an epitaph.

The focus of this entirely separate core centerpiece book is similar to each and every other photo also befittingly featured in this three-part French Quarter pictorial, as a remembrance and reflection of mood and emotion; everything you see is a majestic and moving memorialization of the haunting beauty and grace of the real Vieux Carré, revived, given yet another course in the sun to abscond with our hearts.

The pictures of yesterday seem the same, shattery reflections encased in wrappings of deep and stirring memories; yet they are transformed and spirited into something new, in an altogether different place in time, much as is the New Orleans and Vieux Carré of today.

Here in the Crescent City we look to make sense of our past, survive the present and search for strength for the future.

It all appears too paradoxical and contradictory, but then perhaps not, as the dawn and sunset appear alike. Everything is reformed and coalesced differently, reconstituted. The strong and resolute are able to come to terms with what was, accept what is, and make peace with the past. The rest of us keep striving. Sometimes the greatest hurdles are the ones we least expect. If it does not affect you in the heart there is no connection, no consequence. This is a city steeped in history. The affinities and affiliations that bind us tightly continue.

Confronted with the brutal end of an era, we look to define this day; we search for our sum and substance. With beginnings and closures we did not expect, beyond the brink and outgrowth of destruction, New Orleans still knows how to have a good time. Locals are shrewd observers of life's flagrant ironies. *C'est la vie*. We salute much-needed diversions and moments of escapism, an indulgence into a long past. Most of all, we revere the time-honored beauty still found here in our city, specifically the cache of architectural gems sheltered in the Quarter. The Vieux Carré is the ceremonious décor of New Orleans. She is our center of gravity and glory, and we feel that.

With the fracturable allure of something balmy and delicate, the inset stand-alone *The Secret Gardens* section of this book reveals tantalizing tidbits of the quiet interior spots that reign supreme, largely unexplored by casual onlookers. People who inhabit this world of protective edifices conceal many secrets that outsiders are not permitted to observe; yet this special offset book-within-a-book penetrates the abstruseness of this beautifully mysterious city.

The longstanding acclaimed work of native New Orleanian Guste provides an insider's look at the ethereal gardens and courtyards inherent to the Quarter, flanked by a wealth of archaic architecture. This exclusive all-original and underived work, republished without changes or alterations, is even more valuable, moving and meaningful today as when first published in 1993. A prepossessing work that long delighted those who seek out our city's romantic nature, stemming from its age, gardens and architecture, Guste's wonderful *The Secret Gardens* edition was for years near-impossible to find. Although a cult following of loyal and devoted fans continuously clamored for it, the book was not available except by purchase as a collector's copy. Now the work is being returned to a world in search of poetic beauty, revivified.

Also instrumental and relevant to this rare ensemble presentation of Guste's reintroduction of *The Secret Gardens* is the equally visually arresting work of another lifetime New Orleanian, celebrated photographer Louis Sahuc.

Sahuc's collection of breathtakingly redolent photography is an ongoing body of work that preserves the architecture and uniqueness of life here in this national historic landmark city.

Sahuc's cameos are interwoven throughout Parts One and Three of this book, the *Orléans Embrace* sections. His intricate contributions to the Vieux Carré's legacy serve to define and remind us of the exquisite exterior-and-interior face of the Quarter, unabashed, with full-frame images that say something but not too much. We feel a tone, a feeling, a suggestion of what

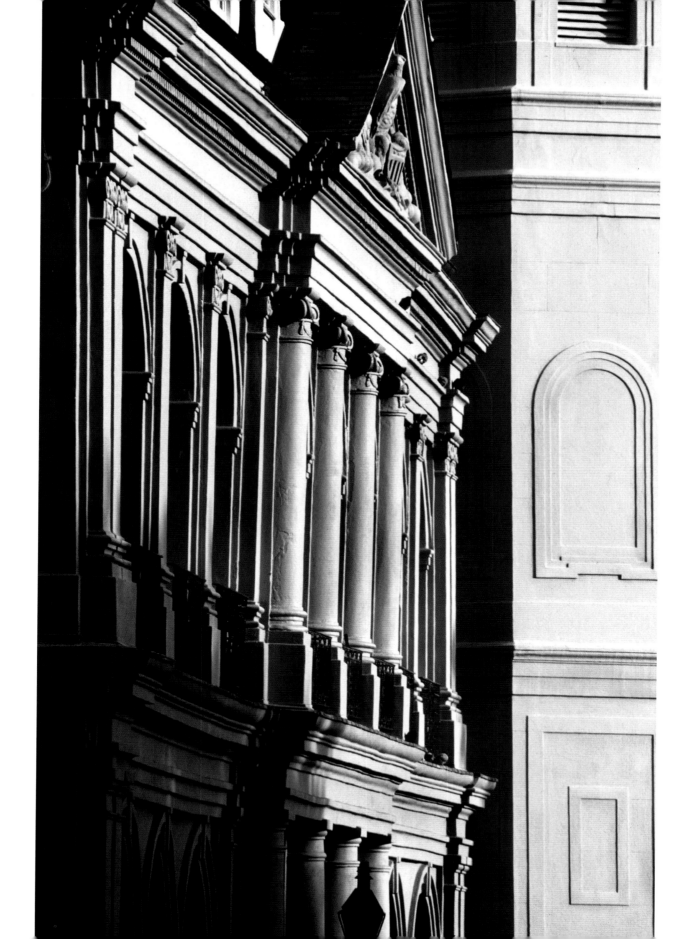

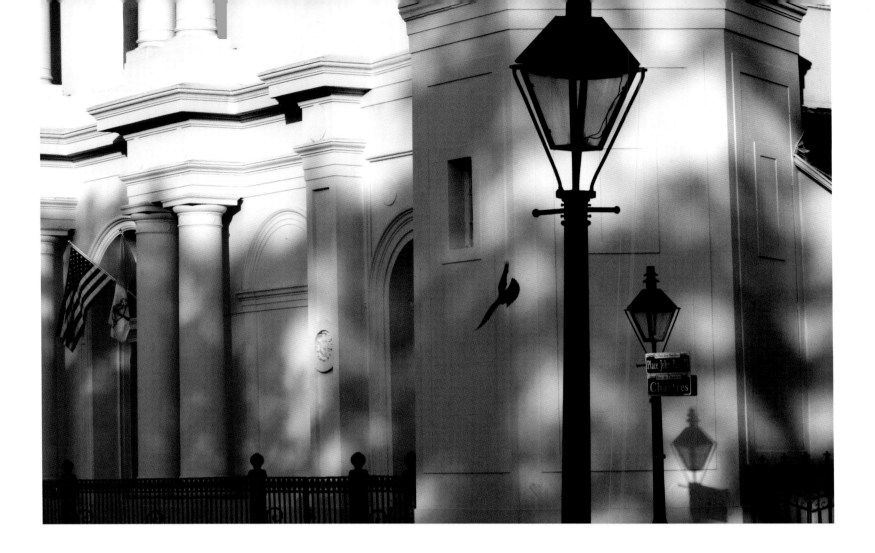

it's like to live life here in the Vieux Carré. Yet his likenesses are illusive enough that we are left to our own devices to fill in the missing parts of the picture.

The French Quarter might initially seem transparent to those innocently unfamiliar with her secrets, but she is translucent at best, and principally opaque. What you think you see is rarely what is there. Most everything here is generally far removed from what it appears to be, at first blush. Most things, properties and people conceal an underlying twist, an edge, and a story.

Sahuc's densely concentrated and unmistakably three-dimensional tintings of the Quarter's subtlest tinges and gradations deepen the depiction of this double-edged city of darkness and light, and we drink it in.

His minimalist photo works allow us to place ourselves directly into the foreground of the moment, fleetingly fateful moments of rich natural lighting and shadow play dancing with

reality. His elemental black-and-white works are particularly heralded for capturing the surreal qualities and ambiance of real-life New Orleans.

Not one to hurriedly take quick snapshots, Sahuc is known to sometimes go back to reframe the same scene an inexhaustible number of times, for weeks upon months on end, even years, just to get that exactly special and perfect one-in-a-million image which he perceives is there waiting to be taken and framed against the recitals of time.

Sahuc's work wakes us and whets our senses, making our mind react and declare, "This is the *true* New Orleans and always will be."

The photography of Sahuc shown in *Orléans Embrace* is nothing like the revisitation of Guste's previously published *The Secret Gardens* work; a wholly separate piece of tender photographic work and ponderings, solely and exclusively featured here in its

complete unaltered entirety. Each of these two French Quarterites has a thoroughly individualistic style — with little to no crossover — of unveiling the Vieux Carré. Fortunately, in the correlating but altogether contrasting sections of this book, Guste and Sahuc unintentionally counterbalance and complement one another, in the ways in which they take an entirely different approach, vision and view of framing the French Quarter's many dissimilar faces and charms.

With the advent of this deliberately out-of-the-ordinary and unique post-Katrina compilation, visual vignettes and narratives evoke and stroke the magic, feelings and stories of what it is like to live in this special place now, in the past, and, we hope, in the future. From the outside to the inside and beyond, reflections of the Quarter's precise yet ever-changing moods, stances and dressings come to life. She is a place of subtleties skirted in overt flagrancy. Pictures communicate this better than words. All photos preserve a shared memory, a legacy, and more. Here in New Orleans, those who have lost all to the miserable depths of watery destruction go to extraordinary lengths to unbury even one single solitary photo from ruined graveyard piles of what remains. We come to understand the miraculous power of pictures to induce our runaway emotions, allowing us — so we might better remember and never forget — to once again gaze upon that which we have known and loved.

In the beginning and ending *Orléans Embrace* sections of this trilogy, Sahuc's expressive photographic essay captures the outward overtones of the Vieux Carré by focusing on suggestive images of elements visitors and locals already appreciate,

identify with, and love. His selective images illustrate what New Orleanians already know — the incomparable uniqueness of our city. We see sufficient hints to envision what percolates just below the surface. With images that initially seem simple and placid, we intuitively long to scratch the surface and look beneath. We immediately identify with the deep secrets, deceptions, happiness, longings and blues that brew there. Indiscernible. Latent. Masked.

In Part Two, *The Secret Gardens* portion of this book, Guste takes us someplace else, as he has before. His core work goes over to the other side, slipping us inside the Quarter walls behind the gates and into the hideaways. He tells a finespun tale in words and pictures, unclothing an internal French Quarter world that very few ever have or ever will access.

With the lyrical photography of these two well-known lifelong New Orleanians now shown and featured together, unusually contrasted and harmonized under one single cover for the first time ever, the enhanced synergistic effect is photographic artistry in motion, in the tone of a gracious and expressive after-Katrina twilight interlude.

The deepness and profundity of the photography shown in this compilation is endemic of New Orleans; an eyewitness account beheld through the eyes of the Vieux Carré's insiders. The Quarter is not a superficial place easily read; her double-shaded characters make for an intriguing rendezvous.

Guste's photo perceptions memorialize the magnetism of what is hidden within depths of the Vieux Carré, while Sahuc's photo speculations commit to memory that which is slightly more obvious on the surface layer façade of the French Quarter's exterior periphery, starkly piquant and provocative architectural elements, often undiscovered.

With respect to Guste's *The Secret Gardens*, a long lost and out-of-print relic of serious collectors and the bookshelves of old, because of Katrina and despite Katrina, this work that laid dormant for far too long has now been reclaimed and dusted off, invigorated with renewed purpose and verve. I am delighted to be a part of this accomplished breakthrough compilation, a milestone and a *coup d'etat* for the Quarter.

In a changed world, the French Quarter remains a niche of unspoken histories, a place that undoubtedly holds old-fashioned modes of living in high esteem. Built upon a substratum and cornerstone of Creole alchemy, a *carpe diem* approach to life is customarily practiced and people "pluck the day."

Every city has a story to tell, to those who will listen. New Orleans, of course, resembles no other city. In abbreviated short-hand commonly used, the initials of New Orleans, Louisiana, spell out NOLA. Look up the name Nola. It means noble. This is a noble, magnanimous city deserving of dignity. Our town is eager to rebuild, its citizens are resourceful and full of desire to redeem and repopulate blighted areas, as soon as possible. New Orleans matters. It is not a place that abides dismantlement.

New Orleans has long been a city in transition. First sited as a Native American portage and trading-route post at the mouth of the Mississippi River, a launching point for explorers and missionaries to travel up into the continent, then a settlement, and later a colony. This gracious old beauty obtained her quintessentially European charm from the melding of many cultures and the influences of a polyglot population. These were people periodically in conflict, occasionally in harmony. A city formerly under the sovereign rule of France, gifted to Spain, ceded back to France, then sold to the United States at the Louisiana Purchase, the Vieux Carré has endured a downpour of calamity and disaster.

The local climate and topography has always been adverse, challenging at best, though this was never considered a detriment to development. To the contrary, her site is a natural stimulus. Her oddities and drawbacks modeled her personality.

Twice rebuilt from the sweep of catastrophic fires, the Quarter later experienced the effects of civil war and the subsequent Reconstruction period. Inconsequential to the century, the Quarter is often praised for her beauty and yet equally accused of being in decline. Snippets of news clippings from the late 1800s and early 1900s read like articles plucked from today's headlines, with comparable recurrent flatteries and criticisms.

I once read an article wondering why my own home did not collapse. The journalist declared my building unfit, in a deplorable state of dilapidation with nothing but thin air holding bricks together. The next wind, he asserted, would topple the walls. That article was written just shy of a hundred years ago. The home still stands today, with the same footprint and walls. The mortar has been repaired.

Despite the turbulent backdrop of the Vieux Carré coming under the authority of multiple and diverse ruling nations, despite the wars, revolts, bloodshed and political upheavals, most of the French Quarter seems remarkably unchanged.

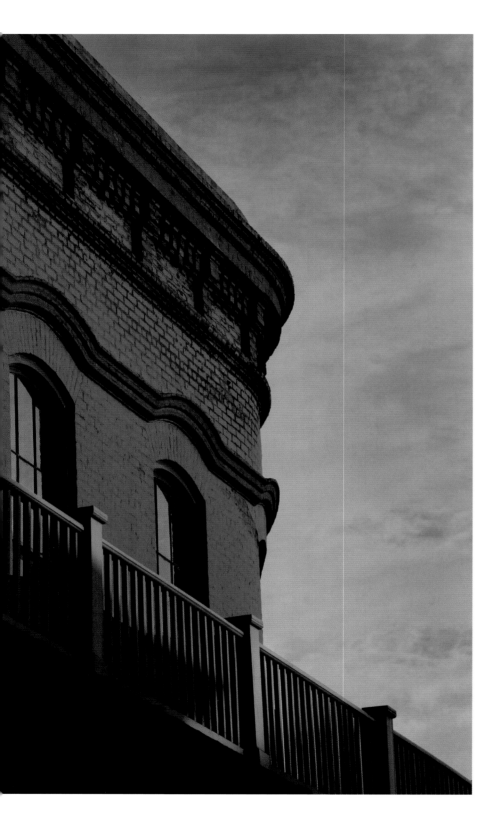

The rotating rows of faces that infiltrate these walls arrive and depart with regularity but some things stay in place. The French Quarter remains a land with a penchant for frequent festivals and parties; a persistent outpouring of food, libation, music and dancing demonstrates the same preoccupations as in earlier French colonial days.

A resolute place that infatuates a world forever held spellbound, this is where Creole society and cuisine originate. A hierarchy of Creole dishes and traditions still reign imperial as the throne's figurehead, like Rex of Mardi Gras and king cake. This kingmaker city pays homage to an unusually proud and magnificent profusion of heritage.

Always at the foreground of culture and romantic intrigue, the Vieux Carré excretes a marriage of myth-enhanced truths. Cajun settlers originally took up residence in outlying bayous and rural regions while Creoles dwelt here in town — yet the Quarter is now renowned as a pedestal of Cajun cooking and music.

This city serves endless palates and plates, catering to connoisseurs of all tastes. The Quarter is a "downtown" major entertainment center with *crème de la crème* hostelries. Her lifeblood revolves around a medley of award-winning cuisine and down-home cooking, from traditional to contemporary yet primarily based on original-flavor recipes and foods typically favored locally. People here indulge heartily in epicurean pleasures.

Formal fine dining in provincial Old World style and innovative, quirky and colloquial eating places can all be found here, each establishment expressing its own individual niche personality and inspirational menu.

Several classic places of business have continuously operated since the 1800s; others from the early- and mid-1900s. The gamut of where to dine runs from swanky to funky, festive to spare. Gastronomic goodies are rampant and the consumption factor high. This territory breeds and feeds a feeling known as "living and breathing" to eat. It is a continual resurgence of this pervasive attitude and pastime that helps keep us afloat.

I would venture to say that these few blocks along with the remainder of New Orleans contain the densest concentration of famed chefs, restaurateurs, cooking talent and dining establishments gathered together in one vicinity, superseding any other setting in the world.

Here you can still walk, not drive, to a tour of restaurants. The culinary attributes and menus of New Orleans rival any other gourmand capital of the world. Bible-like cookbooks born

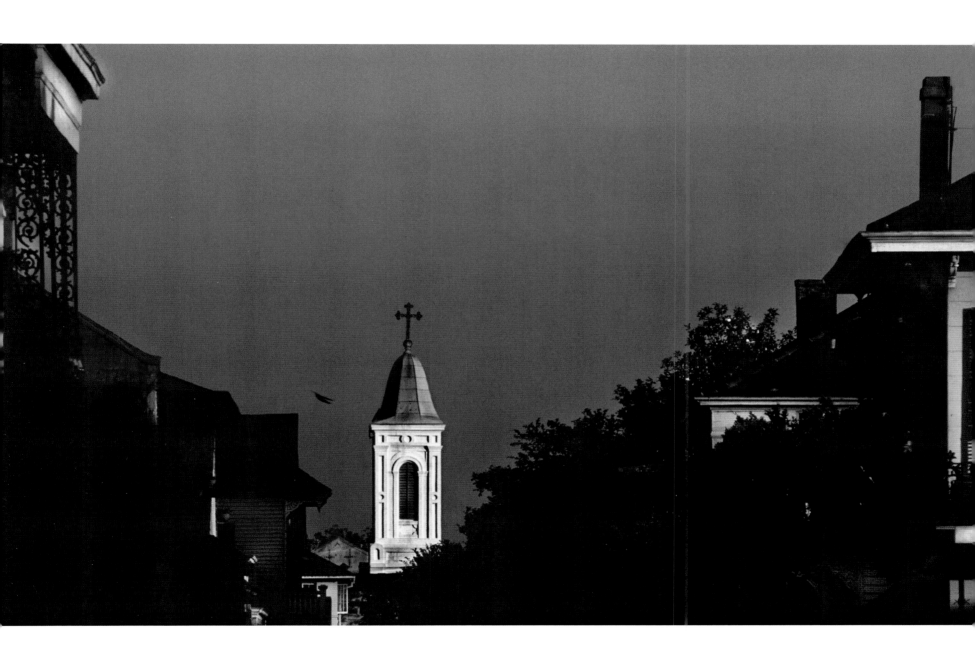

from this inherited hearth of Louisiana are legendary; the recipes and entrees created here are the best and brightest — anywhere. No wonder our hometown ranks foremost among preferred food destinations, premier around the globe.

Artful at aging, the French Quarter has lost little of her character and appeal. At any given moment, even after Katrina, the Quarter looks eerily reminiscent of earlier days, her clogged narrow streets lined with rows of chockablock historic buildings and cottages. Like a tempting magic carpet trail uncurling before us, those besotted by her bizarre mosaic see more than is actually here. Abundantly so.

Tropical blossoms peek out from courtyard recesses, draping vines dangle from lacy overhead ironworks, and cooking aromas drift through scented air. Soft breezes carry musical rumbles and shrieks of laughter, and on most street corners can be heard an atmosphere of gaiety. Thumps and rattles are felt through the skin, like a prickling sensation. Invariably the promise of an

undiscovered dream and excitement appears to be unfolding; as if we tumble through a trapdoor into another sphere of reality, concrete and corporeal yet not. We see an outstretched path paved much like the yellow brick road and are drawn to follow it. We do not want to say goodbye. If only for a brief interlude, all seems right with the world.

This Land-of-Oz town remains enrobed as the historical monarch of merriment and idiosyncrasy, giving us second sight. Interlining the walls of this dominion we see the marks and motifs of anthropology, archaeology, psychology, philosophy, art, music, history and religion.

In the Quarter, vivid accounts, now dependent on memory, are dredged and found. Dig a hole most anyplace here and you are likely to unearth untold shards of broken history. But we of course do not have to actually yank these vanished particles from the ground and walls to feel their presence. They are simply here. We know it. And that is enough to be poignant and

powerful. These masks of eternity cannot be denied if life is to be affirmed; the Quarter is an undying affair, a love story, a story of survival against all odds.

French Quarter characters seduce all. A place that grips the heart, mind and imagination, the Vieux Carré has long attracted, inspired and nurtured generations of writers, poets, musicians, singers and artists. Noted celebrities are drawn here, as well as the fledgling unknowns hoping to make their mark. The frayed, splintered postcard from the past that *is* the Quarter also particularly galvanizes filmmakers, thespians and chefs.

All through history, leading casts of luminaries — those who so prominently impact, change, interpret, color and filter the confines of our world — have been touched by the Vieux Carré. The footmarks of America's beginnings are symbolized here, mixed in with an undergrowth of human spirit gridlocked between the red brick walls and the Mississippi River.

The intense peculiarities and improprieties of this place appeal to the gentrified and commoner alike. The Quarter exhibits two inbred, split-personality faces. Her opposing carnivalesque aspect tempers her imposing stately presence. Regardless of which indigenous character is shown, the incomparable sights and sounds of the Quarter cannot be duplicated. This is no vague, lukewarm town — people who love the Vieux Carré love it with devoted passion.

Celebrities, notables and others from around the world have contributed time and money to recent Gulf Coast hurricane relief and recovery efforts and fundraisers, supporting important work by charitable nonprofit organizations, private groups and individuals. This book project deviates from the norm. In fact, there is nothing quite like it. True to its subject matter, this work exclusively benefits the preservation of the French Quarter.

A special note of thanks goes to Francis Ford Coppola, Nicolas Cage, Jimmy Buffett, Lenny Kravitz, Patricia Clarkson, George Rodrigue, Taylor Hackford, Helen Mirren, Harry Anderson and Emeril Lagasse for their support in recognizing and endorsing the importance and worthiness of preserving this ancient, mystical place called the Vieux Carré.

Karissa Kary, Associate Director, The New Orleans Literary Festival; Rosemary James, Co-Founder, The Pirate's Alley Faulkner Society; James Meredith, President, Ernest Hemingway Society; E. Ralph Lupin, M.D., Chairman, Vieux Carré Commission; Nathan Chapman, President, Vieux Carré Property Owners, Residents and Associates; Joe DeSalvo, owner, Faulkner House

Books; Dorian Bennett and Danny O'Flaherty all contributed to this project, in support of the Vieux Carré's preservation.

You do not have to be a born-and-reared New Orleanian to love this place as wholeheartedly as those who reside here by lineage. Once drawn here, transplants quickly turn into impassioned diehard locals as if they have lived here forever. This city possesses and obsesses a person.

Speaking of literary icons, New Orleans has always had a deep-seated intellectual and literary community with a close-knit concentration of gifted minds. The hazy overcast specter of Tennessee Williams, William Faulkner, George Washington

Cable, Lafcadio Hearn, Kate Chopin, Mark Twain, Frances-Keys Parkinson, Truman Capote, Sherwood Anderson, Percy Walker, Lillian Hellman, F. Scott Fitzgerald — and so many more idols of all time affected by this place — can be felt here, converging and wafting through these courtyards. Their shadows permeate the air and inhabit the space. We see what they saw, feel what they felt and know what they knew. We call to mind the tales they brought to the world.

A bewitching oasis of culture and civilization sculpted from a hostile swamp, New Orleans has always been referred to as a

nonpareil place — with no known comparable. A city that persistently confounds preconceptions, an island of color with a continuing pulse that waxes and wanes, she irresistibly pulls us in close, even in her bleakest of days. Upon these flood-prone banks, many experience in life that which was thought lost but refound here.

More than any other American city, New Orleans secretes a cauldron-like chemistry bubbling up from the streets; a magnet for visionaries and writers of all genealogies, the intelligentsia and Bohemians alike. I call this occurrence the Quarter's *outré* principle, the particle of inducement, some unknown element that rivets us in a way we are unable to fully explain or grasp. The details are sketchy; I guess one must experience the X-factor to identify with it. Many do, even through the long reach of French Quarter prose and photos. Regardless of the era, a plethora of impassioned creative types always fall, and fall hard, under this city's spell. This is not new and is unlikely to change.

Writers, artists and musicians who frequent the road for inspiration come to the Quarter because ending up here is a passport to being on the road, without moving. The well-traveled roads of life have always poured the most interesting of people into these portals, along with the diaries and recitals they carry tucked with them, as everyone wants to share his or her story. The Quarter gives the cold shoulder to nobody. This is a place that permits people to rub elbows with one another, and even the wildest stories are listened to and taken seriously, by someone, because it just might be true. This setting materializes characters sprung from the pages of novels. One must always look twice to be sure. The Quarter is a serious place, curiously primed with the fictitious.

The thousand different shapes the Vieux Carré bears provide fertile background material for works of fiction and nonfiction, the eloquent and shocking things writers compose into words, then recite, leap out at us. This is the city that spawned and fueled the pulse of impossibly larger-than-life characters, voices and dramatic literary feats. These authors and their alter egos forevermore papered our minds and colored our perceptions with images and imaginings of what is here, of what we ourselves might see.

People drawn here find themselves mired in the melded beauty and sadness of a past that rises like mist to cloak this half-ruined, partly forever lost Garden of Eden. Time skirts away into the wings of nothingness but here it is reawakened

and found again. That picture — whether first derived from books, film or theatre — is the primary image we never erase from our minds.

Some view the Quarter as a carnal brick jungle of dissolute dilettantes. Others see a velvet barrio of partygoers. Many concur that the Quarter is a rebellious and insidious "Beignet-and-Bowery Republic" unto itself, taking people down and under; to where, I am unsure. I can only say that this centuries-old place is unusual. Quite puzzling, in fact. It is the city I love best.

The Vieux Carré's fashion and frivolities carry forward the continuum from the eighteenth century to present day. Belles, beaux and gala balls from the eras flutter past in drifting slow motion and then disappear like the *louche* glamour of vanquished demimonde haunts. Coincidentally, about the turn of the century New Orleans was the absinthe capital of North America; second only to Paris in consumption of this cultish libation, the artistic movement's *fin-de-siécle* "toast" of artists and writers. Remnants of a sleepy and blurred dreamy ambiance persist today, parlayed.

Beyond the clamor and fracas of the Quarter, ancient prayers of patron saints sprout like briars of damp growth, calling forth memories. We feel a draft and thoughts of old pierce us. History traipses through our minds. Delicious ambrosia seems nearby, just beyond the brambles and thistles. The Vieux Carré houses the sundown and scintillation of checkered characters and centuries faintly known, misting around us. History intrudes. Filigree twists of the rise and fall of man and memories remain seamed into the bricks.

Of all writers, Williams is perhaps most closely connected with the city. Brilliant, prolific and passionate, his obsessive love for New Orleans lasted a lifetime. A fruitful courtship. He penned his most salient works here and his troubled characters still populate our heads, unshakeable. In 1926 Faulkner began his debut novel here. He honed his own genius talent in the French Quarter, laying the groundwork for barbed-wit works of fiction. Both Williams and Faulkner lived and wrote in the Quarter, and Williams' Vieux Carré secret garden is shown in this work.

The Tennessee Williams/New Orleans Literary Festival and Pirate's Alley Faulkner Society hold separate French Quarter festivals. Their events, outreach programs and writing competitions keep yesterday's legends alive today. These spirited festivities draw fans, international scholars, performing artists and literati from around the globe. It is often said that those with true literary

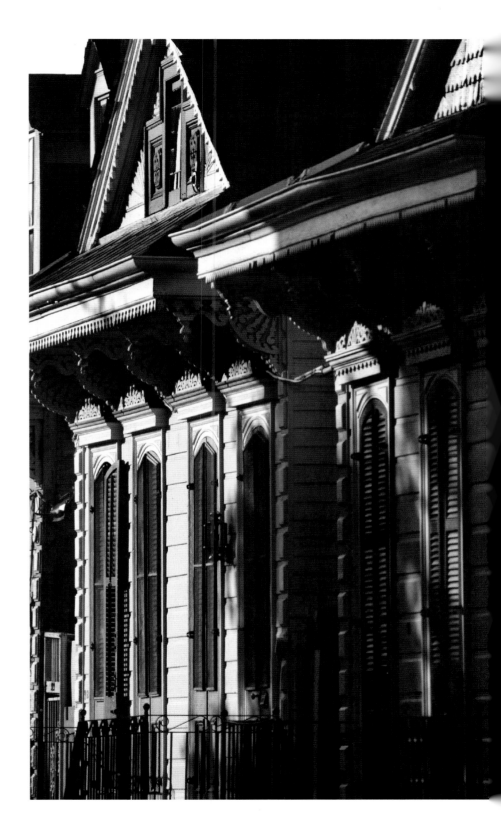

talent find inspiration and transformation here, as was the case with Williams, Faulkner and others.

Although not trumpeted as one of his best-loved haunts, shades of Ernest Hemingway also linger. He, too, prowled these corridors, snuggeries, hideouts and watering holes. New Orleans was among the first to publish Hemingway early in his ascent to literary immortality. Although he never lived here, the allegory association is blatant. People deem the evocative French Quarter "Hemingwayesque" in temperament, attitude and architecture. The allure of olden Spain and Cuba, touched by France, kissed by the tropics and Africa and other faraway distant ports of call are all definitely here. The mix, mystique and essence of unaccountable adventures and the unknown are just around the corner in the Vieux Carré.

No wonder Anne Rice drew heavily on French Quarter settings for her chronicles. Because the lionized literary figures

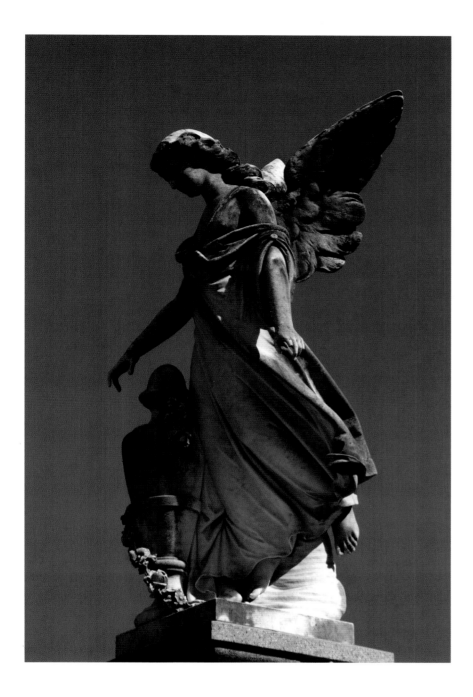

this lost, exotic universe have traveled far and wide; all know of her fascinating, odd essence and beauty.

In addition to an ongoing love affair with some of history's greatest writers, New Orleans has always been recognized as one of the world's most soulful cities, partly because of its rarified love of music. The music of New Orleans has spread to and affected all continents. So have the lyrics. The unfiltered sound of blues, zydeco, Cajun, brass band, gospel, rock 'n' roll and Mardi Gras Indian chant songs all have a long history here. Brooding Irish ballads, sing-alongs, rap and hip-hop do, too. These entrenched legacies and traditions are lodged deep.

While not well known, American opera began here. Although performances occurred earlier, the first documented opera occurred in the Vieux Carré on May 22, 1796. Fully staged opera did not arrive in New York until 1825.

Many who escape into this music-minded town see Storyville cabarets and dance halls that no longer exist. Yet sidewalk serenaders, Jackson Square guitar pickers, curbside horn blowers, and other assorted street entertainers and vaudeville-like performers have picked up the pitch. It is still the cultural capital of a jazz-and-blues-soaked society, a land with an ambiance-drenched atmosphere and a palpable sense of place. Best of all, most entertainment centers, nightclubs, bars, pubs and restaurants promote and feature live music, showcasing local talent.

Outgrowths of tradition and culture carried here through the West Indies and the African slave trade remain synonymous with New Orleans' heart and soul, above all in music. When African kingdoms were robbed of their people who were enslaved and brought to the islands, then here, or sometimes straight here, the descendancy of inbred drumming, dancing, singing and chanting ceremonies begun at Congo Square are felt today. The sense of unity, identity and historical validity is timeless.

In the days of slavery, slaves and freed slaves used music as a "memory thing," a spiritual way of retaining ties to the past and to ancestors they would never see again. Not least, music, the language of the accumulated past, provided a means of secret communications among each other to sustain their own culture on the plantations. This is how they defined who they were and what living meant. To them, to sever contact with the past sealed a meaningless existence. Memory-evoking rituals, music and dancing helped them to survive an unbearable life of separation

we follow have roamed and romped these streets, as do the immortal characters into which they breathed life, it is no coincidence that most feel strangely tied to the French Quarter long before they ever come here.

Citizens of the world are well aware of the Vieux Carré and her strange sustenance; people feel strongly that they have lived and loved here, perhaps in a prior lifetime, or through books, with a definite sense of *déjà vu* for our historic buildings. Tales of

and deportation from their native homeland, by carrying them back into the arms of another dimension, a tribal past. Seeds of these traditions have passed through subsequent generations, influencing nearly every aspect of our inborn music and culture. Implanted African folkways wear on. Voodoo and quadroon balls left prominent imprints here as well.

Our celebrations and ceremonies still send forth the languor and much-needed diversion of momentarily lapsing into enchanted rituals, of otherworldly cultures.

New Orleans is the birthplace of jazz. In the late 1800s, African-American and Creole musicians made history with an impromptu and free-flowing combination of ragtime, blues and marching band music. They felt life "hot" through their horn bells and string-strumming fingertips. These men transfixed audiences with an interior sound of a culture on fire. The spontaneity and improvisational polyphony of the sound grabbed the public by the ear and has never let go. Jazz is an American staple and reserve, exported worldwide. These original New Orleans jazzmen, and the next generation of bandmeisters who followed their beat, some of whom could not even read sheet music, forever altered the course of classical and popular music.

Many more great musical prodigies and virtuosos have been born here since. Local students of the jazz greats and masters continue the ongoing tradition, with or without the benefit of formal training. Professional and street-skilled musicians often co-share a similar limelight here, and participation in high school marching bands is considered crucial. Music matters. The cultural exchange rooted in New Orleans has never stopped.

A mix of moonlight and crescent jazz in the French Quarter rates among life's greatest contentments, and it is seldom that one finds a musician anywhere not in some way connected to New Orleans. Our local and touring musicians and those who play jazz across six continents are ambassadors of all that is the flesh and immortality of New Orleans, keeping her culture, heart and soul forever alive. The world is moved and changed, forevermore.

Who among us can ever forget the raspy gravelly-grit tenor of native-son jazz legend Louis "Satchmo" Armstrong — his proverbial question, his immortalized words and trumpet probing and cutting us to the quick? "Do you know what it means to miss New Orleans?" Yes, we do.

The real French Quarter has been hidden from public view for a very long time, vanished beneath the ruins of her own

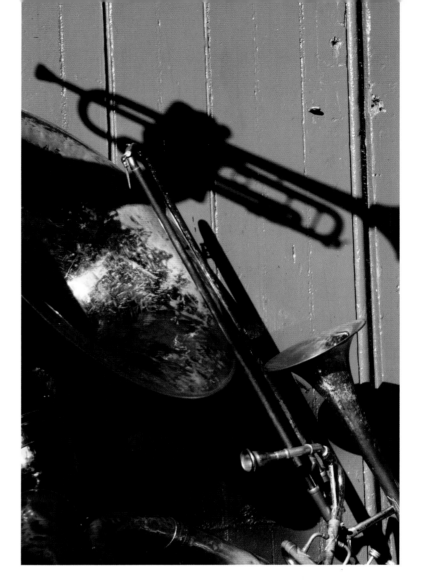

fame. Far too much of her true beauty has been relegated to caricature images emblazoned upon postcards, her bygone glamour trumpeted on trinket souvenirs. This book is the presentment of an authentic illustration of what we had, what we still have today, and what we might hope to have tomorrow — if we join hands and support efforts to save her for future generations.

Amid a blighted New Orleans landscape pockmarked by disaster, a place that weeps cataclysmic ruin, staggering grief and loss, the continued salvation and survival of the most meaningful piece of living history that is the Vieux Carré gives us cause to celebrate. In a region whose terrain spreads out gaping and dismembered, we cherish and honor the traces of what we have left. These days, more than ever, the Vieux Carré resonates with a haunting meditation on the unfinished business

of life. Love lives on. The thrill of touching — a memory — endures over time. This place that speaks to the unfulfilled yearnings that are always with us still snares dreamers, escapists, visionaries and storytellers. The Vieux Carré is our lodestar in blackness, our guiding light in the bleak night. Once a place touches our heart that memory lives within us always, and the

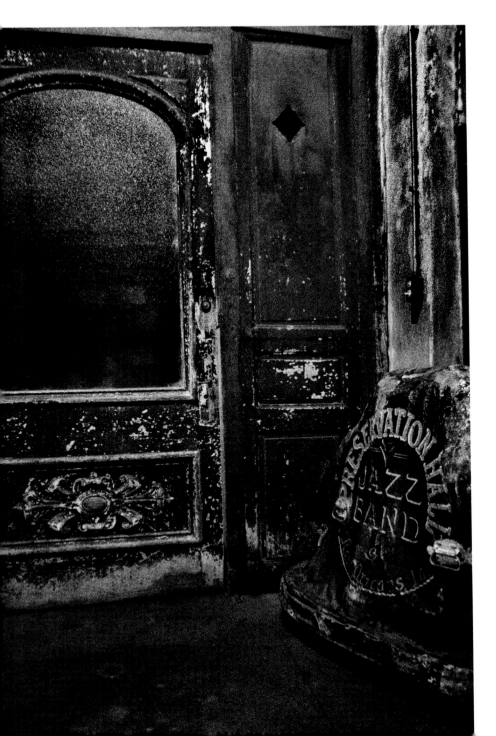

sincerity of our feelings will be passed on to others.

This book, with its majestic photographs, is a deeply reflective work, a work of love for us to ponder and pore over; it is an offering of joy, hope, consolation and contemplation.

The French Quarter exudes the undertones of a tragic quality that cannot be denied; yet the hypnotic effect is otherworldly beauty, stark and startling, pure and paramount. Indeed she is a city that stirs the senses and seduces the soul, for she tampers with our inclinations and toys with the mind.

Morsels of mystery abound close by, impacted into a world of disintegrating bricks and stucco, a site where bowed walls etched with history uphold gas lanterns that illuminate the day and night. Everything we brush up against here has a narrative, a remembrance, a feeling that floats through the air like whispery swirls of breath; invisible, yet felt. In a surrounding that is blotched and scratched, speckled russet with age, paint chipping down through the layers, our faculties are promptly thrown off balance; suddenly that which you cannot prove takes precedence over what you can prove.

In this town each building and relic has meaning to it in the sense of a votive candle, things upon which you can reflect. The presumption of ancient trappings, of all that it promises and dismisses, radiates from foot-worn alleyways and carriageways. These are the unrevealed places that draw us near for a closer glimpse. We detect the invocation of magic that still resides within the flowering of these gardens. And as the steeple bells of the Vieux Carré cry out and clocks toll, she is a sumptuous reminder of greatness. Long ago she made a sweep to greatness, adorned with imperial vestiges, and we see that. When New Orleans calls out to us wordlessly, we are obligated to reply and recall. It is a feeling that cannot be flicked off.

Some things allowed through neglect and dispossessed indifference to collapse and fall into splintered, sundered pieces can never be put back together and made whole again. Ever. The French Quarter is like that; an old grandiose and spiritual place to protect and watch over, for all she has given us. For as long as this twilit town exists, she is persuasive proof that for a thing to be true it does not have to be possible; she is constructed on a paradoxical premise that refuses the bindings of convention, evoking emphatic passions in us. Perhaps that is one reason why we love her so. After all, we are innately infatuated with places and things that are obscure, improbable, implausible, even irrational — sentiments that fascinate and confound us in equal measure.

Undoubtedly humans have an inborn tendency to cling to a hope, a dream and a belief in something beyond our reach or understanding. It is the psychology of man to pick far-fetched long shots, to relish beating the odds, and to applaud when the underdog wins. In this mindset we assume that dreams do come true; the mind believes what lies next to the heart and to a valiant heart nothing seems impossible.

The Vieux Carré was plotted out on a magical mound of ground that is an alluvial natural ridge, blessed by the Indians,

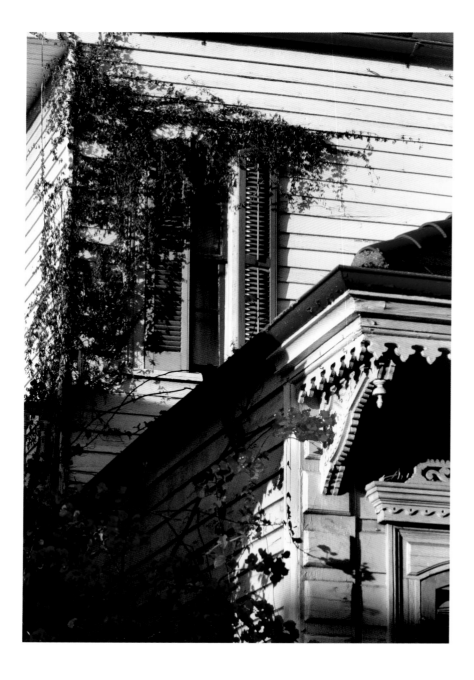

cultivated by the French and Spanish; a site where ancient mystery emanates, streaming up from the ground while guardian angels loom overhead. People's imaginations nurse the notion that a lavish secret life takes place here within this cloistered rampart, and whether or not that's altogether true or partly true makes no difference since illusion is more tenacious than reality. Over time, realness fades while impression lingers.

The resurrection and reintroduction of Guste's *The Secret Gardens* — a rare recollection of imagery and musings, remembrances and reminiscences that only a prodigal son of New Orleans with ancestral genealogy dating back to 1698 could capture so eloquently in moving pictures and words — is a treasury of lastingness to keep and hold. A seamless story beheld, a timeless tale told, this engaging work is a treasure hunt for the human spirit. A personal testament to boundless beauty created by someone so obviously committed to and smitten by the Vieux Carré, it is as if — to bring forth this expressive work to the world — Guste drew upon a moving flicker tape of a lifetime collection of nostalgic buried memories; pent up passions for the city he loves best.

Once you read his crisp narratives and charming anecdotes, you quickly absorb the persona of what it felt like to grow up here, as he recounts a land of dreams of days and childhoods past.

*The Secret Gardens*, shown in its complete original form, exudes the ambiance of a real or waking dream. With a magpie's eye for beautiful objects, Guste undrapes the French Quarter's masterpieces, unobtainable places suffused with the wispy brume of another world. He uncovers the idiosyncratic world that so abundantly blossoms here, just beyond the deceptive outward glitter tinsel-wrap of the external Vieux Carré.

As Guste takes us by the hand to sojourn deep into tangled places that have encumbered and entrapped imaginations for centuries, he propels us straight though the walls of wonderland into the hypnotic ambiance of the French Quarter. As we turn over in our minds the rarefied imagery contained in this work, we are reawakened to the Quarter's vulnerability to vanishing.

For years now, the Old Square abutted the doorstep of low-income areas in decline. Everyone realizes that New Orleans has long been a cash-strapped city with large pockets of poverty-ridden neighborhoods slipping into a quagmire of derelict disrepair, neglect and inertia. Yet, unrelated to breaches of social and economic ills, the community of New Orleans has a strong sense of culture and heritage that cuts across — bisects

and joins — more lines than any other place. Orleans Parish includes a composite mixture of peoples from house to house, block to block and street to street. For those evacuees still in exile, locals miss and love their town equally no matter what part of town they live in. The pain of losing a home is unrelated to the cost or location. The flesh and backbone of this city is but of one face. Regardless of difficulties or shortcomings, home is home — to all.

For those who have no choice but to put down temporary roots in other communities, their permanent attachments remain here in New Orleans. People who reside in unharmed areas of the city have mainly returned, as well as some of the residents from heavily damaged neighborhoods still in limbo, but that does not mean they'll be able to stay for the long term. The ability of families, couples and singles to live, work, thrive and recover in our hometown depends on the overall economics and recovery of the city; the recovery is not based merely on one lone isolated or insulated area, but on the whole city. We ponder the immediate and long-term future. Foregone conclusions are few. Nobody knows, for sure; it's called the art of survival.

The unflooded French Quarter remains one of the city's most desirable neighborhoods, a prime place to relax, enjoy and visit. Here in this authentic place that expels a somewhat false and fleeting sense of reality, she restores and preserves our memories like a perplexing and quizzical sunset stoppage of afterlight. The irony of natural disasters is the preciousness of what's left. Whether people actually live here or not, they move in anyway, at least in their heart.

Nowadays, as noted, the Vieux Carré straddles those shattered edges of a city gone, a town pummeled but proud. Battered but unbeaten. Just beyond the streets of the Vieux Carré spreads a cyclopean swath of pure destruction, rot and decay. Neighborhoods churned, heckled, sucker-punched and destroyed. I am speaking of the cruelly-carved cityscape floodwaters submerged and left in the dark of disaster's outcome.

In the shadow of an epic catastrophe of humbling biblical proportions, more so now than ever, we recognize and pay homage to the fragility yet strength of the Vieux Carré. Her unsealed fate is really up to us, and — since we really do not own or possess her — to what comes next. We are simply her caretakers for future generations. We enjoy and benefit from the French Quarter heritage entrusted to

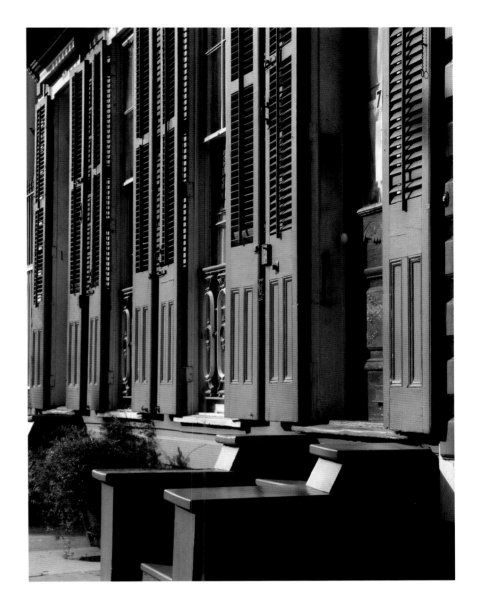

us, though heirship endowment comes with a responsibility to preserve the legacy.

People who do not reside within the Quarter, plus those who do live here, aspire to see what is shown in this work, the calmed world of private enclaves glimpsed in snatches down carriageways. An entirely discreet world lies just beyond the suspended balconies, galleries, ferns and lace-spun iron balustrades that overhang the storefront sidewalks. The lure is irresistible.

All find most engrossing these covert places that do not wish to be seen. Whenever gates are left ajar and unattended, uninvited afternoon guests and tour groups enter into courtyards. Unsurprisingly, the urge to stroll through the secret gardens of

the Vieux Carré is overpowering. Few can resist the temptation. The more we see, the more we want to see. Shadowy scenery, recondite and arcane, lures us with things untold. The soil of the ancients attracts people here to this landscape barely above sea level. All find themselves entranced by a heady whiff of old-world panache. Here strange possibilities exist at every turn, igniting something akin to sensory overload; and if you keep alert long enough, magic will find you.

The Vieux Carré permits us to drink from the chalice of history, each sip bringing a series of reminiscences with stories attached. Here actuality is fleeting yet dreamscapes persist, as do affections for this city; reminding us that the greatest things in life are often totally illogical.

As time passes in an unpredictable fashion, from the street, the Quarter appears deceptive. Occasionally disfigured. Sometimes intentionally so. Not much is as it initially appears. Many properties that first look continuous and interconnected are not. Some are. The majority of adjacent buildings do share a common sidewall; and since lots run narrow and deep, open spaces are primarily situated rearward, occasionally sideward, wedged away out of sight.

What is located inside and beyond the walls and secret gardens is thus reserved from prying eyes. The extraordinary sequel to what one first observes when touring the Quarter is the ragged glamour, riches and dark jewel of a saga lying in wait beyond, sequestered just out of public view. Thus in a habitat where the timekeeper naps alongside a lapsed pendulum, life is a shadowbox full of curiosities.

This endearing town clenches and ferments an unusual coalition of saints and sinners, deep-seated in a buttress of elegance and decadence, grandeur and seediness. The repercussions of peppering together this convergence of highbrow-lowbrow elements — antiquated architecture and *objets d'art* — are crucial to diagramming the particulars of how and why this juncture of magical thinking exists. Some call the Quarter a tempestuous imbroglio; "a nest" of sorts; dissipated and shivered. Regardless, the town is deeply mired and anchored in the marsh — of something. And once it grabs you, it does not let go. A part of your soul is abducted and spirited away. For those who pine for something beyond the conventional, this is the place.

The small-town feel of this historically mixed-use neighborhood is an urbanite's utopia of a true walking city. The lifestyle is geared to pedestrian usage. Cars are unnecessary

nuisances. You can travel by foot everywhere. From A-to-Z, whatever you need can easily be found within these few blocks, including 'round-the-clock restaurants, nightclubs and live entertainment.

The sundry essentials of daily living are also here, mom-and-pop places: a pharmacy, ice-cream shop, book store, grocery store, bakery, florist, drycleaner, laundry, beauty parlor, clothing boutique, veterinarian, shoe repair, mailing service, Internet café, hardware store, day spa, open-air French Market, and more. Though not nowadays, once upon a time even leashed monkeys and parrots were bartered here.

The French Quarter fine-tunes one's spiritual side with ancient cathedrals. Prime shopping, antiquing and cultural pursuits proliferate the streets, including a profusion of art galleries. The Jackson Square artists' colony resembles Paris' painters from Montmartre, with perfunctory oils and easels in tow. Visiting the numerous fine museums housed within the Quarter, followed by a historical walking tour and mule-drawn carriage ride, can round out the days. And when all else fails, invariably there's that captivating pastime of French Quarter people-watching.

As you can see, the Vieux Carré is a great place to live. The best. It has a real infrastructure, a cohesive neighborhood of real neighbors. It is impossible to walk anywhere, even a few blocks, without bumping into friends and acquaintances, and people actually take time to stop, talk and enjoy conversation. Whatever happens, the nature of the Quarter is that the many illusive panaceas of life and worldly pleasures of being alive remain plentiful. The Vieux Carré is the embodiment of a dream lifestyle, a lush life. That is why mainstream America covets a place here to call home.

The Quarter exemplifies a peerless combination of residential and commercial components, a diverse and varied constituency, essential elements to a viable village.

Early on the Vieux Carré emerged from the confluences of a great port city. Colonial sailing ships carrying cargo and people from all shores arrived here routinely, as did keelboats, flatboats, canoes and steamboats. Waves of disembarking foreign sailors, soldiers, dignitaries, immigrants, visitors and the slaves transported here against their will all brought some vital piece of their culture and origins with them, things that contributed a lasting underpinning of intrigue. Much that was unloaded at the docks and wharves remains, or at least a shadow of it.

The entire town typifies the Don Quixotic sixteenth- and seventeenth-century Renaissance passion of *Wunderkammern* — curio collections of natural wonders of the world displayed alongside works of art and man-made feats of ingenuity. This ideal of collecting and displaying exceptional artifacts and random treasures defies rhyme or reason. It concerns a combination of inquisitiveness and curiosity, nature and art that affect you with a "wow" factor. As though Cervantes were still with us, the courtyards and buildings of the Vieux Carré spill over with extravagant things brought back from faraway places, each object replete with an anecdote affixed; some hermetically sealed.

The opposite of minimalist, this is a maximalist town — in every sense of the word. The Quarter imitates art, imitating life imitating art. A friendly, unruffled, easygoing locality, the lively disposition of the Quarter reflects tufts of polite and café society protocol mixed in with the rabbles of society. The end result? An existence and style of living imbibed and enlivened with extraordinary jocularity.

The duality of nature seems extreme. Here the unlikely happens frequently; ironic situations and chance meetings are an everyday occurrence.

The Spanish building-style character of the Quarter is the mainstay crux of these dramatic tall-walled spaces, places with an enclosed feeling and pronounced vertical accents. This architecture originated when the town was Nuevo Orleans, under Spain's flag. Some suggest no garden should be without a wall. The Vieux Carré is a province of walled gardens.

Bastions of brick that encircle our gardens and make up our buildings symbolize many things to many people. Some see pieces and outcroppings of legends and folklore; the romance of chimerical castles built in the air, turrets in the sky. Others see what is there, perhaps what went before. The prequel of our own individual back-story determines each person's interpretation of the French Quarter's multicolored literal and figurative implications.

In the Quarter, history is not merely something observed from afar by leafing through the pages of textbooks. The rich cultural heritage of our forebears still shapes, pervades and surrounds daily life. Each and every block contains an overlaid maze of diverging walls and exotic gardens, insightful places doused with age and wear. An aura of courtliness and a sense of seediness drench the air. The earth here is caked with phantom vapors that encase the old town in webbing that spins throughout

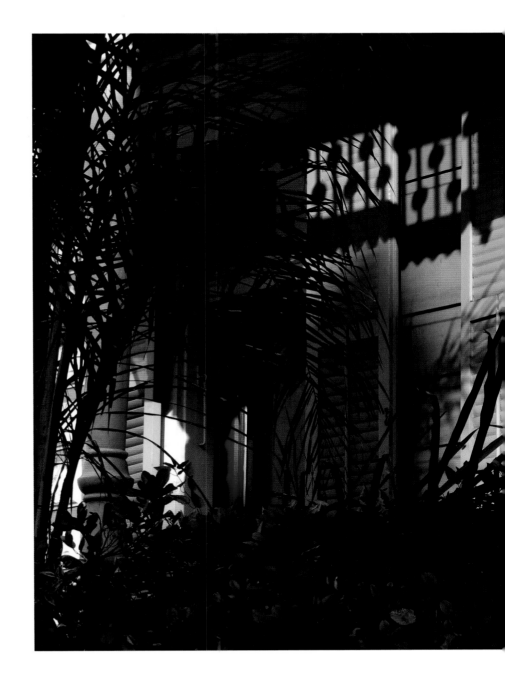

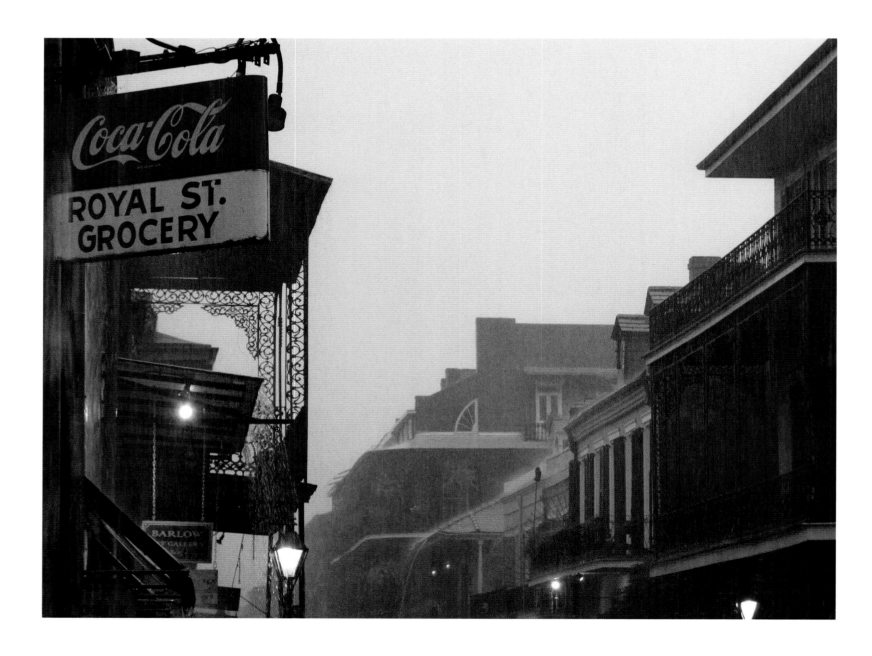

the ages. As noted, this town's sodden history runs deep, leaching into every crevice.

The framework of the Vieux Carré is the most obvious differentiating trait that sets it apart from every other city. The linchpin of its uniqueness is its patchwork configuration of nonstandard blocks; gorgeous muddled mishmash that it is; a jigsaw of lacework and checkerboard squares. Laden with surprises and quiet dignity, unreadable from the street, the Quarter exhibits a jumble-knot of irregular lots and buckled buildings, all with radically diverse yet adjoined provenances.

Larger structures tower over and peer down upon smaller ones. Some dwellings sprout off of each other like reciprocal symbiotic appendages, as though bracing upon one another for diametric balance and support. Interesting projections of ramparts and parapets cohabitate agreeably. For sure this is no symmetrical place. More like a fantasy tour. Nothing is regular here, since

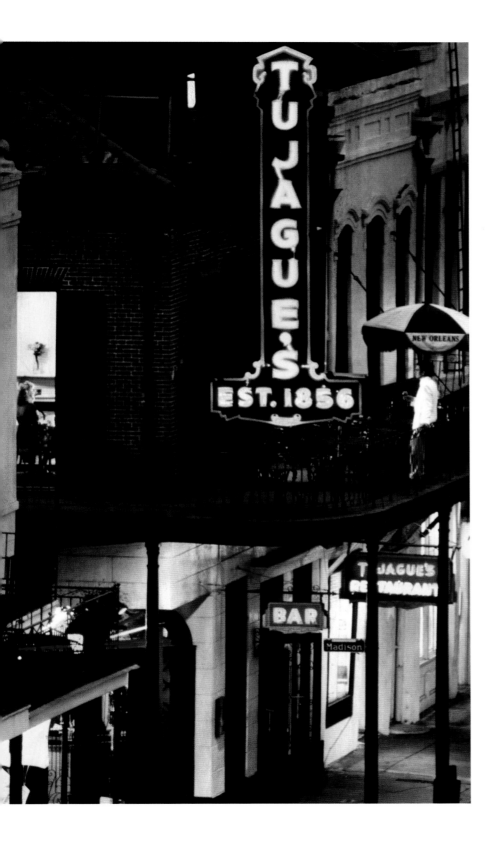

everything is irregular. And occasionally outlandish. A baffling juxtaposition, to say the least.

Similarly, this whimsical camaraderie of being thrust into intimate proximity of neighbors and close quarters is an accepted manner of life. The whole town is a matrimonial tie-in of multifarious styles and construction timelines; the overall appearance that of a delightfully quaint place tweaked from an *Alice in Wonderland* adventure gone slightly amiss; a locale spiced with overtures of lessons learned and written far earlier; perhaps a smearing of Grimm's fairy-tale motifs. The effect of this crooked, distorted, cockeyed fairyland sitting slightly askew is altogether romantic. Of course bits of sober architecture pop up here, too, but visitors especially love the preponderance of arched openings and tunnel-like carriageways that appear as arcades.

The base color and trim work of each residence and business designates the particular era in which the building was built, explaining the multihued contrast of color schemes.

A city of alcoves and walled compounds, some dependency quarters — whether they be attached or detached secondary buildings — are constructed so deep into the interior of the block that they cannot be seen or accessed from the street; only by small walkways.

The rhythm and rhyme of each block is divvied up into misshapen plots, while buildings reflect unequal scales of random height, staggered elevations and setbacks, all predetermined at digressing intervals in history and thus leaving no uniformity in the size or shape of property lines or buildings. Homes and shops often occupy the same structure. The harmony is in the disharmony.

Many houses exhibit features of more than one architectural style or period, since over the years random unregulated facelifts were performed and embellishments added, popular to the particular in-vogue rage. A myriad of ironworks relative to galleries and railings were added to preexisting structures in the 1850s. Nowadays, historically significant buildings may not legally be altered or ornamented externally to become something they are not. With a smattering of elfin-like cottages squeezed between "mansion" townhouses that can reach three or four floors, the conglomeration of assorted cultures and periods is obvious: layers of alluvial brick-and-air façades that can only be constructed over time. A lovely memory that stays true to the heart, the Quarter is a pillar of the past, the spirit of all that we are, recalled.

The Quarter is indeed a preeminent portrait of preservation. The main reason this town — once a fortress controlling the fortunes of the interior of North America — exists today is because of preservation, particularly in times of destruction and renewal. It is an historical marker for the entire world's enjoyment.

The enigmatic gardens of the Vieux Carré are thus miniature misty corners of the ages where you can hide away; amid sleeping-beauty buildings tucked and scraped in sheaths of brick and mortar, ringed by sentinel statues and fountains all barely half-nudged out of their drowsy repose. The deeper you plunge, the more curious it becomes. An encounter in the Vieux Carré could be now, here and today, or it could be a limited view of turn-of-the-century Spain, France, Cuba, Caribbean or West Indies — a seductive slumberland collage amassed from the centuries.

In the past, depending on the period and the residents in occupancy, the irregular and complex central courtyards have undergone a series of incantations and metamorphoses serving a variety of needs and purposes. They have hitched and watered horses, received carriages, constrained farm animals, grown vegetables and flowerbeds; served as working spaces for cooking, cisterns, washing, bathing and privies. They have been paved and unpaved, with wells and fountains, and, with the advent of motorized vehicles, have been used for parking.

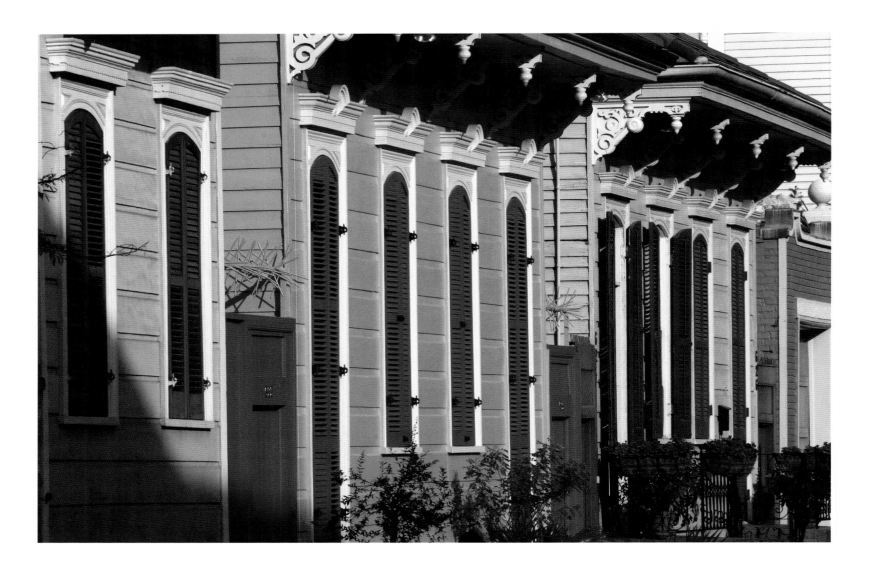

The walled gardens of the Vieux Carré are enshrined in crumbled everlastingness. These broken, cracked places lie beyond the Quarter's scalloped skyline laced with dense protrusions of plunging slate roofs and slim chimneys. The world encased yonder of the sagging shutters is where dreams exist, where solace and fadeout from the maddening crowd are found. These are the muted spots closely guarded by statuettes and wrought-iron gates seemingly ravaged by the years, by weather and neglect. However, even exclusive luxury properties restored to their full glory are deliberately maintained to reflect a pedigree of age, wear and abandon.

Here a hodgepodge sprinkling of blemishes and defects is appraised an asset. Eccentricity and eclecticism are valued. These traits are not considered — as they might be elsewhere — unsuitable deterrents. This is so for people as well as buildings, gardens and architecture. Any attempted intrusion of architectural nouveau, fakeness or picture-perfect perfection is openly scorned. To lust for unadulterated spotless perfection is nothing short of treason — an insult to the gods. The imposition of authenticity is admired. Old buildings are granted the right to have faults unresolved, and personality unstripped.

Whenever our eyes behold the Quarter's courtyards, we loll amid a camouflage of shadows in a lair burnished with a sensual layer of tropical allure. There is an exaltation of the senses as one stares fixedly at these private Eden places basking in that softer light that is, overall, magical. These are the favored tabernacles of each era, places where much history has transpired and meetings occurred. Ivy-twined walls conceal the reverberations of so many conversations, comings, goings and passings.

Here within a luxuriant environment of romantic mossy greens, copious rusts, ruby reds, dusty roses and midnight blues, an uncustomary template of intrigue is woven: an alternative reality. A person's wits and judgment root out and light upon new logic. Absolutely nothing here is clear-cut or succinct. Everything ubiquitous and ever-present comes with a twist. This town perspires sticky steamy secrets that have nothing to do with the temperature; this is the pervasive climate and condition of the Quarter, in addition to humid weather, along with smatterings of sweet olives, honeysuckles, gingers, jasmine and magnolia.

Perpetually overgrown and damp, these tempting courts are sultry shrines of spectacular tropical and subtropical plantings. Bananas, gingers, ferns, various citrus trees,

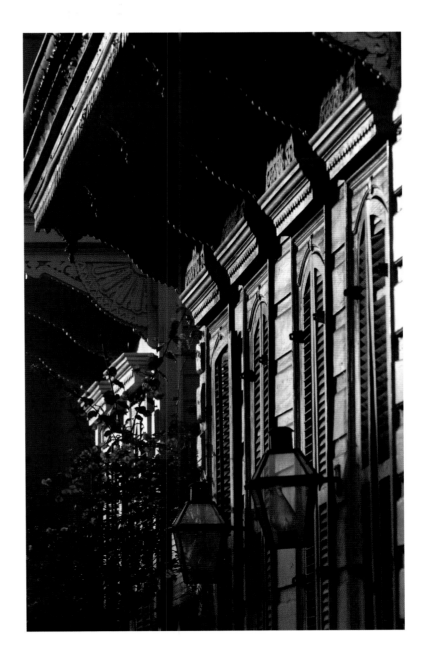

palmettos, magnolia, crepe myrtle, creeping wisteria vines, and all shades of blossoming bougainvillea spill over the brickwork. Such romantic landscapes were lovingly yet realistically depicted in the 1880s by New Orleanian author George Washington Cable, though even Cable, with his remarkable, near camera-like texture of the realistic and with the emotional force of the romantic, would have difficulty

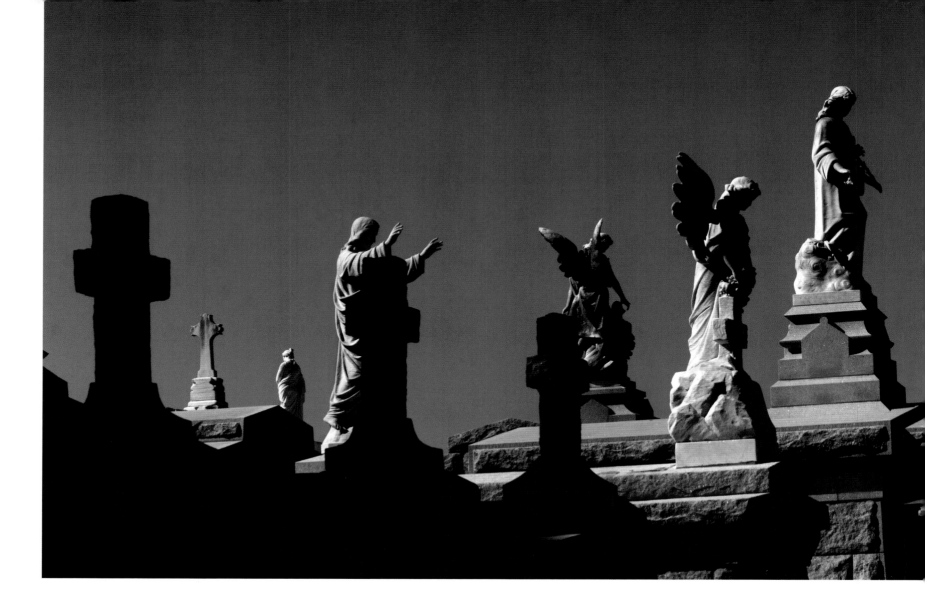

articulating the scenario of the secret gardens with full justice. Almost no literature could do it justice. Onlookers conceive and perceive the images of the ancient riches, mysteries and pleasures beyond, things that passed this way, once upon a time. The heart of the French Quarter is a viewpoint, vantage point and vanishing point.

This compilation is a moving memento of the Vieux Carré's memories and mysteries. Despite all, she possesses the culmination of a repertoire of bewildering longevity, and her original imprint of character still exists.

This collaboration and consolidation of rare photography shown together under one binding sets the gold standard for an exquisite dreamscape pictorial. The assemblage of images portrayed here smudge the distinction between an eclipse of now and 1718. These classical images exalt the cryptic come-hither charm that the French Quarter has always had, pulling you back to the place where it all began.

At this epic moment in its history, through photographs, we see and feel the passed down generational lineage of great-grandparents, grandparents, parents and children, all seemingly touching hands and hearts. Memories last. Circles have no end.

In New Orleans the dead and the living have always coexisted side-by-side with honor and respect. Although cemeteries are often shunned by contemporary society, here our "Cities of the Dead" are highly respected, esteemed sites. In fact they are vibrant cultural landscapes. New Orleanians really do view life

differently and live atypically, and that premise affects all who visit here. Maybe that sums up why the Vieux Carré casts a compelling spell upon us like none other, her dilapidated face and old constitution reaching us and moving us in ways we do not comprehend. She sears our hearts and sparks our minds with impressions of things we have never known; she coddles us with a strange salvation, her essence embodying the long lost missing pieces that link us to other occasions. Everything about her is so hauntingly familiar. We move intrepidly forward through life by revisiting scenes of bygone days whether those visions are factual or fond illusion.

The tempo and color of this city carry the recollections of many lives. Like mist spiraling upward from the moist earth, the manifestations of memories change shape and contour for the occasion. More than we know is summoned up. Memories take many forms; they do not match real life. Here, shimmering like a mirage in the muggy air, we feel historical cultures swarm upon us in a profusion of dialects and accents: the ethnic cross of African, Caribbean, French, Spanish, German, Irish, Italian and Sicilian influences and more.

Even after Katrina, perhaps particularly after Katrina, this postage stamp-sized district of a mere handful of historical blocks remains suspended in a continuing waltz. Yet she is mercurial, full of never-ending surprises. The Quarter derides reason. It brandishes a specter that defies and defines all. These storied and styled streets and gardens are built on layers of elapsing, eroded history; yet the feted French Quarter transcends the inscriptions of man. No matter what historical period, in poems and essays wordsmiths have forever described their New Orleans with words that drip with awe, love and reverence. And there's a reason for that. Most assume time is factual, but here, we know, it is fictitious.

Again, I ask, "Do you know what it means to miss New Orleans?" I love the sound of those words. If you do, too, this book will transport you there. Take heart, for you are not alone. As everyone knows, not long ago the Vieux Carré and her ancient mannerisms were almost lost to the world forever. Once again she was spared, although much of New Orleans was not. As in yesteryear, it is perhaps her role to help soften the wrath of strife and sorrow that fills the skies, her destiny being to light the doorway to the emergence of a new era. A perfect reminder that our nation and the world cannot afford to abandon its great cities; cities that have over the decades provided most of the nation's wealth of scientific, cultural, educational, religious,

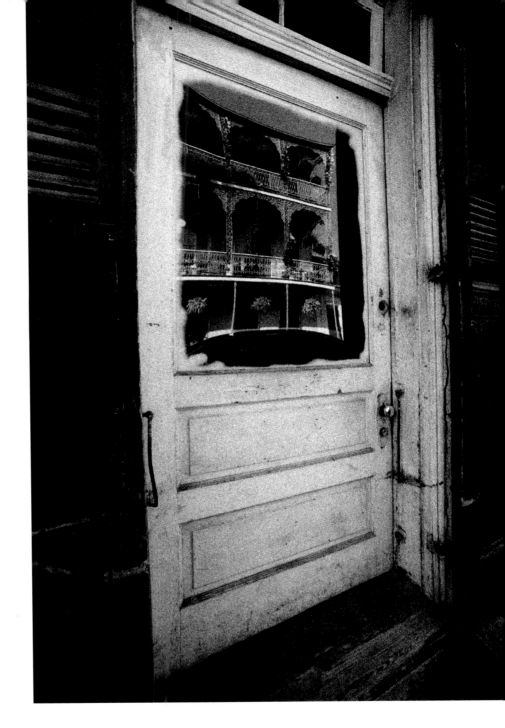

architectural, artistic and other contributions. We reconcile our lives and commit ourselves to where we go from here.

During the span of ages, people from countries around the world have sensed the unmistakable presence of something seminal and real that thrives here in New Orleans, more than mere merriment and the astonishing, aged architecture. She has

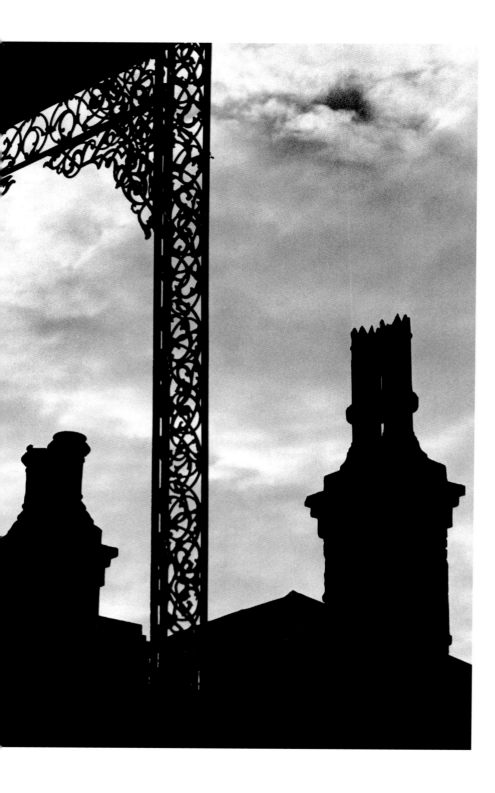

the characteristics of an odylic force — the Odyssean lure of sweet sirens — with the phenomena of mesmerism; her personal appeal and magnetic charm remain unmatched.

Over and over again, the Quarter has always had that intriguing mystical gravity pull drawing us back to her Old World origins. We are disarmed and cajoled; and although we have difficulty grasping how or why this place affects us as it does, we do not complain. We simply accept it. Unequivocally this little labyrinth of magic is an enduring spot that has survived and in fact thrived amidst a dovetail of extraordinary chapters, *quand même* — no matter what — against all odds. It is an explicit point of convergence, a bold and flamboyant site where the grand old massive roots of that complicated history — architecture, culture and traditions — intertwine and run deep.

Those who know her well agree that the Vieux Carré is a real-life manifestation of such a mythical place that murmurs to us in an unwritten language universally recognized and understood. She spins an uncommonly peculiar, aged spell upon us. Her beauty, glowing in the tawny moonlight, smites us. This setting is an infectious manifesto of more than we know, an incantation of the ages. She is the archetype of an old craggy and stooped yet still vainglorious courtesan. Aging, shabby, insouciant, captivating, the Vieux Carré, collecting countless passersby, is adored by most all. Depending on how the haze settles across her buildings and gardens, we see contours and outlines of what inspires us. It's clearly part of her wile, the prowess of her persuasion. She is real, firmly rooted in reality and yet phantasmal.

When legend and documented history come together it is difficult to distinguish between them; yet none who have felt the influence can forget the power of her charms, and few can ever leave her without regret. A chimerical city, she brings pleasure and delight.

In a repetitive, conforming and all-too-often "correct" world of pristine yet unidentifiable run-on communities populated with manufactured cookie-cutter houses and freshly minted suburbs — universes where, even without fast food restaurants things look disturbingly identical to everything else — here in the Vieux Carré you find a freedom not found elsewhere. Here, no two buildings, walls or courtyards are exactly alike. Here, everything is completely dissimilar and individual. Here, most people are so accustomed to artificiality that the absolute realness of the place strikes them as fascinatingly

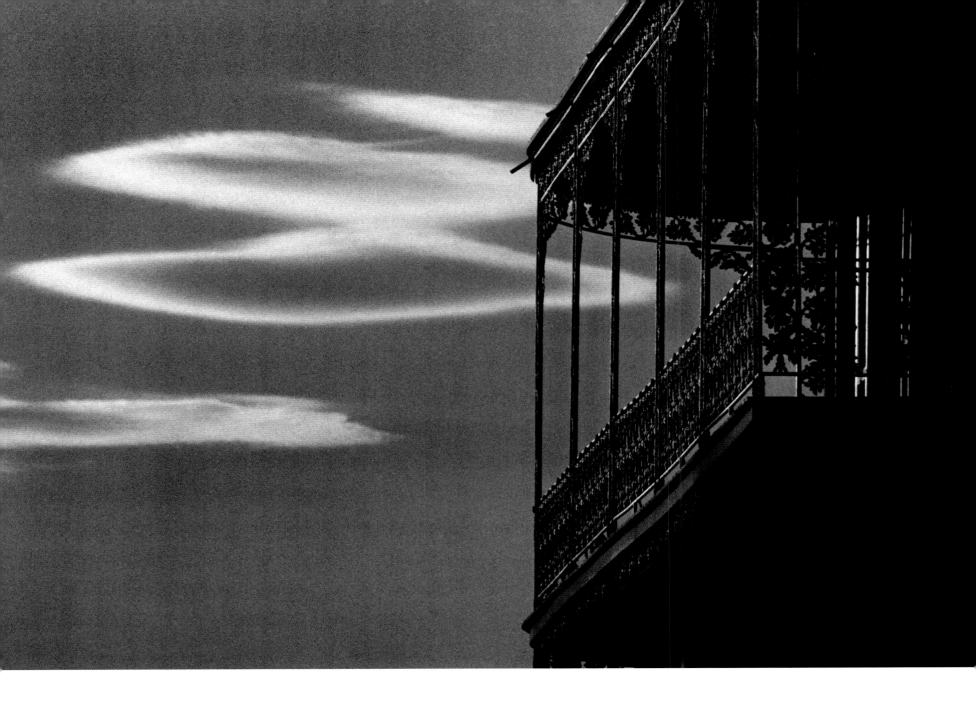

unreal. An invaluable contribution to the nation, the Vieux Carré makes us redress all too many of our own institutions in a new light.

Many come to the Quarter to grab hold of the moment in a place that welcomes and embraces the flawed peculiarities of all walks of life. Here the absurd, abstract, unreasonable and unexplainable intersect. Not least, this *recherché* city remains a peculiar parlor of mysteries where a parade of happiness overshadows heartbreak. The Quarter dictates that mirth and merrymaking trump misery. Victory surmounts loss.

The Vieux Carré adopts us and accepts us into her fold, cradling us to her ancient bosom. From the crib to the tomb one can go here, yet it is not minded as much as elsewhere. The Quarter cossets us close. This is an intense place of deep illusion and imagination, an idyllic retreat, a respite from the charades of the world; and of course we all search for some velvety place to

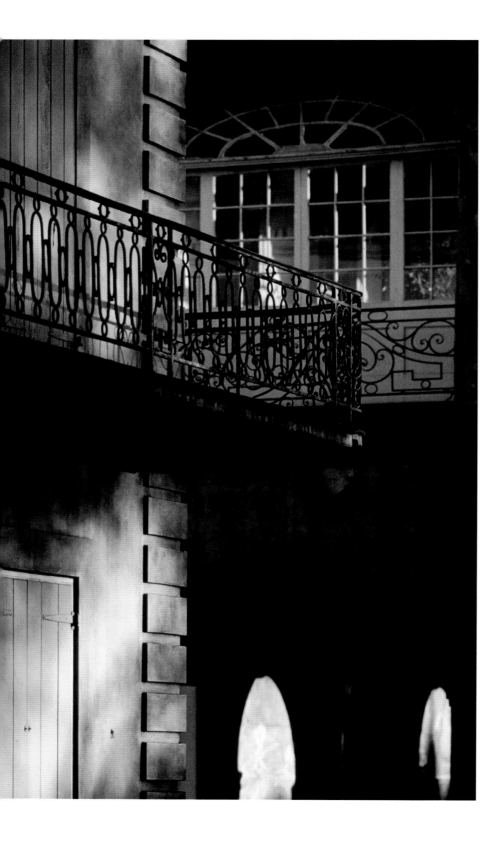

ensconce ourselves, a remote locale where veiled shadows offer inklings of safe sanctuary.

French Quarter life sketches color into the gist of life, the grit and gris-gris as well, and these receding walls give haven in which to escape the harsher, taunting light of full-on reality. People who spend one day or more here generally have to be crowbarred out. Most tumble hard for the Quarter and get hooked, even those who swear they will not. Seductiveness prevails. Inveiglement charms us. Parting is hard. Such sweet sorrow.

Indeed, as though dipped in a veiling of dusty gossamer the Vieux Carré's inordinate essence has spread to and intoxicated many continents. All know of her name and enticements. She has always been an influence peddler, of sorts. Within the bricks-and-sticks confines of the Vieux Carré the requiem of hours is but a long night's journey spent into day.

This picturesque memoir of visual arts transports you here, and there, delving straight into the interior realm and inner sanctum of the Vieux Carré, a city deep in imaginings and dreams, a weightless vault of transitory phantoms.

Both Guste and Sahuc lovingly unmask and caress the distinctive faces of the Vieux Carré's unique character. A definitive tribute to the fleeting beauty of a lost moment in dreamland, their photographic depictions entangle us in the brushstrokes of time stopped, resting within the milieu of the ages-old Quarter.

Here in this city, visitors and residents alike acquiesce to the elegant *mise-en-scénes* that frame the drama of French Quarter life. The Vieux Carré is a tantalizing town imbued with history and culture, whereas the inward world that lies here implies a surreal passage of events.

This heirloom city is the cradle of an anthology of ethnicities and cultures, a pivotal account of how these interwoven cultural threads spin an achingly beautiful yarn, unwinding a tapestry embroidered with wisdom and motivation, misfortune and attrition, pleasure and prosperity. All that has passed this way stippled and scribbled these streets and gardens, leaving an identifiable splotch, a restless message that hums something insistent; we sense it, and our thoughts quicken.

The French Quarter is covered with regalia of murky ground clouds and dank colors aglow with a backlit cast, indigenous to this place, visible even in semidarkness and nightfall. In a town where the dualism of life is heightened and highlighted, blooming flags flap overhead as ancestors sleep in the cemetery, at rest, we hope. Inset in a shady ring of

revelry and regret, inundated with troubadours and minstrels, the Quarter, more than a Southern city, remains a world unto itself.

In Part Two, Guste's *The Secret Gardens* photographs are saturated with an impossible aura of surrealism, dreamily spun across the pages as though hand-painted on canvas in the jewel-tone oil colors of the Old Masters. His richly hued pictures portray what words cannot to form a vivid portraiture of the undisclosed side of the Vieux Carré — a scenario of unwavering history, romance and culture.

With the pure devotion of a local who has obviously spent a lifetime observing the smallest nuances of what the eyes see, and the heart feels, here in the French Quarter he uses his camera to invoke and immortalize an intimate array of arresting places, like inky sandcastles caught in mid-air. With painterly precision, his work sheds light on awe-inspiring Vieux Carré imagery, recapturing and bringing to life a nostalgic landscape we imagine and yearn for in our mind's eye.

After Guste gingerly unlocks the garden gates that lead us down the path into the dark, faded fairyland beyond, from page to page he wanders slowly. A phantom amid the stalking shadows, he takes us on an invitation-only tour of motionless gardens and architecture, all the while entertaining us with snippets of interesting conversation. Guste is a grand host,

charismatic Creole to the core. In pictures that softly unfurl scenes that languish screened from sight, inlaid behind vigilant walls and gates, we are able to touch and feel moments of melted enchantment.

This bantam city that refuses to be beaten by the plunder and pilfering of the ages is the strategic lay of the land the French laid out in a military-style grid orientation of platted squares, totaling approximately one hundred blocks. Its boundaries are the Mississippi River and Rampart Street in one direction, and Canal Street and Esplanade Avenue in the other.

To first come upon the delineating perimeters of the Old Square — something to be remembered always, and not missed — is to stumble upon an optical illusion of earlier days reincarnated. Initially, it does not seem possible. It appears as a delusional fabrication, a trick of light; perhaps a phosphorescent light reflection seen across land, water and sky; apparitions and visual fallacies that mislead and delude us. Yet whether none of this is true, or partly true, is really moot, since the French Quarter is simultaneously both real and unreal.

Today, as throughout the interlock of not quite three centuries, the Quarter's map, squares and street names remain mainly intact, fragrant courtyards abloom. Sometimes, if you choose to see it, when the night is right, some spot the friar's

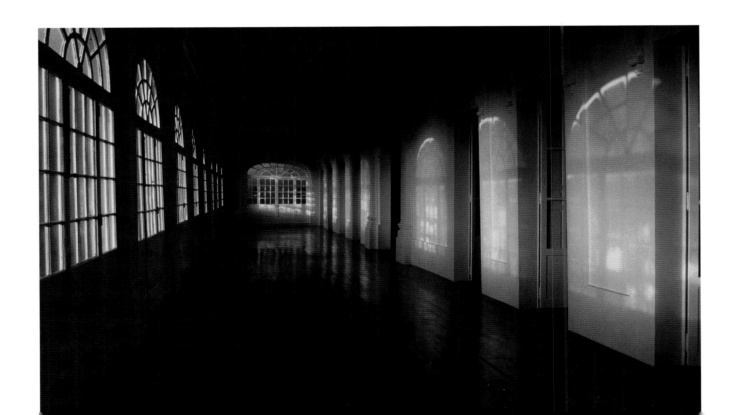

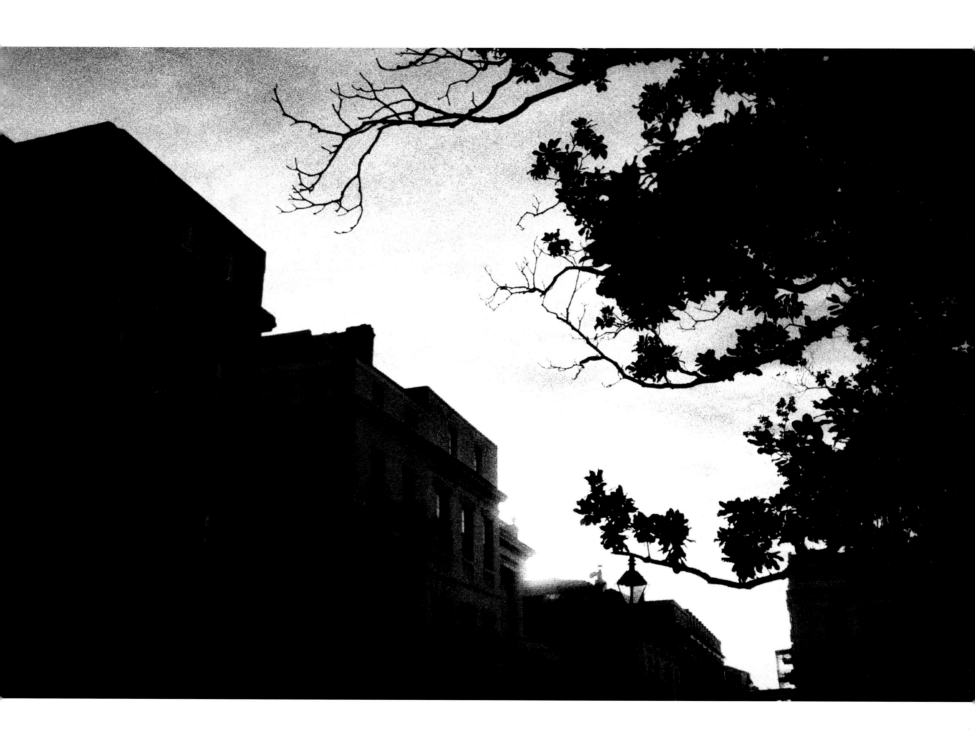

48

lantern. The will-o'-the-wisp halo has been observed hovering near; a pale light that flits and streaks through the secret gardens, perhaps coming from the swamp, below. Whatever you deduce — it's up to you.

The Vieux Carré is a treasure mine of dense alluvial gatherings of generational architectural gems and fetching artifacts, ever-changing yet constant. Respectful of retracing and preserving the footsteps and fingerprints of the past, it is also a place of new beginnings. Locally, and around the world, people continue to embrace and celebrate the jubilantly long and colorful history of this most unusual area. This cocoon of a city is the coronation of a bittersweet rhapsody, a linkage of time abridged.

There will always be those drawn to hold court with this royal and regal aging beauty queen, lured to visit here, live here, walk her streets, see and touch her many secrets unveiled. Few can resist being wooed by an unconventional site that continues outliving the latest consuming umbrages of nature, and more. Today, as much as ever, she remains offbeat, arcane, marvelous, folkloric, enthralling. Only one place uncloaks and personifies the epitome of all the beautifully twisted and preposterous dreamlike universes, and it is the Vieux Carré. Here, it can be confirmed, he conquers twice who conquers himself; and the thief of time is barred from entering.

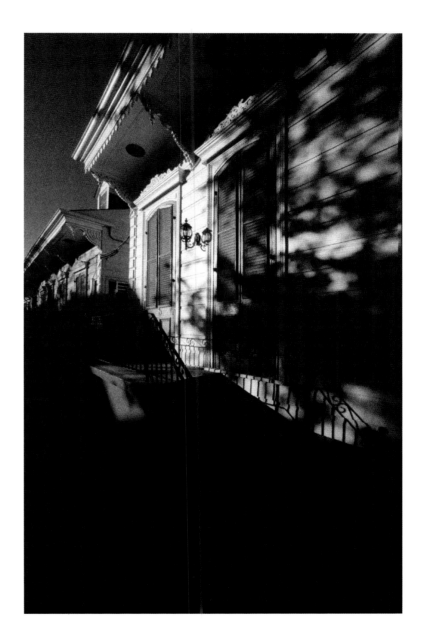

The French Quarter tells the tale of perseverance. A recital and requiem, she is at once steady and stymieing yet shape shifting. Unorthodox yet extremely traditional, her thorny life exposé includes surviving disaster upon disaster — all the while a world held rapt spread rumblings of her sway — and she still stands. Slumped and crumbling yet vibrant and vital, the saga of her waning beauty cannot be denied.

The heavy befog-fringed silhouette of the Vieux Carré gently sloping into sullen light suggests a treasury of destinies. This esoteric transcript redeems an undercurrent of sadness crusted with a fine tipping of jollity. A half-lit aura of melancholy pervades the Quarter's stained, tainted plaster intermingled with imprints of mirth and merriment. A strange realm of otherworldly gossamer tenacious magic is woven from the remnants and remains of grief and loss found here.

This ironic place awakens all of our senses. She will never concede or surrender, for she sings a song of perseverance. She shall never go quietly into the night — how could she? She is a cunning vision of countless compressed faces, secrets and disguises; the original drama queen of all masquerading, a mystic

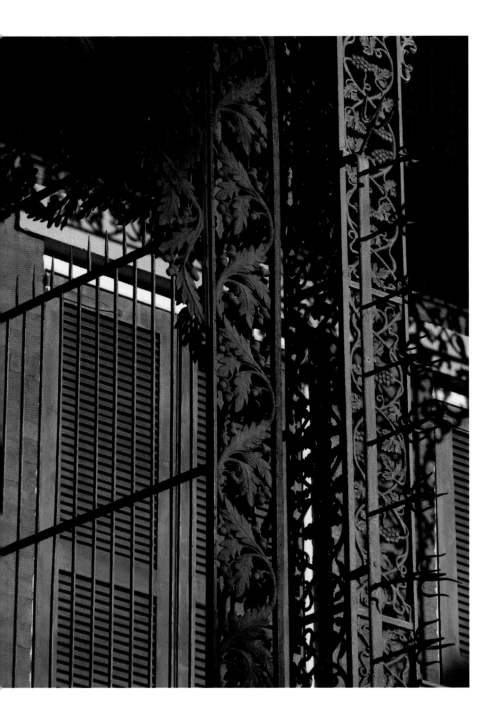

known and loved that called us by name and spoke to our inner being remain a permanent part of us, forever alive in moments that cannot be rewritten or changed, only accepted and admired.

To find a diminutive city with the full wonderment of the world rolled into a few square blocks, a genuine piece of preserved history sprinkled with a reflective air of secretiveness, is a place that few can resist. Recurring echoes of all who have walked her gardens and streets inspire and unfold incessant details of intrigue, desire and adventure.

Yet never forget, she is equally an endangered site. Unrelated to a direct hurricane hit, without people, publicity, education and advocacy for historical preservation she will be lost.

The vulnerable and all-too-fragile Vieux Carré has never sat in a more precarious position in time than right now. The legacy and lifeblood of New Orleans' living history, culture and spirit rest here.

At this sobering juncture of American history, here in this susceptible and storm-clobbered region already badly damaged, with so much of our city destroyed, we who respect the past are fighting hard to keep all that we have left intact from perishing, due to the destruction of mankind adding to the list of casualties and calamities. There is an urgent need to protect this gem of a historic district, exceptionally so after Katrina. The 2005 hurricane season's deadly water and wind assaults destroyed more historic structures than any other event in American history.

A pervasive attitude of *esprit de corps* is much needed to save and patrol history; it is a long and difficult road, an arduous journey, for a few to succeed alone.

Here in Louisiana we have been forced to stop and reassess our situation, stand up and take action. We have an obligation to remind bystanders to come forward. And of course we need to save not only the Vieux Carré but also New Orleans, itself emblematic of other great cities in trouble. For now, the Vieux Carré, with her head above water, is a start.

We fought Katrina, now we collaborate with the impact she made on history, hence, this book.

The Vieux Carré has legions of fans and admirers from the world's four corners; her name rings out across both hemispheres. Each year, up to ten million visitors hail and pay homage to and bask in the simmering essence and concoctions of the queen mother of New Orleans. These paramours of the Quarter will immediately recognize how Guste and Sahuc tenderly render, with the rarified eye of a truly gifted artisté, an opulent portrait

zone of deep roots and eye-fetching affectations, a shopworn darling of duplicity.

The Vieux Carré imparts to others what is already engraved; an ongoing quilt that stitches us to our tradition. Places we have

of the faded grandeur and eloquence of the Vieux Carré. This definitive compilation book is a commemorative undertaking, an unending feast for the world's enjoyment and contemplation.

Every visitor to New Orleans who tries to peer into the provocative secluded secret places beyond the impenetrable barriers of walls and gates will appreciate this book. It is the unwritten rule that the more distant and out of sight, the more unavailable, the more we desire to see it. Remoteness piques our interest. Signs of "Do Not Enter," "No Trespassing" and "Private" do not turn us away but, far more likely, provoke our curiosity. We want to be on the inside looking out. It is human nature to crave a personal glimpse into a closed world. What is forbidden is most attractive.

Indeed, of all secret cities, the French Quarter may be the most secretive; visitors focus on what is kept so protectively secluded, concealed from probing eyes — the places where midnight and secrets draw close.

In Part Two, as private-guide Guste takes us on a slow traipse through the secret gardens of private residences, we see the real essence and small nuances that are the Quarter's marrow. Deep inside these oases of tranquility, Guste stalks the outskirts of a fairy tale. His camera corners a faraway actuality silhouetted against a balmy backdrop; he knows how to make even a solitary French Quarter flower, framed in relief, look special.

To a society perpetually in search of novelty, the battered Vieux Carré seems singularly unusual and unique. Her evergreen face remains a pleasing vision of haunted beauty and grandeur. Her quality of hauntedness is, in a poetic way, filled with historic fragments. Curtains of brick transport us to someplace else, entrapping and extolling the quirks, strangeness and charm of yesterday. For what is antique and authentic reeks of soul.

The Quarter is the embodiment of all sentimental keepsakes, all trinkets funneled down through generations. Beyond her surface pleasures, she is a retrospective of mortality and immortality, clothed in a conspicuous collage of stray, congregating particles. To explore the refinement of her nooks and crannies is to delve deep into an assorted stack of ancestral love letters. Here, when sundown darkens to a luminous bruise many things come out of the shadows and the characters change color.

Amid the languid air and sultry allure, sense and sensibility fade. Some see the unseen. The hour slows, and then reverses.

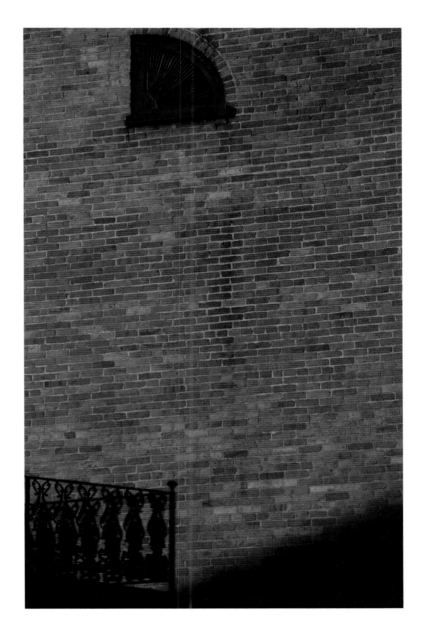

The outside world crumbles and evaporates. Shadows come forth from the beguiling blackness and then dissolve into the infinite night.

Beyond the showcase of vintage pilasters and balustrades, fretwork and dormered windows, porte-cocheres and scrolled railings, galleries and cast-iron posts, there is more; more than French- and Spanish-era pieces. Amid the weatherworn fountains, luxuriant fauna, trellised flora and banana trees, there

exists an elixir-like alchemy; felt yet unrevealed. It seeps up from the saturated earth.

Opposite the bolted gates of these stilled gardens, a picture window opens from one's mind. With a backward glance of unblinking weariness, we peek through slatted shutters and crusty iron and we are welcomed into a cloistered world of beauty and romance. Shortly, foregone conclusions falter, then change shape.

In people and objects the years collect their toll yet also add a luminous varnish, a certain all-knowing incandescent glow and luster that can neither be rushed nor duplicated. Olden treasures are decidedly more elegant and expel more soul, more presence than the new. In New Orleans, the dappled soft light of haunted solitary places conceal such secret parables swaddled in iconic imagery. All succumb to the ethereal lure and shadowed murkiness. Since we long for and canonize etchings of what is lost, the Vieux Carré allows us to redeem not only what has slipped from our lives but also what we have never known or seen.

The fanciful buildings and gardens of the Vieux Carré inhabit a curious zone far removed, somewhere between the filaments of the real world and a fool's paradise. The quality and honesty of "truth" is tough to pin; presumed verisimilitude forever verges on metamorphosis. However pretty, bubbles and balloons rupture when pricked, leaving us with thin air. It is not uncommon to clench dew and see what we want to see. After all, enchantment and mystery depend on perception. Amid a surreal dreamscape such as the Quarter, walking in the footmarks of age can make us ageless.

Here in this wayward city built to unexpected scale, proportion, balance, harmony and rhythm, hush-hush behind these formidable walls and gates lie the fragmented rays of the most wondrous secret gardens past or present, real or mythical, clumped together and resurrected in one locale, inscribed with history's cobwebby hands.

And so, if you say there is not a day you do not dream of a way to get back to the Vieux Carré, this most beloved city forever immortalized, this book will take you there, to the near yet distant vista that speaks of a life less ordinary. The Quarter is the valiant voice of American history and more, whispering at the horizon, as a crier and orator of humankind; an intriguing, oxymoronic town that incorporates everything in life. Her face proclaims and gives glances of the unknowable, and the humanity within. Here a curious cacophonous collage of enshrouded hearts lies asunder,

inextricably linked with memories shared here, awash in a wrap of the years.

This is a place we will never cease to love.

The fantastical and enduring Vieux Carré is feathered into an embankment that sits astride and hugs the Mississippi. This place of jagged walkways, caved-in sidewalks and potholed streets was mapped out, built and cultivated out of the adjacent Louisiana marsh on the premise that sensibilities should be untamed and the dream should never be abandoned. Here everyone trips on or over something unexpected.

To visit or reside in the Vieux Carré is an exhilarating experience verging on dreaming with the eyes of the mind wide open. It is a muffled and yet blaring vista that swaggers the senses and sweetens the soul; a scenario that spews mysteries of old, replete with traces of discolored baroque opulence.

The South's crown-jewel ode to sorrow and endurance, the French Quarter symbolizes a brindled complexion enfolded with layers of lives, a warmth that seeps through the paint and plaster; a distinct dreaminess to chalky crayon-colored old buildings, sullied and stained with nebulous nectar dripping an arcane overlay of exquisite excess, of declining grandeur in cramped spaces.

The Quarter's rheumy voice speaks of mildew; her crown is tarnished with encrusted rust and missing gemstones, but as she is the *objet trouvé* of our affections we pretend not to notice. The "found object," the Vieux Carré, is a wonderworking rubric in a class and category all her own.

Here in a town swathed in a scraped and mottled finish, we rub shoulders with history reassembled in a way we can understand. We transcend the confines of our universe — turn back the hour. It is impossible to avoid succumbing to the poetry of the moment. The occasion of being alive. Here and now. We yield. We acquiesce. We cannot say no.

The Quarter calls out to us in an unwritten vernacular. The future scrawls itself upon the hereafter and we instinctively understand; no further interpretation needed. That which binds us is greater than what divides us; we are, in essence, one.

Residents can readily trace and chronicle previous owners back to the 1700s. In the Vieux Carré, painstaking preservation of documentation reveals the historical ancestry of each individual property. The chain of former owners is considered significant.

New Orleans area repositories house a wealth of archival records dating back to the 1700s. Residents commonly

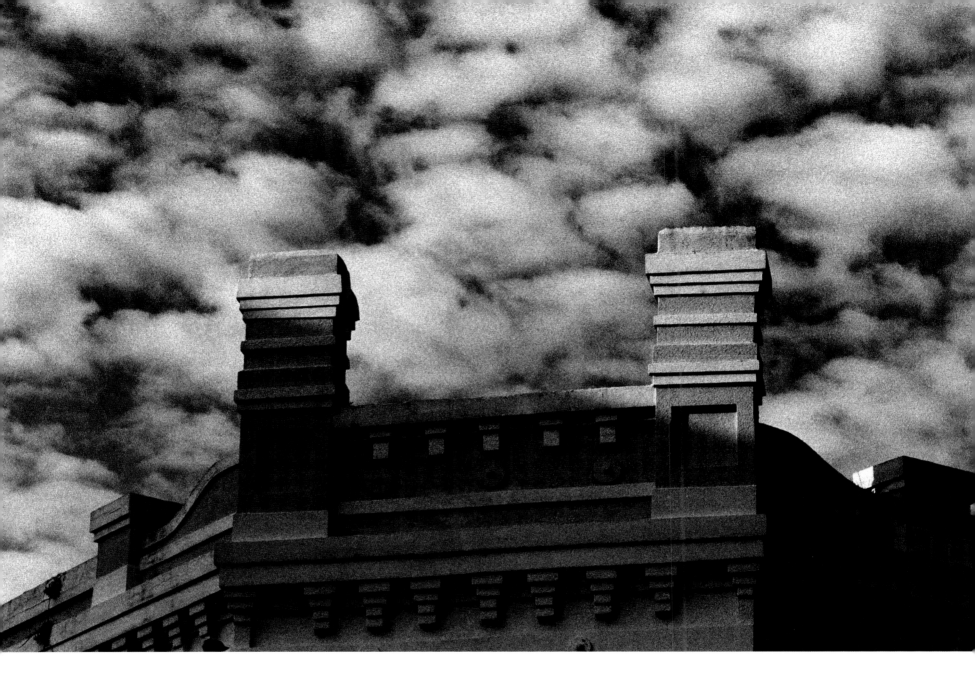

commission local historians to research and summarize their property's history. Many historiographers go an extra step, delving deep, chasing down related notary records, news clippings and other tidbits that cross-reference names associated with the property. This supplementary data helps braid together a recreation of those who owned the property, their business dealings, events that might have occurred onsite, and other significant happenings. I know a free woman of color, a consummate Vieux Carré businesswoman with diverse real estate holdings, built and owned my home as an income-producing rental property in the mid-1800s, shortly before she relocated to Paris in advance of the Civil War. My kitchen housed a mercantile store, the living room was a livery stable, the upstairs was tenement house-type rental rooms, each with a fireplace, and my neighbor's property was a Spanish garrison. I also discovered the existence of secret trapdoors, and more.

Precious few places anywhere in the world give deference and respect to the recording of who owned your property in

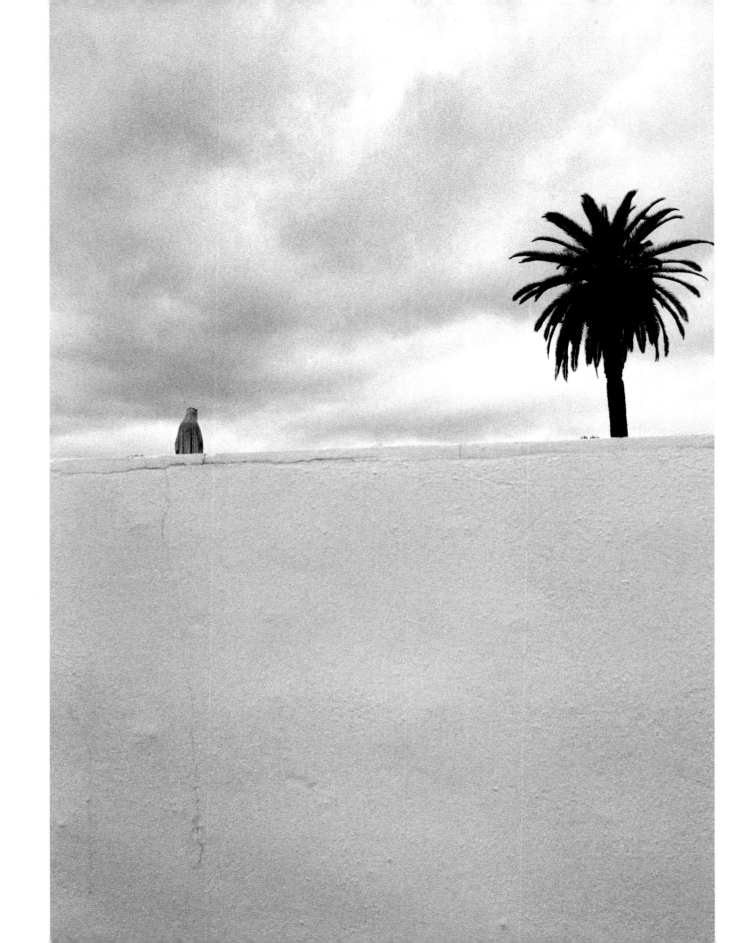

54

1795, 1853 or 1913. It is a uniquely commanding experience to contemplate the men and women who built and owned these same uneven walls and courtyards hundreds of years ago — to pore over handwritten names spelled out in antique lettering, to read the sidebar moments of their lives that left a mark. The rumors you hear are true. Mostly. With a spackling of unreliable varnish. Sugarcoated. The whitewashed ghost stories and mischief forever hangs like mist filtering over the French Quarter.

In New Orleans, yesterday is fluid. Never far astray, it is always approaching; it is somewhere close by, making its presence felt. The transcripts of ancestry, the men, the history, the lives, and all that went before, ebb and flow, enveloping and intermingling with all that is the present.

The Quarter — the real deal, a miniature historical city with a distinguished sense of decorum and eccentricity that conveys a unique perspective — is a quintessential social and cultural vehicle of all ages.

A matriarch among beauties, her antique poetry is intriguing and poignant. Consecrated with the high art and high life of much aged wisdom, she is the one we least expect to end up loving the most. But everyone seeks to get to New Orleans before they die.

The patina of age is an exquisite antidote to this most impersonal techno-age. The inviting intimacy and warmth of the crooked buildings that crowd the narrow streets of the Quarter charm us. Thin phantom voices and sketches of the past shaken out and laid here like powder–covered sprinklings call out to us and we are roused.

Once inside the Vieux Carré, with no real horizon for bearings, only a kaleidoscopic mirage merging with dusky shadows, we seem to travel without moving; the world comes to us. As the imagery and mystery envelop us, all that we know and judge of "what's what" crumbles. Dreams reborn take hold. Secret gardens remain forever in bloom. Creativity is courted and emotions exalted. There has never been another Vieux Carré and never will be again.

Soldered deep within bricks lining these fabled blocks is a dense mix of mankind, a thicket of legends and legacies; the world has always brought its cache to the Vieux Carré. The eras waft past and all who have gone this way have left an imprint.

Secret stories and spaces cannot be ignored, denied or evaded. Sometimes for a lapsing moment the Quarter seems forlorn, morose, desolate. Tidings of epitaphs and eulogies are

everywhere. Yet sometimes, when we blink, the fog vanishes from eyesight as quickly as it came and the Vieux Carré is once again young and lighthearted; effervescent, perhaps because from one façade to another so many ghosts are assembled, hidden in the corners. We cannot see through walls but we sense what lurks in the spectral surfaces, like mystical slides; and we are able to glimpse our reflection on the opposite side of Alice's haunted looking glass, the tribulation and jubilee of yesteryear today. We feel the strangeness, humor and anguish. We take it all in and we cannot turn away.

The Quarter affects us deeply, dissolving whatever brittle stone or calluses lurk within. Our shielded coat of armor evaporates and we feel lighter, freer; more alive. The Vieux Carré, a sovereign essence, beckons us to return.

Over dozens of decades, each era's scribes send out dispatches enraptured by the Vieux Carré's entrancing oddness; but how do you explain being enamored by something inexplicably unexpected and peculiar? Sometimes pictures better capture what we feel. The mind listens to and holds sacred what is stored in the heart.

Yet it is easy to articulate that here people take pleasure in living; simple things take on a magnificence not apparent elsewhere. And those of us who love the Vieux Carré see well beyond the surface. Casting our eyes upon the corroded splendor of our declining buildings and the dark romance of our gardens, we are carried through a trajectory of chapters. We see the essence of an age buried in the slumped sky and soaked soil, the vapors and ashes of the ancients preserved.

New Orleans takes pride in recognizing and honoring magical moments doled out in increments. The sheer joy of being alive is observed, along with remembering what is lost. Here, where feelings are not suppressed, little is considered inconsequential; here the locals tend their aboveground crypts with sacrosanct regularity, practicing deep devotion to the saints and heavens above. Some businesses remain shuttered on Ash Wednesday and All Saint's Day.

Yet here, this spot that Katrina and her brackish floodwaters swept past, we don't long dwell on tragedy or wallow in self-pity. We are able to partition off life's pain and clasp it in our palm; remembering, yet — despite our predilections for escape — not running; knowing that without anguish, there can be no joy. Thus here, sooner rather than later, even the most somber seasons of tragedy eventually give way to joyful music, song and dance.

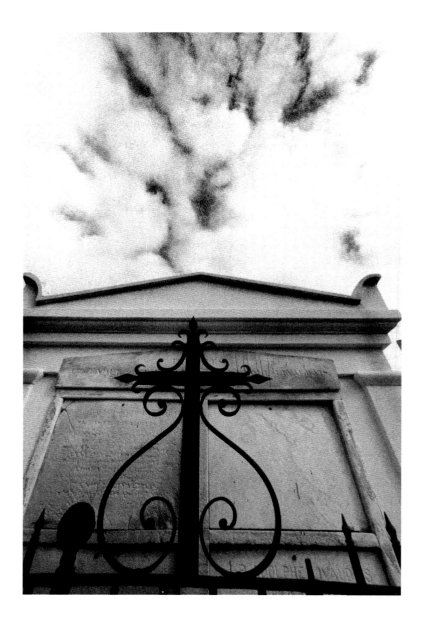

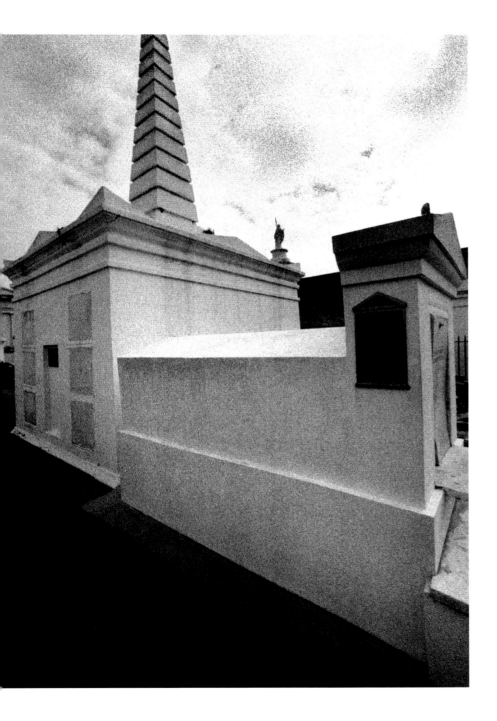

Ashes to ashes and dust to dust. Who among us does not think a jazz funeral the finest type of a send-off? To me, this tradition is the multicultural advent of the ages. When it comes to a final resting place, limited space is still available in the St. Louis Cemetery No. 1, an abiding lime-washed home to the noble and ignoble, just outside the Vieux Carré across Rampart Street. These gated quarters are closely packed, yet famed and unique. If not, perhaps consider adopting a family vault to restore, since a highly regarded conservation project is underway there, with funds sorely needed. To save history, we need to save our cemeteries, too. In New Orleans, beginnings and endings are never as important as legendary ones since what people say about you after you are dead and gone counts, a lot. Thus some prefer to live life to the limits.

New Orleanians believe funeral music is rebirth music; parading and revelry are considered a God-given right; the cult of cooking and the art of eating are minor religions, all good fodder and superb tonic and assiduous care for whatever ails you. In the Quarter, deep longings and peculiar flights of fancy spring to life and take up residence, sometimes permanently. No one asks or even cares what century you choose to live in.

This is an opulent city with a wide cast of characters as colorful as its brick-and-mortar physical locale. When falling in alongside the second-line band, twirling a small umbrella overhead, marching across the center stage of life, one is permitted to be a prince, a pauper, a poet, a fool, a renegade. It's a good show. Our way of healing and persevering.

We know the hearse is coming for us, too, inevitably, but prefer to delay the ride; we prefer to live life to the fullest and always try, for as long as we possibly can, to outrun the cruel caress of the cold marble tomb. If you can at all avoid it, never let a hearse drive you to church. All of this is wordlessly understood. The mythology of our past colors all, bringing traditions and hope forward so that, no matter how hard life's trials, we might press on joyfully with an air of jubilation.

Here people neither impose order nor worship newness or perfection. Life is lived as in an epoch that no longer exists. Unafraid to behold dreams, devotees of the Vieux Carré give credibility to life's inexplicable moments. Since the Vieux Carré neither recognizes nor adheres to any real measure of sequential events, and since life is not metered in traditional ways, the fleeting beauty of a moment colored by glimmers of the past is detained. Nothing here is de facto.

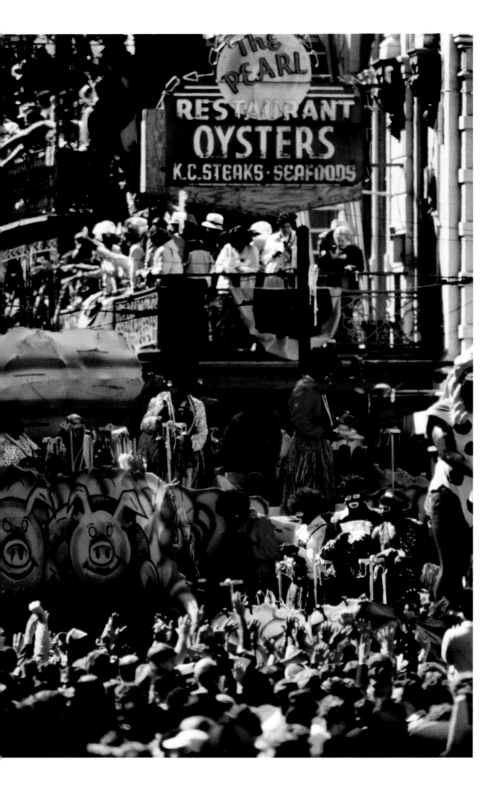

Harmonious with the *trompe l'oeil* paintings of the eighteenth century, the Vieux Carré still amazes. Beneath her covering of cracked and peeling paint overspread with thick layers of rue, when you look beyond the frivolities of raucous Bourbon Street, she is a mass of symbolism and paradox. As though peering into a shrine, grotto or catacomb, then noting a false wall, you can never be quite sure of what you see and what you think you see. She is an overripe Byzantine complexity of romance and intrigue and the unexpected, her charms manifested in a utopia of many hues.

The Vieux Carré is an ever-incomplete tracery interlaced with people, places and things of old. Separations between space-time continuums disappear completely. Each new scenario seems marked by a moveable slipknot. Each building, each wall, each garden, exudes the murk of some earlier adventure. Traces of many lifetimes have slipped away, leaving vestiges comparable to interchangeable leftover scenes nabbed from a Hollywood movie; yet the Vieux Carré, hardly make-believe, exists in flagstone and stucco, not cardboard. She is a genuine town. The Vieux Carré was not conjured up by any writer's figment of the imagination. This place did not arise from any novel, nor did it crop up from some theatrical production or as a celluloid film scene broadcast upon the big screen — she just evolved.

Unlike mass-produced reproductions, newly shellacked replicas — the fusty veneers of the bejeweled threadbare cloak she wears are ransomed relics. Here is a city that beholds and attests to a chronology. The majestic slant of her buildings in decrepitude is a sight to regard. Most structures are humped and uneven, some are off-balance and lopsided, many take on beauty in their cycles of wither and renewal; the gracious, fading decay embraced, not ridiculed. She is forever resplendent, festooned in tattered finery torn from the ripped pages of another era.

The seductive old siren, the potent provocateur, remains an iconic symbol of faded grandeur. She is a place of dole, amour, abstruseness and beauty. Embellished with shabbily elegant regalia from the past, her opulence obscured through the prism of the years, she is indomitable.

As the world's most sublimely illogical, irreverent, reverent and idiosyncratic city — a place with an elaborate thumbprint — New Orleans and especially the French Quarter is a den of antiquity and eccentricity that appropriately appeals to connoisseurs, to lovers of excess, to people with daring notions.

In the Vieux Carré, long a mecca for a coalition of *bon vivants* — antiquarians, historians, revelers, gourmands, aficionados of culture, CEOs, drifters and dreamers — we see them all flock together, reveling in a pointed clash of cultures: the privileged, those who have lost their privilege, the disenfranchised, all sip from the same flute, glass, mug or teacup — Salud! Skol! Cheers! It is a stamping ground to be savored. If not entirely boasting a similarly slanted view of life and logic, all enjoy the same prerogatives: pirates, rogues, renegades, mavens, mavericks, misfits, socialites and poetic *émigrés*, all feel at home here.

Taboos are few and far between. Grandiloquent ramblings are frequent. In actuality, the entire town is a salon of social and intellectual distinction. The culture and subculture does not float down from high but oozes up from the streets, from a phantasmagoria of ancestors. Whether visitors here come for a day or for a lifetime, in no other state or locale in the union do people live as intensely and passionately as here. Within the circumference of the French Quarter, nobody feels like a stranger in a strange land; everyone seems to fit in, one way or another.

A rhapsody of stargazers, astrologists, card readers, psychics and mediums, those who come from near and far, claim to experience here a surreptitious and life-giving kinetic energy. Even scientists seem to sense how the stars appear to line up here. Actually, New Orleans — the site in the mid–1700s of one of the oldest observatories in America — has a long history of sidewalk astronomy.

Many believe that a good portion of our city's magic is closely linked and spelled out with powerful folklore surrounding the Mississippi River, a rope that ties the heartland of America together.

Those who know American history know that New Orleans is not merely an inconsequential port located at the mouth of a waterway; she is, in essence, the queen mother of the Mississippi River. We deal with deluge.

In the Quarter, many shed their old skin, and sometimes their clothes, to indulge the moment. To seize the day. *Laissez les bon temps rouler.* Here in this milieu people are, indeed, influenced to eat, dance, sing, laugh, kick up their heels and be merry, for tomorrow — well, you know.

For some unknown reason, to tempt fate and live directly on the edge, walking alongside the brink of disaster, is to feel twice as much alive as anyplace else. Better to reside and be fully alive in the moment, even with the constant threat of impending

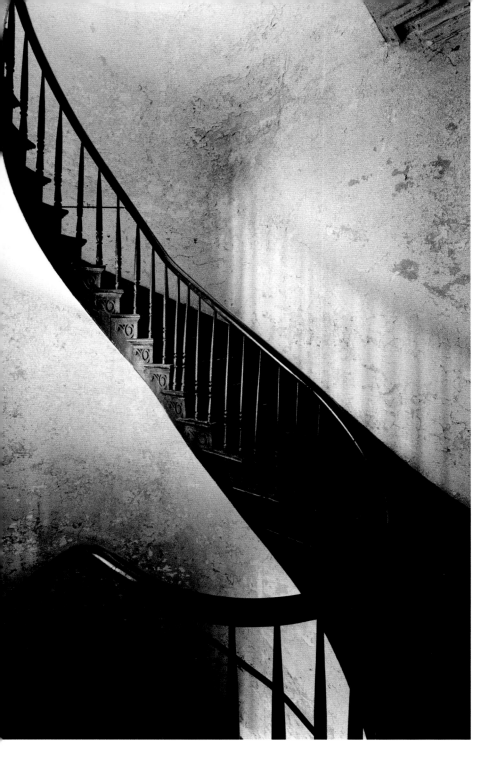

posture. This is so even when faced with a painfully slow recovery of a city stricken by a thunderous storm; worsened by both obvious and inconspicuous grievous blunders. This is a way of life here in New Orleans, deeply entrenched, like our streetcars that ride us though the mist. We soldier on.

Even our local antique staircases have a specific design, uniquely stylized to this city. Our colloquial and perhaps symbolic steeply curved and spirited old wooden stairways, originally built by Creole and African-American artisans, are appropriately called "dancing winders." Likewise, we, too, carry forth the tradition of dancing and winding on in the face of adversity, ascending and descending through the steepness of it all, the ups and downs of time. This does not mean we are unaware of life's calamitous, precipitous and portent nature. We simply choose to hoist ourselves up and move forward. The alternate upclimbs and downfalls make a circle.

Despite reverence for ancestry and traditions, the Quarter is not a place that worries about what others say or think of her. She has always dodged conforming to society's demand for homogenized gentrification and repetitive sameness. It is a sacred way of life here that drastic differences of backgrounds, opinions and lifestyles are equally welcomed and tolerated. A predominance of any one particular thing, style or mode of thinking does not exist.

Here passionate loyalties come with a degree of equanimity; accorded, not least, to a love for fine food, winnowed antiquity, grand entertainment and graceful architecture. Clearly, this is a munificent place of unrivaled multicultural heritage, music and cuisine. Affection for the rare moment, the very present that will soon pass and never come this way again, is realized and celebrated, making life sweet, misery bearable. Within the confines of this city lies an inner circle of rather bizarre buoyancy and brightness, a domain which cannot be described, duplicated or altered; only absorbed. This is not a town that casts aside peculiarities; what is damaged, imperfect or deemed out of date. Nothing is labeled as passé. Here there is no purging of the past, no quest for perfection.

Oddly, most who come to the French Quarter of New Orleans see shades of every legendary place they have ever loved or read about, whether it is some place latched onto from books, history, travel or from a mythological place of the mind, a Camelot or Avalon. Things magnetic in the air and earth here inspire the inner eye to peer far over the equinox point, rewriting

catastrophe, than anywhere else. These are the strong personal bonds we have with the ideas and ideals of Louisiana and America, the hardihood of our civilization. The vertebrae of the spine may be weak or stoic. We prefer staunchness. Upright

ancient bricks and cobblestones here with florid imaginings of all we have never actually seen or experienced, not in this lifetime. The wraiths of the past stay with us, always.

The French Quarter appears to be a mossy aboveground portal offering brief snatches of insight into bygone cities and vanished worlds. The clues are all here. Now and then when the candles flicker a soft breeze blows and the cadence of the carriages punctuates the languid air. Our minds ramble. Moody shadows slowly creep across the walls. Hues of old Paris, Barcelona, Havana can be seen glinting in the streets. For a moment fluent whispers of European royalty, Southern belles, quadroons and military men in uniform can be overheard drifting from courtyards and balconies. Those who eavesdrop can perceive virtually three hundred years of music, gaiety, laughter, singing, sorrow and the clink of glasses.

The Vieux Carré speaks to us recasting our innermost dream scenarios, and once a place grabs hold; the fingerprints are always there. The Quarter caters to the world's dreamers and romanticists. Buried within the overlapping layers of soft brick inlaid with so much more, there remain oddments of a dateless city; someplace near yet now so far.

More than any other place, the French Quarter is defined by the quality and history and the experience people have had here. This city remembers everyone who has ever lived, loved and laughed here. The moments trickle out and away differently here. Indeed, we can't help but join the parade. This city holds onto and illuminates all of our memories, joys, sorrows and triumphs.

An unbound place of chaos and order, New Orleans has always possessed a reshuffled inner logic and rhetoric at once mystifying and gratifying. Rich in culture, language, tradition, religion and cuisine, aside from nestling all demeanor of persons close to her chest, in her former heydays, the Vieux Carré has been a glittering golden-era lady of the world and a noblewoman of prominence who controlled and influenced the wealth of a nation. She has alternately been an ostentatious showgirl adorned with brassy accoutrements; a bewitching vixen, an exotic courtesan of the ages putting an intoxicating spell over all who succumb to her curious marvels. Sadly, as with some other cities, she has also been neglected, left near destitute, shabby and down in the heels, the years demanding payment now.

The Vieux Carré is one of the few places in America declared a national treasure, a landmark district. The preservation of her buildings of great historical significance to the promise of our American heritage and way of life. Preserving this city helps preserve our nation's values and ethics. No one knows the troubles and dreams we have seen in New Orleans. We are all caught up in the life, death and rebirth of our city, as it is our

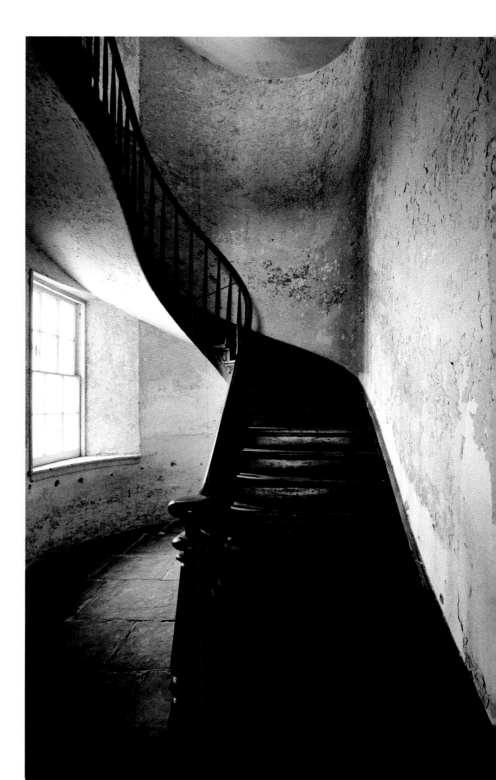

own silhouette we see in the twilight mist. Our response now to the current moment will shape history books. From the future we will peer back into the watery depths and see a reflection of how we view not only ourselves, but how the world views us and how others will look back at us a hundred years and more from now. This is the living legacy we leave, here in the Vieux Carré.

If you know what it means to cry for New Orleans, then you understand why we who love the Vieux Carré actually believe the struggle to persevere and preserve developing history is worth it. The Vieux Carré is not duplicable — she must never be forsaken, abandoned, forgotten. Las Vegas and Disney World tried to emulate her and they cannot; no, not really, because her essence cannot be captured or copied. Only a cold snapshot shell imitation, a skeletal representation made in her honor and tribute, is possible. She is authentic, not a historical reproduction. During the ups and downs now just short of three centennials, New Orleans has remained an unforgettable setting whose mysteries can neither be denied nor described.

To even begin to reclaim the broken pieces of our lives from the inconceivable horror that has befallen New Orleans, we must continue to protectively watch over the haunting remnants of what remains — the Vieux Carré. If we fail to preserve this stalwart touchstone of our past, this bellwether vanguard of our future, then we head down a one-way road to

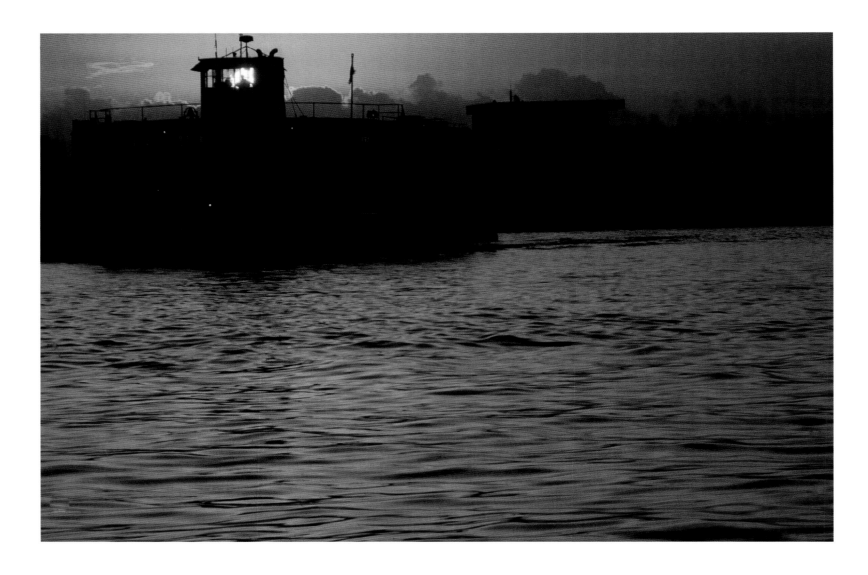

where the comeuppance for ignoring the obvious is swift. Ripples become riptides that cannot be turned back.

The Vieux Carré may invite us to escape reality, to dream, to reflect. The lure of a fractured, fragile fairyland is always seductive. Over many eras, the ordained royalty and the common man alike have come to embrace and extol the saintly and errant virtues of this spot. A dreamy, transcendental yet tactile place — trumpeting all of the collective lifetimes that went before — this is the mansion of many. Her offhand seedy elegance and warmth envelops you straightaway.

The post-Katrina poignancy of life here lends a strange, unusual air of spiritual conquest, scared and secular, set amid the rumpled shadings of a blemished city that eternally cherishes the fine joys and details found only in small moments. With feelings unfettered, we appreciate what we have. The Crescent City is still reeling, that much is true, yet we salvage what is left and reaffirm our ties. Here in this place we are lucky enough to call home, locals forage through the broken picture pieces we long to see blended into one shared vision for our city's recovery. Our town remains a city of faith, hope, diversity and unity.

Everywhere we look we see the nuances and urgency of mystery and symbolic meaning in the smallest of images, the same yet reborn differently. We live with history, the ravages of time and the implications of timelessness. All the aberrant incongruities of life mingle together here. Disaster or not, our weird world is astounding and captivating. The spirit, something ancient born of the soil and of the water as well, cannot be taken from this place. Blessed with a touch of irreverence, we often favor the moment at hand even in the moorings of misery and try not to take ourselves too seriously.

Every city's ongoing destiny is somewhat governed by geography, climate and weather patterns, including the winds of change and destruction; New Orleans is a preordained city situated on a troubled site. Her fate is wed to the waters. The matrimonial ring of water that surrounds this fisted hand-and-fingertip lay of land is the Crescent City's reason for being, her historic *raison d'être*. Water is our city's lifetime partner, friend and foe.

People here previously felt protected by an undecipherable and mazy warren of longstanding canals, walls, dikes and pumps; however, we now know differently. We suffer the firsthand gravities and consequences of what happens when these man-made mechanisms separate, collapse and fall short. Regardless, we do

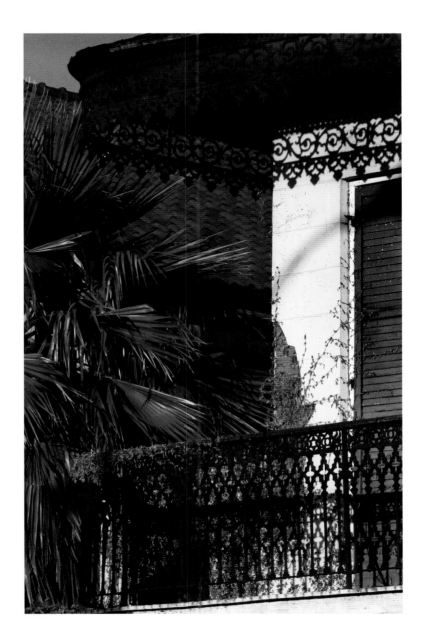

not abandon or acquiesce this land. We remember history. New Orleanians believe there is no such thing as being in pursuit of a lost cause. We regroup, refashion life and make do.

Our American red, white and blue spirit is seasoned with an allegiance to New Orleanian purple, green and gold spunk.

The Vieux Carré exudes a dream of what we want to believe in. An ancient muse, she waves a wand, weaves a web and holds us as we walk hand-in-hand with what is and what was. Although

most Edens are invisible, here the music of the muses penetrates and invades our senses. A languid clairvoyance peels away and exposes the paper-thin covering that conceals the rhymes of the human condition, and within these walls the blueprints reveal that no paradise is without suffering and time betrays all.

Amid the placid sculpture of French Quarter gardens, all who enter embark on a journey over the years, slow-dancing across a strange stage from beginning to end. Perhaps that is why these secret gardens sedate us with a strange sensation of solitude. We recollect and reassemble the scattered inner pieces of ourselves that have wandered away. Within the fabled courtyards of the Vieux Carré, one is never lonely; the company of the past is always within reach. Fledgling and old dreams come to life. We love the French Quarter not only because of who she is and what she symbolizes, but because of who we are when we are with her.

I suppose there is a fascination for ruin that is romantic and seductive, and many find that here. The breath of the Vieux Carré is instilled with something strangely eternal. It is an ever-emerging tableau with an irreverent twisted aesthetic eye, a true essay of life in the grand manner. It is a place where a culmination of reverie, religion, rainbows, romance, hopes and dreams converge, and we are obliged to follow her drumbeat and sweet melody. When the spirit triggers us, in good and bad days, yes, we do the second-line strut as well, pulling out all the stops, with parasols, feathers, plumes, beads and noisemakers.

With her long legacy of surviving disaster, decay and calamity, the famed French Quarter is the anointed empress of all incantations and rebirths. Despite the hot breath of eternity that continually blows upon her back, breathing close on her neck, she refuses to die, refuses to be forsaken. She will not leave you unmoved. To view her at dusk is to see a hundred Mona Lisas rolled into one, eyes that gaze forever at something not of this world but beyond it, in the sky. And we feel the melancholic ache of a lingering backward wistful glance.

In the following preface that Guste penned in the early 1990s, when *The Secret Gardens* was first published, he authored the now prophetic words, "If the rest of New Orleans were to suddenly disappear, we would still have a complete community within our twelve-by-six-block grid: a small community, but complete nonetheless, and perhaps ideal."

There is never as much time, for anything, as you think. Therefore please savor the moment of reliving the remembrances that the coming pages will bring you; bringing back into focus the unforgettable imagery of New Orleans, a beautiful old enchantress so very imperfect and interestingly scarred; her images shall forever swarm upon us, sleeping and slumbering deep within our heads; her beauty lingering somewhere in the twilight, since we can never sever from sight what we have seen and loved.

Once she has gripped your heart and wrapped you in her spell she will never let you go.

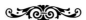

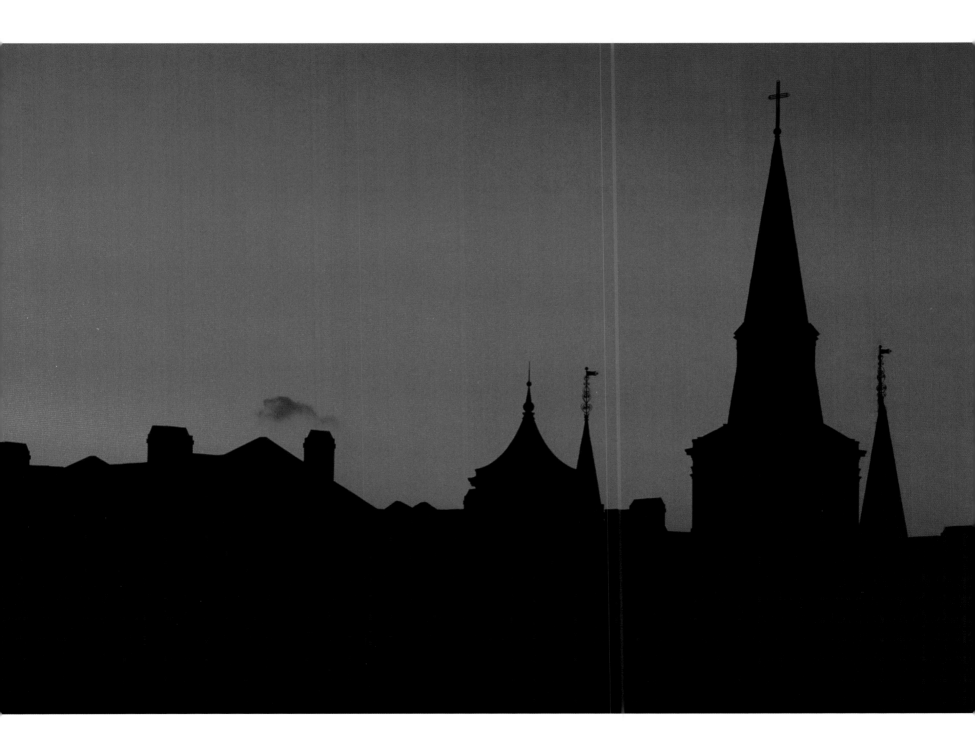

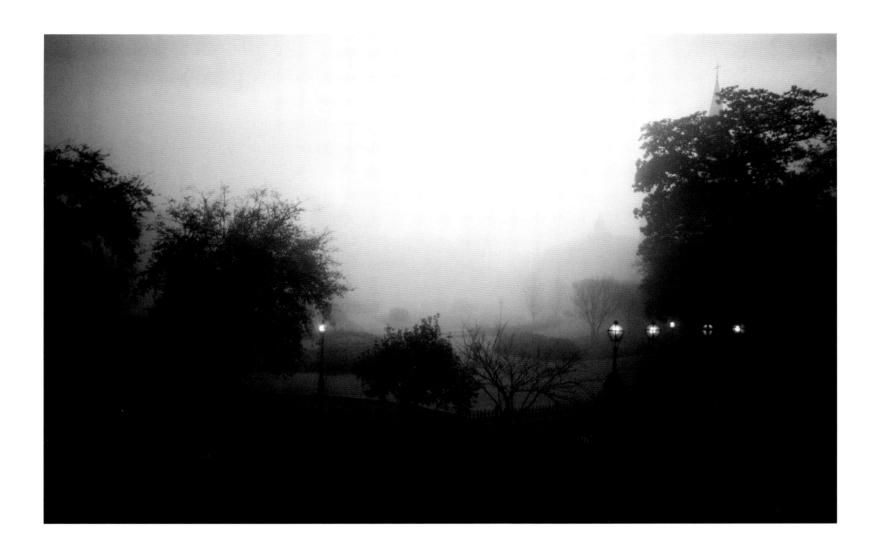

# *Orléans Embrace* Louis Sahuc Photo Works captions by TJ Fisher

## Covers

*Lost star of myth and time:* the captivating romance and legacy of George Washington Cable's "Sieur George," Le Monnier documents and the old Creole days linger at the Pedesclaux-Lemonnier House deep in the heart of the French Quarter. An undercurrent of rich stories, a complex sensuality and mystery and layers of meaning of many lives lived — centuries of interwoven history, passions, customs and culture — radiate from the walls and balcony here in the Vieux Carré, the soul of New Orleans.

## Introductory Material

i     *Layers of legends and lace:* heavy with whispers of a bygone era, a lavish French Quarter iron gallery transports onlookers deep into the nineteenth century when these rococo structures served as custom-made, personalized, gilded opera boxes providing a splendid view of the open-air and freewheeling below, *Theatre d'Orléans.* Today the tradition continues; only the players have changed.

ii     *A cupola with vision:* perched atop the Cabildo, this exclusive vantage point offers a dramatically unique bird's-eye perspective, an up-close-and-personal view directly into St. Louis Cathedral's legendary tapered towers as they crown the Vieux Carré skyline. The tall towers stand loyal guard over the city, marking the eclipse of time and history every 15 minutes and tolling the bells on the hour.

iv/v     *Traces of Old World elegance:* beautiful and admired since Colonial days, artistic and expressive ironwork is abundant in New Orleans. Intimate, charming, graceful galleries and balconies of the French Quarter remain one of the city's most prominent and memorable sights; the best place from which to watch the ever-passing parade of characters, no matter the century.

vi     *A glimpse of yesteryear:* view from a Pontalba gallery, looking onto St. Ann Gates and Jackson Square abloom, with the Cabildo and two of St. Louis Cathedral's towers peeking through the park's flowering and abundant greenery. The cast-iron fence surrounding the square was erected in 1851.

ix     *Yesterday, today and tomorrow:* at the crossing of Dumaine *(Rue Dumaine)* and Royal *(Rue Royale)* streets, aged brick buildings assume a moody stance against Father Time and Mother Nature. Thick drifting clouds and a motionless lace apron of iron mark the moment.

x/xi     *The intersection of beauty and age:* two buildings of fundamentally diverging heights, elevations and ornamentation come together and unite, enhanced as one, their distinctive and decorative ironwork cohabitating closely, locked in a festive dance and caress of history.

xii     *Preeminent Pontalba:* today as in earlier days, the block-long Pontalba buildings that flank Jackson Square house a combination of private residences and commerce; French Quarter residents occupy upper-level floors and merchants operate shops and dining facilities at street level.

Part One

10    *A town of close neighbors:* pair of Royal Street *(Rue Royale)* buildings, one boasting an ironwork-embellished gallery typical of those that line Old Square streets, framing the adjacent structure's board-and-batten shutters.

11    *Will tomorrow come:* residence at 1032 Bourbon Street *(Rue Bourbon)*, featuring a gabled roof with a finial in the shape of a cross, decorative cornice, running-trim eave millwork and classic hexagon shingles, as billowing clouds gather overhead. A four-bay late Victorian frame shotgun cottage, c. 1891.

12    *Mirror image:* where Ursulines *(Rue des Ursulines)* and Bourbon *(Rue Bourbon)* streets meet, an eye-catching pair of enlarged room-like shuttered dormers, each with triple- and round-headed window openings, connected by a catwalk balcony.

13    *Meet me at Pirate's Alley:* room with a lookout view through a traditional six-over-six and double-hung sash window, peering directly into the picturesque St. Louis Cathedral's St. Anthony's Garden, first laid out in 1727 and the legendary dueling site of numerous *affaires d'honneur.*

14    *Time rewrites all:* romanticist's dreamy vision of Jackson Square, seen through a portion of a c. 1850 Pontalba Building's gracious iron gallery grillwork. The intricate balustrades incorporate the interlaced initials *"AP,"* representing the Baroness de Pontalba's family names of Almonester and Pontalba. The Upper and Lower Pontalba Buildings, twin structures that face one another across Jackson Square, are believed to be the first apartment buildings in America.

15    *The guardsman:* fierce and ornamental night watchman, an elemental Vieux Carré lion's head set against a brick-and-mortar wall.

17    *The past in the present:* foliage-shrouded glimpse of Mississippi River-facing St. Louis Cathedral. Two of the Cathedral's three towers are revealed, flanked by the Cabildo which exemplifies the period's mansard roof and cupola.

18    *Ancient waters:* at the Crescent, a paddle wheeler churns up the Mississippi River waters, steering between cargo ships and headed toward the West Bank.

20    *Time does not change all:* the Cabildo, one of the most architecturally significant and historical buildings in America, is the site famed for the Louisiana Purchase transfer in 1803. In this building documents were signed for the United States to acquire the Louisiana Territory, an 800,000-square-mile swath of land stretching northward to Canada. With the stroke of a pen, and a $15 million purchase price, President Thomas Jefferson doubled the size of the United States. The land purchased now translates into the better part of thirteen separate U.S. states, the heart of the American continent. Jefferson's vision and idealism led to the single largest land purchase in U.S. history; a purchase that has since enabled the nation's expansion and development of the continent for more than two hundred years. In the afterlife of what began as a Spanish town hall, the Cabildo is now a Louisiana State Museum housing more than a thousand artifacts and original works of art.

21    *A stroll through yesteryear:* Chartres Street *(Rue de Chartres)* pedestrian walkway, at the corner of St. Ann Street *(Rue St. Ann)* fronting the Presbytére, a structure designed in 1781 and completed in 1813 to match the Cabildo. Built in 1789 as a residence for Capuchin monks, this Louisiana State Museum is now the permanent home of the exhibit *Mardi Gras: It's Carnival Time in Louisiana*, memorabilia and a study of the masking, parading and balls that are deeply linked to the city's culture.

22    *Spirit of the nuns nearby:* the shadow of a corner street light splays across the exterior of this c. 1824 classic early double Creole cottage, a shuttered structure at 600 Ursulines Street *(Rue des Ursulines)*, at the crossing of Chartres Street *(Rue de Chartres)*.

These traditionally square one-and-a-half-story structures derived from the urban cottages of France and Spain. This home was originally built for Ursuline nuns.

24 *A curve of unwavering beauty:* expressive c. 1884 building by architect Thomas Sully at 1100-10 Ursulines Street *(Rue des Ursulines)*, emits the lively rhythm and romance of Italianate architecture, constructed with native Louisiana bricks and an attached wooden gallery.

25 *For whom the tireless bell tolls:* cross and majestic copper-topped bell tower of Tremé's c. 1842 St. Augustine Church, the oldest African-American Roman Catholic parish in the United States, anchors tree-lined Governor Nicholls Street *(Rue de l'hôpital)*, the Quarter's only all-residential street.

26 *There's a season for all things:* customary and languorous Vieux Carré balcony cascade of fetching flowers and vines, prominent and memorable; elevated displays of teeming tropical gardens.

27 *The flowering of time and culture:* the simple beauty and harmony of the historic French Quarter's secret gardens and plant-laden balconies, captured in a solitary flower.

28 *Mondays:* New Orleans' traditional day for washing, and for red beans and rice; a view from a room reminiscent of the haunting Tennessee Williams' characters and images who forever inhabit the French Quarter and New Orleans.

29 *Shutters and shotguns:* an Eastlake-style home is shown, detailed with a complexity of façade, including a variety of exterior trim work and wall surfaces.

30 *Dome of legacy:* classically-styled cupola atop the Cabildo, with detailed louvers and Renaissance-style rooftop balustrades, edged by magnolia. Built on the city's first square, this public monument, featuring classic Spanish Colonial Era architecture, originated as a Spanish-reign town hall in 1795. The mansard roof was added in 1847.

31 *Guardian angels:* one of New Orleans' immortal cement statues, an earthbound flying lady of consolation, etched stone face pensive, wings uplifted and arms outspread, forever watchful.

32 *Music matters:* an unseen trumpeter's arm along with an adjacent grouping of musician-less instruments hint at the lingering litany of legacies and long shadows cast throughout the world by New Orleans' music culture.

33 *Let the tune be unbroken:* Preservation Hall, a living tribute to the age-old musical roots of New Orleans, the birthplace of jazz and its all-time greats. Hometown music remains the ever-flowing lifeblood and soul of the French Quarter.

34 *Sweet dreams of American culture:* vine-covered St. Philip Street *(Rue St. Philippe)* gingerbread-style home, typifying the diverse architectural types, styles, components, building materials, construction methods and eras represented within the Quarter.

35 *A doorstep backward:* a nineteenth-century four-bay frame shotgun cottage at 717 Barracks Street *(Rue du Quartier)* displays an assemblage of brightly painted louvered and panel shutters, enabling the passage of light and air, alternately providing privacy from the streets and passersby. In the Vieux Carré, no bare or stained woods are permitted; all exterior woods exposed to the elements must be painted.

37    *The allure of semi-tropical days and nights:* intriguing reflections shadow-dance across this green-shuttered Vieux Carré home at 1226 Royal Street *(Rue Royale),* as the palm fronds appear to sway and bow in an unseen breeze, even in the photo. A c. 1890 two-story, four-bay frame house with Eastlake detailing.

38    *Romantic rain-slick days:* neighborhood cityscape caught in an afternoon downpour, exuding the small-town feeling of a uniquely historical urban setting, a milieu that elicits fascination and wonderment at every corner.

39    *Eat and be merry:* the c. 1827 two-story brick Creole building at 823 Decatur Street *(Rue de la Levee),* long a commercial structure, is currently one of the oldest continuous eateries in town; period neon signage shown.

40    *Poetic antiquity and architecture:* an ornate row of "painted ladies," as locally nicknamed, features fanciful combinations of ornament and color, brackets and Victorian-era elements of design.

41    *The texture of dreams:* St. Philip Street *(Rue St. Philippe)* home with Victorian character, heavily detailed with an enhancement of fancy millwork, including brackets, pendants and window-header trims.

42    *Gravity and grace:* a cotillion of angels and saintly statues assume a lifelike appearance, as if moving forward toward the unseen, though mounted atop rows of above-ground crypts in St. Patrick Cemeteries, established in 1851. The Christ figure appears to be giving comfort and a benediction blessing to souls who sleep there.

43    *Into the looking glass:* reflections of another world emanate from a weathered and battered old French Quarter door aglow with images of gallery iron railings and columns, heavy with hanging ferns and flowers, mirrored from across the street.

44    *Vestiges of another horizon:* a vision of grandiose iron lace and aged chimneys, capped with chimney-shaft pots, European in nature, contrasts majestically against a mysterious Vieux Carré sky.

45    *Memories and messages:* at the intersection of Dumaine and Royal streets *(Rue Dumaine and Rue Royale),* an appealing Old World canopied gallery protrudes from a nineteenth-century building that appears to float beneath pillowy and handwritten clouds, punctuating the sky.

46    *Multilayered story:* this enchanting 1820s-style French balcony looks down on the intersection of St. Peter *(Rue St. Pierre)* and Chartres *(Rue de Chartres)* streets; welcoming French doors are headed by arched mullion transom; quoins, dressed concrete cornerstones, define the corner, with archway visible in the shadows.

47    *Insight into the colorful course of history:* a warm, burnished glow and seemingly enchanted undercast illuminate the lingering spirit of the high-drama and unforgettable Cabildo Room, site of documented and untold historic events. The eventful and prestigious *Sala Capitular* — the legendary room of official ceremonies and the "room in which to surrender" — was the setting where New Orleans was transferred from Spain to France, then from France to the United States just twenty days later.

48    *Compelling reminiscences:* dark shadows cloak this street scene, yielding and unveiling an unusual aura and presence indicative of its complex past. This block was home to several Creole dueling-era fencing masters. In the early days of the city, more duels were fought in New Orleans than in any other American city. Creole gentlemen practiced swordsmanship for the sake of rivalry, honor and social standing.

49 *Haunting beauty:* bold shadows sheath the front of this 919 Orleans Street *(Rue de Orleans)* c. 1900 frame Eastlake shotgun home, offering a sense of movement as if the unseen past swirls nearby, bespeaking the French Quarter's eventful legends, lore and secrets.

50 *Treasure trove:* like oversized ornamented bird cages stacked over sidewalks, flowery and geometric patterns of cast and hand-crafted ironworks manifest an airily arabesque dimension; the most celebrated wrought-iron dates from the late Spanish Colonial period.

51 *Antiquated wall of remembrances:* fan-like louver covers a quarter-round opening, set into a brick wall that tells many tales of the Vieux Carré, tales of a commingling of many generations of brick types, evincing a long and interesting chronology of countless repairs. Here in this quaint Creole city of olden days, filled with unique influences and impulses, the decades pass slowly.

53 *Dignity beneath a sodden sky:* dressed in late Victorian Italianate details and parapet design, this c. 1890-95 structure stands at St. Ann *(Rue St. Ann)* and Chartres *(Rue de Chartres)* streets, its roof line set against billowing clouds; in the 1840s and afterward Italianate façades were frequently applied to French Quarter American (not Creole) townhouses.

54 *A long heritage of strength and perseverance:* St. Louis Cemetery No. 1 fortification wall encases the many secrets and stories at rest there, a burial site established in 1789; a lone date palm and the Virgin Mary keep vigil. This cemetery is the final sleeping place for many of New Orleans' earliest pioneer families. Stonecutter's engravings mark the names of the notable and ignoble.

55 *Silent influence:* the slant and stilt of this three-dimensional cross, simple yet powerful in repose, designates a time-pitted gravesite in Lafayette Cemetery No. 1. The cemetery, established in 1833, carries centuries of distinguished history; the men and woman of old, who lie beneath the ancient tombs of New Orleans, fill the cemetery vistas with a feeling of melancholic brooding, that is overall poignant and captivating.

56 *Every tomb tells a tale:* inside the gates of St. Louis Cemetery No. 1, at the Vieux Carré's edge, shell paths lead the way to 700 tombs, tomb ruins and markers, all peculiar to the place including this iron cross and above-ground tomb. Elaborate cemetery fences and gates, fashioned of ironmasters' art, depict a theme or motif. These silent symbols remind us of stories of those entombed. A cast-iron fence, crowned with a wrought-iron cross, lyre and fleur-de-lis, guards this tomb.

57 *Passing of the decades and centuries:* within the confines of St. Louis Cemetery No. 1, a cramped city within itself, an obelisk stands amid Platform, Society, Step, Sarcophagus, Parapet and Pediment tombs, plus wall vaults, most designed for multiple uses, and housing many generations. In a town at odds with sea level, surrounded by swampland and subject to torrid rains, many are entombed in what resembles rows of small, windowless houses. The overall effect is that of miniature communities, locally referred to as "Cities of the Dead."

58 *Live this day:* pre-Lent extravaganza of Mardi Gras festivities — costumed parading, laughter and merrymaking. New Orleanians enjoy the revelry in elaborate tradition with Louisianian roots that date to the seventeenth century.

59 *A key moment:* a pianist's fingertips hover poised above the ivory keys denoting a memorable slice of music, the heart and soul of New Orleans.

60 *Suspended:* the antique staircase of a Pontalba Apartment, twin rows of original Creole townhouses that front Jackson Square, echo the voices and characters of Faulkner and other literary icons.

61    *Ups and downs:* continuation of the spectacular flight of steps and curved stairwell pictured on Page 60, the first landing, Pontalba ground floor. Many of New Orleans' surviving staircases are made of Louisiana cypress wood.

62    *Another chance:* the house of the rising sun is haloed by the ferry operator's pilothouse window as dawn breaks, casting shimmering reflections across the mighty Mississippi's tumultuous currents.

63    *Whispers of yesterday:* North Rampart Street ironwork shows the stylistic appeal of a curved radius railing and canopy adornments; a corner of exposed brickwork can be seen beneath chipped exterior stucco, edged by a native palmetto palm.

65    *Rare red sky Vieux Carré twilight:* a surreal silhouette of majestic ancient skyline colored by a cloak of dusk; jutting St. Louis Cathedral steeple tower holds dominion over aged rooftops of long ago.

66    *History walks here:* Many profess that Jackson Square possesses a fascinatingly strange and heavy sensation of unusual quietness, a stilled and somber beauty, particularly evident in a fine draping of mist. In this city of captivating contrasts, many things can be read into, and superimposed upon, the interpretations of lingering specters of the past that spring to life in the Vieux Carré. Remembrances of bygone French Quarter days and secrets of old still take hold and flourish, seeping upwards from the ripe ground like haunting mist, reminiscent of the days and men of eighteenth- and nineteenth-century New Orleans.

73    *A place where dreams of old take root and flourish:* historic French Quarter structure cloaked in a thick two-story cascade of bougainvillea climbing skyward, its verdant leafstalks heavy with tropical clusters of glorious rosy magenta flowers abloom.

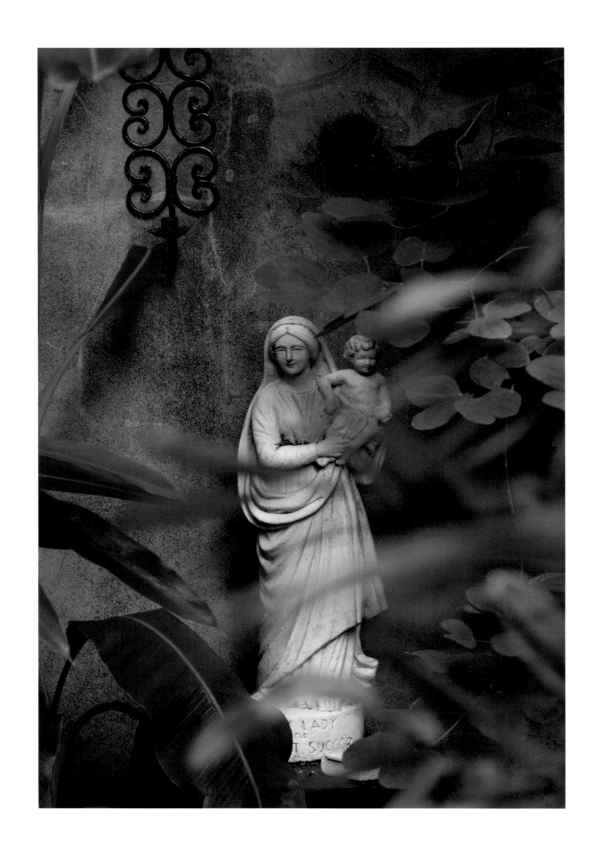

# New Orleans

1879

*"An atmosphere of tranquility and quiet happiness seemed to envelop the old house, which had formerly belonged to a rich planter. Like many of the Creole houses, the façade presented a commonplace and unattractive aspect. The great green doors of the arched entrance were closed; and the green shutters of the balconied windows were half shut, like sleepy eyes lazily gazing upon the busy street below or the cottony patches of light clouds which floated slowly, slowly across the deep blue of the sky above. But beyond the gates lay a little Paradise. The great court, deep and broad, was framed in tropical green; vines embraced the white pillars of the piazza, and creeping plants climbed up the tinted walls to peer into the upper windows with their flower-eyes of flaming scarlet. Banana-trees nodded sleepily their plumes of emerald green at the farther end of the garden; vines smothered the windows of the dining-room, and formed a bower of cool green about the hospitable door; an aged fig-tree, whose gnarled arms trembled under the weight of honeyed fruit, shadowed the square of bright lawn which formed a natural carpet in the midst; and at intervals were stationed along the walks in large porcelain vases — like barbaric sentinels in sentry-boxes — gorgeous broad-leaved things, with leaves fantastic and barbed and flowers brilliant as hummingbirds. A fountain murmured faintly near the entrance of the western piazza; and there came from the shadows of the fig-tree the sweet and plaintive cooing of amorous doves. Without, cotton-floats might rumble, and street-cars vulgarly jingle their bells; but these were mere echoes of the harsh outer world which disturbed not the delicious quiet within...."*

Lafcadio Hearn
(1850–1904)

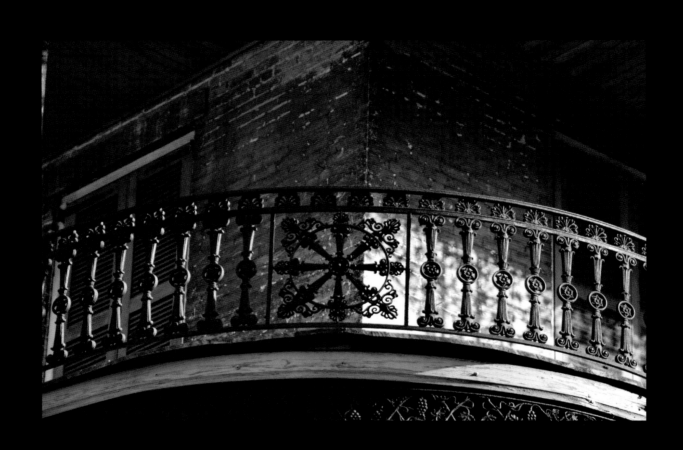

# Part Two

1993

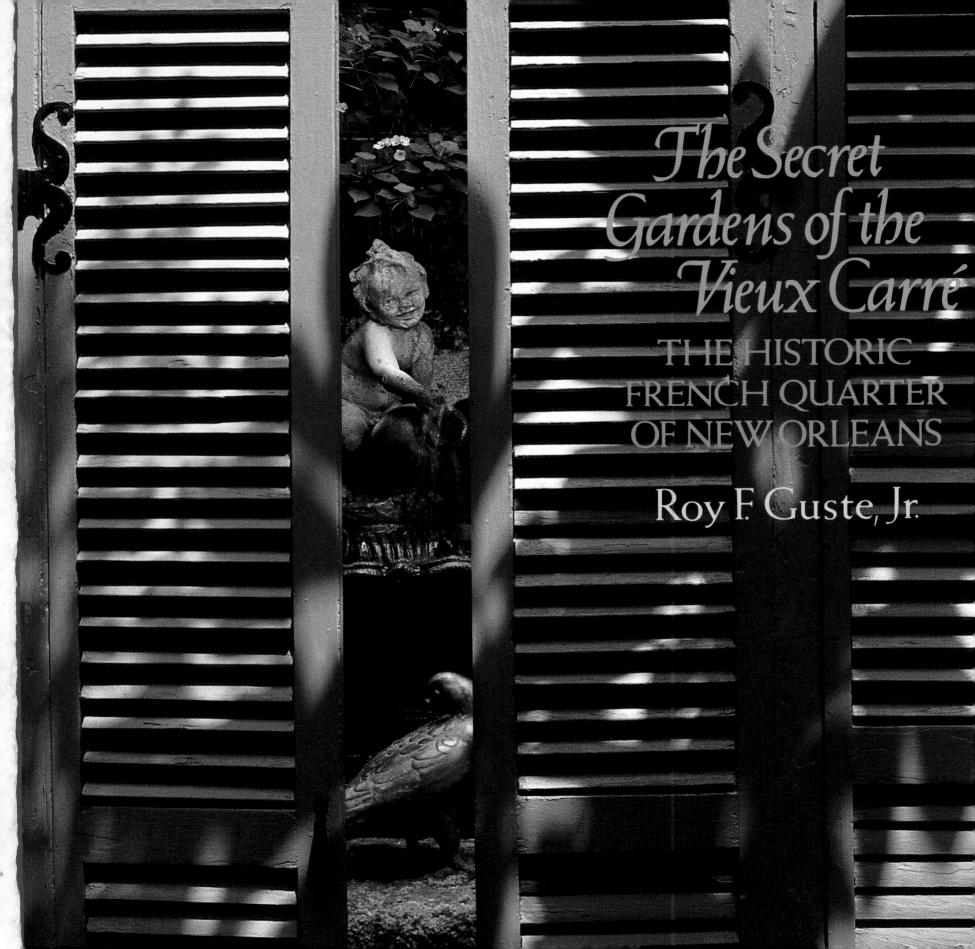

# The Secret Gardens of the Vieux Carré

## THE HISTORIC FRENCH QUARTER OF NEW ORLEANS

### Roy F. Guste, Jr.

# The Secret Gardens
of the

# Vieux Carré

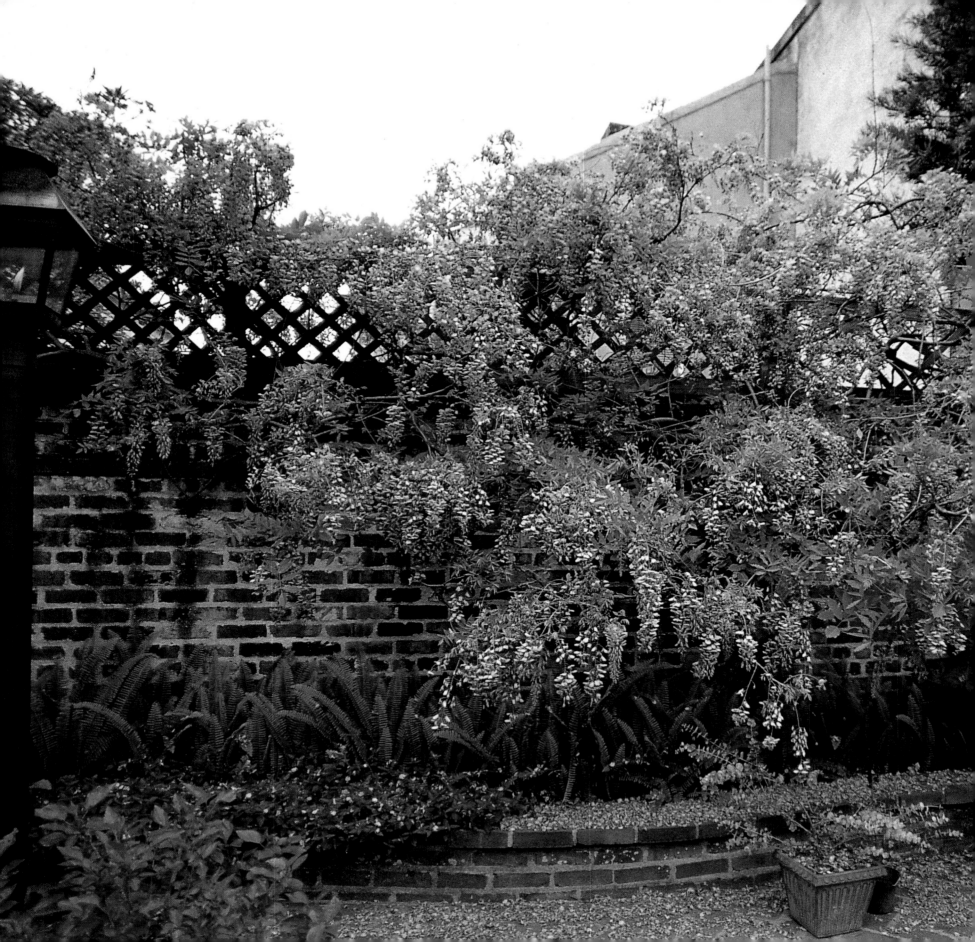

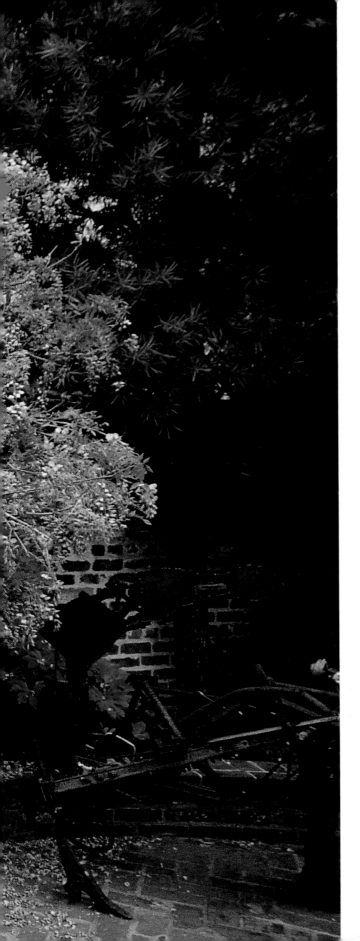

# The Secret Gardens
## of the

# Vieux Carré

### The Historic French Quarter of New Orleans

Roy F. Guste, Jr.

# Acknowledgments

*For Mimi, as always*

I offer my gratitude to all the people who assisted in the production of this work: Robert Abramson; Harold Applewhite; Alice and Lewis Barry; Mary Adele and John Baus; Lindy Boggs; Shirley and Eldred Cieutat; Ken Combs; Dan, mayor of Dumaine Street; Lynn Dicharry; Bill Fagaly; Stuart Gahn; Betty Guillard; Doc Hawley; Dale Leblanc; Rebecca Lentz; the Levecques; Brobson Lutz; Milton Melton; Betty Norris; John Ordoyne; Steve Scalia; Sharon Simons; Rodney and Frances Smith; Peachy and Henri Villère; Mary Louise White; Hal Williamson; the library staff of The Historic New Orleans Collection; and the many others who aided in the development of this work.

My special thanks to the horticulturalists and designers who assisted: Vaughn Banting, Steve Coenen, René Fransen, and Annie Zipkin.

Merci, mes amis.

# Contents

# Preface

The New Orleans French Quarter, or Vieux Carré, is a unique place for these United States. The French words literally translate to "old square." It is this old square that was the original city of New Orleans, drawn in Paris by the engineer de la Tour and physically laid out in its location on the east bank of the Mississippi by his assistant Adrien de Pauger in 1721.

The sprawling New Orleans of today has grown up around this central *coeur,* this "heart"; it beats to the rhythms of old cultures past and new peoples present.

The children of our forefathers were themselves unique: the Creoles, the descendants of the French and Spanish who settled this land and established this metropolis. And there were the children of the enslaved Africans, brought here to cultivate the sweet sugarcane. With a sprinkle of Germans here, a dash of Irish there, and a generous dollop of Italians to romance the pot, it is the children of all these people, separately and together, who make up the population of New Orleans today.

One aspect of the French Quarter that has not changed since its founding is that it is a living city — now a city within a city. Its residents are people who have chosen to either remain or to arrive of their own free will. It is a place where no one is trapped by circumstance. If the rest of New Orleans were to suddenly disappear, we would still have a complete community within our twelve-by-six-block grid: a small community, but complete nonetheless, and perhaps ideal. It is a diminutive city of neighbors. We of the Vieux Carré are accustomed to passing familiar faces at every turn. We are also accustomed to visitors, both from other areas of New Orleans and other cities of the world, who come to enjoy the quaint feeling of our *petite ville,* our little city.

Our streets still bear the names of the Bourbon-Orleans family: kings, regents, princes of France from the late seventeenth and early eighteenth centuries. Street markers remind us of old and temporary street name changes during the ensuing Spanish domination, before New Orleans was returned to France, to Napoleon, for transfer to the United States as its largest territory. We live engulfed by this history every hour of our days and nights.

We are keenly aware of the desire of others to know the secrets of our place. Daily, passersby peer into our courtyard entryways hoping to catch a glimpse of the life behind: the secret life that exists calmly and quietly in contrast to a bustling contemporary time. Ours is an expression of another age when life was enjoyed with a Latin fervor unknown in the rest of this country.

As a living community we are able to enjoy all aspects of our lives here. As a survivor, as a "real" place, not some bloodless developer's confection of a new "old place," the Vieux Carré stands testament to a people, to the Creoles and their compatriots, who perceive life as one that includes an ambience, a *tout ensemble,* a joie de vivre, in order to be complete.

The courtyards and patios of the Vieux Carré are living spaces. They are used and enjoyed, and rarely kept as pristine images of some designer's whim. The photographs will explain better than words the reality of these coveted and well-used spaces. Imperfections exist: as in all of life itself. But it is the degree of imperfection that warms and relaxes the heart in the acceptance of it. The patina of the French Quarter is here to be appreciated, not repaired. To continually restore this imperfect beauty would be to destroy its essence, and its essence is what makes it unique.

Enjoy, then, this glimpse as introduction to, or as remembrance of, an uncommon place: the Vieux Carré and its extraordinary secret gardens.

# The Secret Gardens
## of the

# Vieux Carré

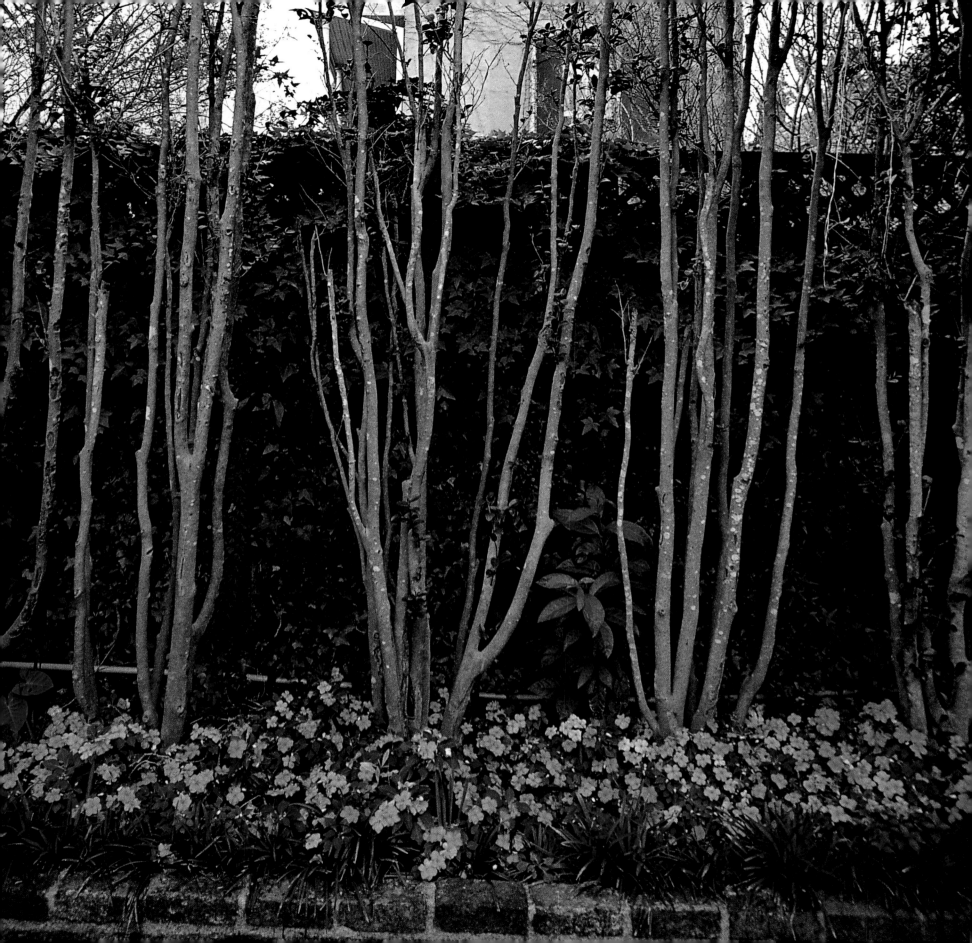

# Introduction

My earliest memories of my lifelong interest and love for the secret gardens of the Vieux Carré begin rather indirectly as a result of time spent in the French Quarter during our marvelous Mardi Gras season in New Orleans.

As a child, and just old enough to be walking on my own, my parents would take me and my older sister to the French Quarter — the original city of New Orleans, which encompasses a six-by-twelve-block district — to our family's restaurant, Antoine's. We would climb the long stairs to upper rooms where we would meet with the throngs of other family members — great-grandparents, grandparents, parents, and the many children (all cousins) — to spend some lively moments of perennial reunion when familial ties, friendships, and camaraderie were reinforced.

Soft drinks for the children and cocktails for the adults would be enjoyed, along with varied appetizing tidbits prepared below us in the great kitchen on the ground floor, as we waited for the parades to begin. This yearly, citywide observance of the Carnival season would begin almost two weeks before the actual day of Mardi Gras, and the parades would roll nightly through the French Quarter, the Vieux Carré, or old square, of the city, riling the citizenry into a gradual frenzy that climaxed on Fat Tuesday, Mardi Gras Day. The celebration of that day itself derives from the Catholic observance of Easter Sunday, before which is the season of Lent. Lent is meant to be a time for penance and austerity — some forty days — during which time one gives up some pleasure (or food) in atonement for sins. Naturally, our forefathers the French, long before the founding of New Orleans in 1718, had celebrated the last day of freedom before Lent by a festival of overindulgence. The observance of the festival in New Orleans became par-amount to its Catholic residents and grew to fruition as a two-week-long revelry.

In those days, we, the children, would be the alarm for the coming parade. Out from the crowded upstairs dining room and onto the adjoining balcony that fronted the restaurant on the second floor, overhanging the sidewalk to the street, we would march. There we would stand guard, perched, waiting and watching, with growing anticipation and excitement, for the first sign of the red flashing lights of the police cars that would precede the parade, clearing the width of the narrow Vieux Carré streets of the human jungle crowding the avenue. With the distant red flash of the first lights, we would fly squealing back into the interior room with the clamored announcement, "The parade's coming, the parade's coming!" The adults, knowing that we had only seen the lights from a good distance, would take time to refresh their cocktails before they exited the cozy warmth of the interior for the chill of the exterior balcony.

On those nights in February or March (Mardi Gras is a movable feast), when the winds blew cold and strong through the streets, we would stand bundled yet freezing, uncomfortable yet excited, waiting for the first paraders to come into view. The truck with the flashing lights would pass first, to the din of the waiting throng on the streets below us. Next came six or eight exquisite stallions conveying proud dukes dressed in all of their glorious Carnival majesty of lush velvets and satins, all masked and tossing the prized doubloons to lucky nearby onlookers. These are the coins that are minted individually for each parading organization, of which there are now some eighty, and thrown as souvenirs of the year's festivity.

Next would come the first float, a tall and magnificent

gliding papier-mâché tableau, almost high enough to reach us standing above the street, on which perched the king and queen of the parade, the proud agents of a sacred trust: to be Mardi Gras royalty. They would pass amid the cries of the throng; then would come a marching band playing the brassy rhythms of some popular song, cymbals crashing, bass drums pounding.

Accompanying all floats — and there would be some fifteen — would be an encirclement of brightly burning oil lamps atop a tall pole held by a carrier. These troupes of *flambeaux carriers* would encircle each float to illuminate the spectacle for the crowd. The carriers, who were simply referred to as *flambeaux,* dressed themselves in white sheeting from head to foot — which was blackened by the soot of the smoking lanterns — for protection against the flames they carried. They danced a rhythmic mambo to the beat of the brass bands as they cavorted alongside the tall, glittering rolling tableaux of bright colors and gold and silver foil leaf. These foils reflected the dazzling dancing flames. The masquers, riding atop their sparkling kingdoms, were appareled in glistening silk and satin costume finery of yellows, purples, reds, and greens and all colors that glimmered in the night. There the animated riders, smiling behind their guises of painted papier-mâché masks, played to the thrill of the crowd as they cast out their treasured token baubles in the form of sparkling beaded glass necklaces and myriads of trinkets of all variety.

On the street below us, the cries and shouts of "Throw me somethin', Mister!" from the throng to the paraders would precipitate a quick scrambling to the ground of treasure seekers, as the pinging sounds of a tossed handful of prized doubloons hitting the stone streets reached everhopeful ears.

Those nights were always cold. The crowd below hunched together for warmth and then lunged forward from the curb to get nearer to those in possession of such treasures as tossed necklaces, doubloons, and trinkets, tokens of the night's revelry.

As the cold wind bore down on the crowd in the streets, it stirred together the perfumes of the avenue with those of the street vendors confecting their sweet delicacies: the heady aroma of the pink cotton candy; the tobacco smoke of the crowd; the candy apples' sweetness, mingled with the fumes of burning oil from the *flambeaux* lanterns; the sweet incense of caramel corn; the fetor of the horses; the hot roasting peanuts; and the diesel exhaust of the tractors pulling their grand floats.

When the excitement of the parade was over, it would be time again to make our way through the narrow streets of the Quarter, back through what seemed like an endless number of blocks, to where the car had been secured for the time. It was then that the mysteries of the Vieux Carré came alive for me. Even though the excitement of the revelry was still ringing in my ears, my senses now turned to something even more exotic than a Mardi Gras parade.

As we made our way through the crowds, mingling and laughing and celebrating in the streets, our hands were held tightly, my sister and I between our mother and father for protection. Along these mysterious *rues* we voyaged, each of which called out some new mystery in a dark and wonderful way.

As we walked, I would catch a glimpse from time to time through the bars of a narrow wrought-iron gate between ancient buildings that stood then in a state of decaying beauty, as of some forgotten aged ladies, *les demimondes,* draped in faded and tattered finery from another era. Passing each iron entryway, I would steal another glance down a narrow side alley, or through an ornamental element set carefully into a battered wood door to provide the insider with a view of the outside. Through these doors I would be teased into imagining what was beyond. The faint light of the gas or kerosene lamps that glowed dimly from deep in the alleys and the secret places to which they led was the ultimate mystery, one shrouded in veiled beauty and secrecy. Beyond these buildings, back and hidden away from the streets, were the secret gardens of the Vieux Carré.

Those nights, when we returned home tired and excited from the evening's adventure, I would lie awake, those last moments before sleep, remembering not the parades and the frivolity but the mysteries of hidden places. Morpheus would soon descend and take me in his arms to dream enigmatic dreams of places yet unknown to me, of gardens filled with mystery and intrigue. Were there things as ghastly as the ghosts of the tortured slaves in the haunted house on Royal, or was there some diabolical voodoo ritual

being practiced in that clandestine court behind the famed home of Marie Laveau, the long dead voodoo queen?

As the years progressed and I passed from adolescent to teenager, grade school to high school, my interest in the hidden gardens grew. On Saturdays, I would leave our uptown home and ride the streetcar down the line to Canal Street, which borders the north side of the French Quarter. On those days, my announced mission was a midday movie at one of the grand old downtown theaters where I would spend two hours quietly and safely secured. But after that, I would quickly sink into the Quarter and roam the streets, marveling at the beauty of the old streets and buildings.

The Quarter was not the fashionable place that it is today. No, it was a place that was run-down, decrepit, you might say; yet it had a beauty that could not be denied, like a fallen angel drifting softly in a timeless void where she could be observed but not possessed. And so, I observed.

From time to time, fortune would be with me and I would find a gate open or an old black mammy standing at the entryway of a hidden garden, swapping stories with the neighboring servants. She would catch me stealing a glimpse into the alleyway and say, "Come on, hon', git yosef' a look, but make it quick now, fo' ma' mistress fin's you back tha' goggling!" I would enter, quickly and quietly, relishing the excitement and the beauty about to be experienced in the court beyond.

The alley led past the side of the house to the courtyard. The ancient brick wall surrounding the court was inevitably covered with some flowering and perfumed vine, a honey-suckle or a Confederate jasmine. In the far corner there was a sweet olive tree, the brick surface beneath dusted with its fallen, yellowed perfumed blossoms. All around the base of the walls was a slightly raised planting section flush with giant elephant ears crowding out into the court under towering banana trees, whose huge lavender-and-fuchsia central blossom was birthing the first tiny fingers of the delicate banana fruit. A Japanese plum tree to another side would be heavy with fruit as was the ancient fig tree in a corner, so full of the largest, darkest purple fruit, as big as your fist, that the branches pulled wearily down to touch the very ground beneath.

A crescent-shaped, knee-high raised brick pond hugs the center of the far wall. The bricks are darkened in blotches with the slick green-black of a tight moss, while a fantasia of tiny ferns snuggles into the cool wet corners and cracks of the fountain pond.

A stream of water trickles delightfully into the pool, poured eternally by an elegant statue of a nude woman. Tempted beyond reason, I lean in, close to her bosom, to taste the cool waters flowing in a gentle stream from the urn in her arms. I am seduced. . . .

Fat goldfish hang close under the water's surface, beneath the veneer of protection conjured by the wide rounded leaves of the water lilies. Their tall blossoms stand upright in raiment of flushed pink, defying the necessary restraint of the life-giving waters below.

A movement to the side, a glimpse of motion out of the corner of my eye, a sinister reflection in the pond's mir-rored surface; the fish dive deep into the murky depths for escape. A cat, black as a moonless night, encircles the gar-den on the crest of the walls and leaps high onto the roof of the neighboring house, seemingly taking flight as in its apparent weightlessness it floats up to the very heights of the roof's peak. I shudder slightly. The coolness of the yard is unnatural.

Regaining my calm, I am refreshed by the air's moist breath, air that is ever replenished by the greenery.

The fragrance of the flowers is overwhelming, an opiate to the addict. One fragrance fights against another to gain control of my senses. I surrender, relaxed, into this world of sublime serenity.

My reverie is broken by the call of the servant at the outside gate. I am dismissed to face the reality of life. Out-side on the street, in the blazing afternoon sun, movement of the passersby is sluggish and heavy. I become as they, and make my way out of this dream place back to Canal Street, the streetcar, and home.

On entering my college years, I chose to live and work in the French Quarter, where I could drift deeper and deeper into my infatuation with its beauties. My first resi-dence away from the family home was a small slave-quarter apartment overlooking an exquisite, lush courtyard. I felt very much at home in my worn and tiny brick building, on the second floor, with its narrow wood balcony overlook-ing the flora of the garden, the flora of an older and — in a

decrepit way — more elegant New Orleans than the one I knew.

I spent my days studying at the university, my evenings at work in the restaurant, and my late afternoons and nights learning to love and enjoy my life and the world around me. In those early years I learned what it was to be in love, the pangs of being hurt, and what it meant to be alive.

My love for the gardens and courtyards increased and developed so that I soon measured the beauty of each new dwelling by the charm and complexity of the courtyard and its flora. From the simplicity of a balcony garden or a postage-stamp-size patio, planted with urns of night-blooming jasmine and honeysuckle, to the grand antiquated lush courtyard crowded in from the brick walls by the dense foliage of banana, elephant ear, ginger, and fern, I became a hopeless slave to their resplendence. How would I know that the enchantress of my life, my beguiling and possessive mistress, would be the Vieux Carré garden?

During the twenty-five years that I have now lived in the French Quarter, and in the many locations I have inhabited, I have spent countless hours in quiet thought and calm contemplation in the cool greenness of innumerable hidden courtyards. They are a part of my life — a warm and wonderful part of my life. My life is far better because of them, for I have given in to my passion and now record the charm, the allure, of the femme that has taken me as her victim — a willing victim, I assure you — for all the curious to know.

I will venture forth now to bring you those secrets that live in a world apart, beyond the plastered walls, beyond the streets ever so busy, into a secret world. It is a world where one can escape from the drudgeries of daily life into a cool green paradise, where you, too, can become enraptured by the serene beguilement of such sweet tranquillity.

So, let me open the iron gate, my friend. Please step off the street, out of the bustle and the glare of the sun. Walk back into my serene life beyond the walls; into my garden, lush and green; into the cool of the shade. And please, have a seat . . . there, under the sweet olive tree. Relax for a moment, catch your breath. Allow yourself to relinquish the tensions of the day. Put your mind and heart at ease, while I step inside and prepare us a mint julep — I'm told I make a fine mint julep, you know. Be calm . . . and turn, with me, a page of my life.

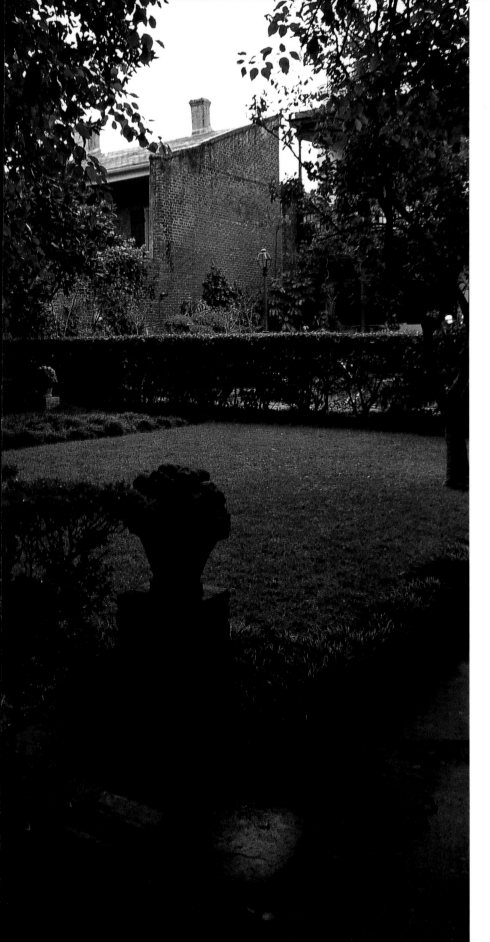

# Arsenal

<span style="font-size:200%">P</span>art of this complex was originally marked off as an area for the French Army Arsenal on a 1722 map of New Orleans. Later it was given by King Louis xv of France to the Ursuline nuns, as their concession when they arrived in the early settlement to begin their work attending to the military hospital and teaching the children of the colonists. The nuns also were the guardians of eligible young ladies, called casket girls after the small carrying box containing a meager trousseau delivered to them by the French crown. These young women were sent from France to Louisiana to become wives to the many young men who had come before them to build the city of New Orleans and the surrounding areas of this French Colony of Louisiana, so named by the early explorer La Salle in honor of King Louis xiv.

*The complex is composed of two lots that have been joined to make one of the Vieux Carré's most lovely spots. Hidden behind a high wall, the great magnolia tree overhangs the banquette, or side-walk, on the street from behind the garden wall.*

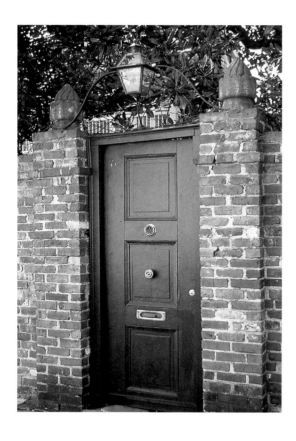

The small entry door opens to a shaded grass lawn surrounded by a border of ferns and lush, green tropical perennials. The stately building to the left was designated by Frances Xavier Cabrini — representing the Missionary Sisters of the Sacred Heart — as a Catholic school, from 1904 to 1921. Now the school building is residential and is divided into apartments that overlook the lovely gardens.

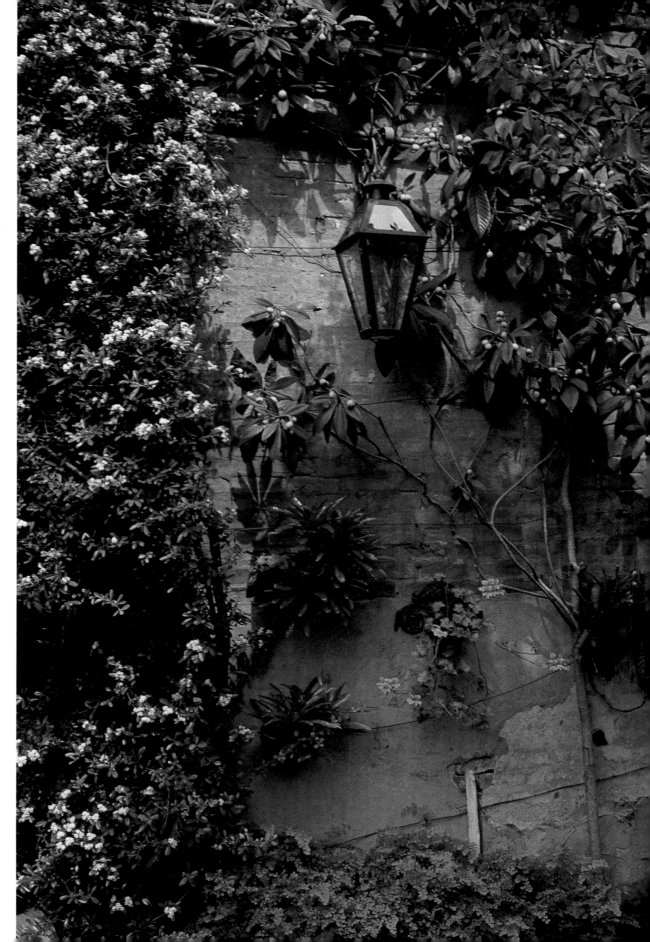

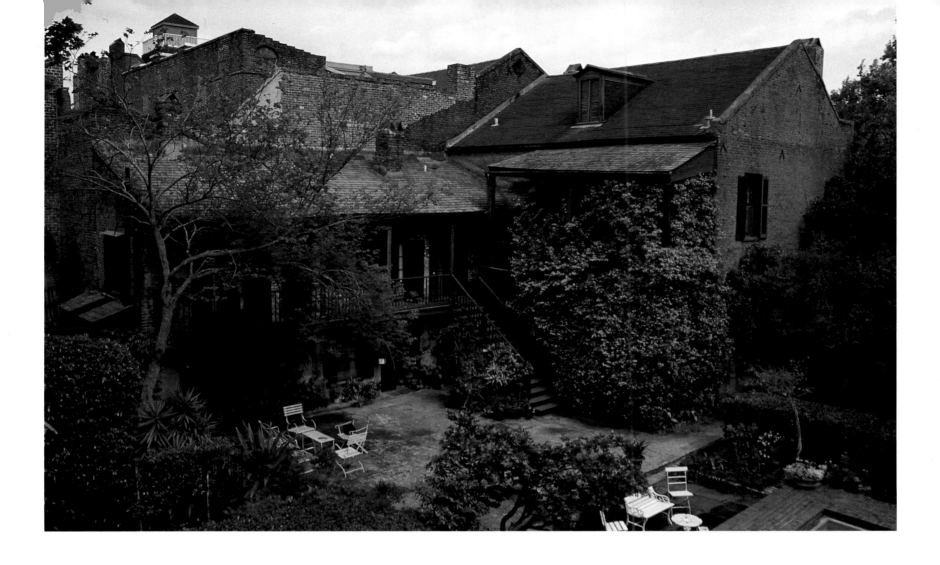

Between the shady lawn and the old school is a pool made private by boxwood hedges. Along the wall of the building to the right as we enter are a collection of bromeliads; a pink geranium; a Japanese plum tree, or loquat; and a thick pyracantha vine, heavy with flowers. The bed is planted with sword and maidenhair ferns.

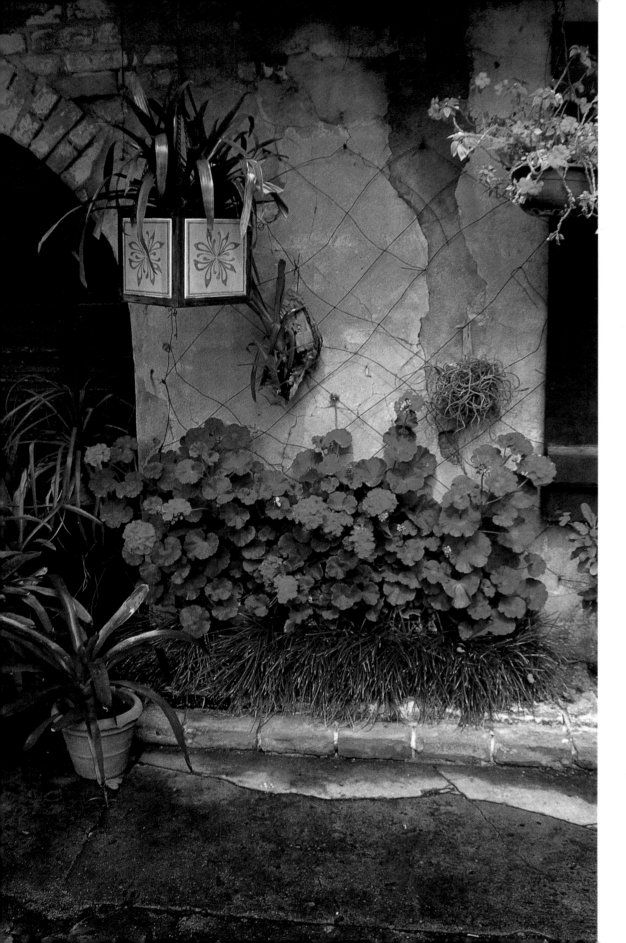

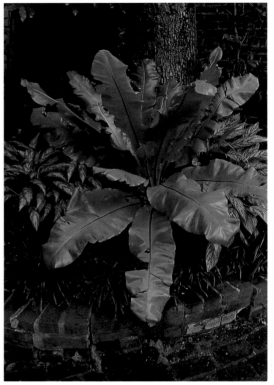

A view from the old schoolhouse gives an unobstructed, comprehensive feel of the space and buildings here. Beneath a balcony, a grouping to color a shadowy area includes hanging pots of bromeliads and begonias and red geraniums.

Deeper into the complex is another small court surrounded by brick walls and shaded by a sycamore tree. The central, circular raised bed is planted with delicate, small pink impatiens and monkey grass and is punctuated by an iron planter thick and overflowing with a large bromeliad. This particularly quiet courtyard becomes a sitting area for relaxing and reading. Plantings in this area include a walking iris, or NEOMARICA, and a splendid ASPLENIUM NIDUS, or bird's-nest fern.

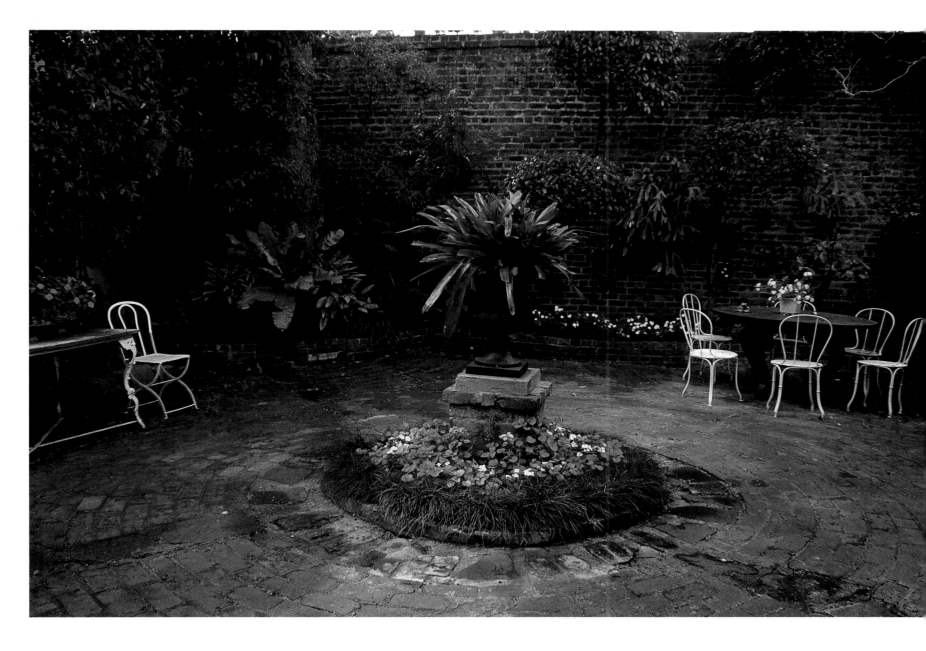

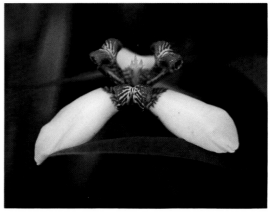

A cast-iron and marble side table boasts two
antique leaden urns planted with red impatiens.
The exotic pink flower of a bromeliad leans out of
its pot into the pathway.

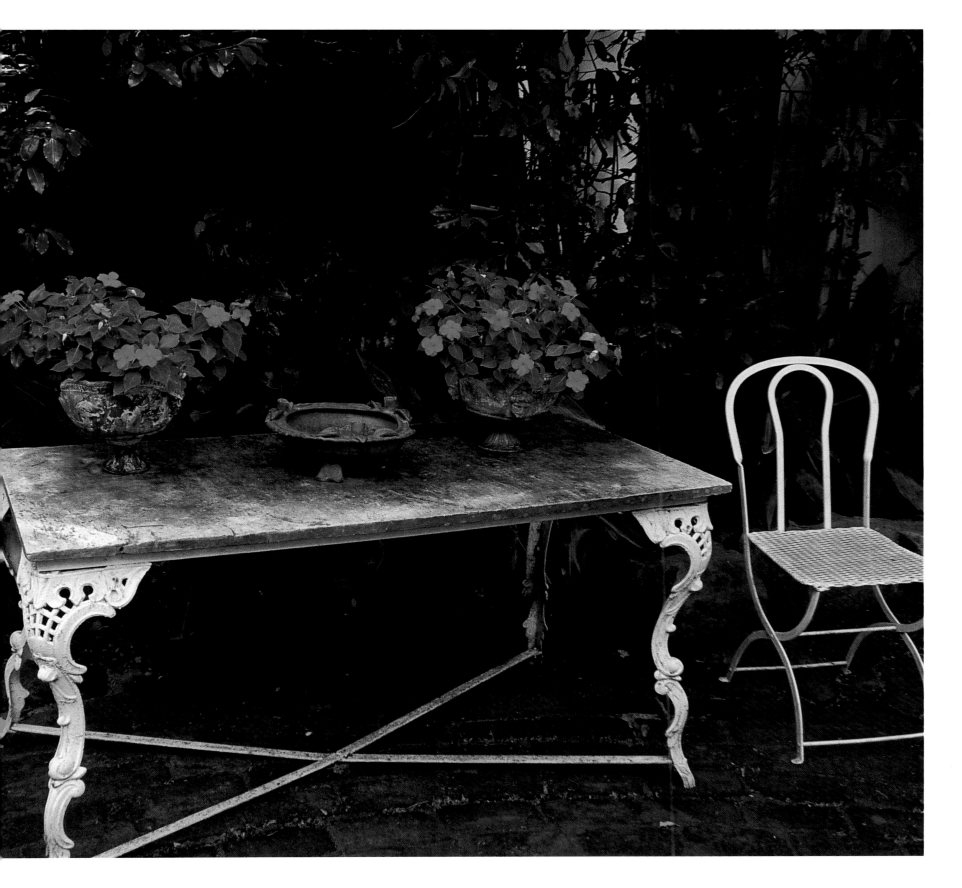

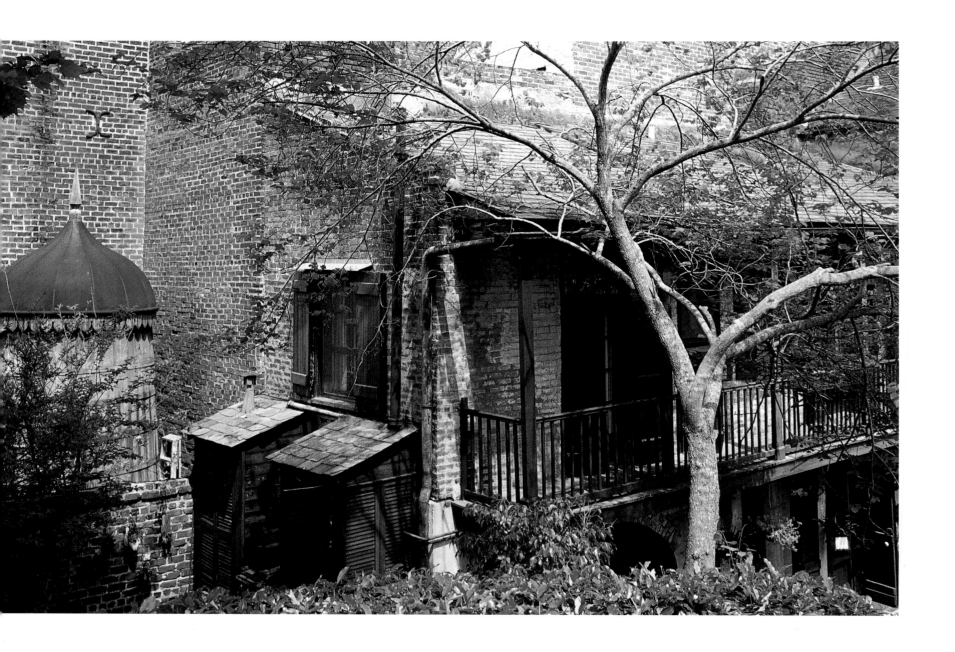

*Over the wall is an archaic cistern once used to hold rainwater for the neighboring home. The tall redbud tree,* CERCIS CANADENSIS, *is just showing spring leaves.*

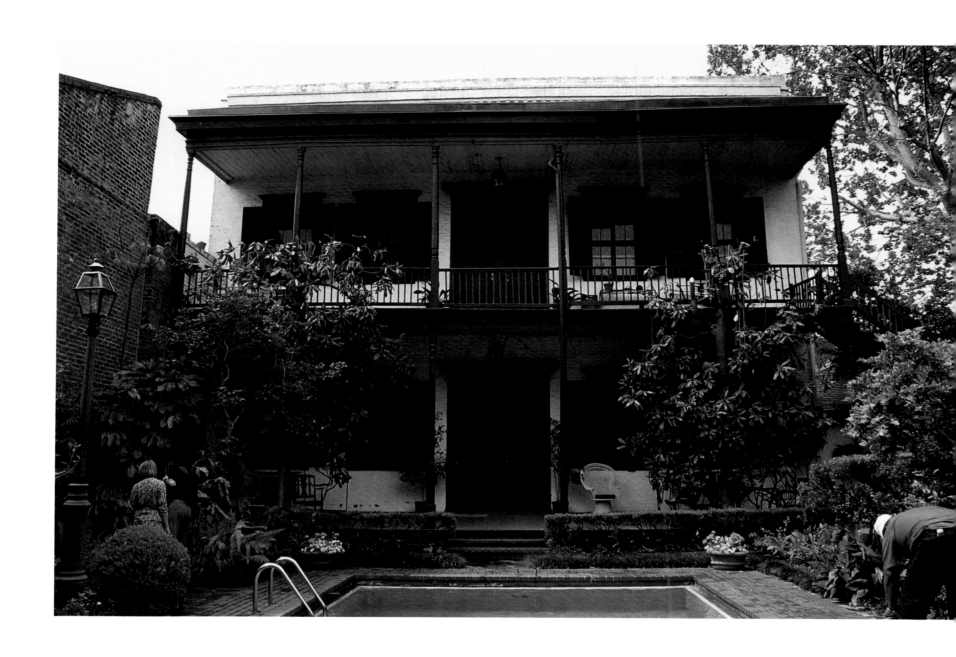

*Turning out into the open is the area that once
served as the yard for the old school building of the
complex. This building was the school of Saint
Louis Cathedral and the schoolyard is now sup-
planted with a lovely pool.*

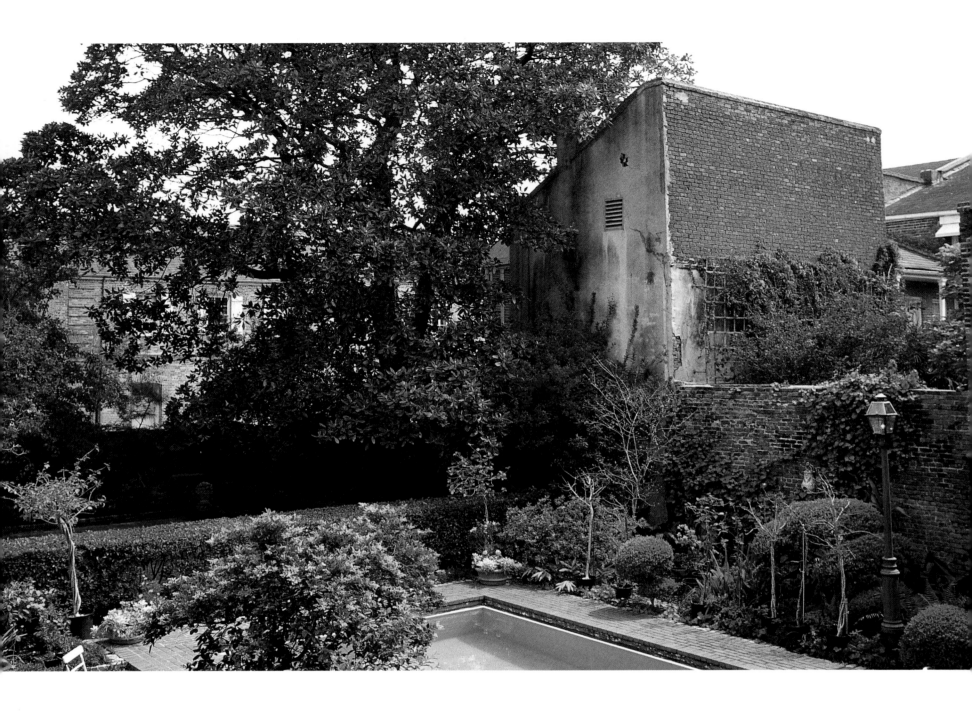

From the gallery of the old school, a wide area of the compound can be seen: pool, gardens, lawn, patio, old buildings, flowers, trees, rooftops of the neighboring structures. The walled side of the pool area has several small displays of interest, each designed as a singular composition. One display includes a bacchanalian face peering through the English ivy covering to a fountain, shrouded by assorted ferns including staghorn, maidenhair, and wood.

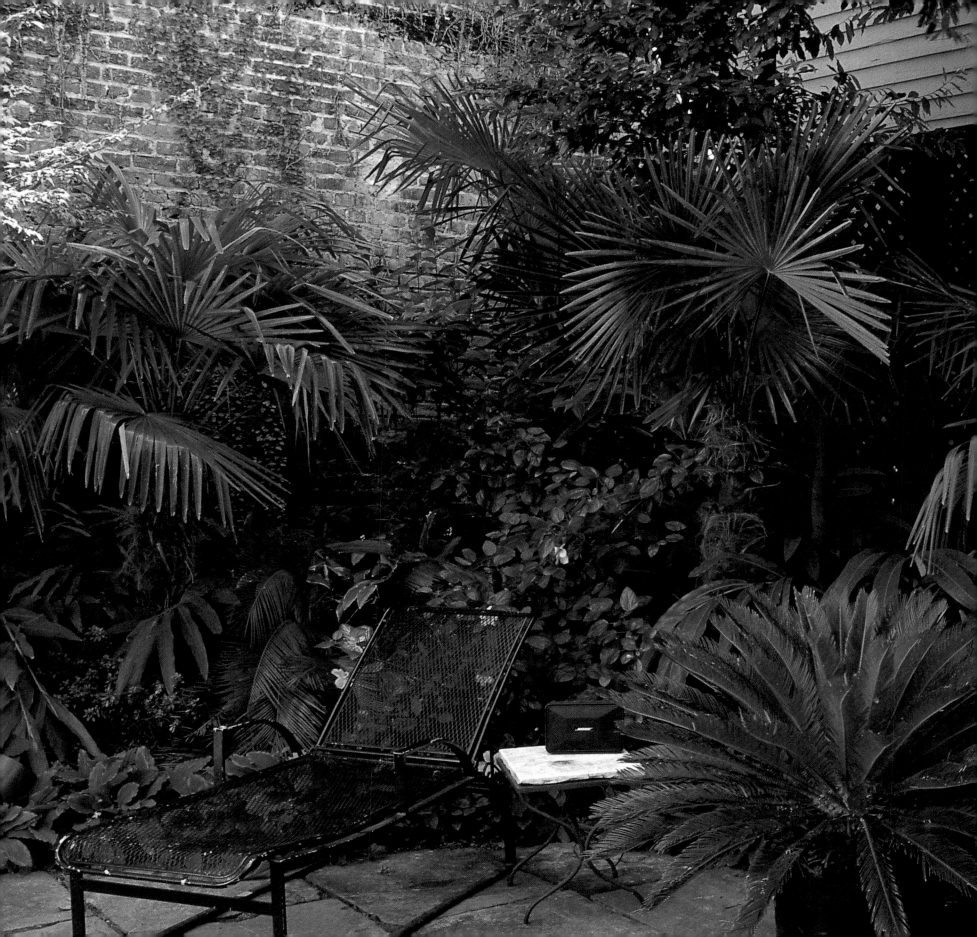

# Beauregard

*I*n 1855, John Slidell, U.S. congressman and diplomat from the South, built this two-story Edwardian frame structure as a wedding gift for his sister-in-law, Marguerite Caroline Deslonde. That year, Caroline, as she was known, married Pierre Gustave Toutant Beauregard, an American army officer who had already distinguished himself in the Mexican War from 1846 to 1848. They made their home together here.

When Louisiana seceded from the Union, in 1861, Beauregard resigned from the American army to fight for the South, eventually becoming a full general in the Confederate army. His involvement and able leadership in every major campaign of the Civil War gave him the reputation of an illustrious combat commander. But P.G.T. Beauregard suffered more from just the battles during those years: his beloved wife, Caroline, died.

The house was sold after the Civil War, with subsequent owners making alterations to the character of the building. The tiny patio that remains is only a part of the original courtyard, yet provides a lovely, small area for cool relaxation and contemplation.

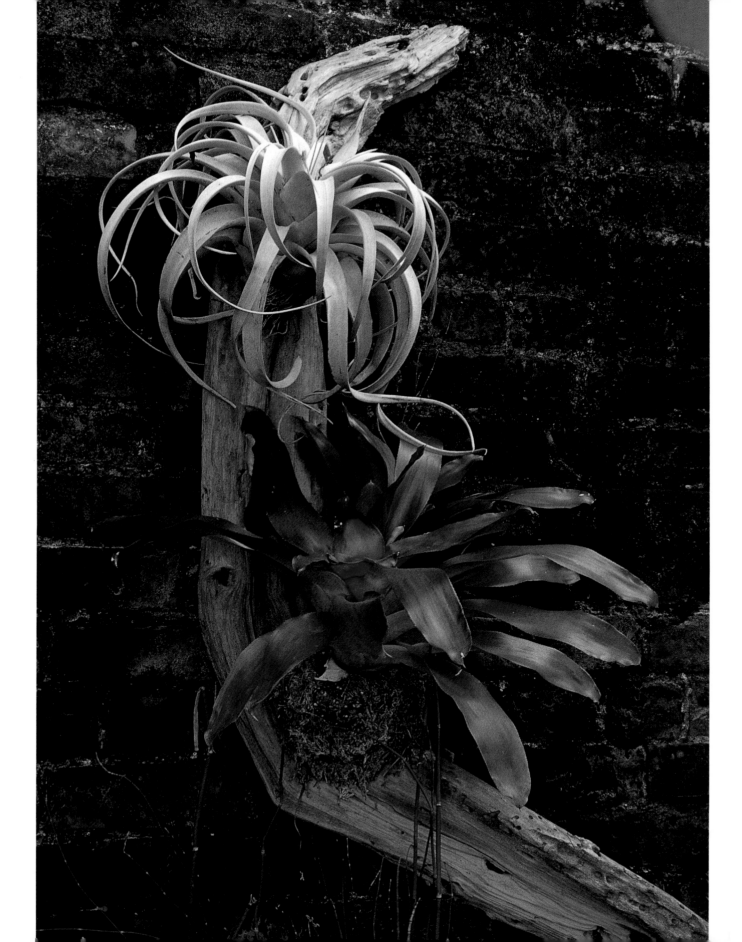

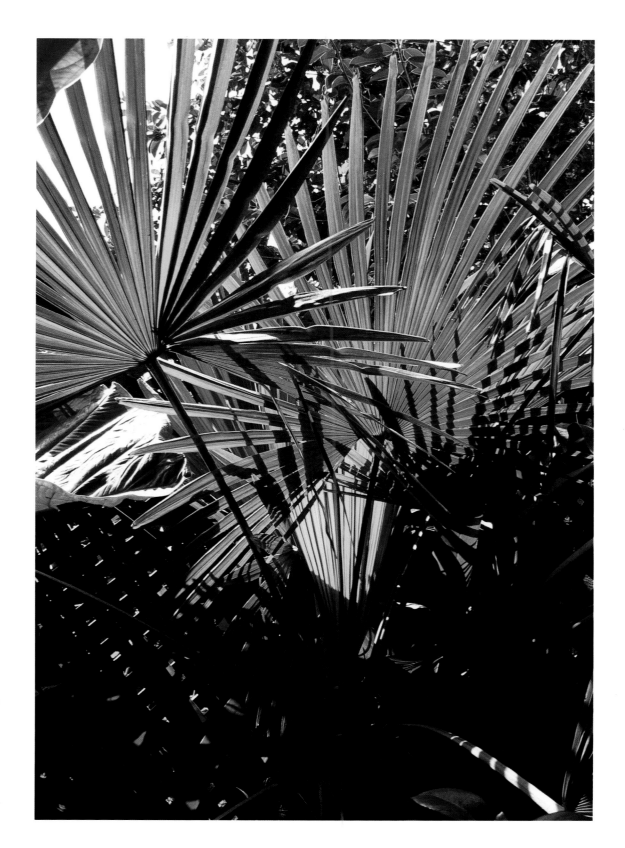

*Preceding page:*

*A full view of the left corner of the area, shaded by the shadow of the tall surrounding walls, reveals the spiky, fanlike fronds of several varieties of palms including Chinese fan, windmill, and sago.*

*Entering the court from an open walkway, down the left side of the building from the street, a cypress driftwood elbow attached to the brick wall cradles two bromeliads. The top is a wispy gray tillandsia, the bottom a rich-green-and-deep-vermilion* NEOREGELIA.

*The leaves of another windmill palm catch the afternoon light that streams into the far corner of the patio.*

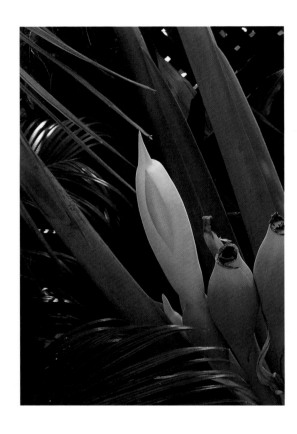

A giant elephant ear, ALOCASIA MACRORRHIZA,
flourishes in the sun of the same corner; its white
spathe glows in the protected shadow below.

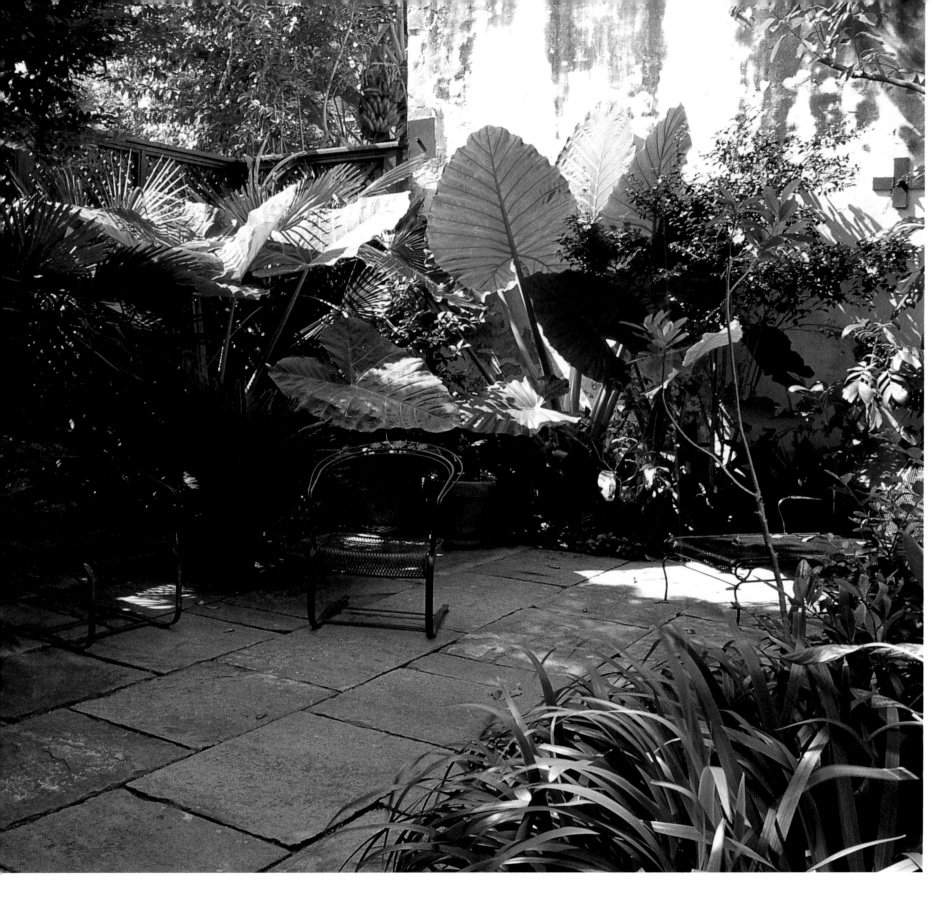

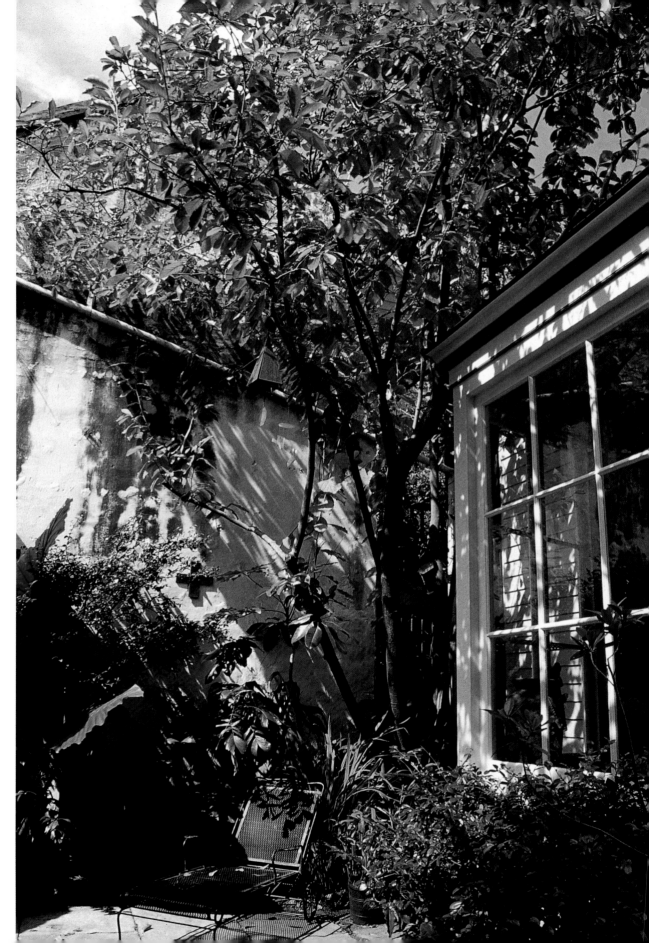

*A low showing from a Japanese maple stands before the leaves of a ginger plant.*

*Another corner view of the patio shows a large bay window of the house that extends into the court.*

*The wall of the adjoining property appears monastic. The thick metal cross is positioned there for salvation — the salvation of the wall. The cross anchors a metal rod that bolsters and strengthens the once-sagging wall.*

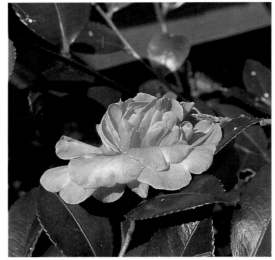

It is appropriate that in this same garden a resurrection fern, now a brown dead-looking fur on an oak branch, waits only for the next rain before it comes alive again to resemble a furry green coat. A single camellia blooms its pink flower.

The view from within the house out into the secret garden provides a painting of greens and light, both close and far. The sky holds another reminder of the Creole life here: the steeple of a nearby French Quarter church.

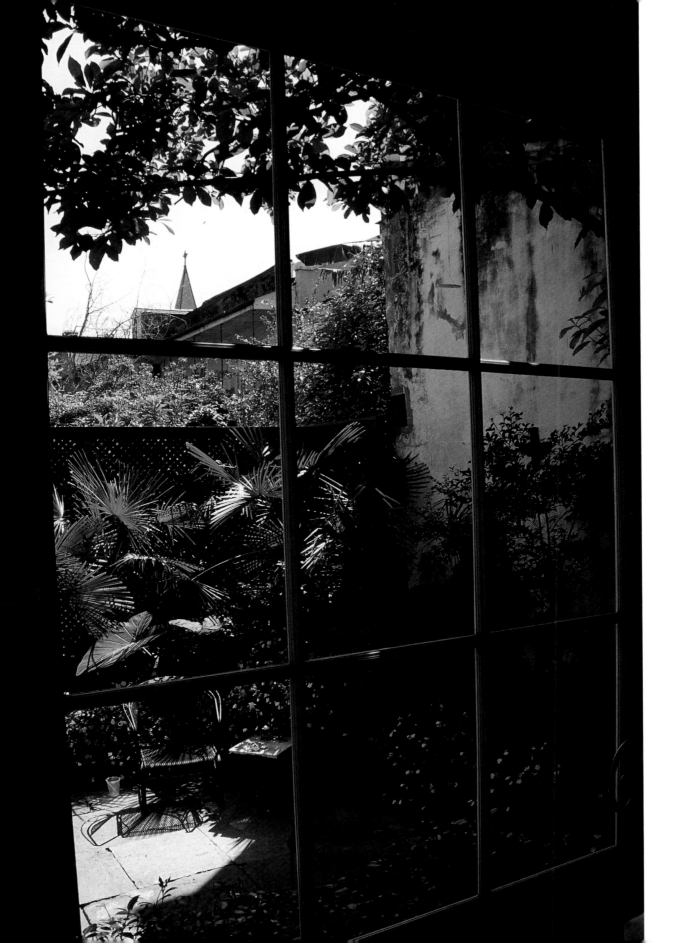

# Begue

❦

*I*n 1853, Philip Kettering and his sister Elizabeth arrived in New Orleans from their native Germany. Philip worked as a butcher in the French Market and soon met Louis Dutrey, a butcher from Gascony, France. When Philip brought Louis home to meet his sister, Louis became entranced: he soon asked Philip for her hand in marriage. After the marriage, they opened a small, single-dining-room restaurant on an upstairs floor near the corner of Madison and Decatur streets called Dutrey's. The eatery became a favorite among the butchers of the French Market.

The butchers had long been an influential group in the market. Years before, a Frenchman named Robin, traveling through the city between 1803 and 1805, commented in his papers:

> Many individuals practice themselves (or have practiced by their slaves) the trade of butcher. In no other country in the world do the inhabitants eat so much meat. The Louisianian deserves the title of "carnivore." Everywhere on the table one finds small pieces of bread and large pieces of meat. The children eat so much of it that a European would fear for their health, but they grow tall and vigorous and appear perfectly healthy. . . . Vegetables are found only on the tables of the rich. Meat is the food of everyone.

> Thus, there are many butchers doing a good business. Business is so brisk at their stalls in the market that they are sold out by eight or nine o'clock in the morning. (C. C. Robin, *Voyage to Louisiana, 1803–1805*, trans. Stuart O. Landry [New Orleans: Pelican Publishing, 1966], 37)

When Louis Dutrey died in 1875, Elizabeth kept the restaurant open with the help of her able friend Hypolite Begue. Elizabeth eventually married Begue and changed the name of their restaurant to Begue's. They prospered and gained international notoriety in 1884, the year of the Cotton Centennial in New Orleans. A little book printed in 1900 describing some of Madame Begue's recipes recounts the experience: "But you mount the stairs, and are thrust, as it were, into an atmosphere of succulent herbs and redolent peppers. You have passed the narrow portals and lo, are ushered into that particular and peculiar domain presided over by that genius of Epicurus — that saint of gourmet and gourmand — Madame Begue."

Elizabeth Kettering Dutrey Begue died in 1906 and Monsieur Begue in 1917, which marked the close of the restaurant. This was their home on Bourbon Street and is the location of this fine secret garden.

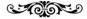

*This fine building demands attention with an unusually opulent display of greenery on the exterior balcony — just a hint of what lies beyond. The large structure also has a large back house, the slave quarter, that serves as several apartments. The tall magnolia in the center of the courtyard shades the entire garden. The view to the left shows the variety of plantings: azaleas, ferns, gardenias, and impatiens.*

*Silhouetted is an unusual life-sized deer topiary, standing in the shade. Another unusual topiary, grown into the shape of a monkey, swings in the breeze over a soft bed of white impatiens.*

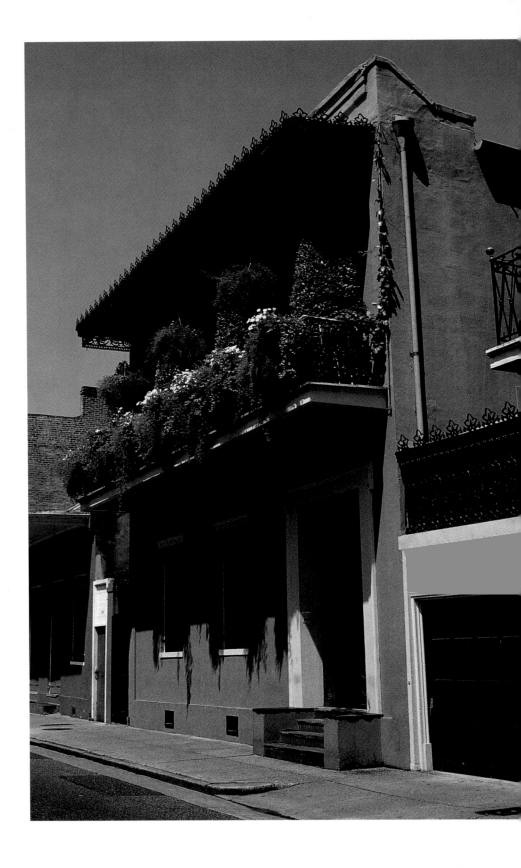

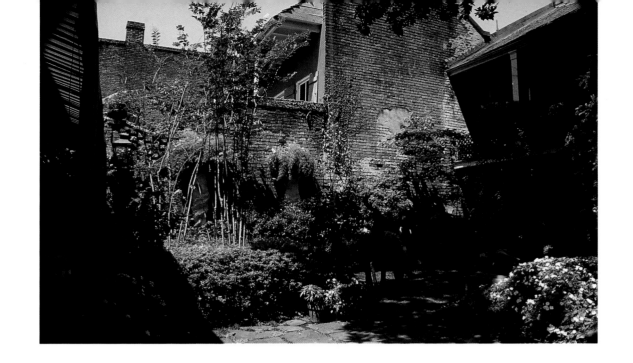

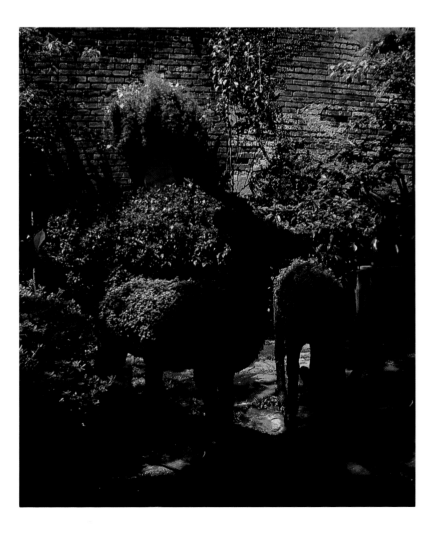

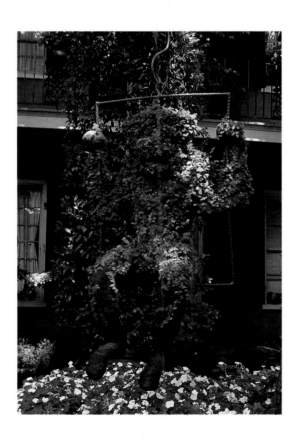

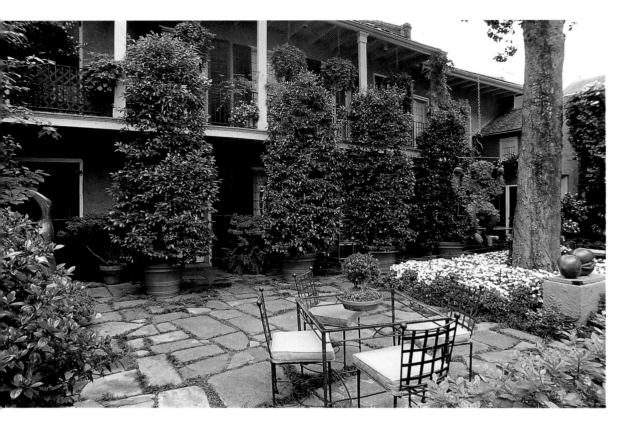

*A wide view toward the back house shows the tall potted cherry laurels and the flagstone surface, which has been laid onto the bare earth with space between the stones where tiny ferns and welcomed grasses can thrive.*

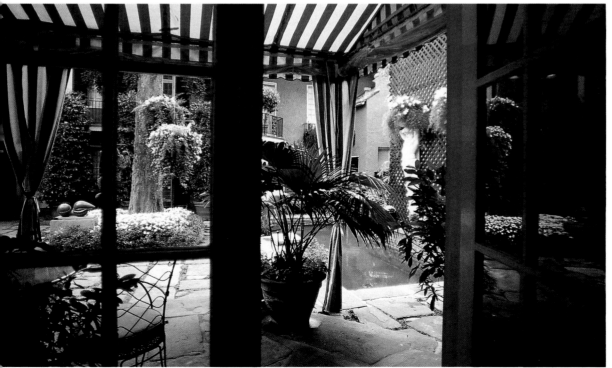

*Through the solarium door of the front house is a view of an assortment of greenery, statuary, and a swimming pool. This L-shaped pool hugs the wall of the right border of the court. The wall itself is latticed and hung with baskets of white impatiens.*

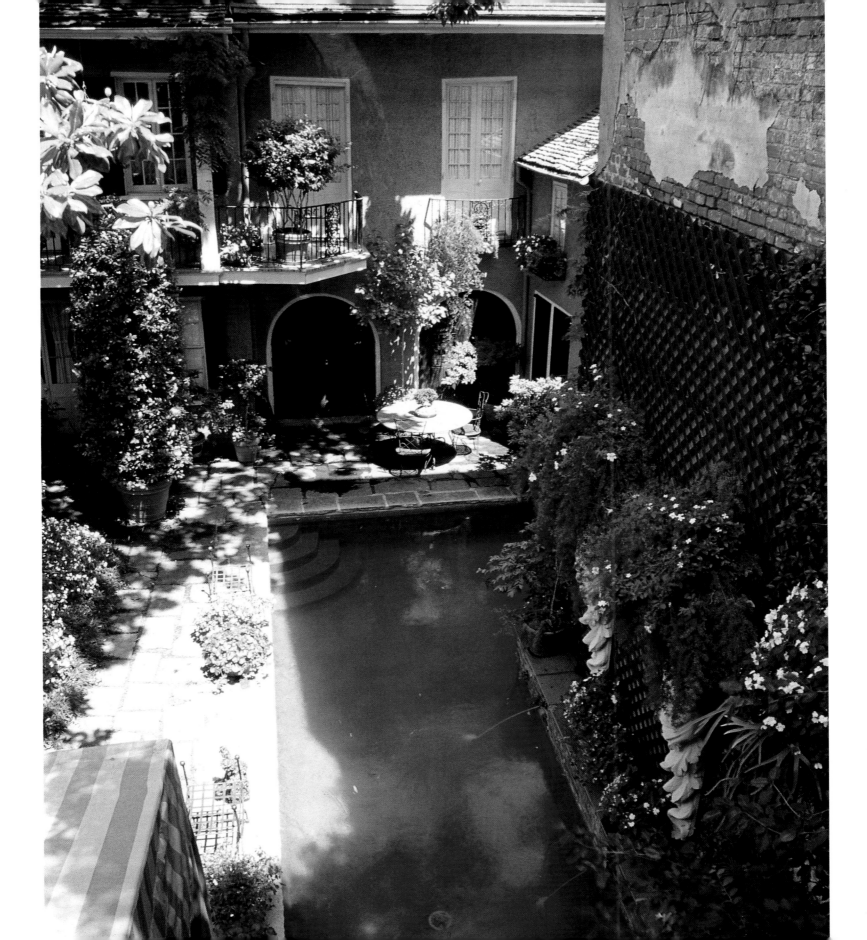

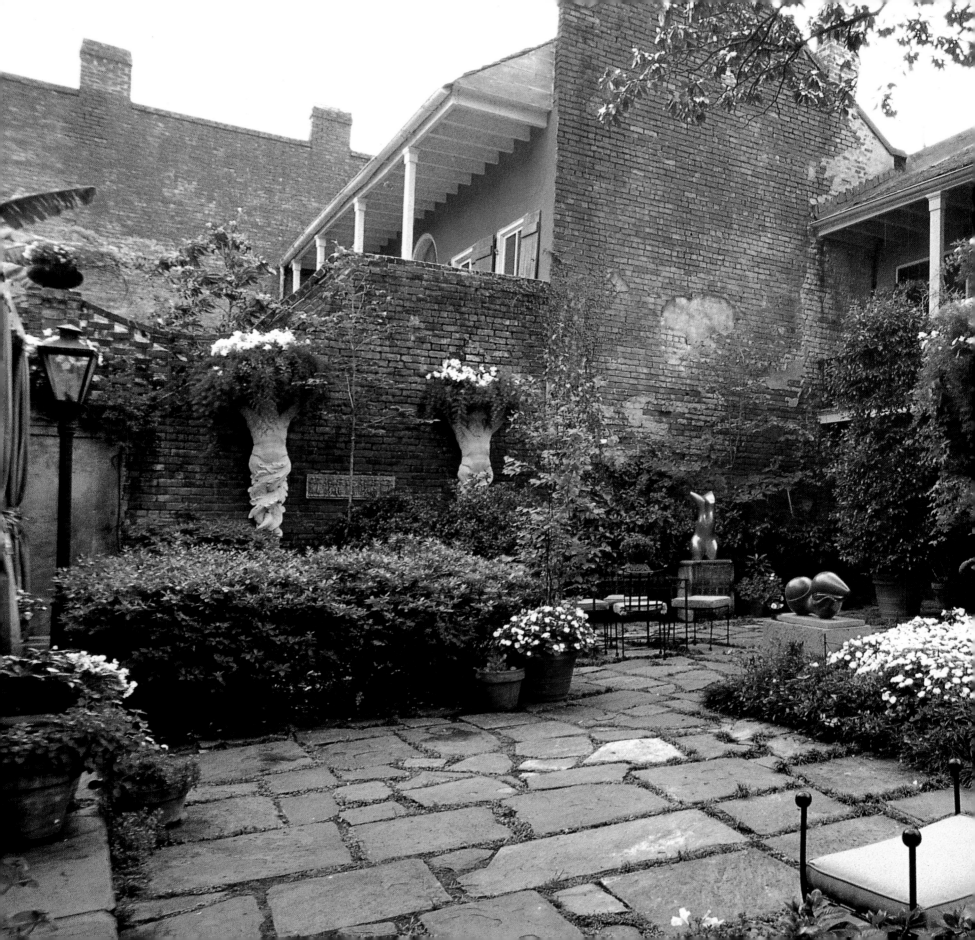

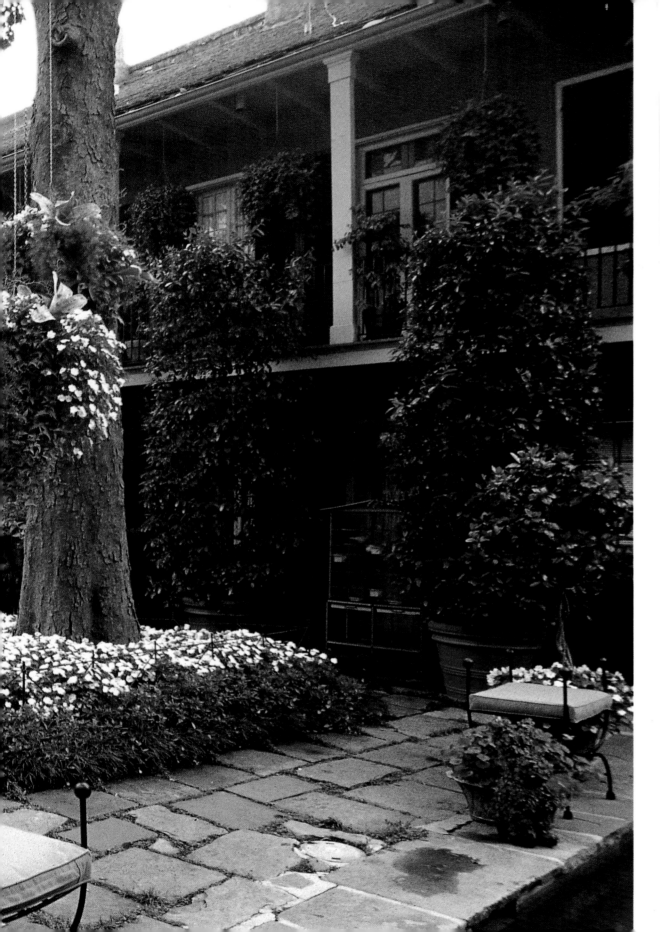

The full view of the courtyard from the pool side delineates the areas of plantings and flagstones. Almost every flower in this garden is white, enhancing and lightening the deep greens of the abundant foliage. The small elephant topiary stands atop a rose marble table . . .

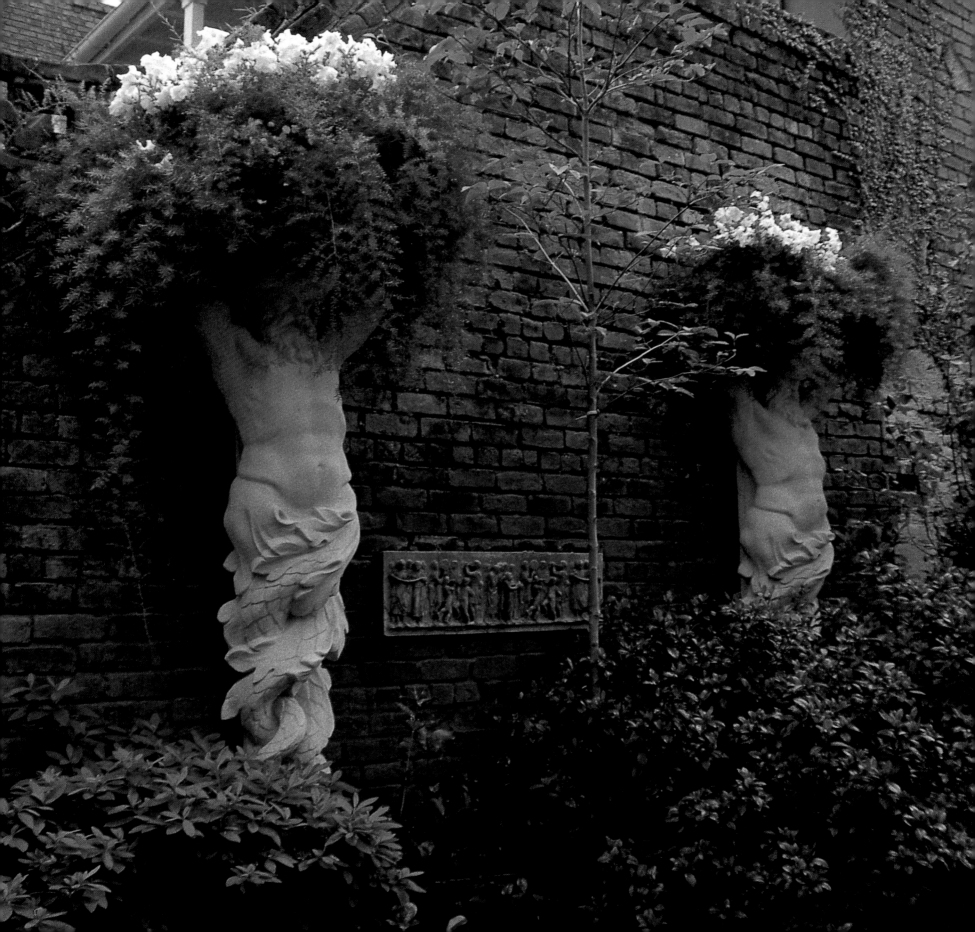

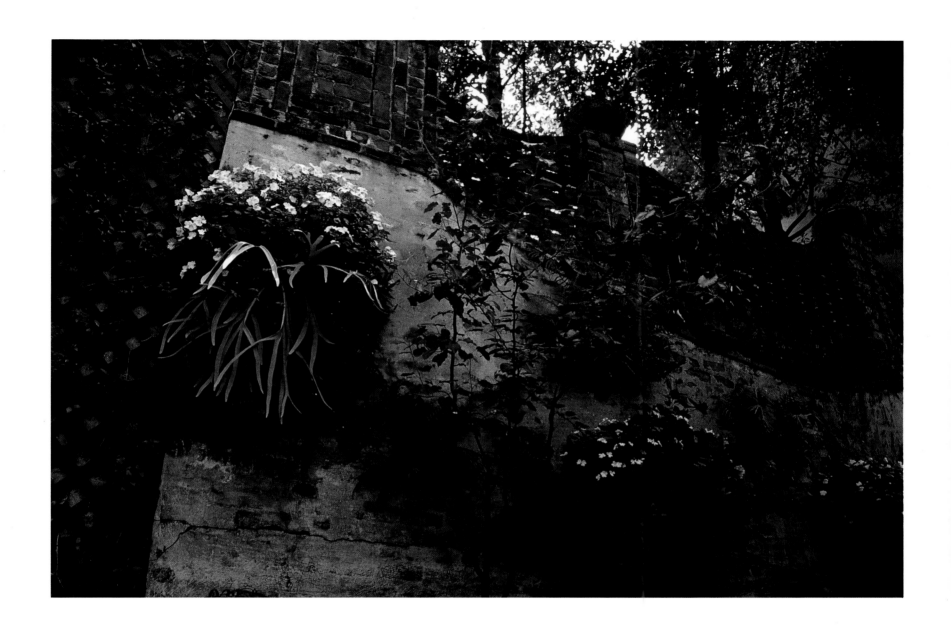

*while mighty stone torsos uphold great boughs of fern and petunias, with azaleas and gardenias at their feet.*

*A high wall in a shaded corner holds baskets of white petunias and staghorn fern, white and pink impatiens, and other autonomous ferns that have determined their own location.*

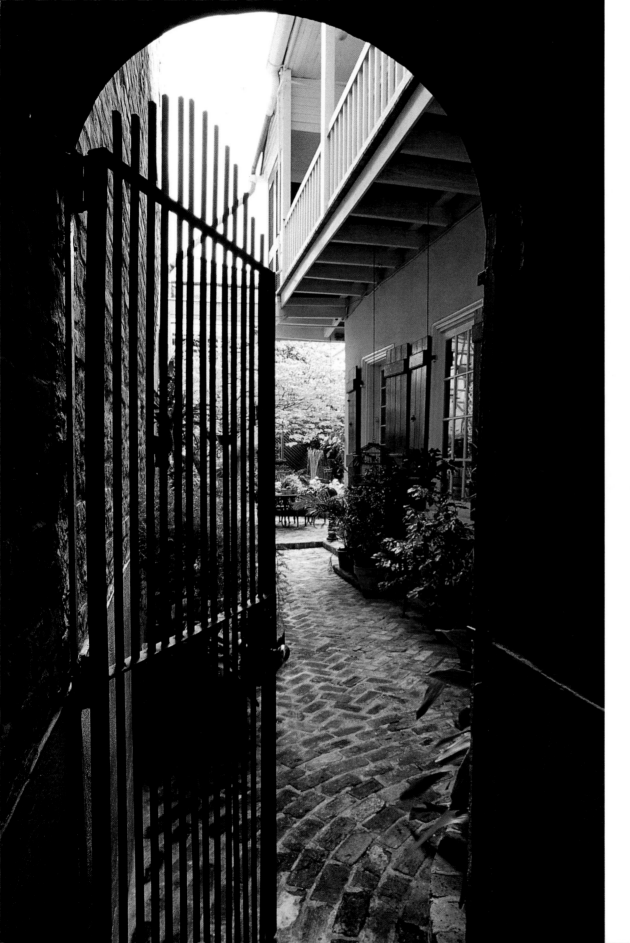

*This small courtyard is a precious jewel, or* BIJOU, *as the French would say it. From the unpretentious entryway on the street, the court is entered down a side corridor and through the iron gate. Old bricks have been laid down in half-circle and herringbone patterns to enhance the ground*

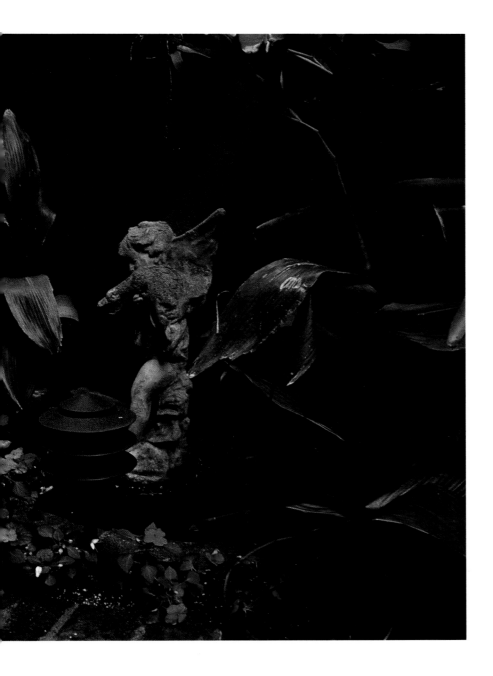

# Bijou

One of the delights of the gardens in this collection is their variety of size. This little garden, though one of the smallest of the group, is one of the most charming. The little house that claims this jewel is again located on a lot that was originally assigned to the arsenal of the French army in 1722 and was later given to the Ursuline nuns by brevet of King Louis xv of France. The land given to the nuns was substantial within the overall scheme of the small settlement because their wide range of duties required ample space. Not only did the Ursulines care for the sick in the army hospital and teach the young girls of the colony, but they were extremely involved with medicine, herbal treatment of disease, and botany. A large part of their land was given over to an herbal garden where the nuns grew and experimented with local herbs as well as those brought here for cultivation from Europe and the Caribbean Islands.

When the Ursulines sold their land and moved their convent and school to another part of New Orleans, much of the area was divided into lots and sold to home builders seeking permanent residences. The home here, which dates from 1836, was found in such terrible repair when its renovations began in 1968 that the new owners had a unique opportunity in that even the courtyard required complete renovation, landscaping, and planting.

*surface. A stone boy holding a goose is fountain-head for the small semicircular brick pond along the way. The tall leaves of* ASPIDISTRA ELATIOR *provide his hiding place; a sprinkling of pink impatiens adds a splash of bright color to this cool spot.*

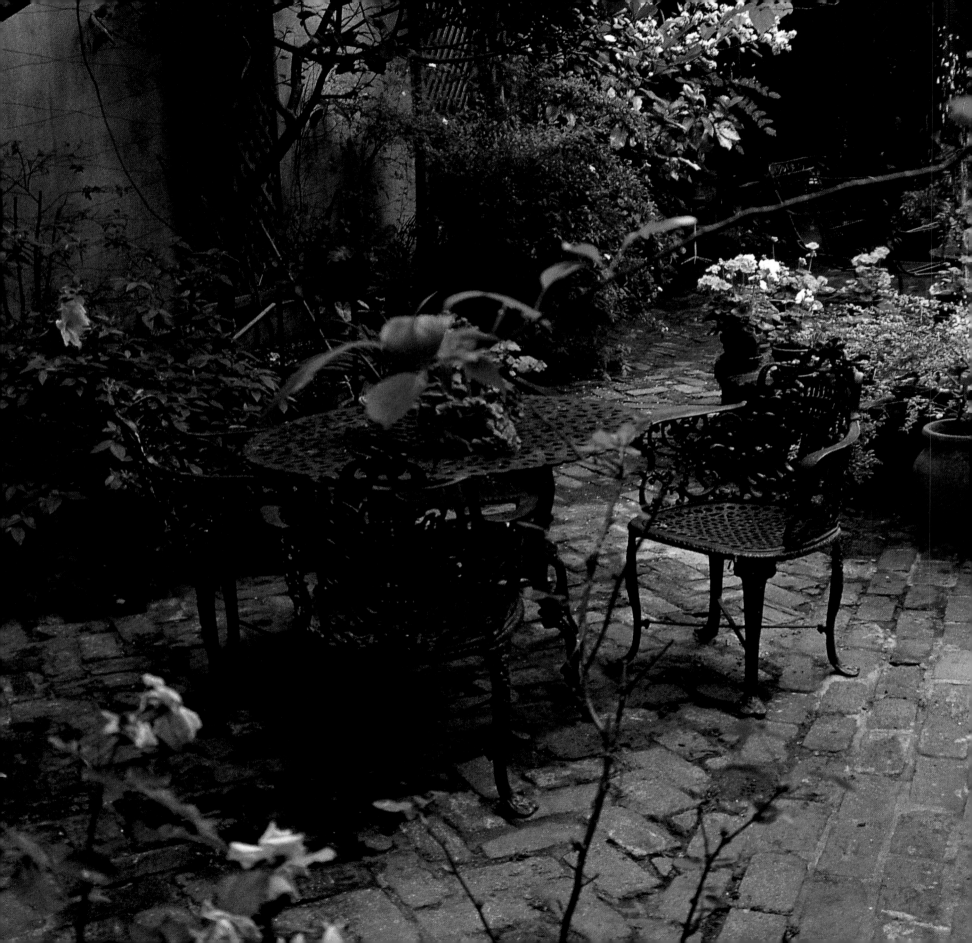

The walk continues underneath the balcony of the
L-shaped building into the open patio. Handsome
wrought-iron furniture provides a dining area
decorated with a basket of orange-flowered kalan-
choe, bromeliad, and English ivy.

The central fountain splashes delicately, drawing attention to a border of variegated LIGUSTRUM; pink, white, and red geraniums; and pink impatiens behind.

A white-cluster flower of bridal wreath, SPIRAEA VANHOUTTEI, sways in the slight breeze.

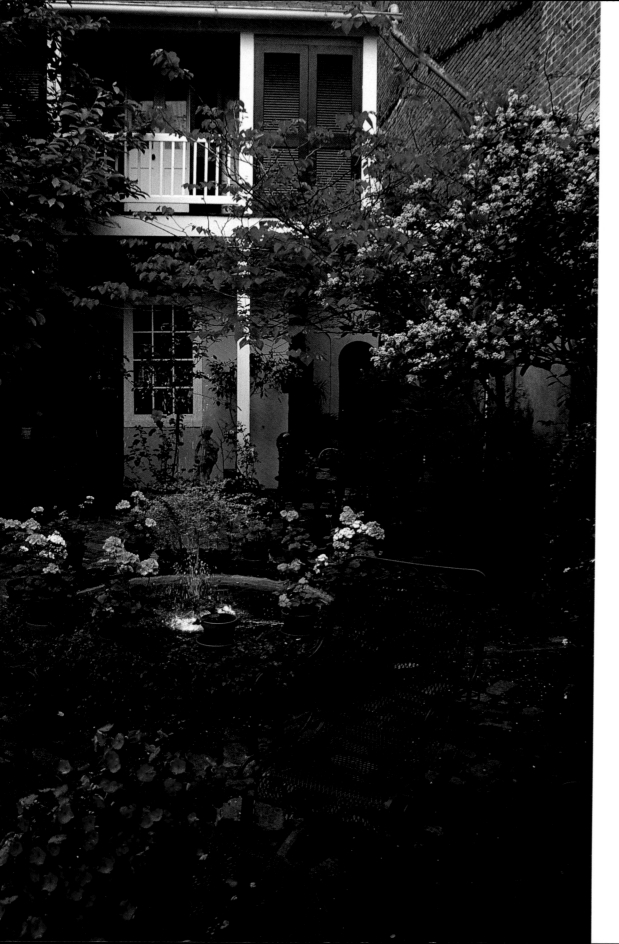

A ray of sunlight reaches down into the shade to illuminate a blooming flower of a variegated ginger plant, and two lovely white lilies reach up through the foliage. The statue in the rear of the court lingers quietly as company to garden visitors.

From the rear of the court, the view forward is beautiful. This patio truly captures the essence of a Vieux Carré courtyard.

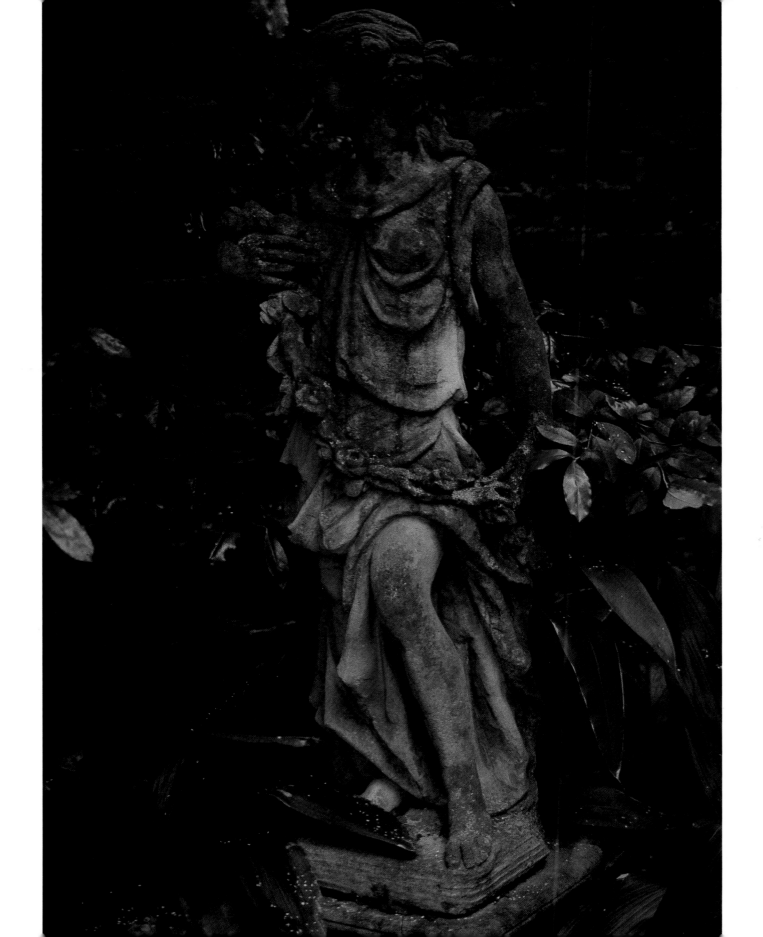

To the right, the heavy, pale pink blooms of a PRUNUS ACCOLADE *stand tall against the neigh-boring wall. A stone boy standing above the dusty miller and pink begonias guard the serenity of this French Quarter* BIJOU.

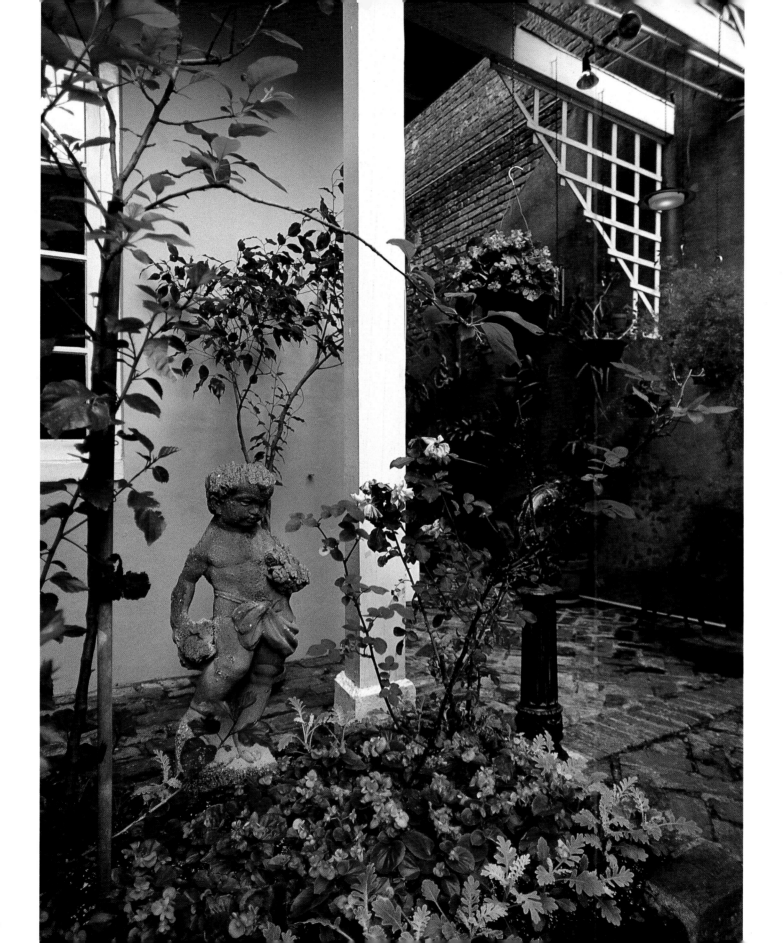

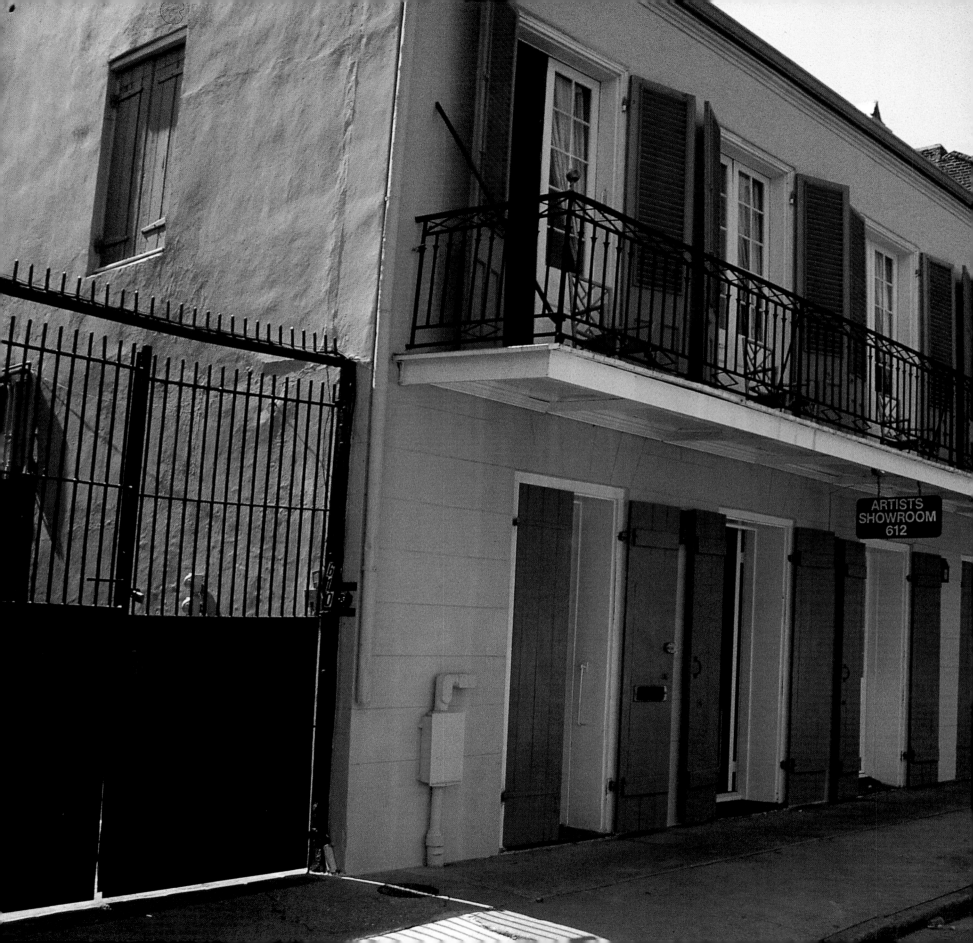

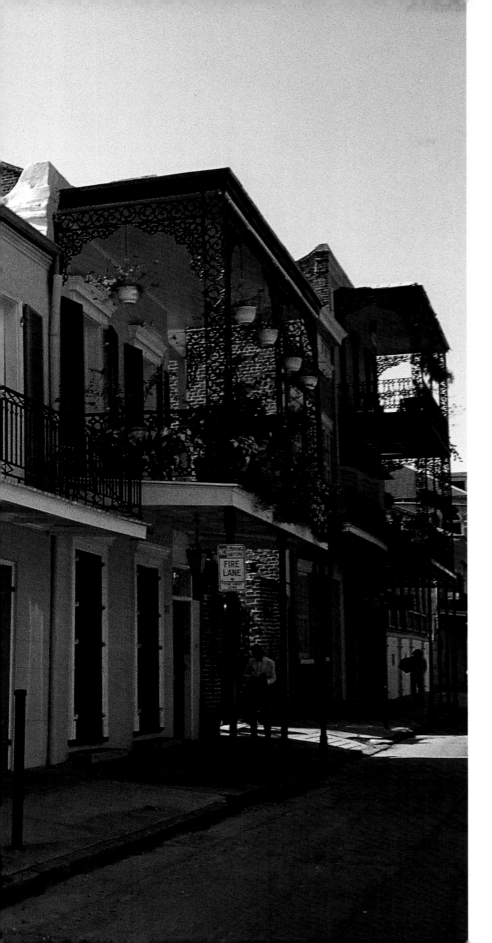

# Bouligny

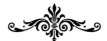

In 1769, when New Orleans was transferred from French to Spanish possession, Commandant Don Alessandro O'Reilly arrived with an impressive army of three thousand soldiers. One of these soldiers was Don Francisco Bouligny. O'Reilly was not the first to arrive in the name of Spain, however. He had been recently preceded by Don Antonio de Ulloa, who was unsuccessful in wresting government control from the French colonists. They believed that France would regain dominion over the land.

When O'Reilly arrived at the Belize — the term given the mouth of the Mississippi at the Gulf of Mexico — he sent Bouligny upriver to the city to ascertain the attitude of its citizens. Bouligny found them willing to submit to Spanish rule, having by then finally become convinced that France would not intervene on their behalf.

When O'Reilly was assured of a successful Spanish domination, he left the colony and Bouligny behind. Bouligny had that year married Louise d'Auberville, daughter of the marine commissioner of Louisiana, and he remained in Louisiana. Bouligny was eventually appointed acting governor. His son and grandson became statesmen and left a time-honored Louisiana legacy in the name Bouligny.

In the location of this secret garden, Don Francisco Bouligny and his wife, Louise, once made their home. In 1810, the existing building was erected and remains one of the oldest structures in the Vieux Carré, having two small patios and a rooftop terrace. The property also has the distinction of being owned by an art dealer who appreciates her artistic environment in the gardens as well as in the building itself, where she and her husband live and operate a small, exclusive art gallery.

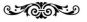

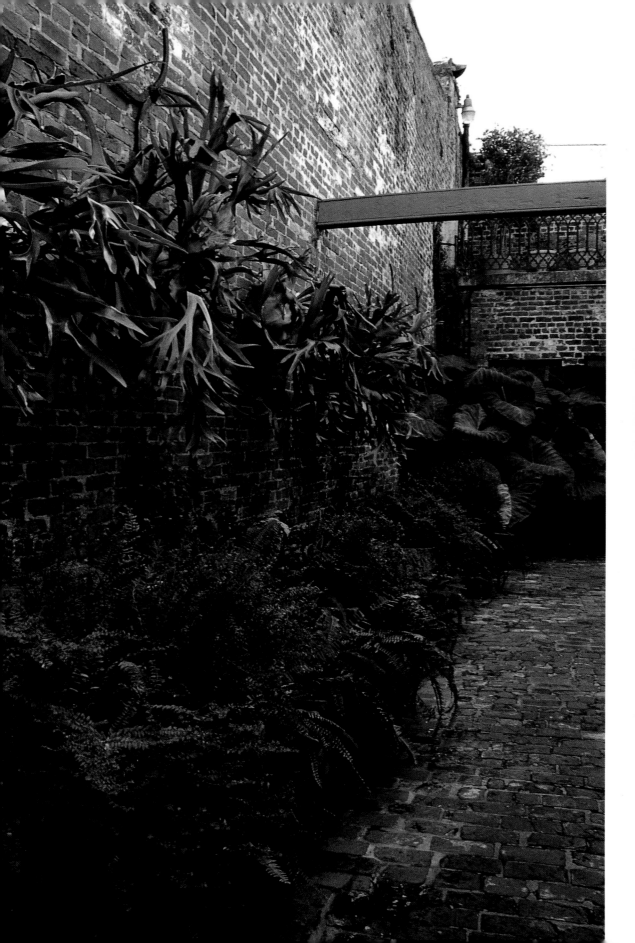

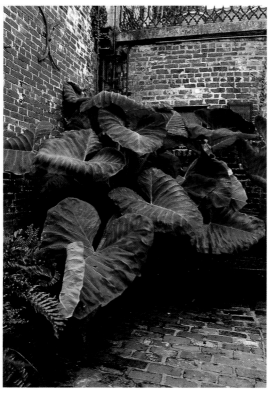

*Preceding page:*

*Through the iron gates of a side driveway — a luxury in the Vieux Carré —stands the high wall of a neighboring building that holds a collection of staghorn ferns. The brick bed, running the length of the wall to a back court, is planted with Mexican heather, brimming with tiny purple flowers, and ferns. A swell of giant elephant ears fills the corner space, which turns into the first court of the property.*

*A look into this first court reveals an elaborate cast-iron bench, painted a deep green, which blends with the leaves of the* PHILODENDRON SEL- LOUM *standing behind. The arched iron gate to the left opens to a walk that tunnels through a back slave-quarter building to another court. This back court is enclosed by high walls, allowing a thin shaft of light to enter, which moves across the area as the day passes.*

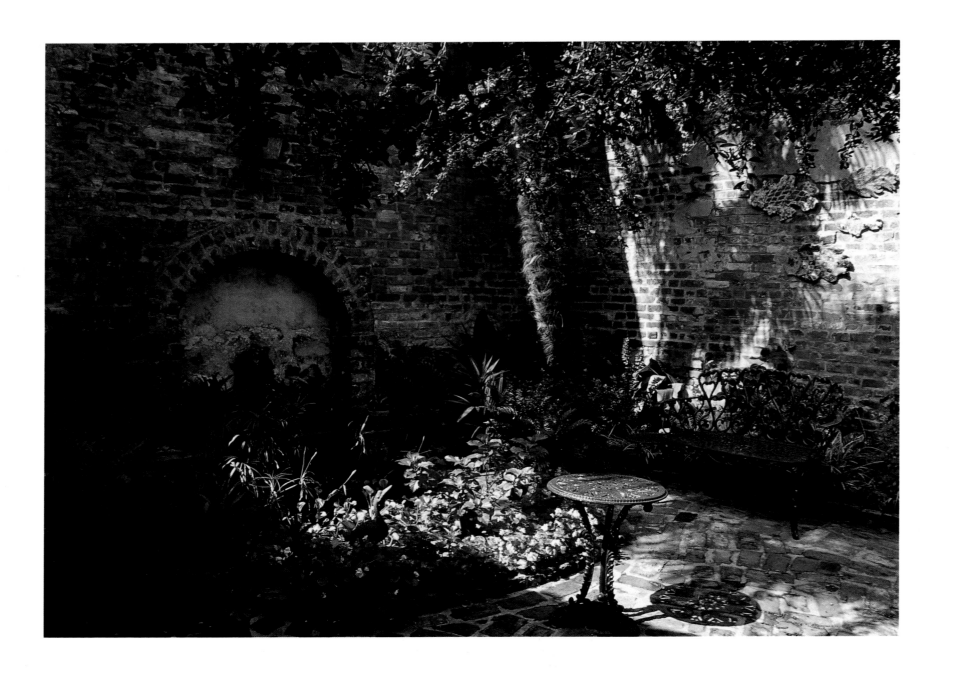

*In this back court, which contains a fountain in the arch against the side wall, there is a great deal of humidity, which contributes to the health and growth of the many fern varieties here. A lovely holly fern, rooted directly in the wall, grows near the fountain. Another wall displays a selection of bromeliads above and a* FATSIA JAPONICA, *or Japanese Aralia, below.*

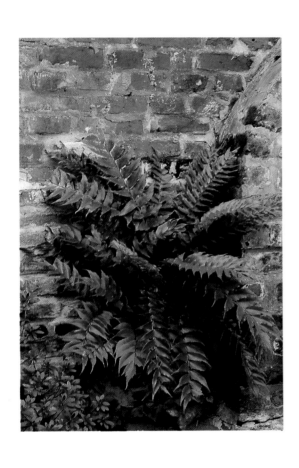

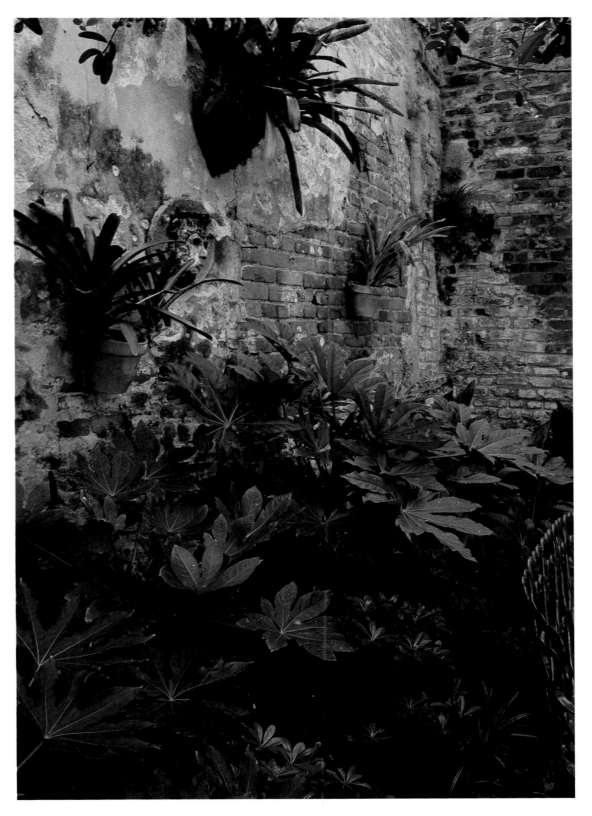

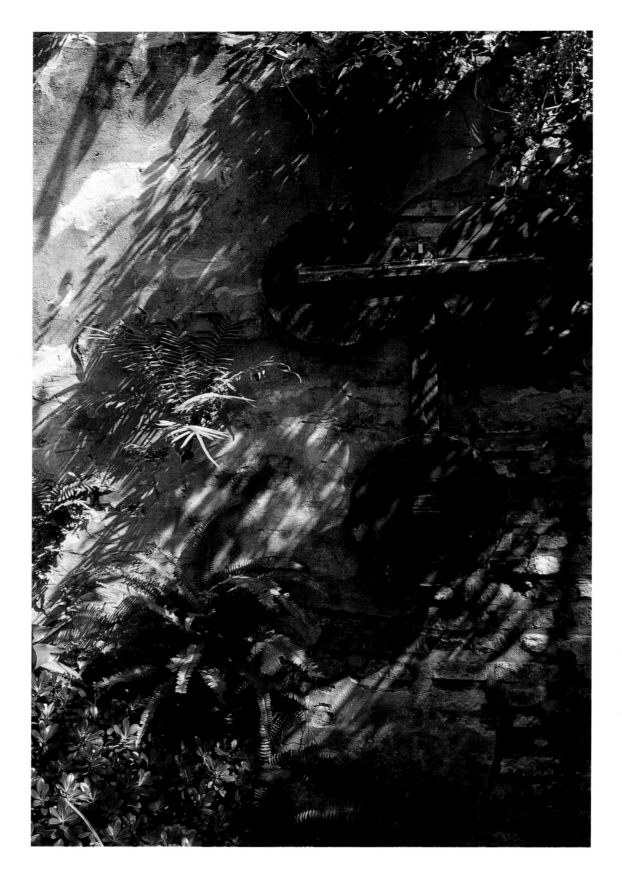

A palette of plastered and exposed brick displays a metal weatherproof artwork, balanced by a variety of ferns in the wall, to the left, with wisteria and pyracantha above.

Above the slave quarters there is a terrace, most often used for entertaining, barbecues, and cocktail parties. A magnolia rises from the court between the front and back buildings.

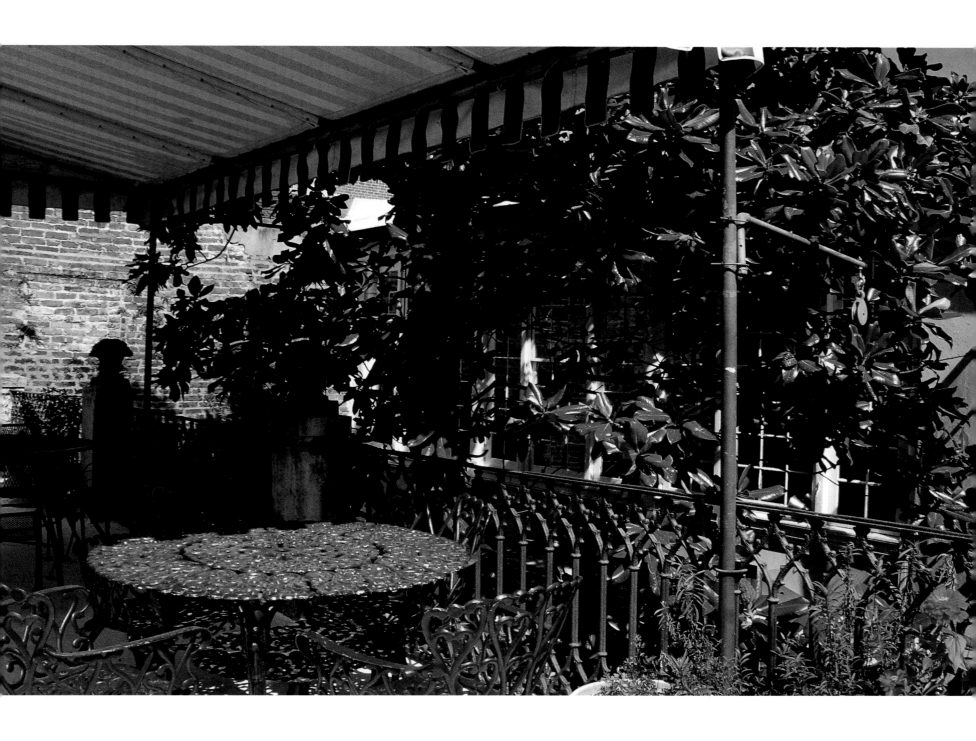

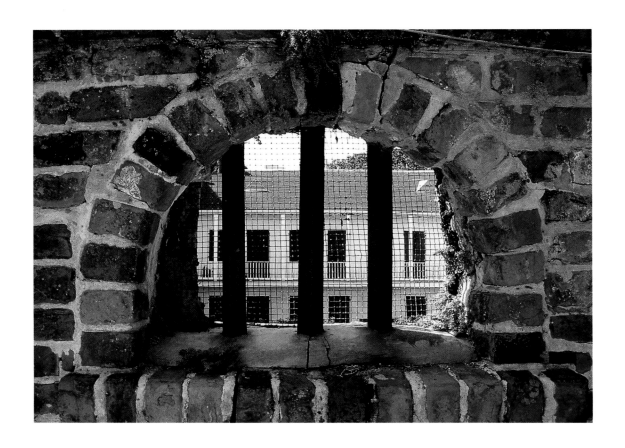

Through the wall of the terraced area is a small barred arch, only large enough to view rising smoke from oncoming fires, which were calamitous to the city in 1788 and 1794. From the terrace view, a tall banana from a neighboring patio hangs its flower and early fruit into the court below.

Another exterior artwork — an ocher shield face — guards the tranquillity of this secret garden.

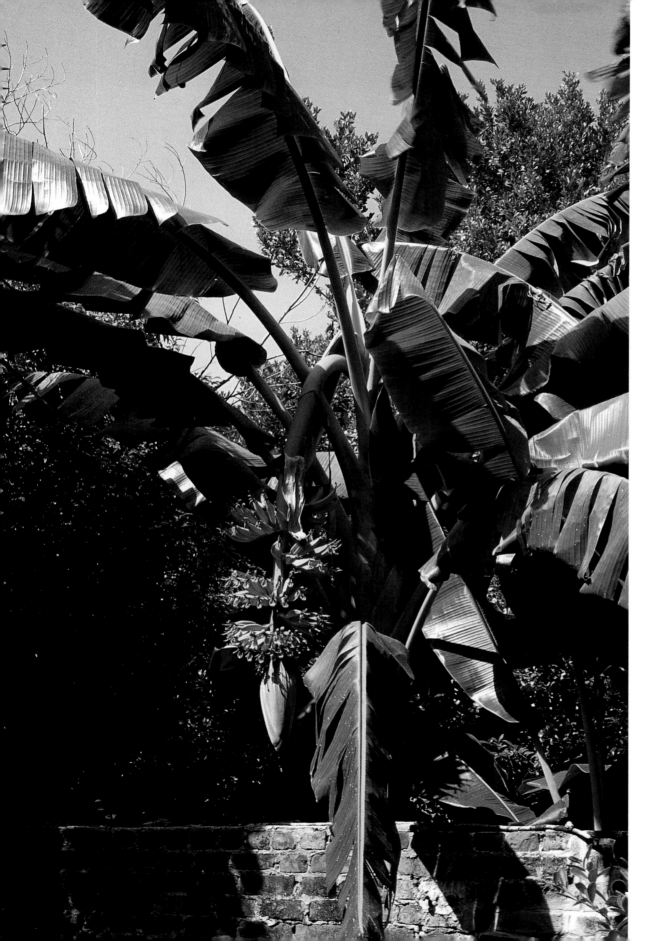

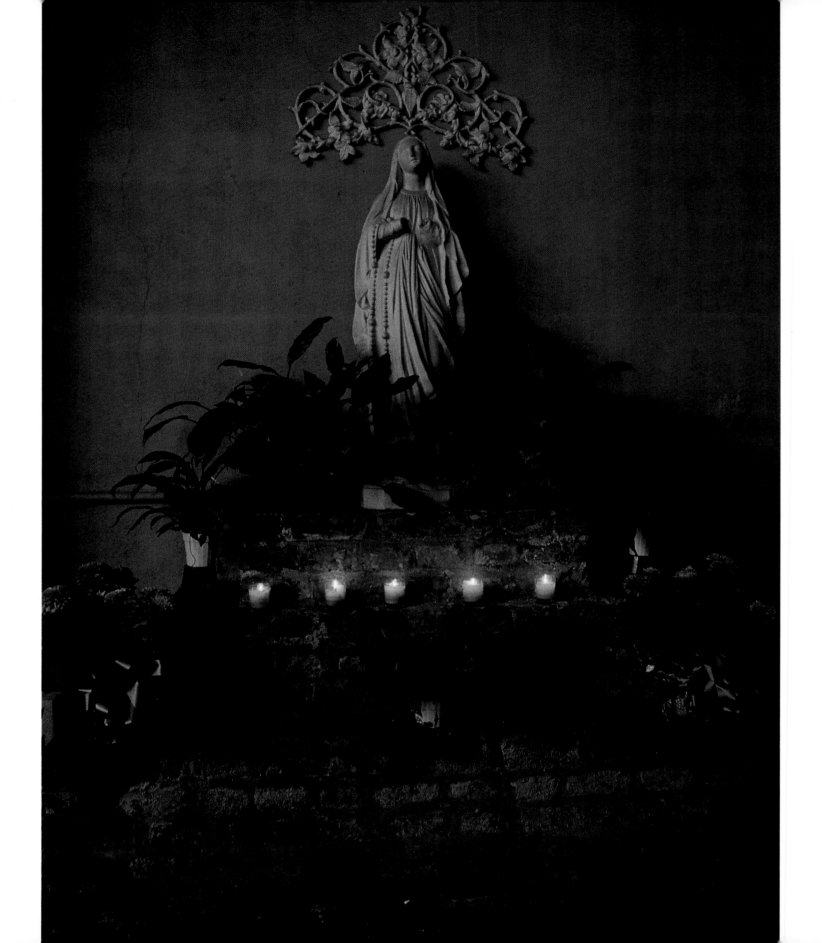

*The stately courtyard of this 1795 building is entered by a porte cochere from the street. The porte cochere is a carriageway that was built through the building, wide and high enough for the family carriage to enter — tall-hatted driver and all. At the end of the carriageway is an altar with a Spanish Virgin, Madonna of the Roses. This was a once-common sight in old New Orleans courtyards. The high arched entrance provides a view of the entire court.*

# Bourbon

The space and size of Vieux Carré lots were determined by the French, as was their practice of building directly on the banquette, or sidewalk, securing privacy in the courts and gardens behind their primary living quarters. The French also possessed the Gallic sentiment of desire for privacy in the home. The original front houses were smaller than today's Spanish-influenced homes, with larger garden areas for growing vegetables and raising poultry and farm animals to feed the family; but as the buildings were replaced either because of the great fires, or the fashion, or the fortunes of the property owner, interior space increased and exterior space decreased. Land use changed. Due to the success of New Orleans as a port, no longer did the growing number of wealthy merchants occupying the inner city have to rely upon their gardens for provisions. The French Market, only blocks away from any residence, was flourishing with the growth of the city. As the market provided the French and Spanish cooks in the city the foodstuffs to develop a cuisine native to the area, the wealth and imagination of landowners allowed a new, indigenous architecture to develop: French in concept, Spanish in design.

The court of this property is behind a magnificent residence located on famed Bourbon Street. Bourbon Street was not named for the whiskey of that appellation but for the Bourbon-Orleans family, rulers of France, of which Louis XIV and the Duc d'Orleans were members.

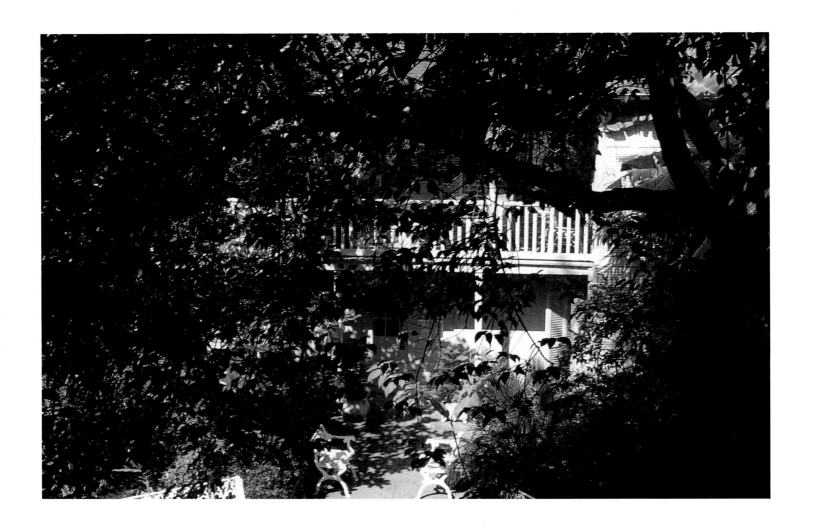

Through the garden to the rear slave quarter, the jungle of trees and plants is designed to be appreciated as a whole, rather than to be viewed as individual plantings. A view from the slave-quarter balcony through the trees, which include a magnolia to the right, reveals the fountain and glassed high archways on two floors of the main building. These archways were originally open to the grand interior stair and landings, which now serve as interior space.

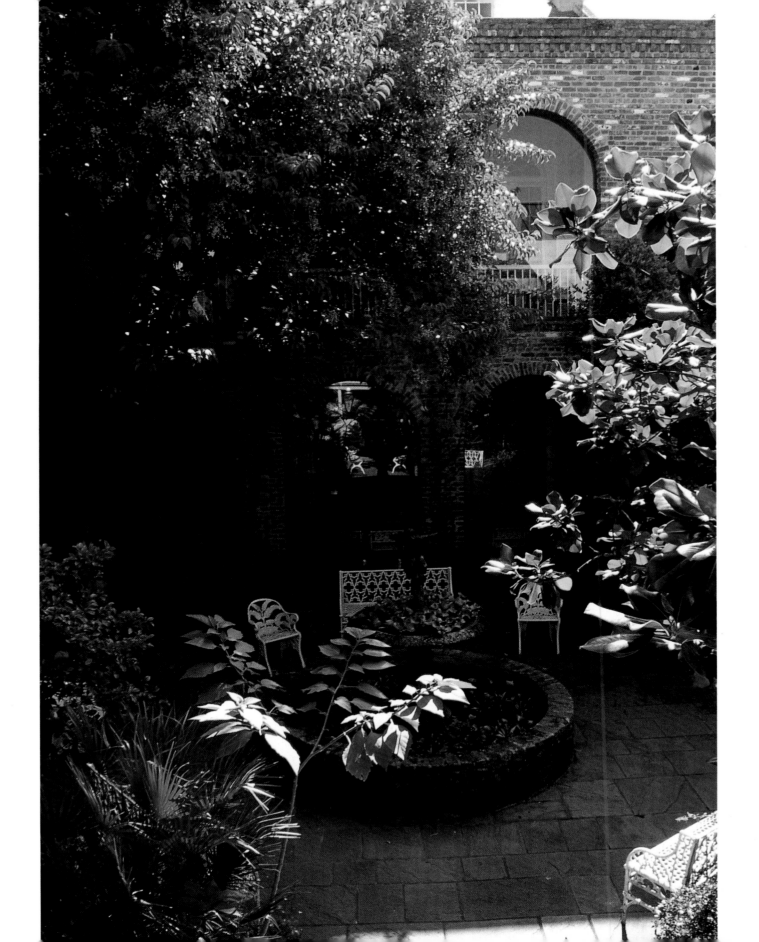

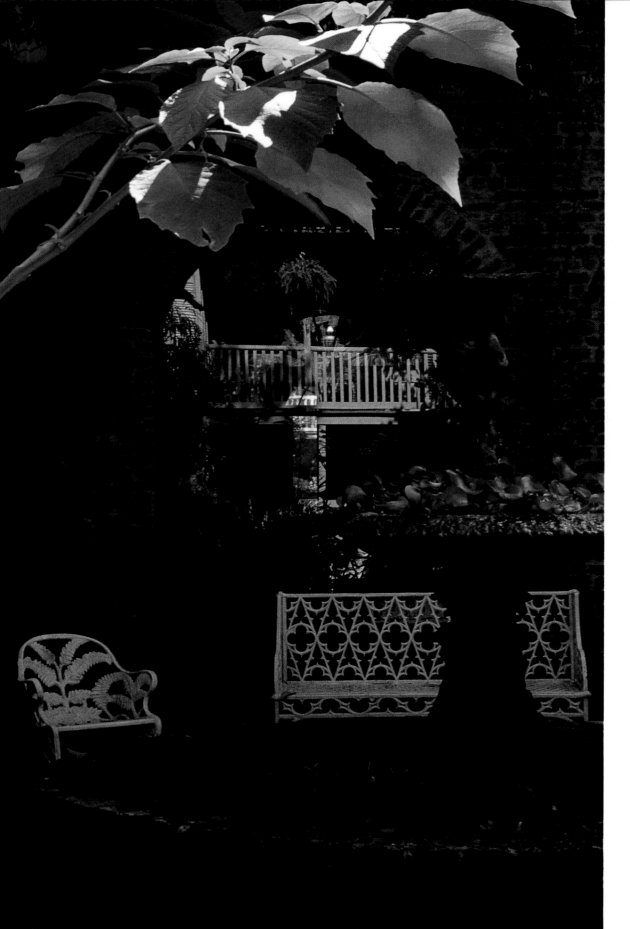

*A closer view of one arch beneath a datura branch and past the fountain reflects the balcony of the rear building.*

*A crowded corner contains a palmetto, an important indigenous Louisiana species.*

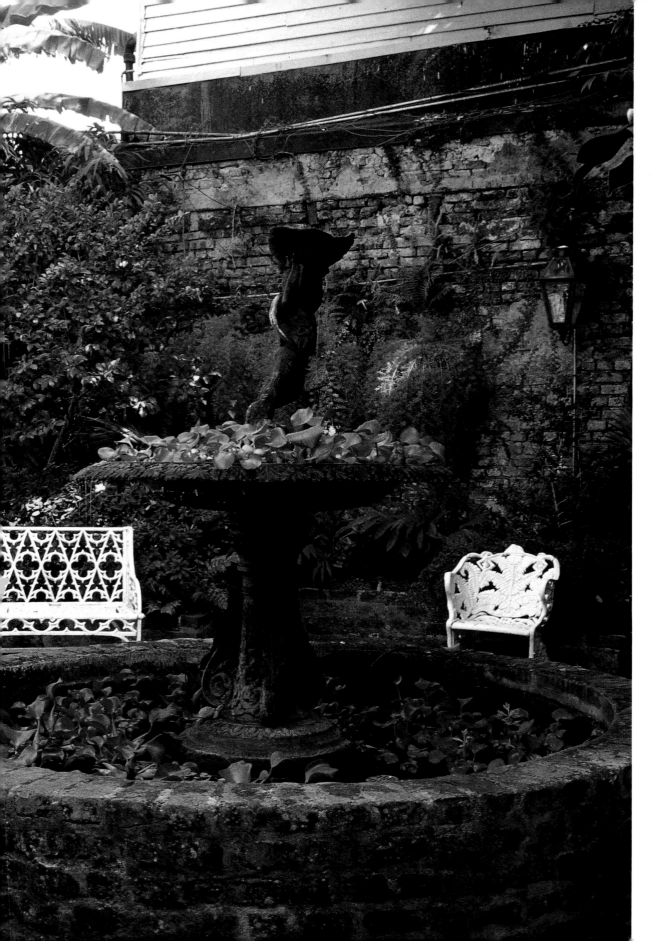

The cast-iron fountain drips water tranquilly into beds of water hyacinths. The water hyacinth, or Richardson lily — EICHHORNIA CRASSIPES — is a water plant found in many Vieux Carré fountains and ponds. Its delicate purple flowers and fleshy reptilian leaves add to the exotic collection of Louisiana plantings.

63

Of specific note are the white-painted cast-iron chairs and benches found in this garden. They were popular designs made in Paris in the 1840s, few of which made it as far as New Orleans. Because of their unusual and elaborate designs, these pieces have been copied by a local ironworks as patterns for manufacture.

At the exit door on the street, a cast-iron grille serves as a look-through to Bourbon Street outside and the bright sun of midday.

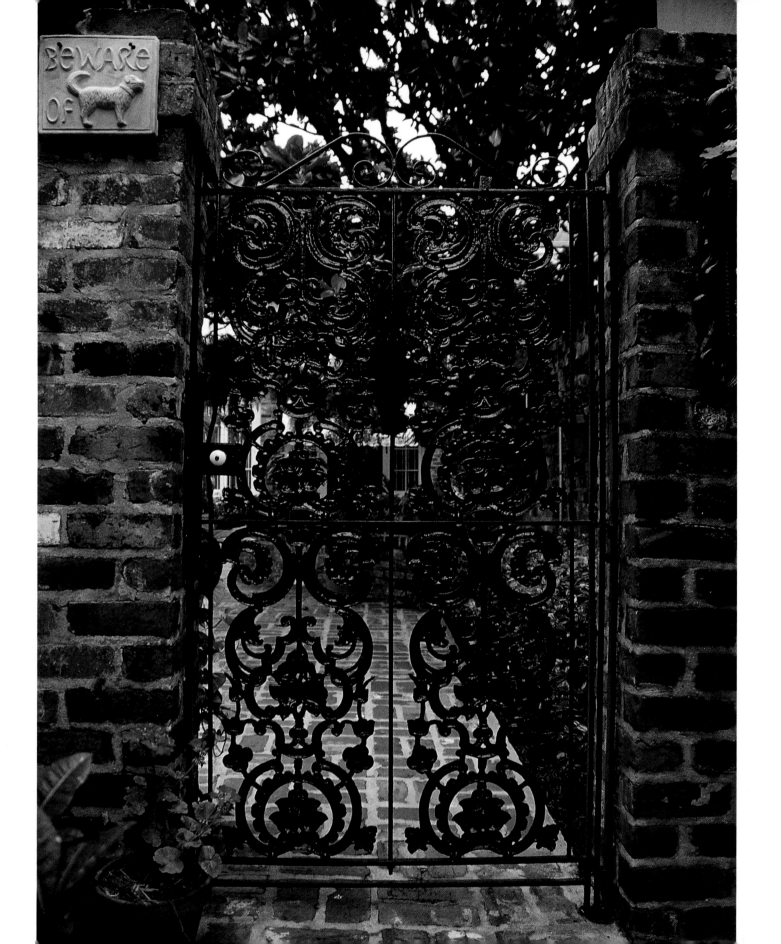

# Briquette

*The patio is entered through an elaborate iron gate past beds of red geraniums.*

The first buildings constructed in New Orleans were wood frame with cypress shingles —barely more than protective huts.

Historically, the next group of buildings were of *bousillage,* a mixture of mud and moss that was formed into walls and allowed to dry and harden. This indigenous Louisiana moss was called Spanish beard by the French, and French wig by the Spanish. It was the moss we now call Spanish moss, *Tillandsia usneoides.* It is not a parasite but attaches itself to other plants. This plant draws water and dust from the air; that is all it needs to survive. It is found here mostly in oak and cypress trees.

Later in the development of the city, when things were becoming more economically stable and buildings needed to be more durable, the most common building method became *briquette-entre-poteaux,* or bricked-between-posts, construction. In this method, wood posts, cut from cypress, would be set crisscross standing up from the ground to form the frame of the walls. The bricks were then fitted into the spaces and cemented with mortar.

The first bricks to be used here were made from a red sand found at the crescent of the river. The hardened bricks were not as hard as the bricks in use today, but they served their purpose. The mortar was the key to the success of this construction method. It was made from a mixture that included the dust of burned clam shells, which formed a firmer bond than many newer products. The recipe for the mixture is lost, but many of the walls made this way are standing today in the Vieux Carré. Because of the softness of the red bricks, it was necessary for the walls to be plastered. This is why the bricked-between-posts construction is not visible to the eye in our structures.

After the great fires in 1788 and 1794 destroyed almost all of the city, bricks were sold at a premium. The government, as well as the people, desired more substantial buildings, and brick was the preferred material. As time passed, harder bricks began to be imported into the city. These harder bricks allowed the construction of larger buildings, many of which dominate the French Quarter today.

The location of this secret garden was the main brickyard in the city. It was centrally located but never had any substantial or architecturally significant structures built on it. In the twentieth century, as construction supply stores were moved to locations with larger storage areas, the brickyard moved and a home was built here — a brick home, of course.

There is a large open patio, also bricked, and walls of brick that surround the area.

*A wide view of the patio shows the house to the left, built at the rear of the property rather than directly on the street, as are most Vieux Carré properties. A table near the fountain against the wall is used for alfresco dining.*

*Around the fountain area are thick plantings of bananas. A single early flower shoots up through the mass of fleshy green leaves. Several varieties of canna share one bed: a large double orange canna flower stands aside a red CANNA IRIDIFLORA.*

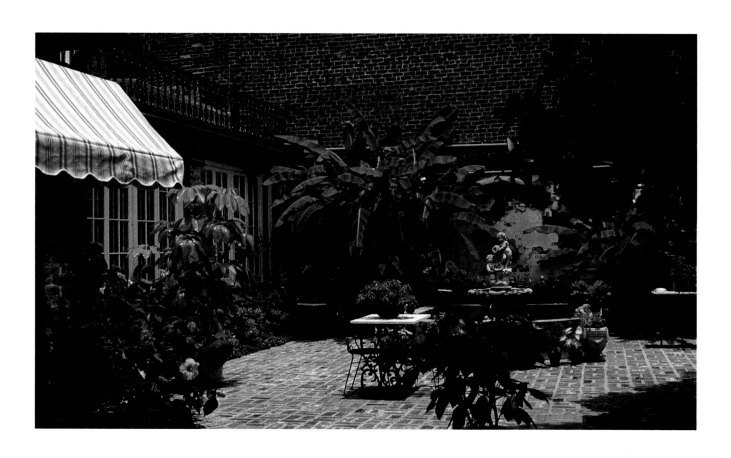

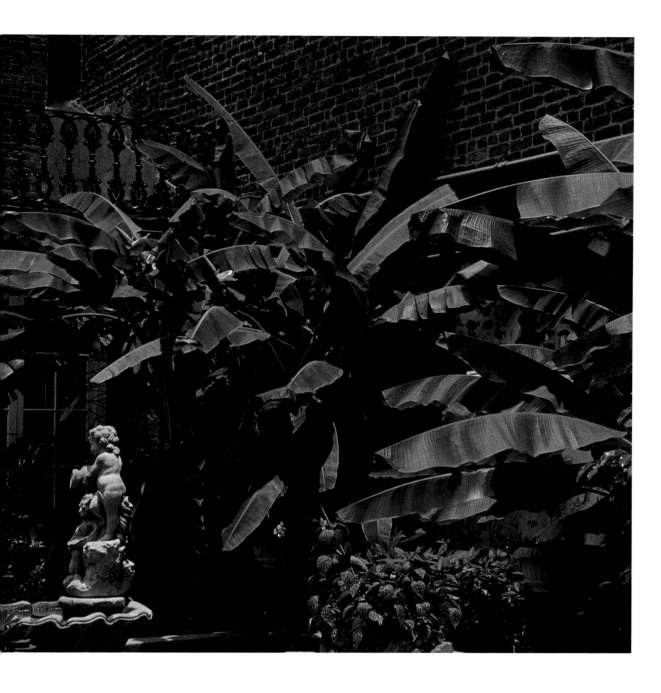

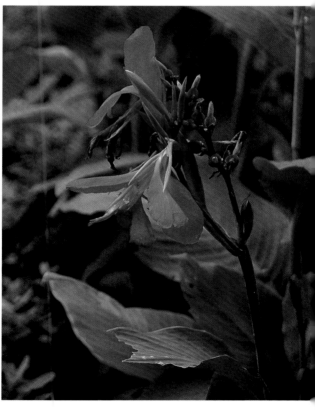

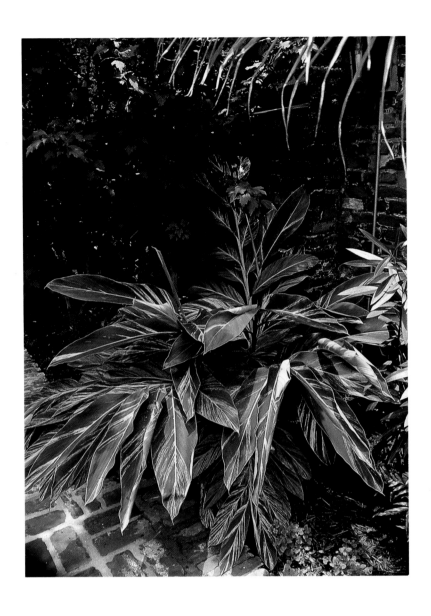

In the center of the patio stands one of the largest magnolia trees in the French Quarter. A ground area beneath it has been left for its roots to breathe, where a grouping of bromeliads, dracaena, spider plant, and garden elves shares the space. Leaves of a variegated ginger extend into the path.

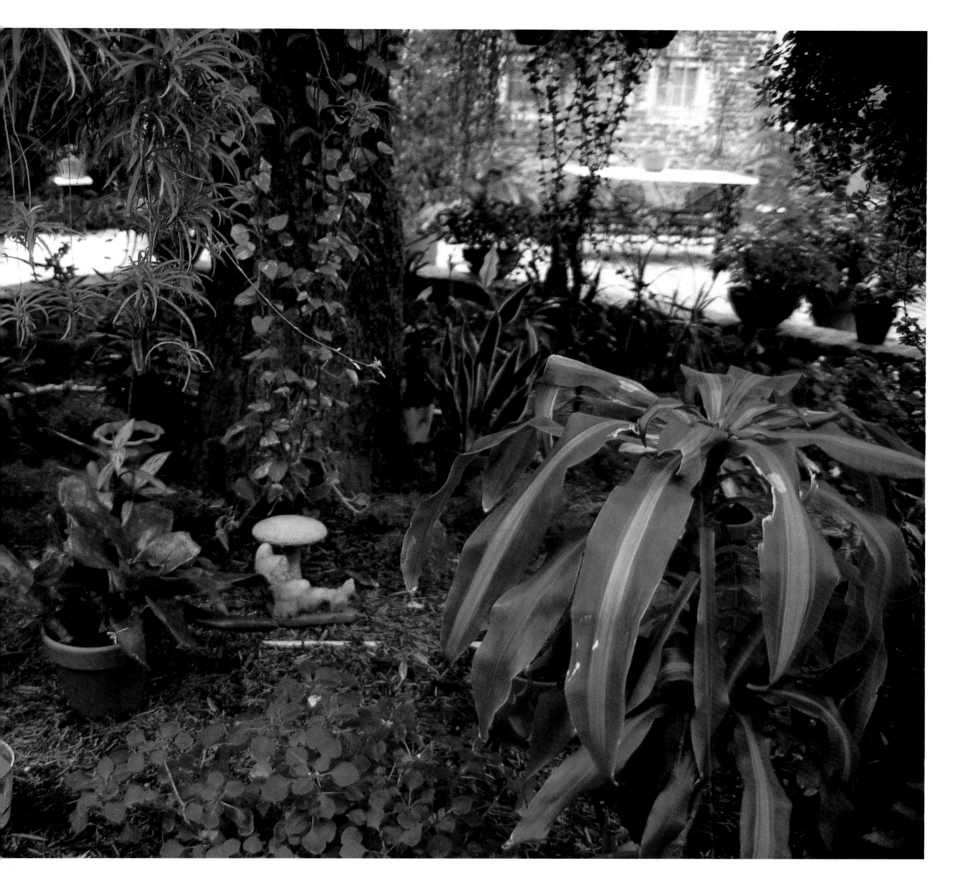

*One wall is covered with a giant pathos vine,
while another is home to a hanging basket of
bird's-nest fern* — ASPLENIUM NIDUS.

*In a corner of the patio grows a fig tree. The pelican, Louisiana's state bird, stands quiet . . .*

close to a sago palm. A vigilant kitten watches
over the patio from a soft bed of pink ageratum.

# Conflagration

The Vieux Carré suffered two disastrous fires during the Spanish domination, which virtually destroyed all the original buildings. Governor Don Estevan Miro described the first fire in his dispatch to the Spanish Court:

> On the 21st of March, 1788, being Good Friday, at half past one in the afternoon, a fire broke out in New Orleans, in the house of the Military Treasurer . . . and reduced to ashes eight hundred and fifty-six edifices, among which were the stores of all the merchants, and the dwellings of the principal inhabitants, the Cathedral, the Convent of the Capuchins, with the greater portion of their books, the Townhall, the watch-house, and the arsenal with all its contents. . . . Almost the whole of the population of the smouldering town was ruined and deprived even of shelter during the whole of the following night. (Charles Gayarre, *History of Louisiana.* Volume 3, 3d Ed. [New Orleans: Armand Hawkins, 1885], 203, 204)

It had happened that the bells of the Catholic Church of the Capuchins, which also served as alarm bells, were not sounded due to the regulations of the good fathers that the bells remain silent on Good Friday, the day observed as the anniversary of Jesus Christ's death. One spectator who had experienced the tragedy firsthand commented, "A civilized nation is not made to adopt maxims so culpable towards humanity, and this trait of fanatical insanity will surely not be approved by sensible people" (Grace King, *New Orleans, the Place and the People* [New York: Macmillan, 1895], 131).

Six years and eight and a half months later, another fire occurred. Governor Baron Francois Louis Hector de Carondelet notified the court of Madrid of the fire of December 8, 1794, that

*This property, having a deep "key" lot, has a flagged side court, as well as an enclosed "piscine," or pool area, in the rear. Along the wall are several small areas of plantings; an orange-pink hibiscus begins the potted flowers.*

a conflagration, but too well favored by a strong north wind, and originating in Royal Street, through the imprudence of some children playing on the courtyard . . . which was adjacent to a hay store, had consumed in three hours two hundred and twelve of the most valuable dwellings and magazines, the property of private individuals, as well as edifices of the greatest value belonging to the government. (Charles Gayarre, *History of Louisiana,* vol. 3, 3d ed. [New Orleans: Armand Hawkins, 1885], 335)

In his dispatch, the governor recommended that the Crown give "premiums" to those rebuilding the destroyed properties "with terraced roofs, or with roofs made of tile instead of [cypress wood] shingles as formerly" (ibid., 336). These premiums were probably in the form of a relaxation of taxes levied on imported Spanish roofing tiles and perhaps even further reduction of taxes on the structure and lot.

Devastating as these fires were to the burgeoning — then Spanish — town of New Orleans, they consecutively cleared away many inferior, ill-constructed buildings and impressed the residents that it was essential to erect more substantial, fire-resistant structures.

The buildings standing today are the result. They are far more grand than their predecessors. There is an undeniable elegance in them, resulting from their Spanish, not French, architecture.

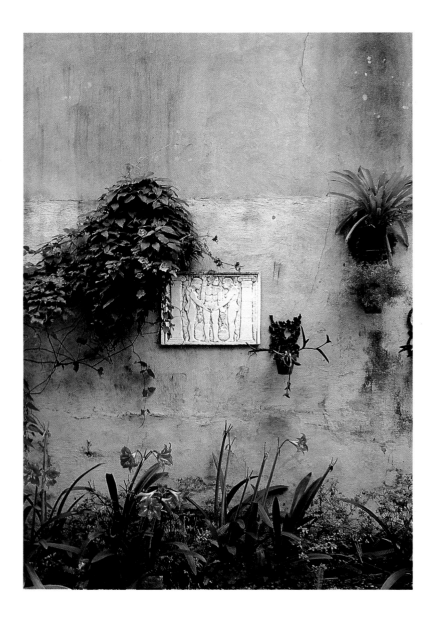

*Farther along is a grouping that includes orange and yellow hardy amaryllis in the bed, a morning glory vine to the left, a small bromeliad and asparagus fern to the right.*

*A bricked rectangular fountain boasts a statue overseeing iris, elephant ear, and potted coleus.*

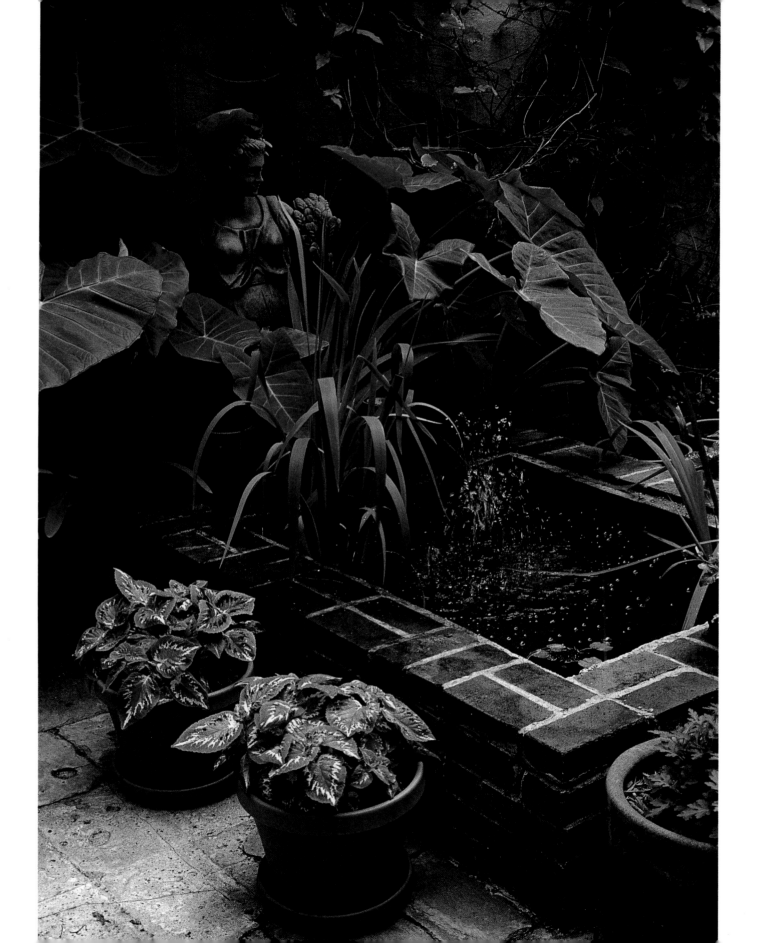

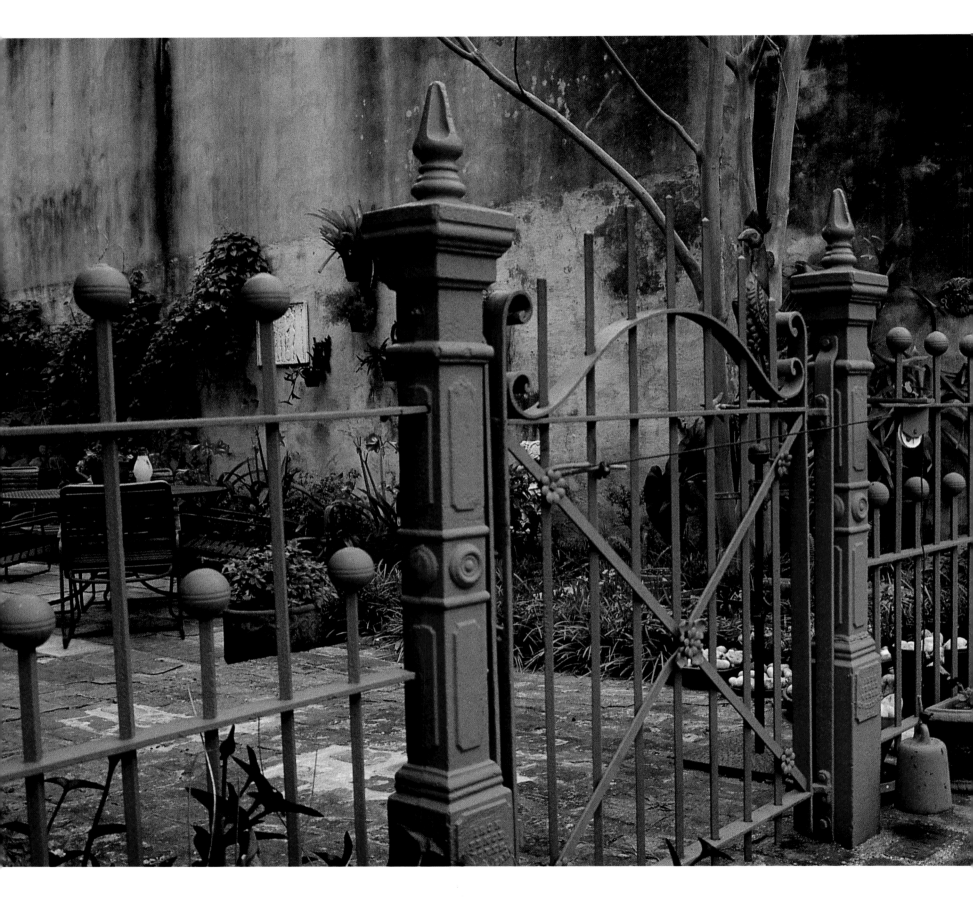

Nearby, against the brick wall, is a collection of potted pink, magenta, and red impatiens and a variegated privet. A red kalanchoe flower glows from under the shadows.

The pool area is separated by an antique cast-iron fence, painted rusty pink.

A MAHONIA BEALEI *grows to one side, its prickly leaves best not touched, while a bright yellow iris bloom contrasts with its own dark green leaves. A small cast-iron fountain hangs on the wall, probably brought here by an early group of Germans, who came to farm some of the nearby plantations.*

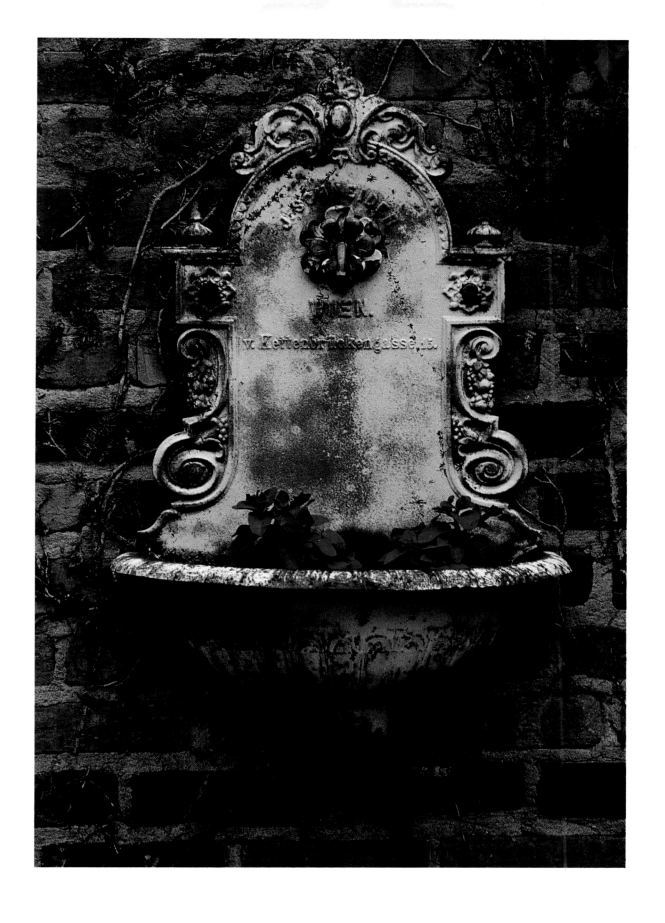

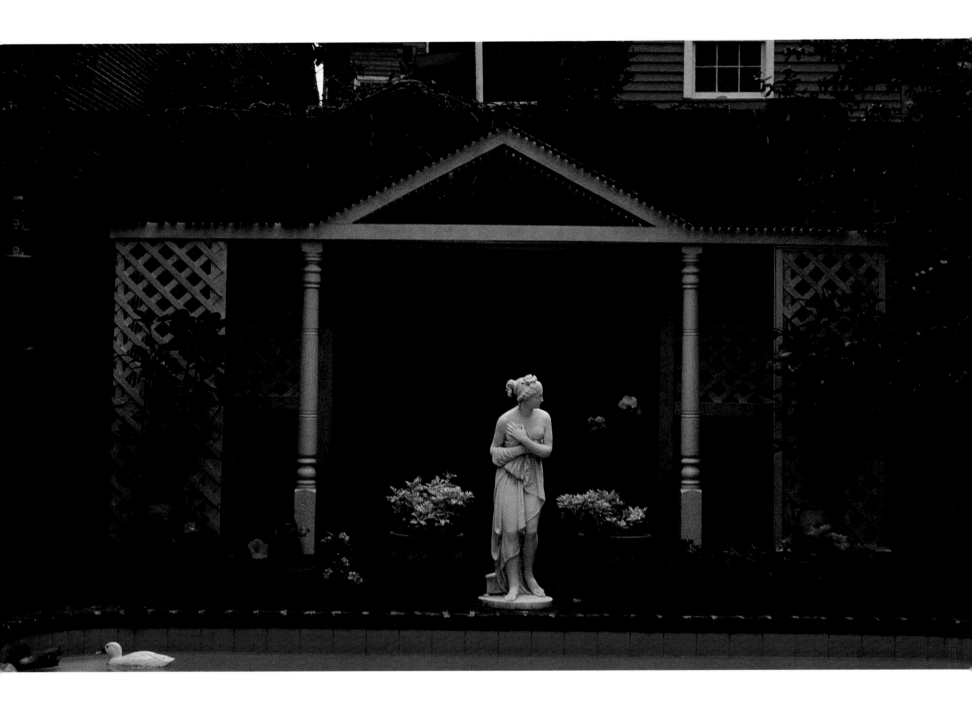

In the rear there is a latticed sitting area and a statue of a maiden watching the fountain. Hibiscus, dusty miller, and croton border the pool.

A view back toward the house shows the shuttered windows and doors, balconied second story, and dormer window in the attic area, as well as the corridor exit to the street. All are signatures of French Quarter architecture.

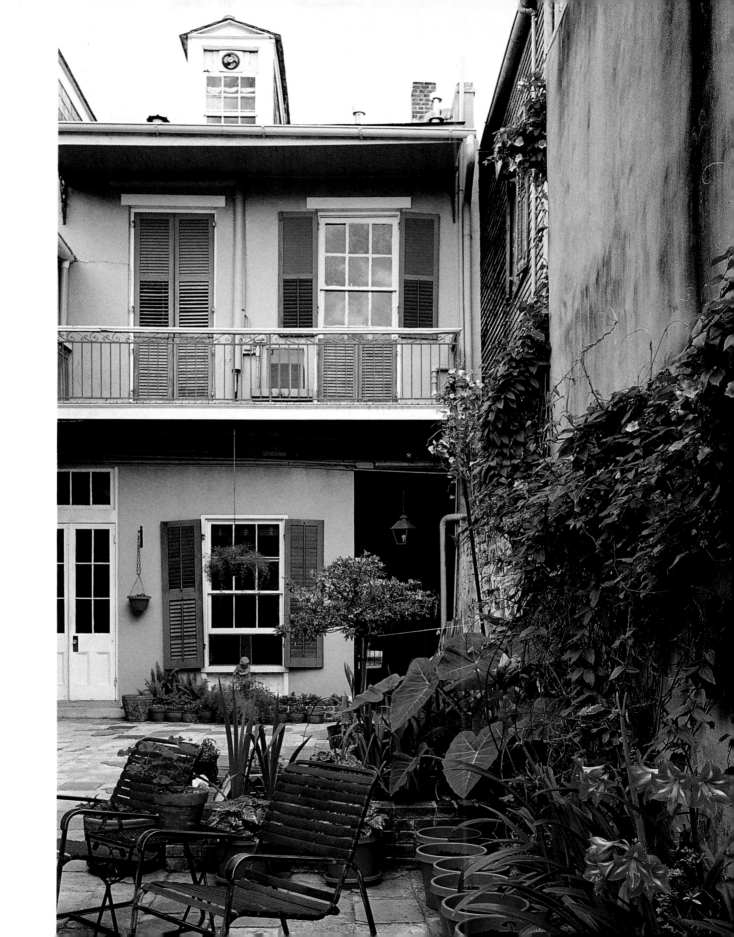

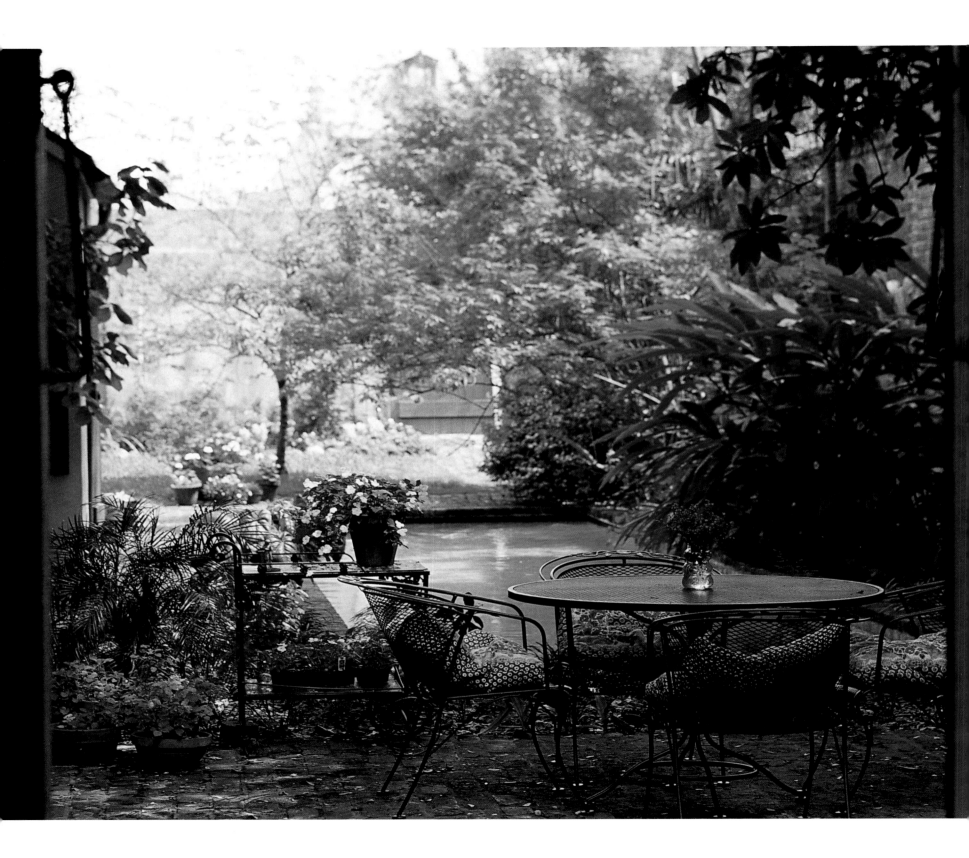

# Heguy

The Vieux Carré survives today as one of
America's most well preserved architectural
places. The history of the city is spoken in every
facade of every building that hugs the banquette,
or sidewalk, or relies on the common wall of the next
structure for mutual succor and support. The Vieux Carré
is a living and thriving city within a city. The charm and
quaint attitude of the eighteenth- and nineteenth-century
buildings is preserved alongside other buildings of equal
enchantment that were built in the twentieth century, in
accord with the design and *tout ensemble* of this vicinity.

However, the French Quarter was not always as healthy
as it is today. In the 1920s and into the early 1930s, the
Vieux Carré was suffering a decay that almost destroyed it.
Other than for the few proud old Creole families — the
direct descendants of the French and Spanish who built
New Orleans — who lived in and maintained their ances-
tral homes and businesses, the architecture of the locale was
fast deteriorating due to the poverty of the owners or disin-
terest in the area at a time when it was no longer fashion-
able. The city had grown rapidly since the 1870s, and
newer areas had become the seat of commerce. Many
choice residences were being built in the emerging vogue
neighborhoods.

It was during the 1930s that a group of concerned citi-
zens, residents of the Vieux Carré, banded together and
formed what is today called the Vieux Carré Commission.
The purpose of the commission was to spearhead a drive to
turn back the deterioration and advancing destruction of the
French Quarter and to preserve the *tout ensemble* of the rare
architectural treasures of the area. Today the French
Quarter — through the work of the Vieux Carré Commis-
sion and the many property owners who have spent a great
deal of time, money, and effort through the years in piecing

*Today, the walk through the house brings us to
the entrance of the garden, which is unique in sev-
eral ways. Its extended depth has allowed the
owners to develop several separate areas or envi-
ronments, offering multiple attitudes. The sea-
soned brick surfacing and high bordering walls
render an ambience of antiquity, while the pool
defers to our contemporary culture. The pool,
designed as a lap pool for exercise as well as a dec-
orative oasis, was built to fit inside the diminutive
width of the area while still allowing space for a
small contemporary pool cottage.*

*The wall along the right of the court is planted
with several trees and shrubs. A flower of the FEI-
JOA SELLOWIANA, a pineapple guava, is already
blooming its smooth white petals with purple sta-
mens touched in yellow.*

the French Quarter back together — is a beautiful and unusual place.

The neighborhood of this residence was one that included small, unpretentious homes that were generally occupied by laborers of the early city. The record books show that in 1811, this building was passed in ownership by a gentleman of the city to one Alexandrine Heguy, "f.w.c.," or free woman of color.

The building is fabricated of the antiquated *briquette-entre-poteaux* construction and is now enrobed in a lively chemise of yellow plaster. The home is not a large one, measuring only 32 feet in width, but it is located on a lot in its city block that was once designated a "key" lot. The key lots of each block, of which there were two, were situated in the center of each square and spanned equally into the full depth of the block's center, backing up to one another. This lot of approximately 160 feet in depth is as long as any in the French Quarter. Another two-story back building, a fatality of time, once housed a kitchen and quarters for the servants.

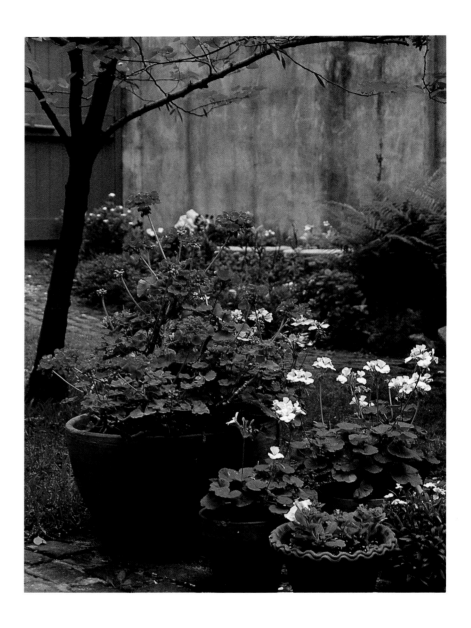

*Against the wall at the end of the pool grows a Cape Honeysuckle,* TECOMARIA CAPENSIS, *its orange blossoms just beginning to share the summer light.*

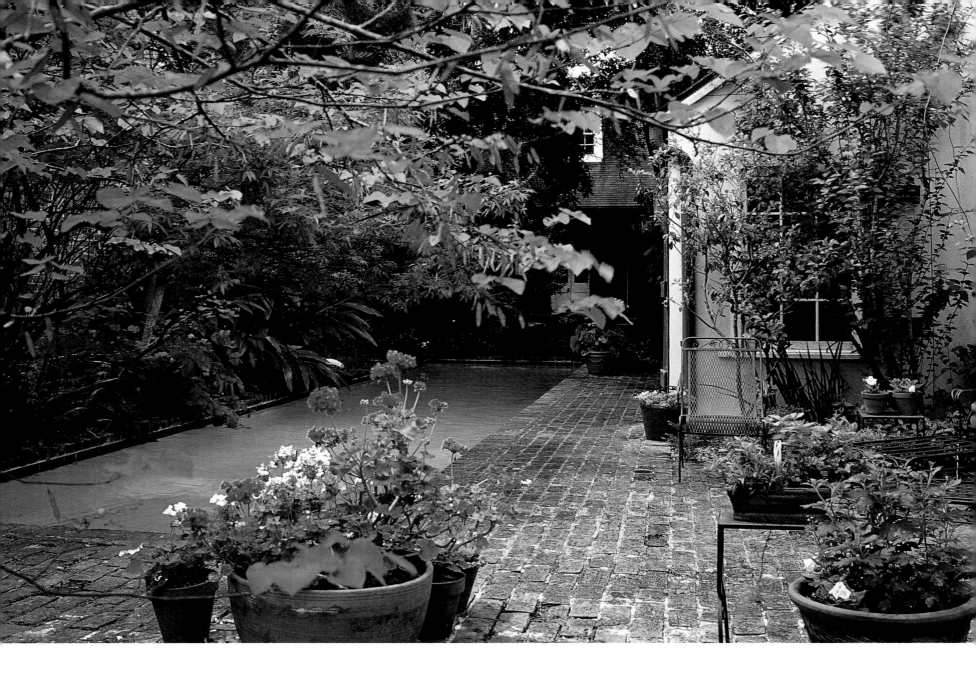

*The view back through the garden, framed by the branches of a redbud tree, looks across the pool, where lush foliage overhangs the water. An arrangement of potted white, pink, and red geraniums brightens a corner of the brick path.*

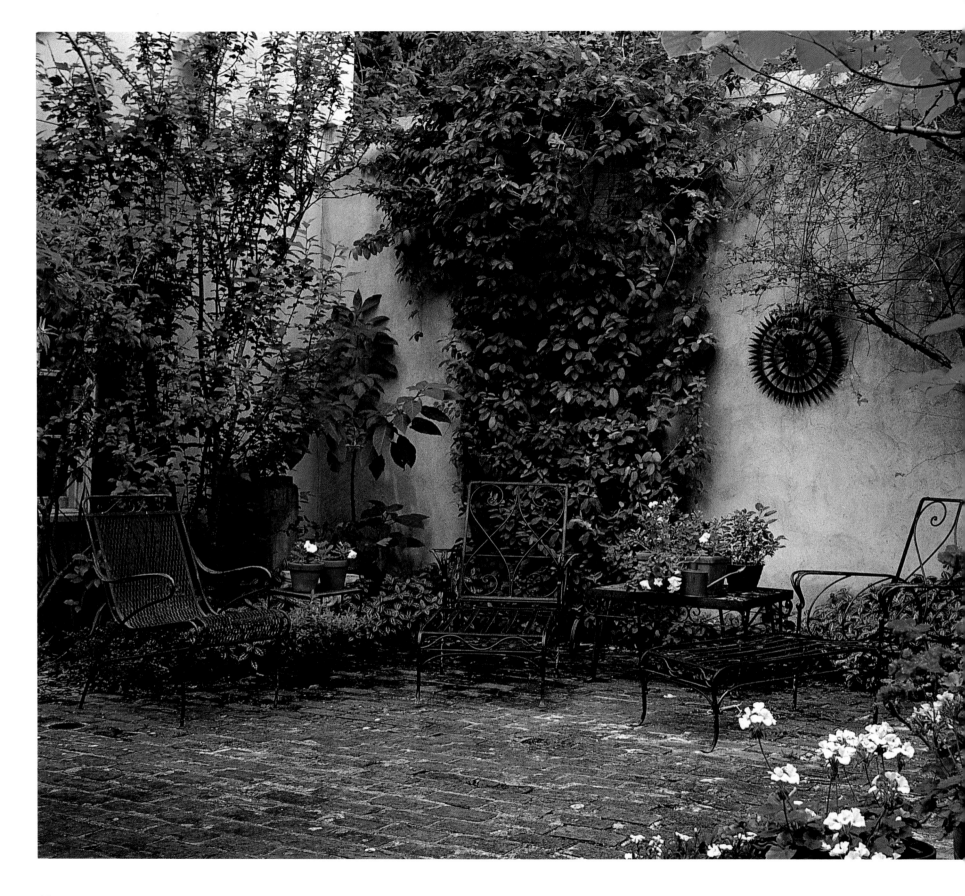

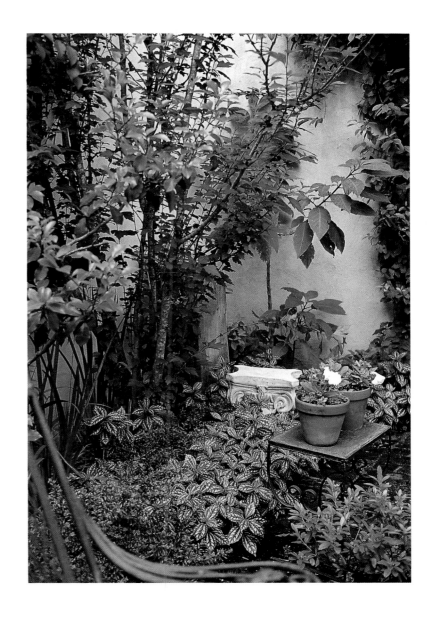

To the right, a small domain has been designated as a sitting area with an interesting variety of greenery. The farthest corner boasts PILEA, Mexican heather, in the low beds; a young althaea, or rose of Sharon; and a honeysuckle vine climbing the wall to the right.

*The plump green pods of a datura will open to become beautiful white angel trumpets. A low table is set with purple and white petunias and a small copper watering can.*

*A single magnificent red rose hangs heavy from its stem.*

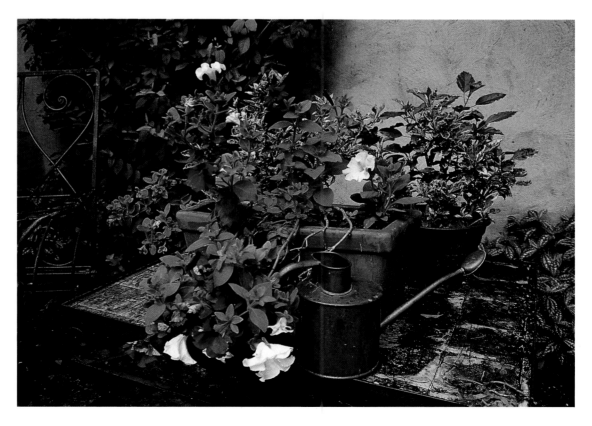

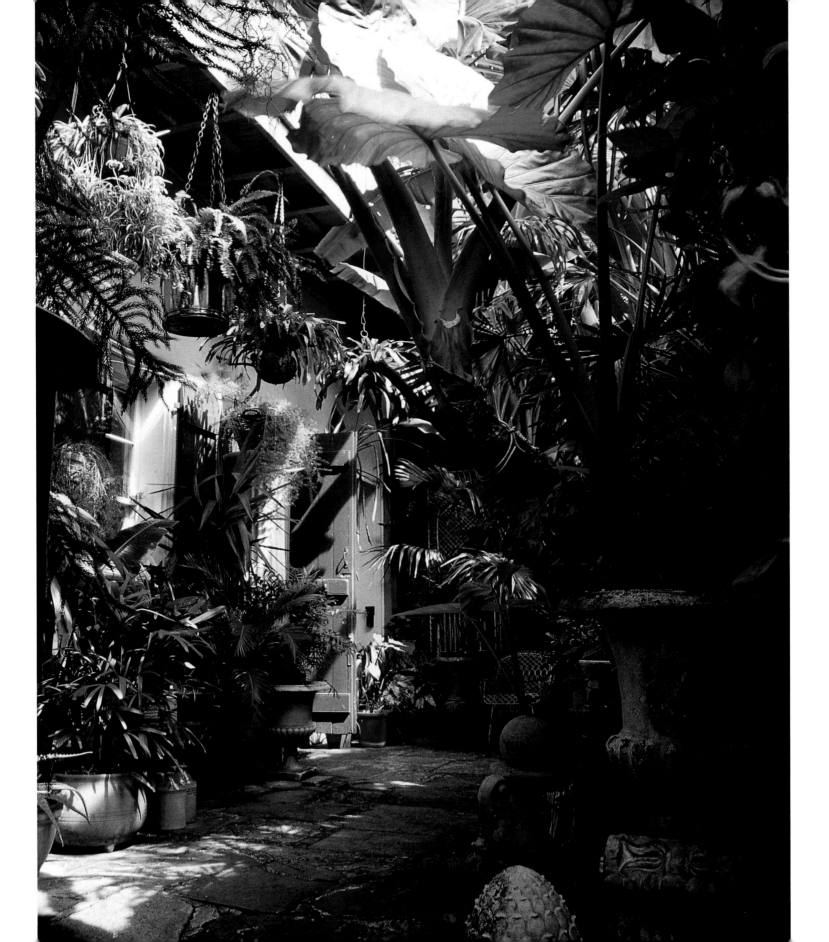

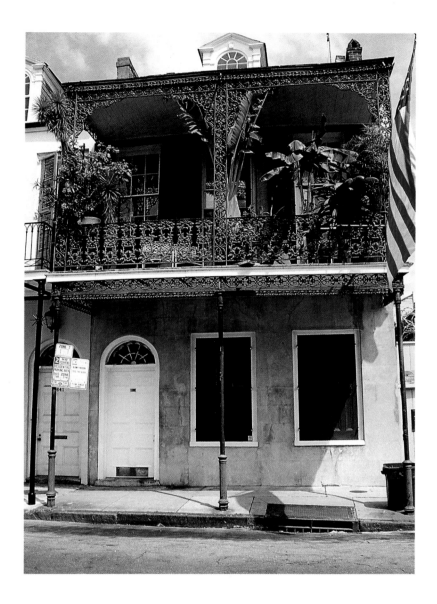

# $\mathcal{I}mmigrant$

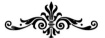

*A view through the courtyard from the entryway of the house shows an impressive grouping of tropical, leafy green flora from lady palms, or RHAPIS, and yucca on the left, to giant elephant ear and banana on the right. Hanging from the balcony are baskets of spider plant, fern, and bromeliads.*

$\mathcal{D}$uring periods in which the French Quarter was shunned by New Orleanians as the unfashionable place to live, its structures were left to fall into decay and, sometimes, destruction. During these times the poorest of the populace — the newest arrivals from foreign shores — would inhabit these buildings.

Ironically, it was because of the destitution of these people that the buildings, in many cases, remain today. Rather than having the wherewithal to raze a building, or even to alter it architecturally in major ways, these people were forced to make do with what existed and to accept the conditions of their homes as adequate. Improvements consisted principally of fixing the roof of leaks and maintaining the shell of the building sufficiently enough to provide the family with protection from the elements. In effect, the integrity of the engineering and design of the structure were preserved.

In the early 1900s, many Italians, coming from Sicily and other areas, made up the greatest number of that period's infusion of immigrants. Arriving in the Creole City, they relied on trades familiar to them, such as fishing, farming, and the purveyance of vegetables. They virtually overtook the French Market and became the principal vegetable and produce vendors of New Orleans. Soon, they became able to purchase many of the properties in the Vieux Carré that had been originally built by the French and the Spanish. The area of the French Quarter bordering the French Market became almost entirely populated by these resourceful, hardworking Italian families.

Because of this cultural phenomenon, this home remains architecturally intact today; its small, interesting courtyard reflects in its plantings the feeling of the original design.

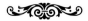

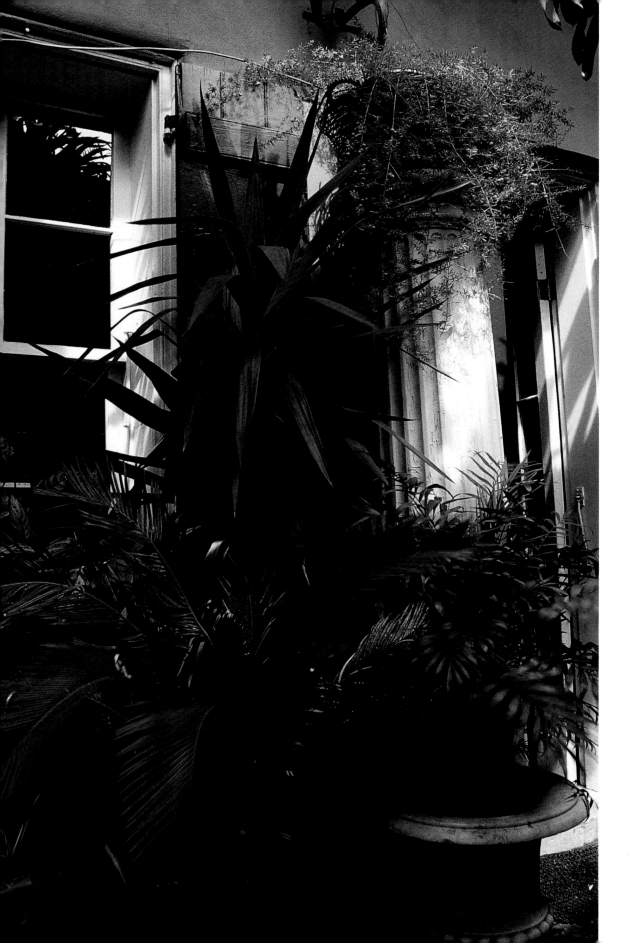

A closer look at the collection to the left identifies a sago palm; a tall yucca; an asparagus fern in the planter on top of the white column; and a NEANTHE BELLA palm, CHAMAEDOREA ELEGANS, in the white cast-iron urn on the flagstone surface. This tall variety of yucca is called a Spanish dagger. It is often used, as in the past, as a discouragement to intruders who might venture climbing over the wall into the privacy of a patio.

An aloe vera is located where it can catch a slim ray of garden sunlight. The nineteenth-century wire chair, a souvenir of a previous age, is a prize found by the owner of this property along the riverfront wharves.

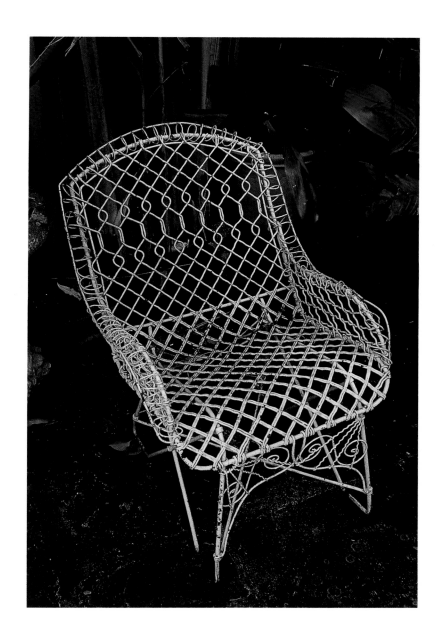

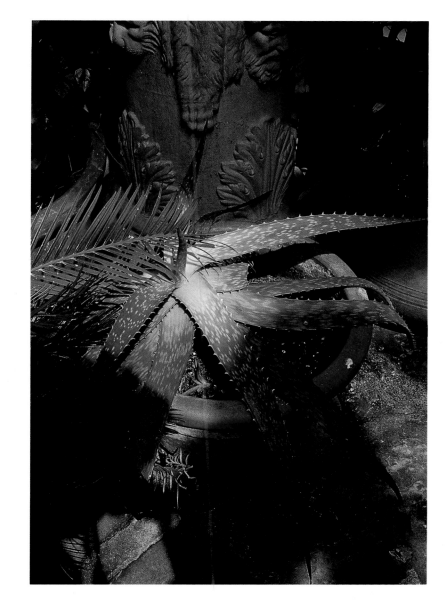

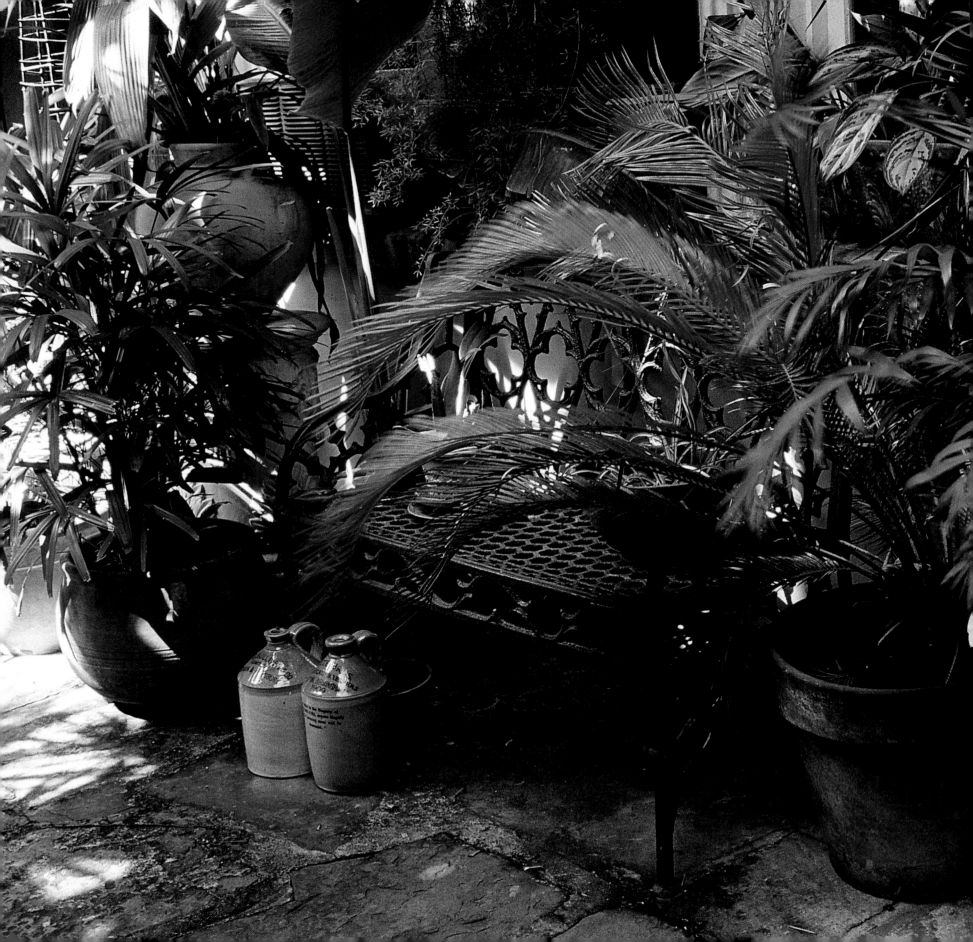

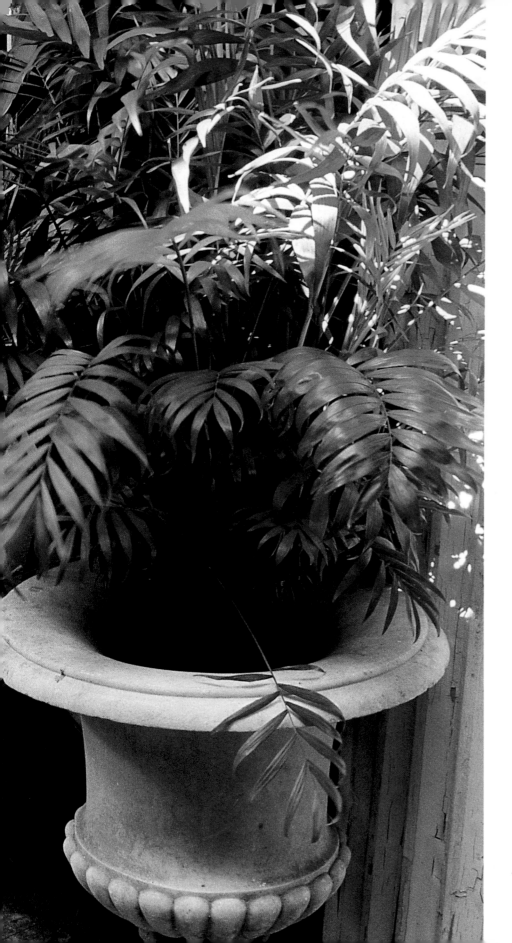

*A cast-iron love seat is hidden among the palms.*

A collection of wall plants includes spider plant, bromeliads, and pothos surrounding a small cast-iron fountain. The familiar olla, the huge Spanish olive oil jar, serves as a decorative planter and reminder of the Spanish domination of the city.

The arched door that enters the patio is also Spanish in design. Light filters into the court and the upper-floor balcony on which stand several yucca.

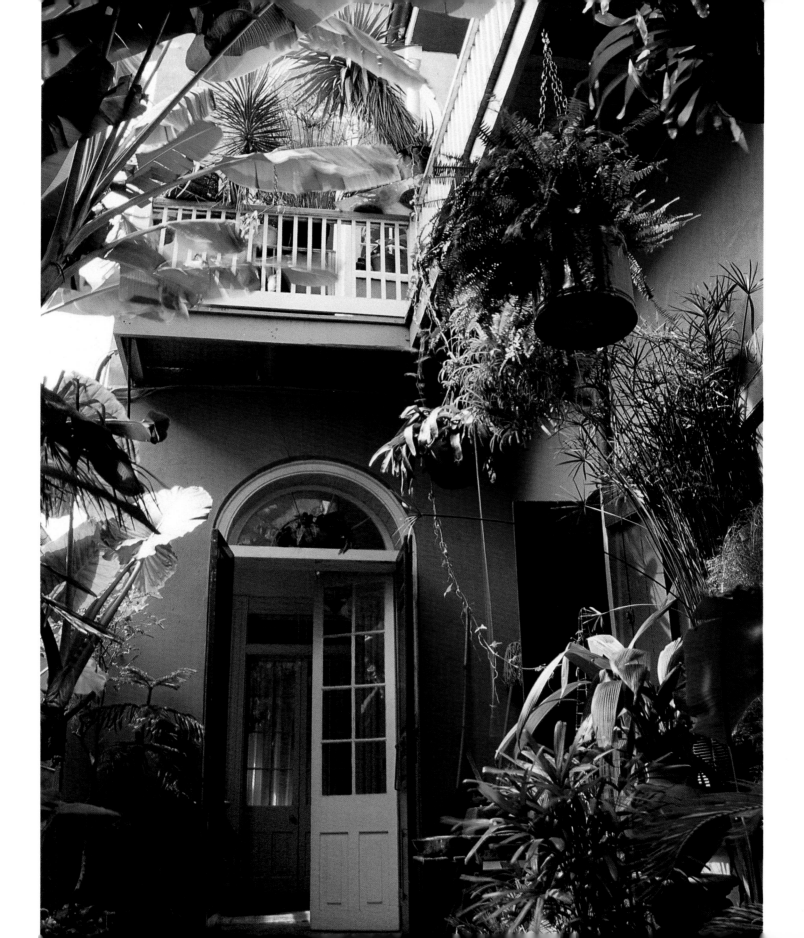

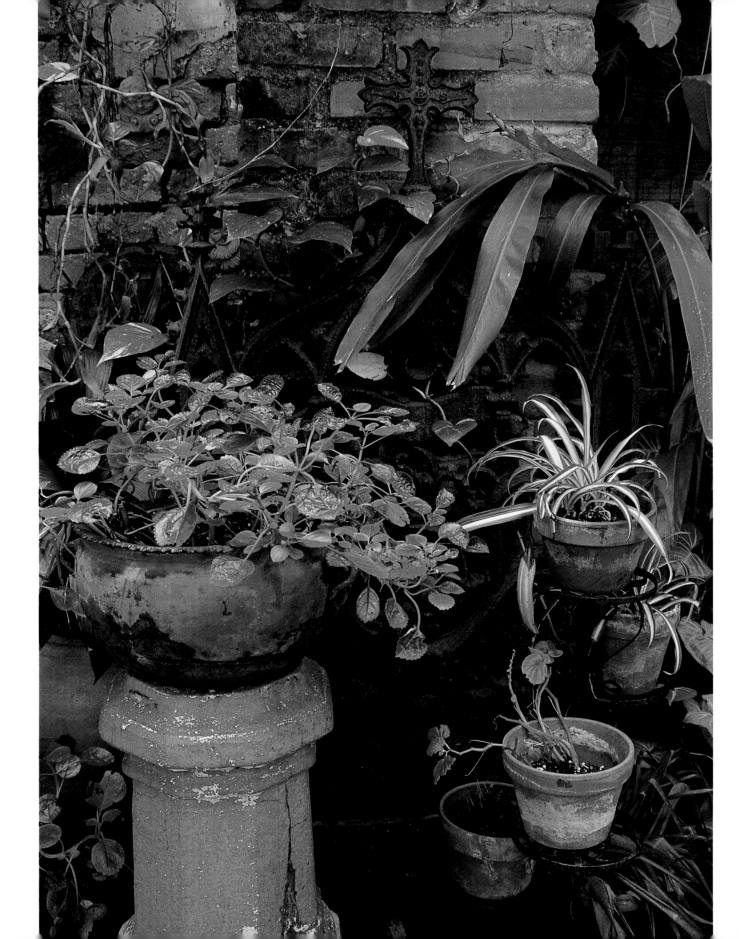

At the wall of an old chimney stands a rusted iron cemetery gate, surrounded by Swedish ivy, ginger, and a small potted spider plant.

Giant elephant ear and bananas fill the planter bed along the wall that leads back to the door from which the patio is entered, and an exit is now taken.

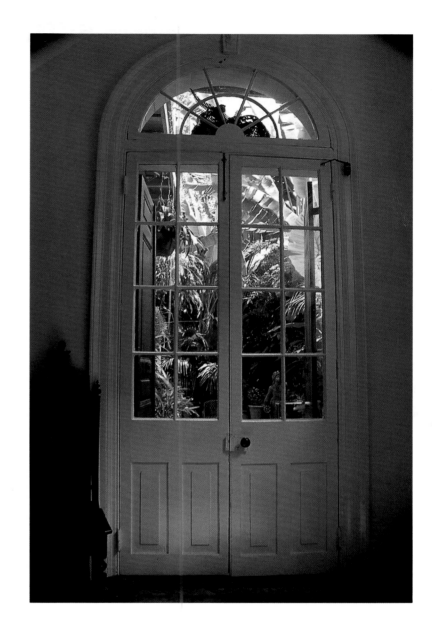

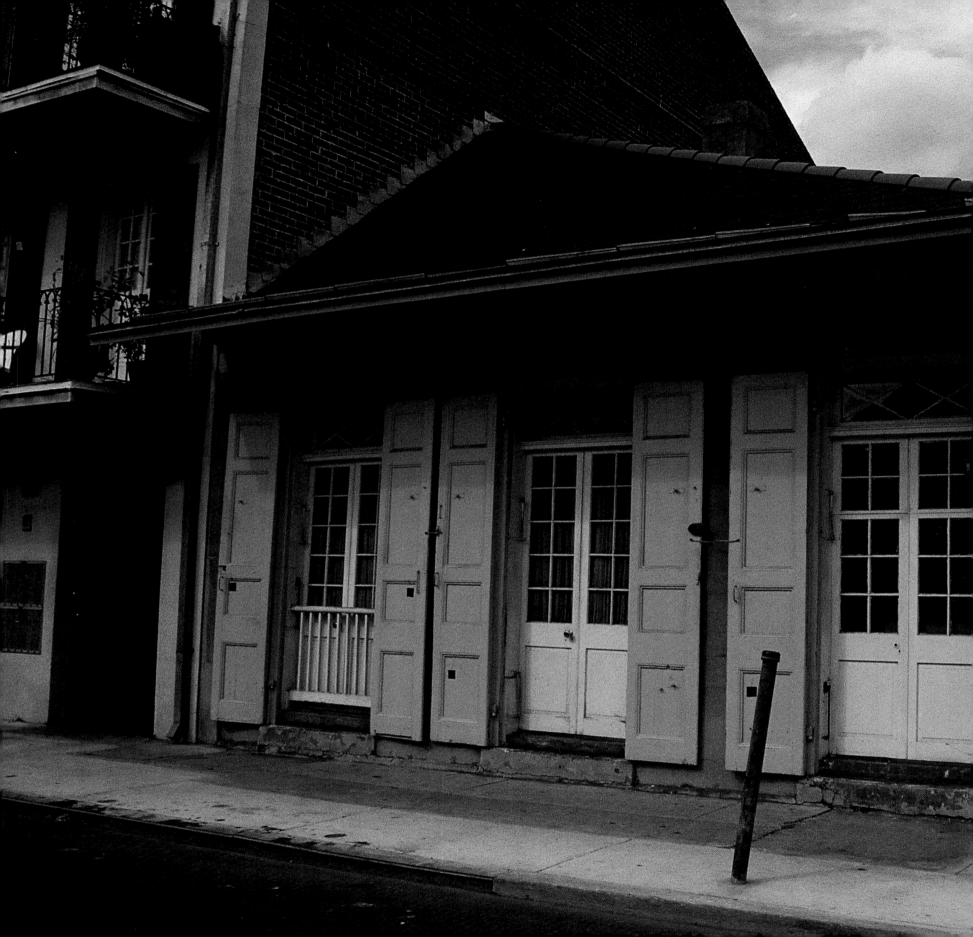

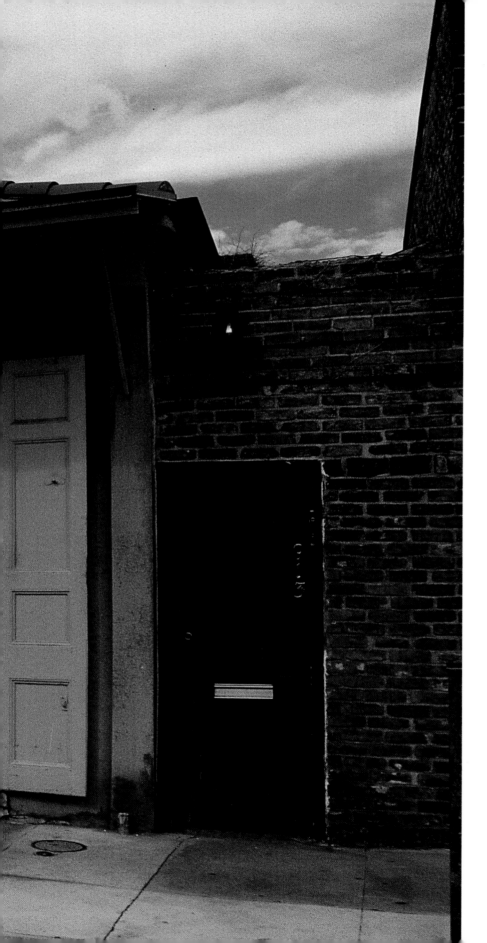

# Jalousie

This late-eighteenth-century Spanish colonial cottage was built only a few years before the United States took possession of New Orleans as a territory. This little house of *briquette-entre-poteaux* was first erected with a one-story front house and a two-story rear kitchen, a separate structure. The small area between the two is the patio, which now serves as the interior/exterior living room of the complex. The two buildings were joined by a third, narrow two-story structure that runs along one side of the court from the front to the back buildings. Erected in the mid-twentieth century, this middle building expanded the indoor interiors of the property advantageously.

During the Spanish colonial period of New Orleans, government officials were forced by necessity to find new ways to tax people and, at one time, levied a tax on every interior closet and staircase in residential structures. For this reason, there are no interior closets authentic to the original design of this building complex. It was because of this closet tax that the armoire, a large wooden cabinet holding one's entire wardrobe, became popular. Since interior stairs were also taxed, many stairs, as are these, were built on the exterior of the edifice. This house was built by a white Creole gentleman for his illegitimate quadroon daughter, whose mother was an enchanting and exquisite mulattress and mistress to the father.

The building is of Haitian design, built by a free Haitian of color who had come to New Orleans as a refugee from slave uprisings in his own country. The buildings originally housed a *boulangerie* (bread baker's shop) and residence in the front and an unconnected *garçonnière* in the rear. The *garçonnière* served as living area for the male progeny of the family so that they would have their privacy from the

females. In these times, the sons of a family were allowed an indulgence of freedom while the daughters were over-protected and chaperoned every moment, until they were given away into a marriage or fixed in some other acceptable arrangement.

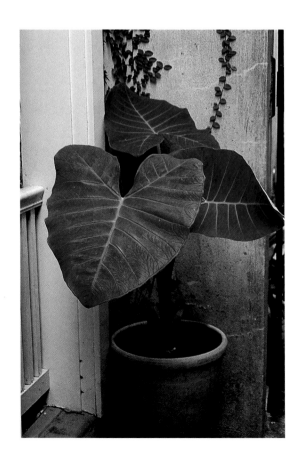

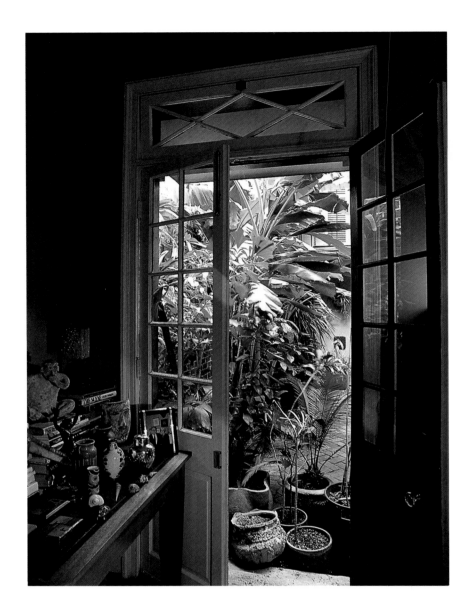

*The entryway to today's cottage is at the right of the property. The sea-foam green shutters help maintain the Haitian look of the exterior design, while the dark green door insinuates luxuriant herbage. As you enter the outside door, a fleshy elephant ear crouches happily in the corner of the doorway leading into the house. On entering the house, the focus of one's attention is dominated by the view through the doors opening onto the courtyard.*

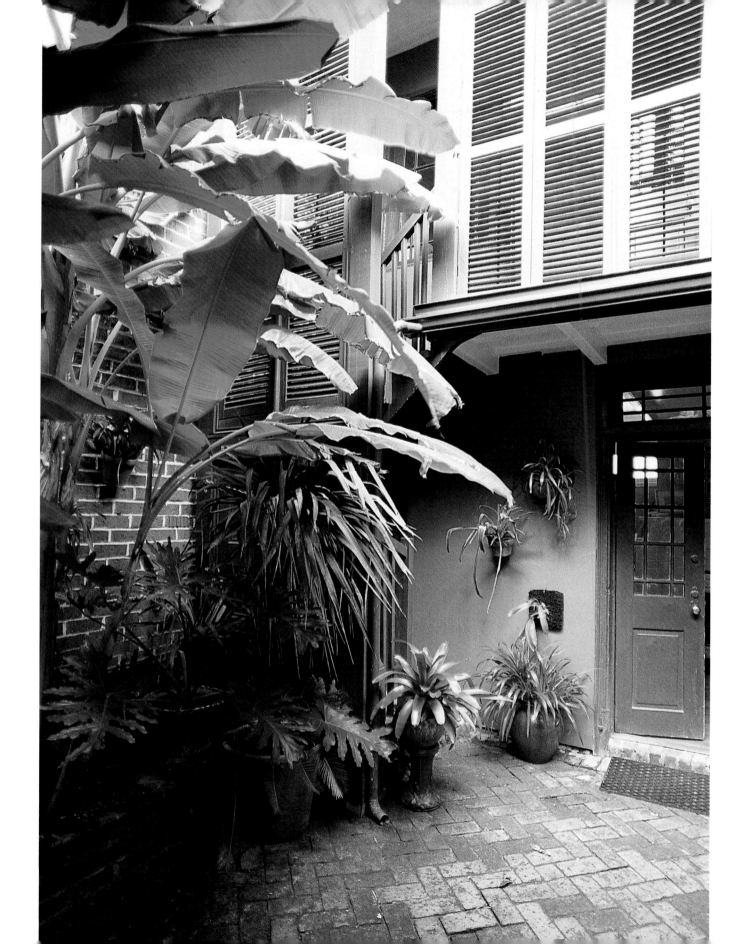

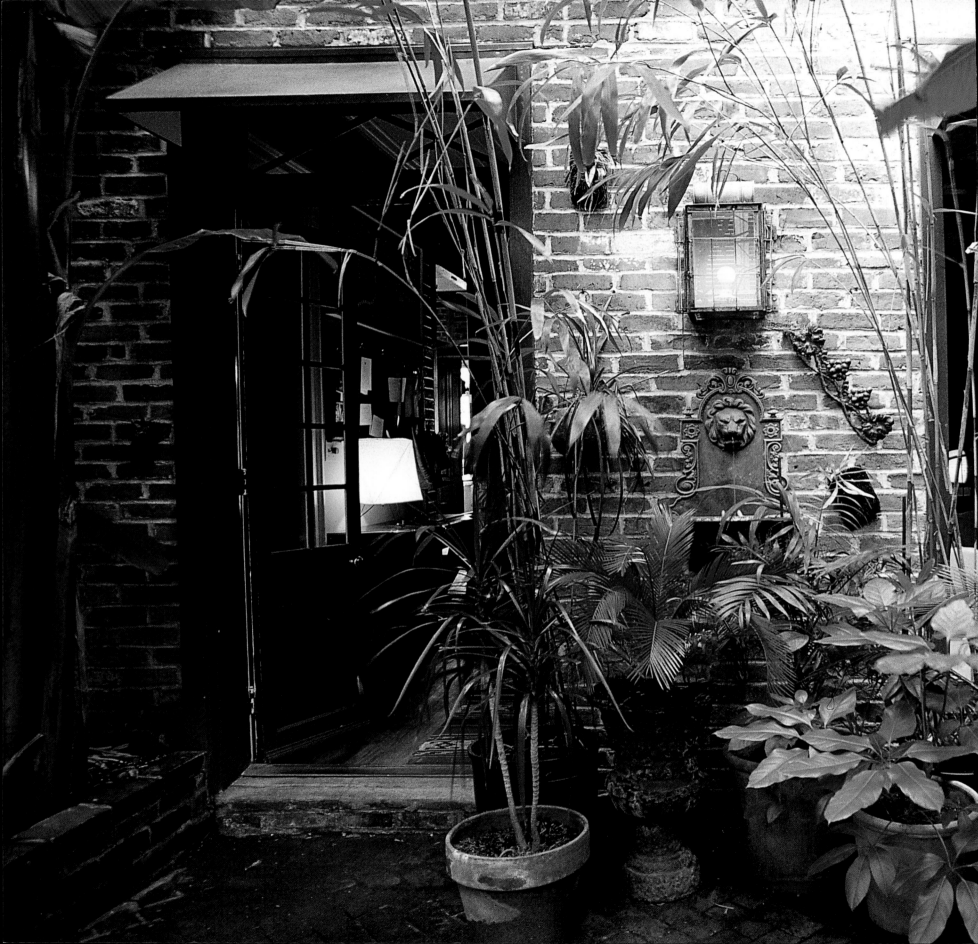

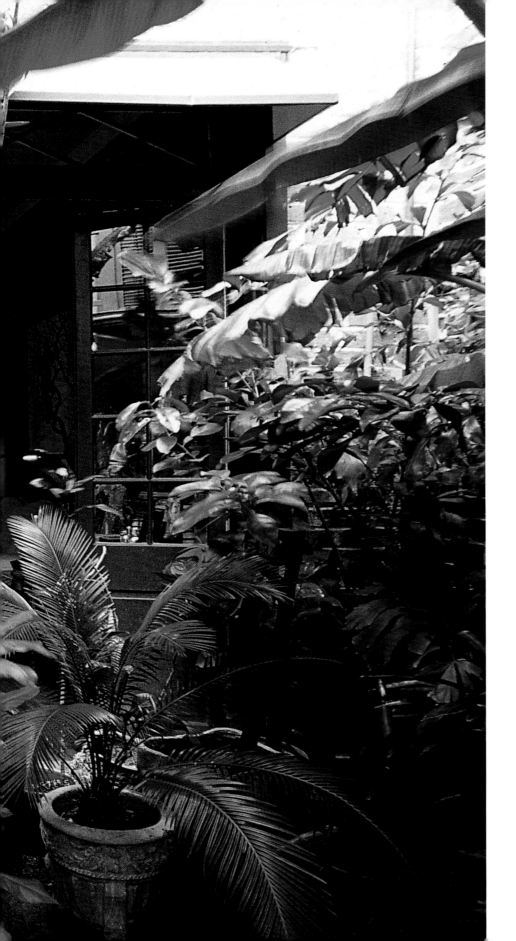

The small courtyard is treated as an interior living room as much as an exterior one. The surrounding buildings and walls keep it cool in the hottest of summer days, while the warmth of those same buildings repels the chill of winter's low temperatures. The banana trees and the fish-tail palm line the walls to the left. A view across the patio to the rear building exposes philodendron, yucca, and bromeliads. To the other side is a Chinese fan palm, LIVISTONA CHINENSIS. There is an openness to this small enclosure.

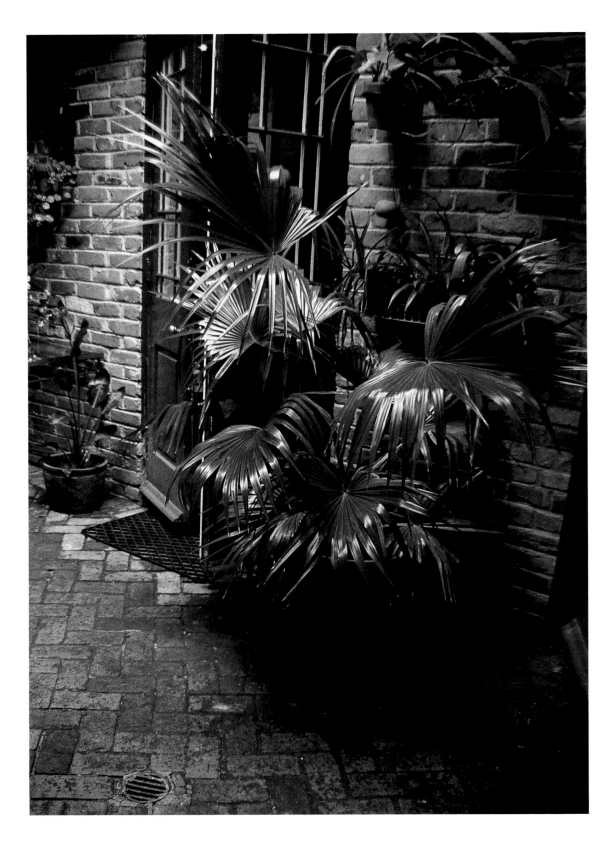

The back rose-colored wall holds a small collection of bromeliads, while an exterior jalousied stair and balcony hide the spaces behind. The jalousie looks like wide shutters. They were designed to secure privacy while admitting the breeze to pass through. Other potted tropicals include tall skeletal bamboo, sago palm, and SCHEFFLERA. The amber cast of a verdigris wall sconce illuminates the tinkling waters of the tiny fountain and the plants below.

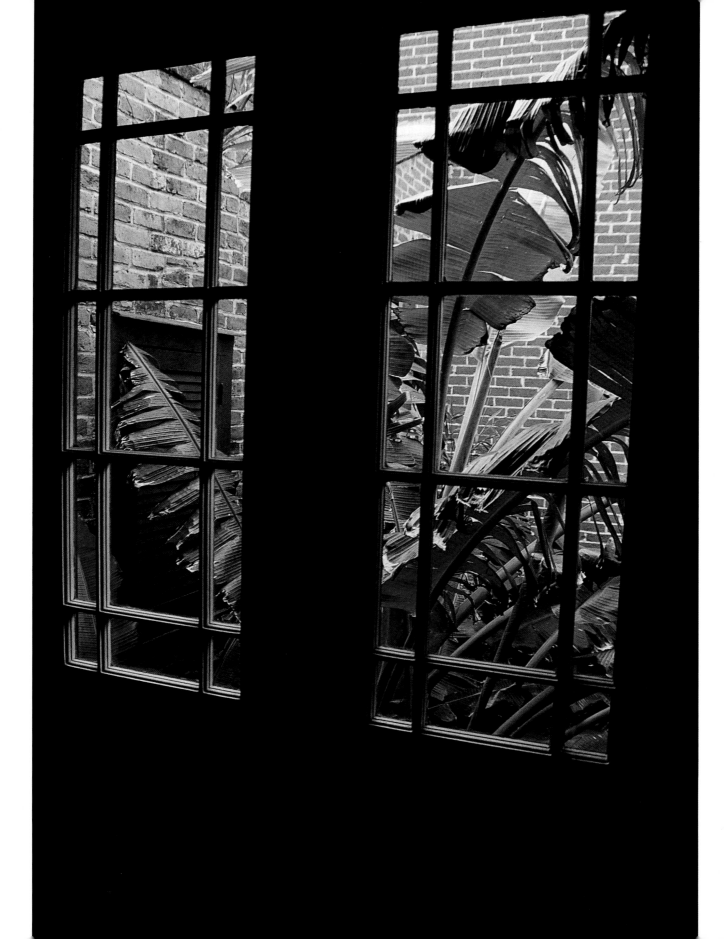

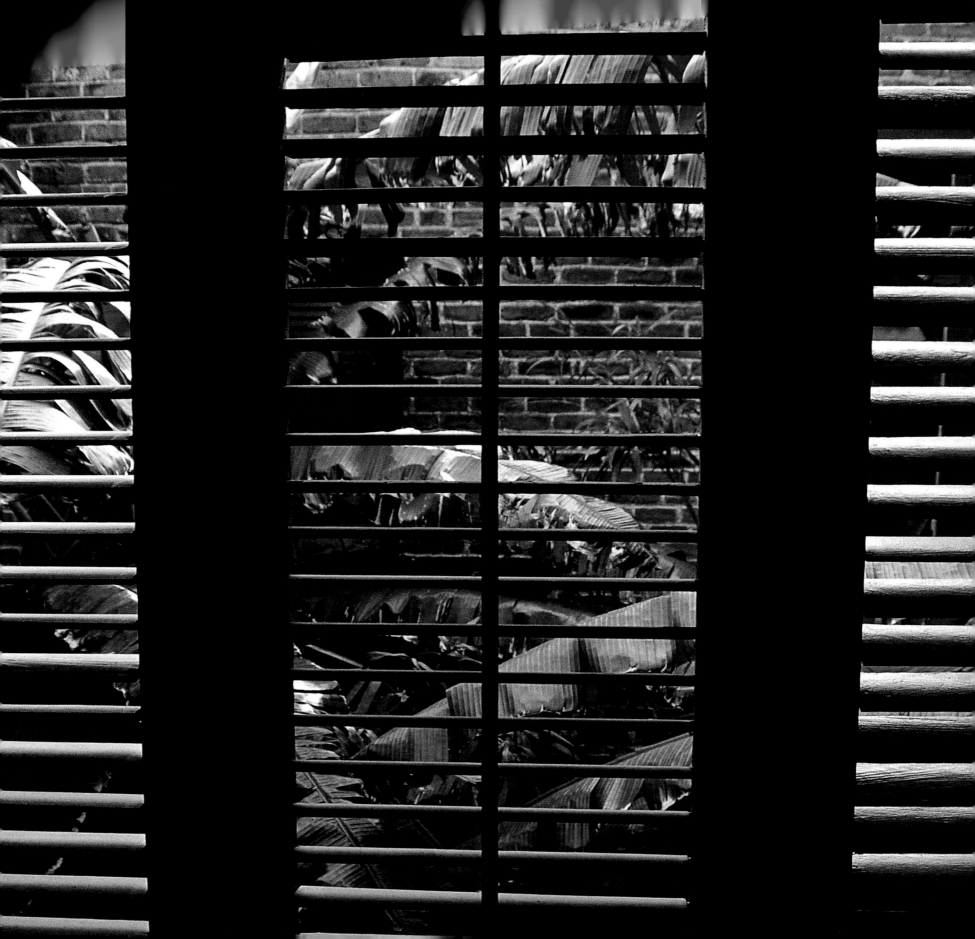

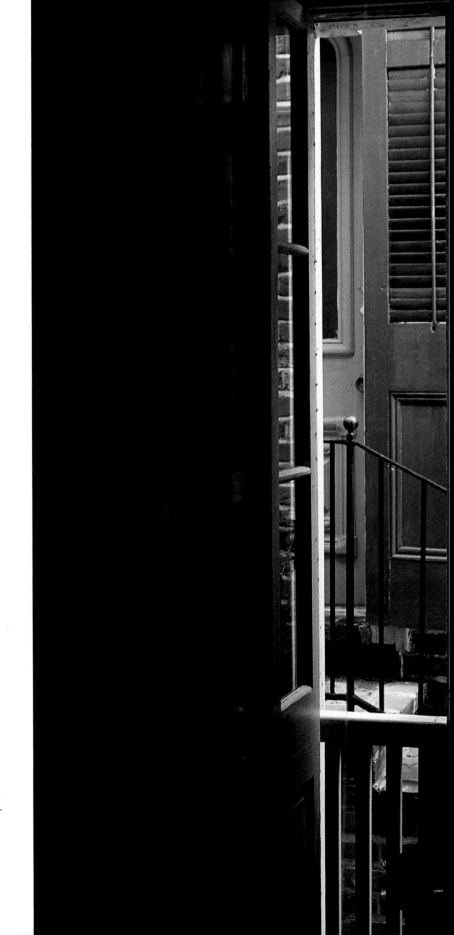

*Seen through a window of the upper-floor bedroom, as well as a louvered shutter, the tops of the bananas stand tall, tattered by the breeze. Another door lends a peek at the entrance to a neighboring house, colors, stairs, and shutters: shades of another time.*

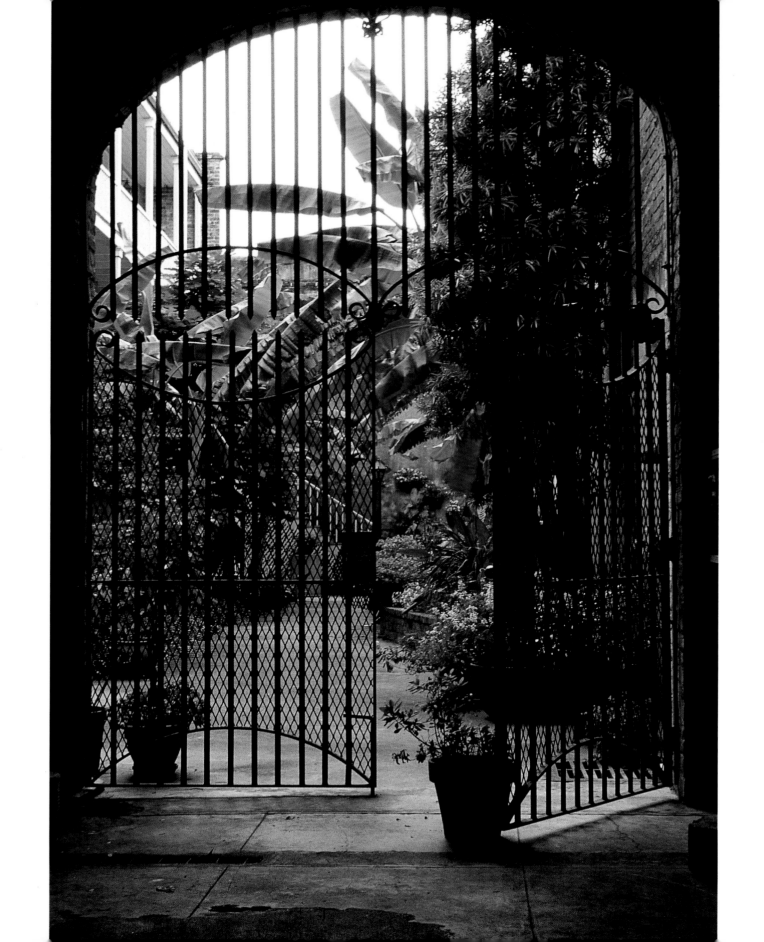

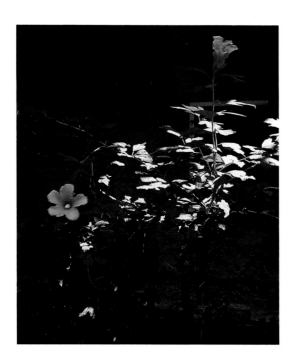

# Mercantile

There is a variety in both use and design in all of the French Quarter buildings. This grand building with its comparatively large courtyard once housed a stable with room enough in the rear for dray carts, as well as a wide carriageway where elegant carriages could be parked. During the Spanish colonial period of New Orleans, from 1769 to 1803, only a single Spanish design cart was allowed to be used for drayage in the city. It was chosen by the officials because it made a great deal of noise, which made it difficult to cart untaxed goods without detection through the streets to and from the ships waiting at the quay for import or export.

This substantial edifice was built to house a large commercial enterprise on the ground floor; there were also balconied upper-floor residences and back buildings in the rear housing stables, additional second-floor residences, and storage. The building has, in the past, served as a location for a grocery and a winery depot. Today, the entire complex has been transformed into residential areas with apartments of various layouts and sizes. The front apartments offer a view of the street below, as well as an overview of the court behind. This wide court has been surfaced with cement, with brick beds along the outer wall.

*From the street, one passes through two sets of massive gates to the interior courtyard. The tall banana trees, their leaves swaying in the breeze, create a tropical feeling.*

*The young althaea, or rose of Sharon, partially shaded by the overhang of the balcony, yields two lavender blooms.*

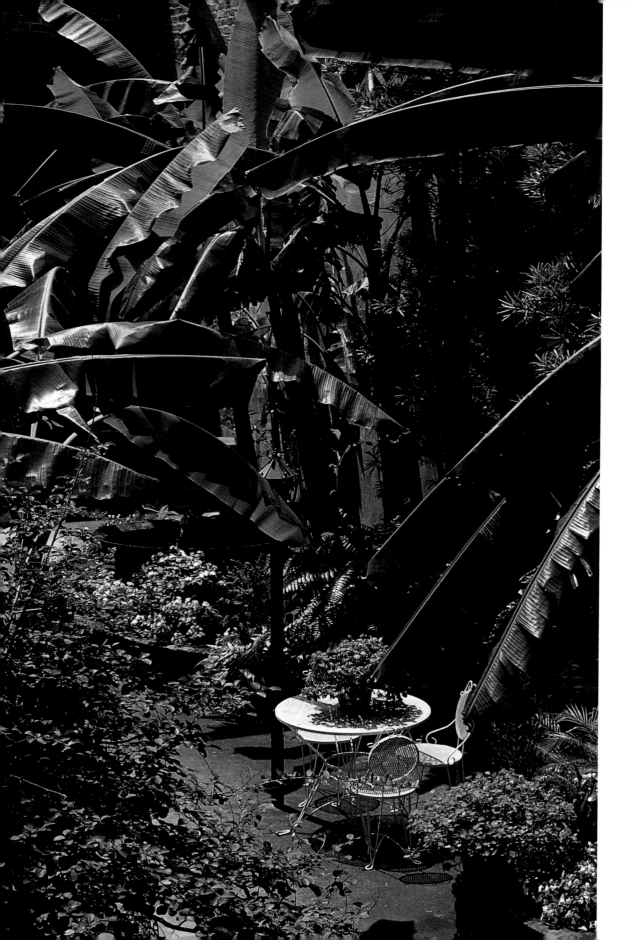

The view into the court from the slave-quarter balcony allows an overview of the entire court.

The wide-spreading FICUS CARICA, or fig tree, is heavy with early green fruit. The fig is one of the trees that came to the colony from the Mediterranean with the Ursulines and the Jesuits.

The fig fruits profusely in New Orleans. When ripe, the fruit is harvested and made into delicious jams, preserves, and wine, as well as pies and ice cream.

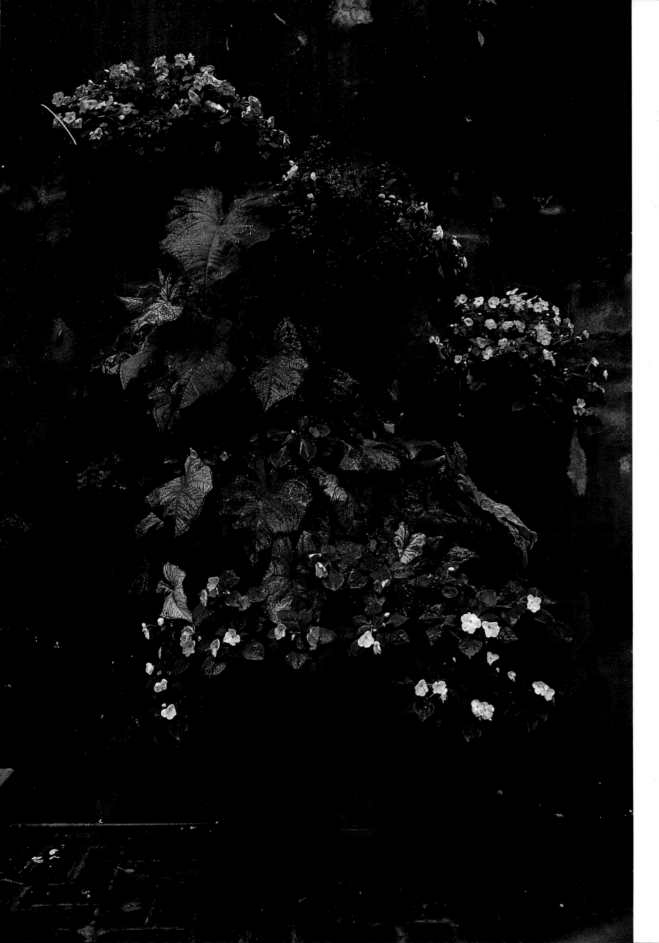

At the far rear of the garden is a stairway leading to the upper floor of the slave quarters of the back building. In years past, many homes had quarters attached for the household servants and their families. Throughout the Vieux Carré, these buildings have now been elegantly renovated into some of the most posh residences of the district.

On the wall by the stair is a charmingly grouped arrangement of impatiens in whites and varying shades of pink, with rose and green caladiums that brighten the somber gray patina of the cement covering on the wall.

119

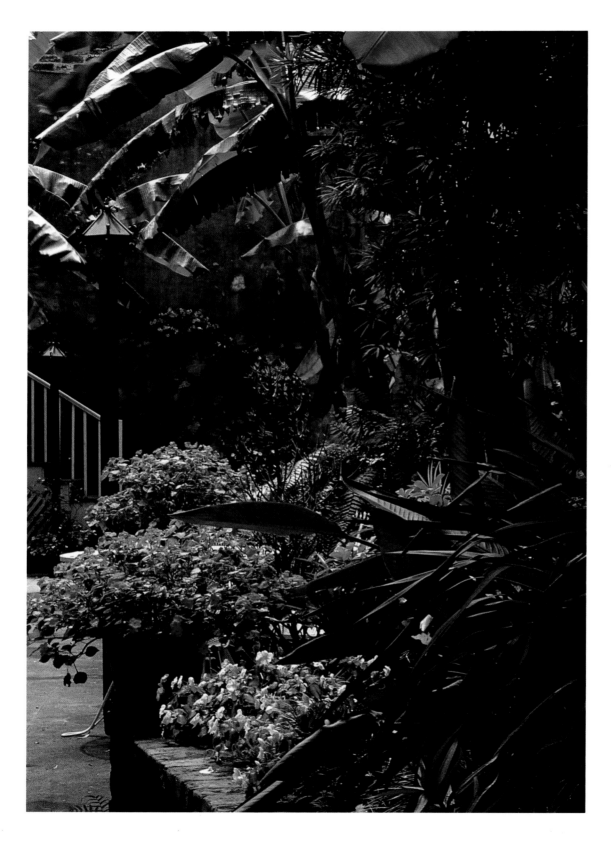

Moving back into the court, a grouping of plantings consists of orange and white impatiens, bananas, yucca, Japanese yew, and bird of paradise. Through the courtyard, toward the street, the Spanish arches of the fan window on the second floor and of the portico are visible.

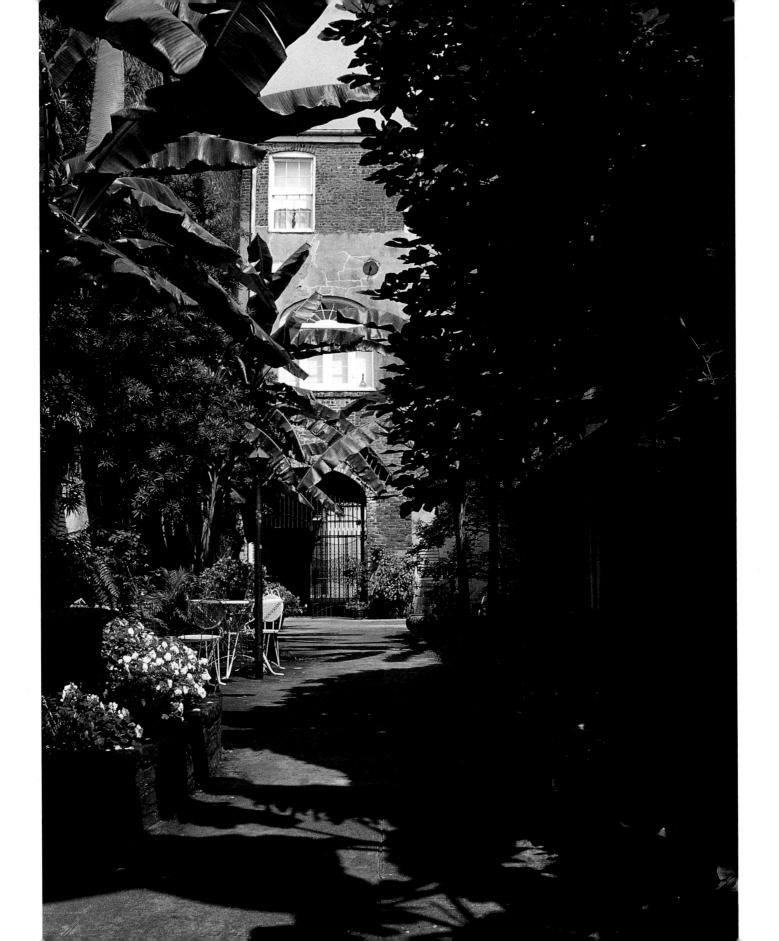

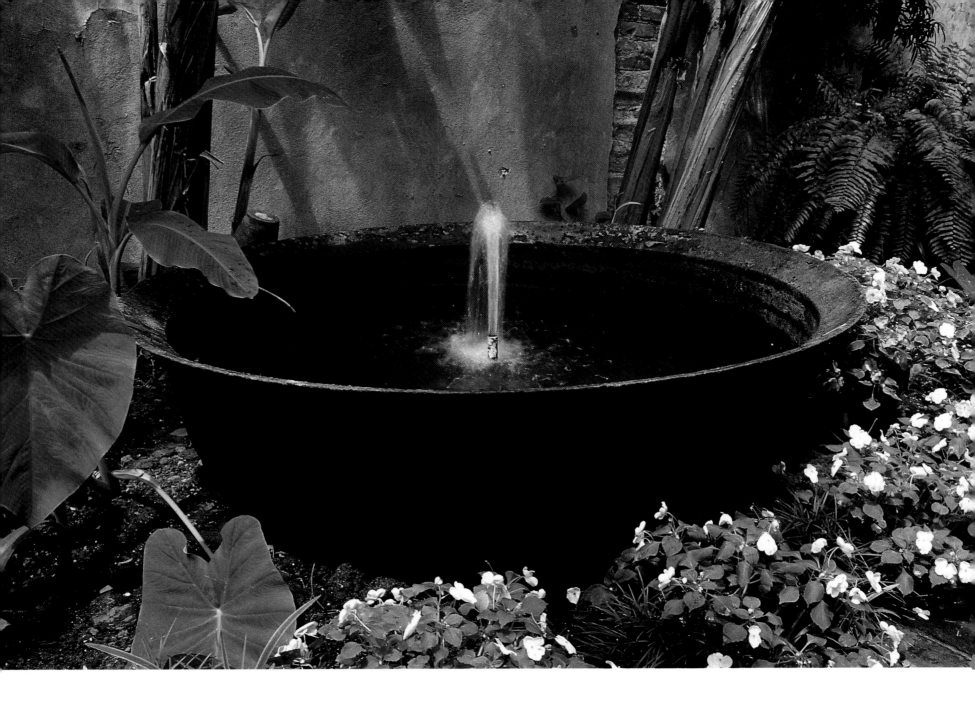

Bananas, white impatiens, and small elephant ears surround a large and rare sugar caldron, once used to boil sweet thick juice crushed out of the all-important sugarcane into a syrup. This remaining vessel stands as evidence of an industry that saved the early settlement from bankruptcy and turned a troubled and dying colony into a thriving economic phenomenon, leading the world in production of sugar for many years to come. The caldron now exists as a fountain with a single fount that gently adds a note of calm to the sounds of the court. It is a place for goldfish to live, for visiting birds to bathe and refresh themselves before moving on in their busy, frantic lives.

A healthy sword fern holds tight against the wall from which it grows.

*The yellows and oranges of a lantana peek out from under the shade. A painted tile plaque on the wall, a souvenir from the Spanish era, remains as tribute to the Catholic influence of past cultures.*

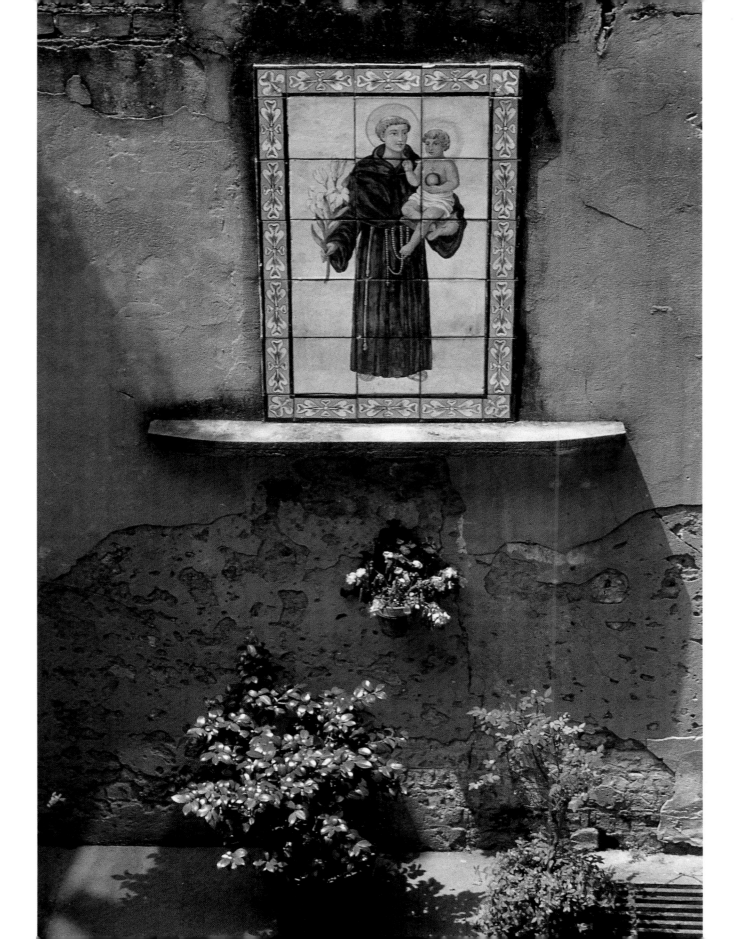

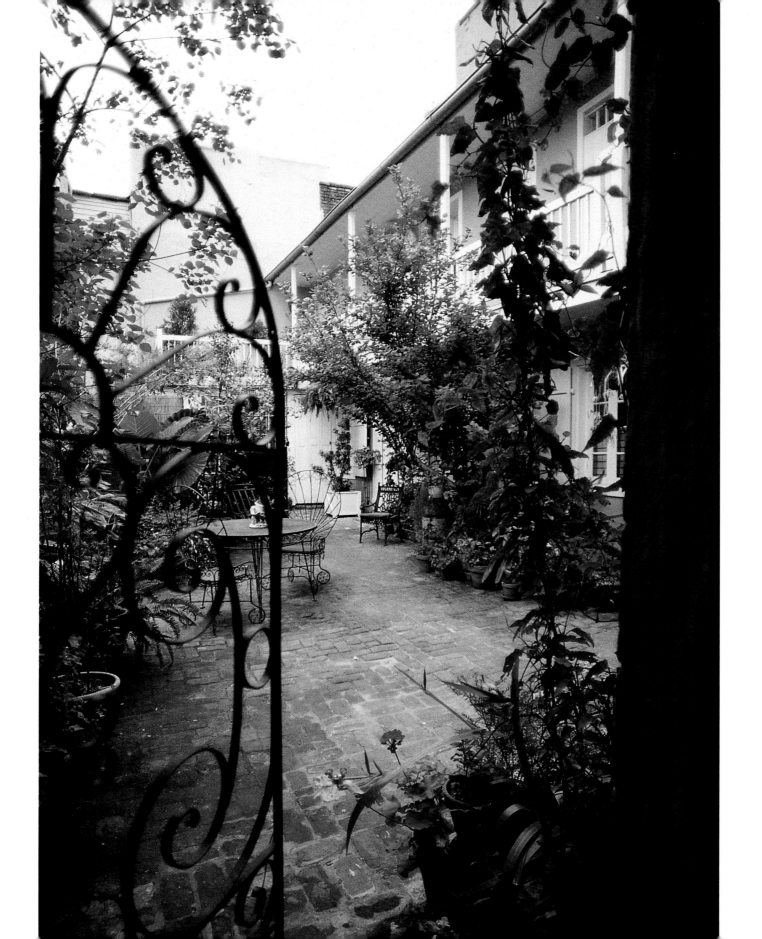

# Orleans

*U*nusual in color and marvelous in design is this secret garden located on Orleans Street. When the plan for the city of New Orleans was drawn up by Le Blond de la Tour, he was instructed to name important streets after the French royalty and their patron saints. The Rue d'Orleans was named after the Orleans faction of the Bourbon royal family, and the city was named after Philip II, Duc d'Orleans, regent of France, and brother of the recently deceased Louis XIV. In 1715, Louis XV was not quite ready to take the throne at his great-grandfather's death: he was only five years old. Until he reached the age of thirteen — his legal majority — his uncle Philip, Duc d'Orleans, acted as regent.

In a letter dated April 14, 1721, sent by Adrien de Pauger, assistant to de la Tour and the engineer actually on location laying out the city, de Pauger wrote for approval of some changes:

> [The land] being higher on the river bank, I have brought the town site and the locations marked for the houses of the principle inhabitants closer to it, so as to profit from the proximity of the landing place as well as to have more air from the breezes that come from it. I have likewise indicated the distribution of some of the lots of the plan . . . in order to proportion them to the faculties of the inhabitants and of such size that each and every one may have the houses on the street front and may still have some land in the rear to have a garden, which here is half of life. (Samuel Wilson, Jr., *The Vieux Carré New Orleans: Its Plan, Its Growth, Its Architecture* [New Orleans: Historic District Demonstration Study Report, Bureau of Governmental Research, 1968], 12)

*This secret garden on the Rue d'Orleans, or Orleans Street, is entered by a side corridor and a lacy wrought-iron gate. The unusual lavender color of the building gives a relaxed feel to the bricked courtyard. A first splash of floral color comes from this orange-yellow snapdragon.*

The streets in New Orleans were laid out to best answer the climatic realities of this southern location. So that the heat would not become too severe in the summer, the streets were measured at a width of only thirty-eight feet, in order that the buildings themselves would be shaded by one another. Orleans Street, however, was laid out at a width of forty-five feet as the central grand rue of the city.

*Nearby, a red impatiens shares a spot with a wandering Jew. Farther into the court, a comfortable corner serves as a dining and lounging area aside a trickling fountain. Variegated ginger, elephant ear, and crepe myrtle fill out the corner.*

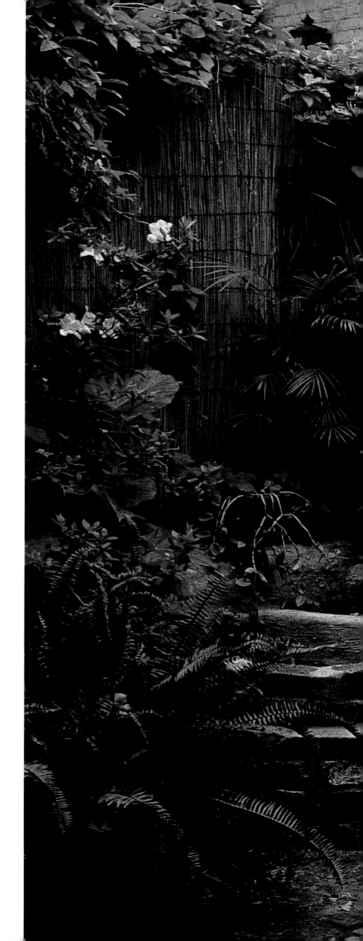

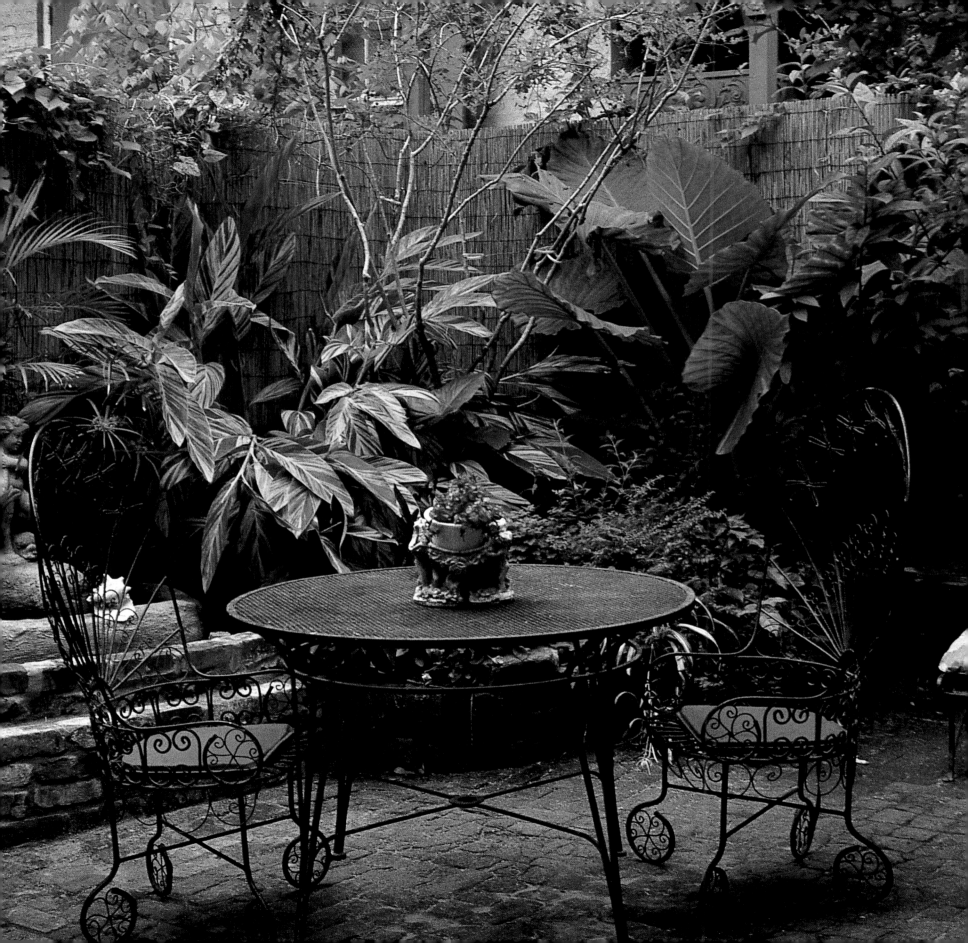

Lower, in the same corner, is a mixture of more variegated ginger, a rhoeo vine with pink flowers, Mexican heather with tiny purple flowers, white pansies, yellow marigolds, and purple violas.

To the side of the entrance to the patio is a grouping containing THUNBERGIA vine, impatiens, geraniums, begonias, dusty miller, and Johnny-jump-ups. A beautiful walking iris — NEOMAR-ICA NORTHIANA — reaches its beautiful white-and-purple flower out into the court.

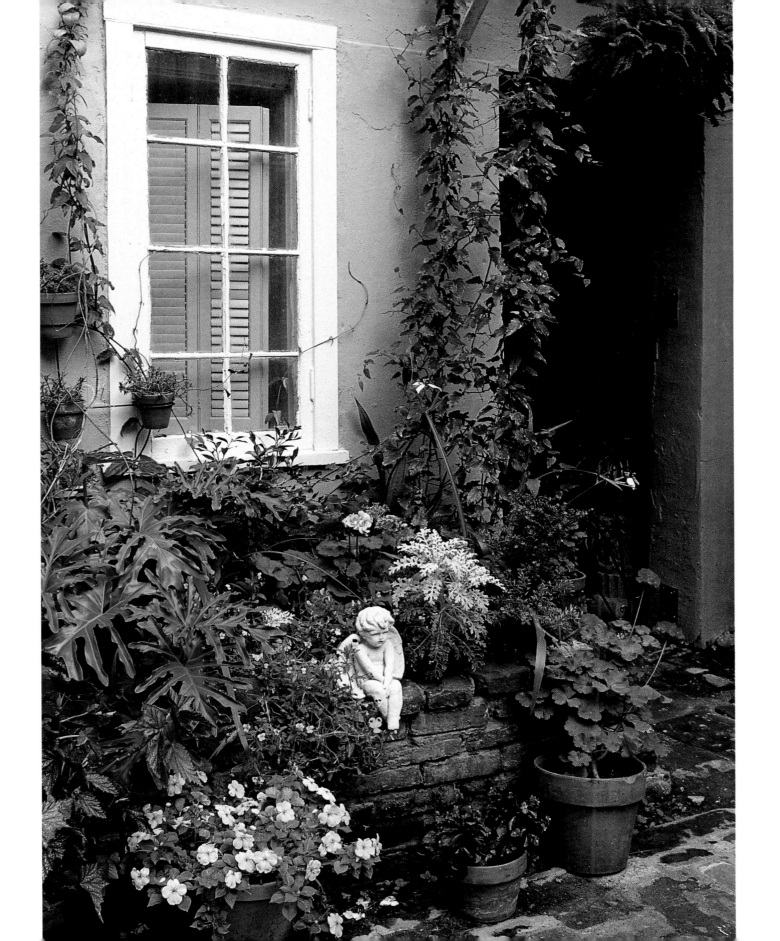

A small pink begonia sits aside a large strawberry pot with side planters, now home to sweet alyssum and English ivy. A nephthytis vine climbs the wall of the impressive exterior stair to the upper floor of the home and slave quarters. From the balcony of the slave quarters the taller trees are more visible. There is althaea to the left and a crepe myrtle to the right.

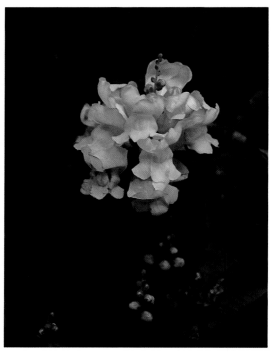

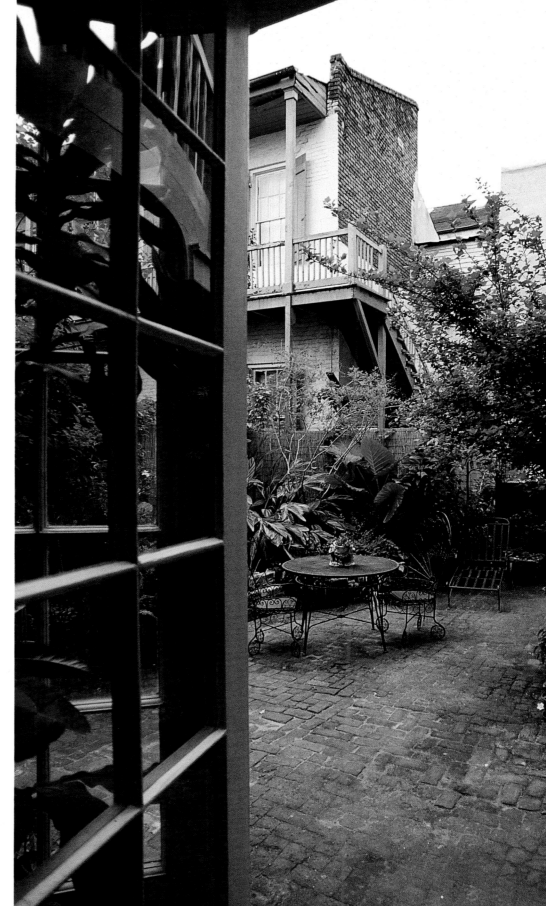

A freestanding iron gate partitions the court into two defined areas, while in the shadows a kalanchoe flower's fiery red color burns upward from the variety of green leaves below. Next to the red kalanchoe is a yellow snapdragon.

At the rear of the front house is a bay of windows that allows a full view of the court from the interior of the building. In this small room, it is possible to enjoy the courtyard at all times, no matter what the weather or temperature may be.

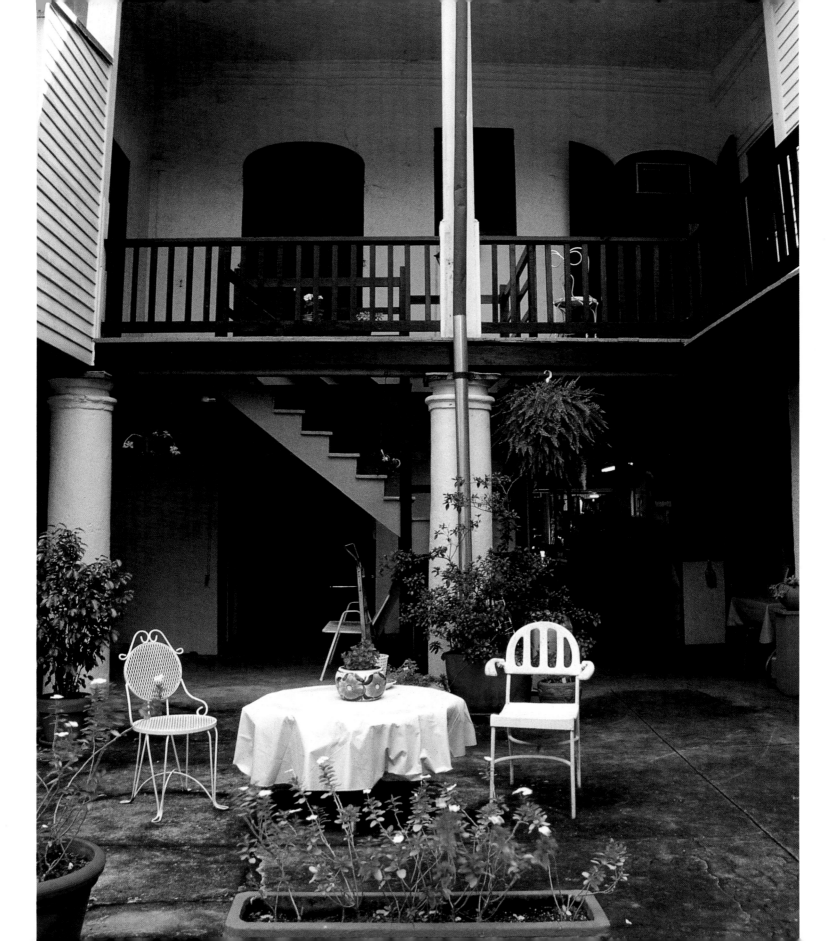

*This court is unusually spacious, and the simplicity of its plantings maintains that openness.*

*The balcony provides a full view of the court. It is easy to imagine La Petite Patti coming out from her rooms, through the magnificent Spanish door on the second story of the house, to the landing where her guests, gathered in the court below, would raise their glasses in a toast to her latest performance. She would greet them all from her perch, then descend into the court to greet guests individually.*

# Patti

This court, more open than most in the Vieux Carré, has a dramatic history. In 1777, it was acquired in a partnership by Antoine Cavelier, a descendant of Robert Cavelier, Sieur de la Salle, the man who claimed the lands of the Mississippi Valley, including Louisiana, for King Louis XIV of France. The current structure was built by Antoine around 1789. Buildings on the property before that time were destroyed by the first great fire in New Orleans, in 1788, one that nearly leveled the entire city. Miraculously, this edifice survived the second great fire, in 1794, and is one of the oldest buildings in the Vieux Carré.

A more romantic aspect of the courtyard's history is that the building was once occupied by the young coloratura soprano Adelina Patti, who was born in Madrid in 1843 as Adela Juana Maria Patti. La Petite Patti, as she was known in New Orleans, had sung concerts in New York from the age of seven, making her opera debut there in 1859 as Lucia in Gaetano Donizetti's *Lucia di Lammermoor*. She and her sister Amalia; Amalia's husband; and Adelina's director, Maurice Strakosch, arrived in New Orleans soon after to sing in the French Opera House here. Tradition has it that the opening performance of the theater had disappointed patrons of the opera thoroughly, and financial ruin seemed in sight for the opera house. However, La Petite Patti sang in *Lucia di Lammermoor* and thrilled the music lovers of New Orleans. Her continued successes in a repertoire of seven favored operas made her the toast of the town. Her rooms and court became one of the great social rendezvous of the time. Many gatherings were held in the court to honor her. Upon leaving New Orleans, Adelina Patti performed at Covent Garden in London, where she won the hearts of opera lovers, as she had in New Orleans.

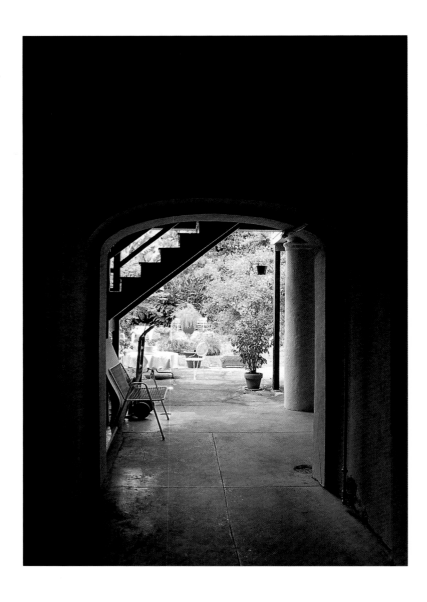

The entrance to the court from the street is through a portico of Spanish design. Its rounded arch and exterior stair to the upper floor, or ÉTAGE — as the New Orleans French called the second floor — are typical of buildings constructed during the Spanish domination of the city.

The herringbone-bricked court is enhanced by a welcoming show of yellow daylilies, above which stands a terra-cotta urn displaying a feathery green asparagus fern. To the right corner of the patio, behind the fern and lilies, stands a large ERY-THRINA, also called a coral, or lobster claw, tree.

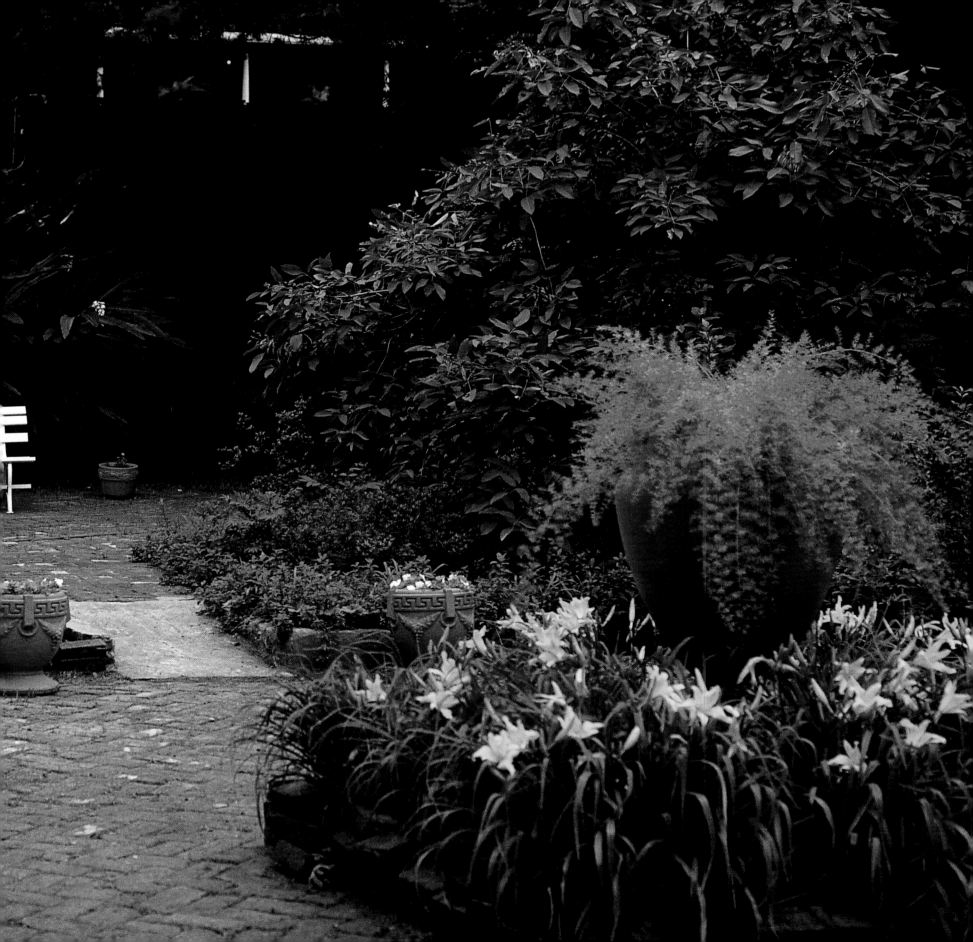

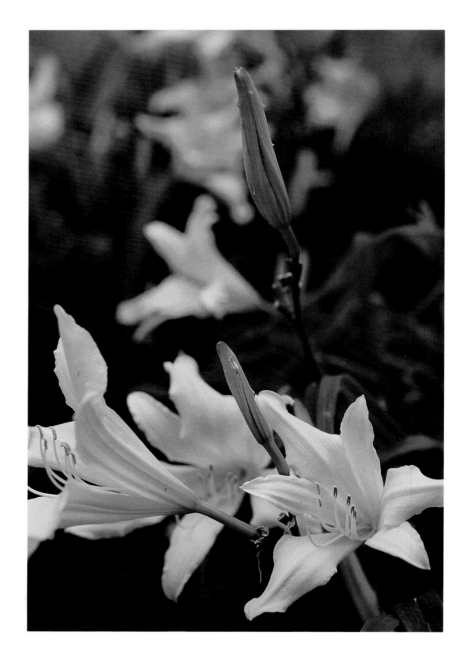

*Its pink, waxy, birdlike buds hang like a display of tiny Chinese lanterns.*

*The center of the rear of the court is neatly punctuated with a white wood and wrought-iron bench, behind which rises a magnificent* ALPINIA SPECIOSA, *or shell ginger shrub, in full bloom.*

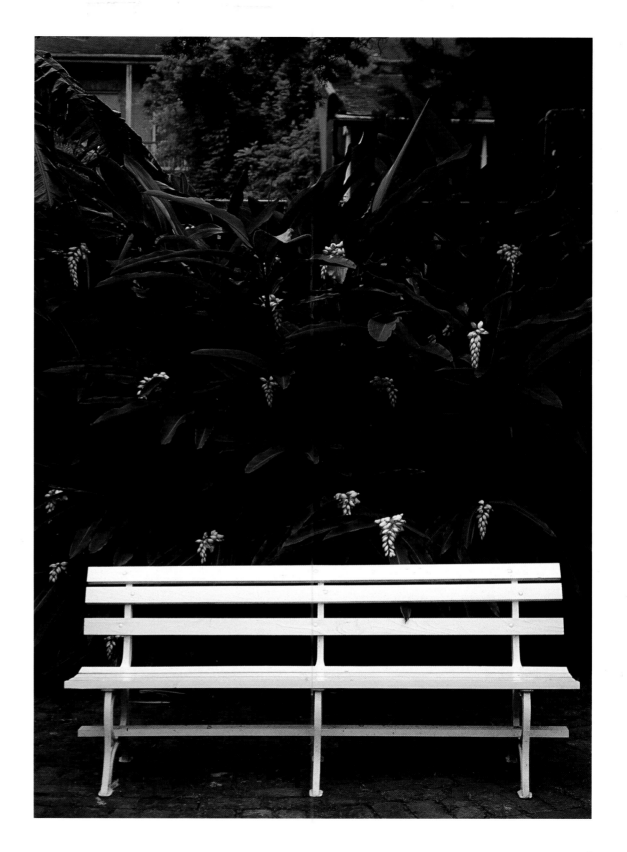

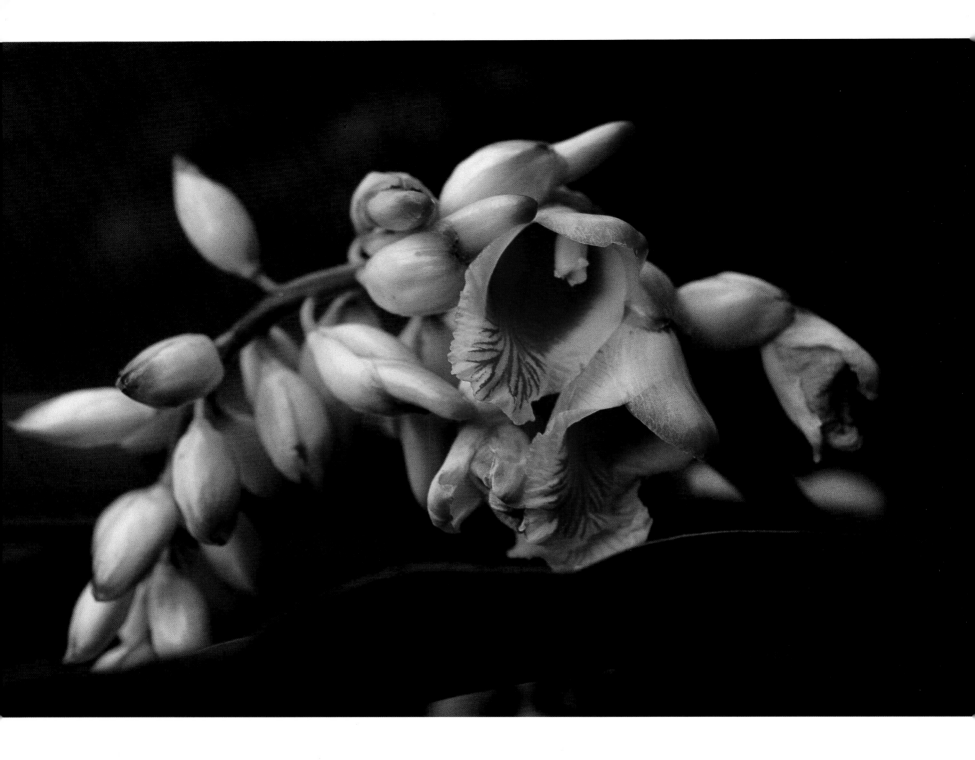

The unusual flowers dangle like necklaces of seashells or clusters of pale grapes, with the larger buds of each cluster unfolding to reveal the canary and scarlet inner blossoms.

A requisite patch of giant bananas, leaves tattered from the river's breezes, stands to shade the court.

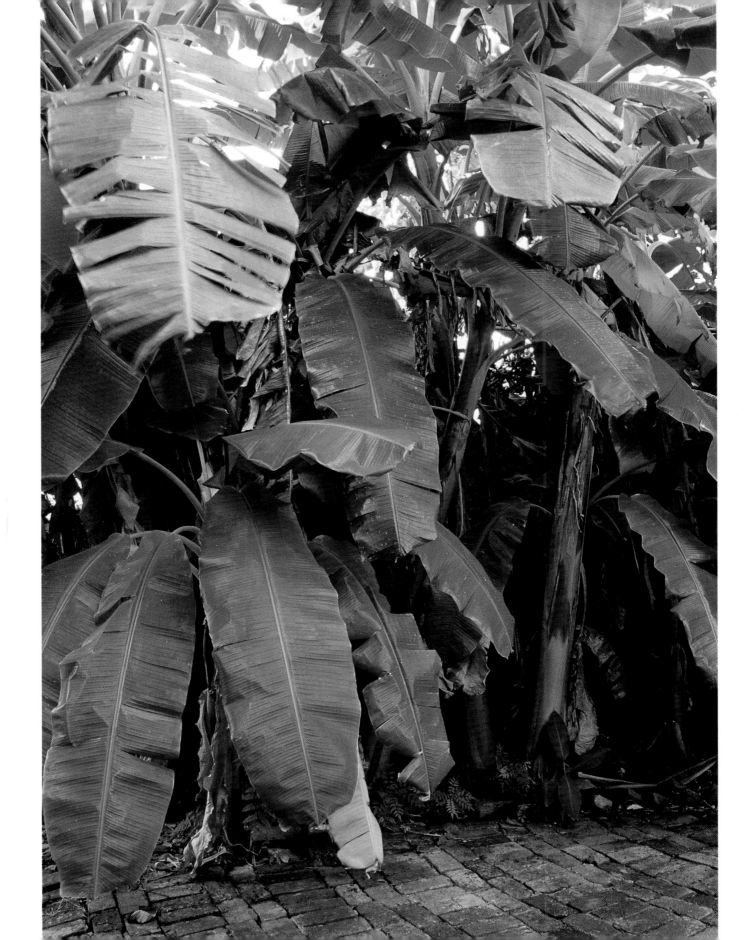

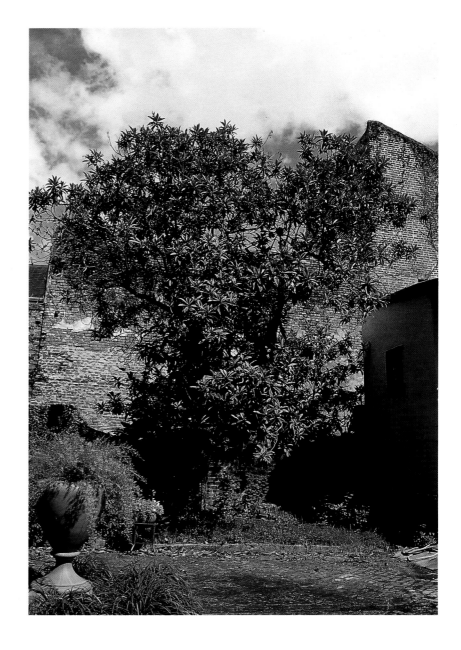

In another corner a huge-leafed ALOCASIA, or giant elephant ear, enjoys the subtropical clime. A very tall loquat tree rises high above the second-floor building, reaching almost to the top of the three-story structure behind. A patinated wall, rich in mauve and pink, supports an English ivy and the smaller-leafed claw vine.

The plantings remain simple, leaving the space refreshingly open for the French Quarter. Adelina Patti's fame will live on in this Royal Street court.

144

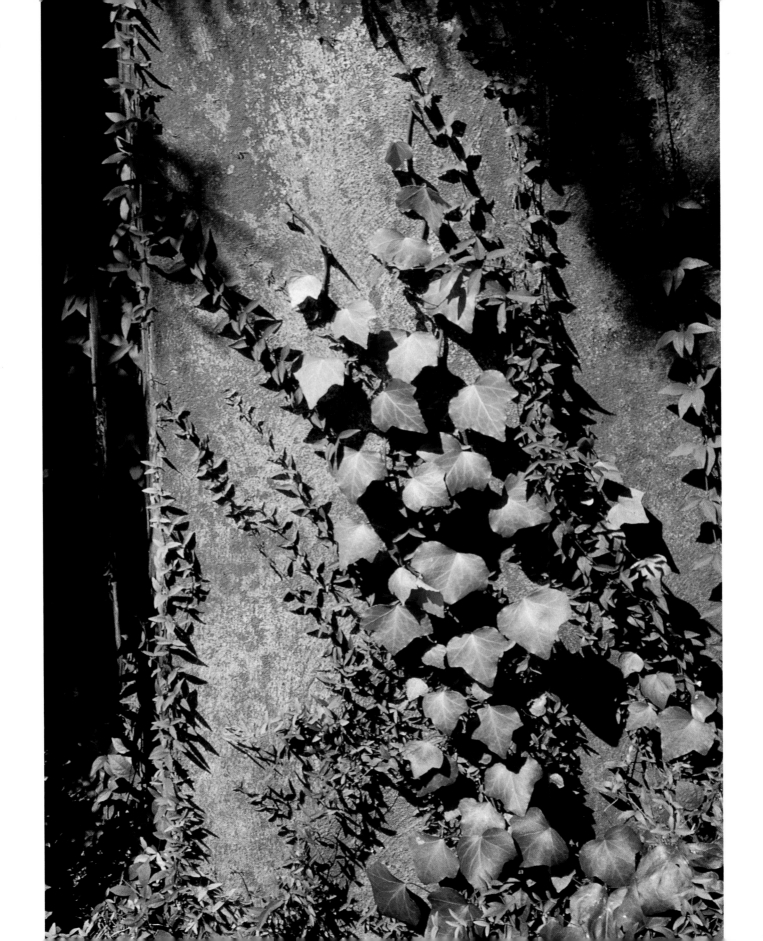

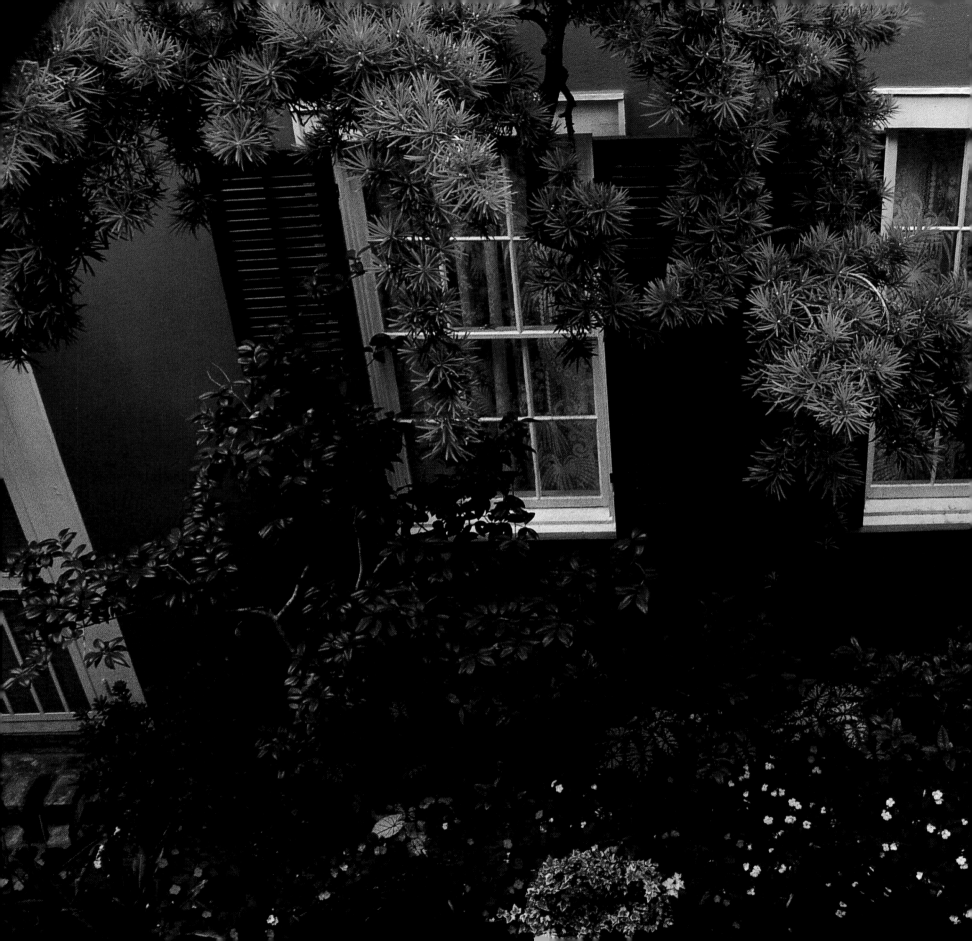

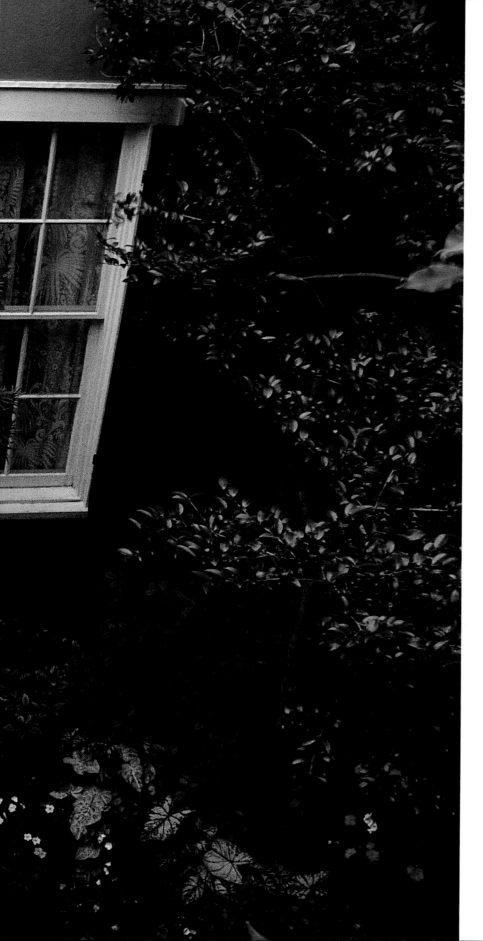

# Reconstruction

The minor buildings existing on this property were razed in 1865 to accommodate the construction of this home. The plans were laid out clearly in a contract written between the owner of the lot and a contractor named Frank Guitare, who accepted the job for $4,500.00 and signed the contract with his *x* mark. The adjoining homes were occupied on one side by a free Negress, and on the other by a free woman of color. This historical record is a reminder of the quadroon and octoroon society that once enjoyed a mysterious and elegant existence in New Orleans. However, the struggle to reach this position was an arduous one.

In 1724, the *Code Noir,* or black code, was promulgated in New Orleans and the rest of Louisiana. In this civil code, designed to regulate the slaves and their masters' treatment of them, it was stipulated that marriage between whites and blacks was strictly prohibited. The obvious evidence of miscegenation — mulatto children — was appearing in New Orleans as well as on the plantations. However, children resulting from the marriage of blacks, or *gens de couleur* — people of color — inherited the status of the mother.

The master of a slave had the right to give that slave his or her freedom. If the mother was a slave, the children were also slaves, yet if the mother was a free Negress or a free woman of color, the children would also be free. These children became the first free society of color in New Orleans.

They grew up not only excluded from the rights of the whites but also removed from the society of the black slaves. As these children became adults and had their own children, grandchildren, and great-grandchildren, the progeny became more and more fair in complexion, until they were often indistinguishable from whites, other than in their reputed possession of exotic beauty. These were the

quadroons (one-fourth black) and octoroons (one-eighth black) who became so famous in New Orleans demimonde society.

This garden is located in an area of New Orleans that at one time was primarily inhabited by free women of color, who were often the mistresses of Creole gentlemen who supported them and were forbidden by law to marry them.

The contract that Mr. Frank Guitare, the contractor, signed with his *x* on July 12, 1865, describes the proposed building as follows:

> To be finished in a No. 1 style, it being distinctly under-
> stood that the lower portion shall be finished complete,
> the ceiling to be corniced and a large decorative plaster as
> centerpiece in the ceiling. A large hall on one side with
> granite steps, box style for entrance, two windows
> below, three openings above on the front, four openings
> on the side and four openings in the rear of the house
> with iron balcony and top verandah, in addition to this
> the party of the second part will place the yard, kitchen
> and outhouses in complete order, shall make a large gate-
> way and gate on one side of dwelling, and fence of sepa-
> ration between the adjoining lot of that side. And the said
> party of the first part covenant and agrees to pay unto the
> said party of the second part for the sum of Four Thou-
> sand Five Hundred Dollars, lawful money of the United
> States.

The value of this property today approaches several hundred thousand dollars.

The Civil War had ended on April 9 of the same year, with General Lee of the Confederacy surrendering to General Grant of the Union army at Appomattox. The construction of this building was undoubtedly precipitated by that event and could be considered part of what good may have come from the dismal period of Reconstruction.

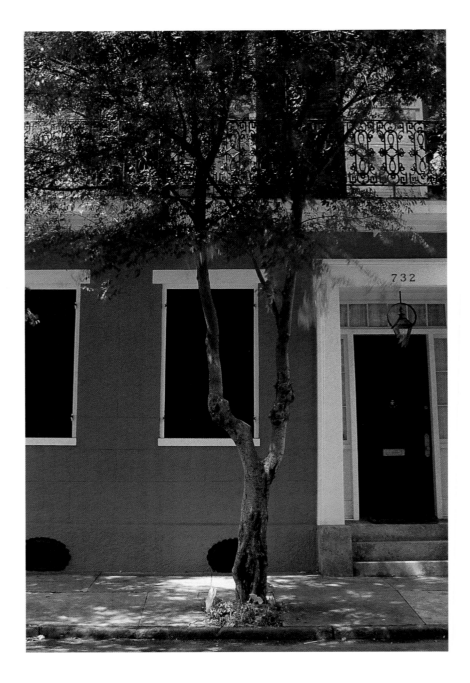

A front view of the property shows that it is still maintained as described in the building contract, now shaded by an elm tree. At the rear of the house, plantings in this small courtyard begin with potted pink impatiens and birds of paradise. The planter bed along the back wall of the front building contains white and pink impatiens, azaleas, Japanese yew, caladiums, and a CAMELLIA JAPONICA.

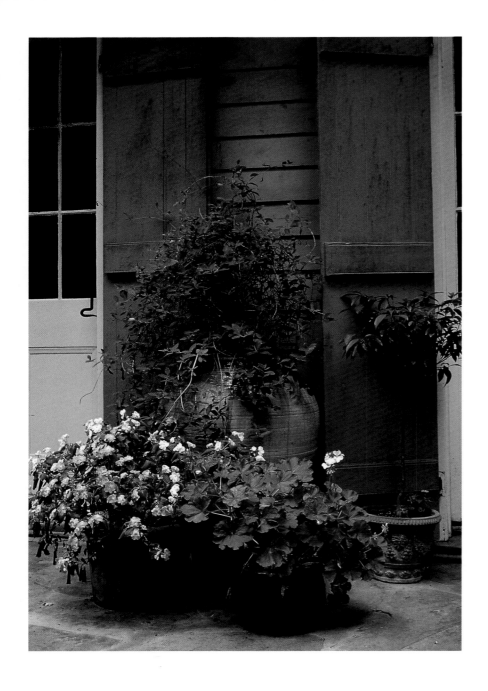

A grouping arranged against the muted pink and blue of the back slave quarter includes pink and white impatiens, geraniums, and an olla of ARDI-SIA JAPONICA, or honeysuckle.

Across the courtyard, the sun shines on a MAGNO-LIA GRANDIFLORA, or Southern magnolia, against a high brick wall of the bordering home.

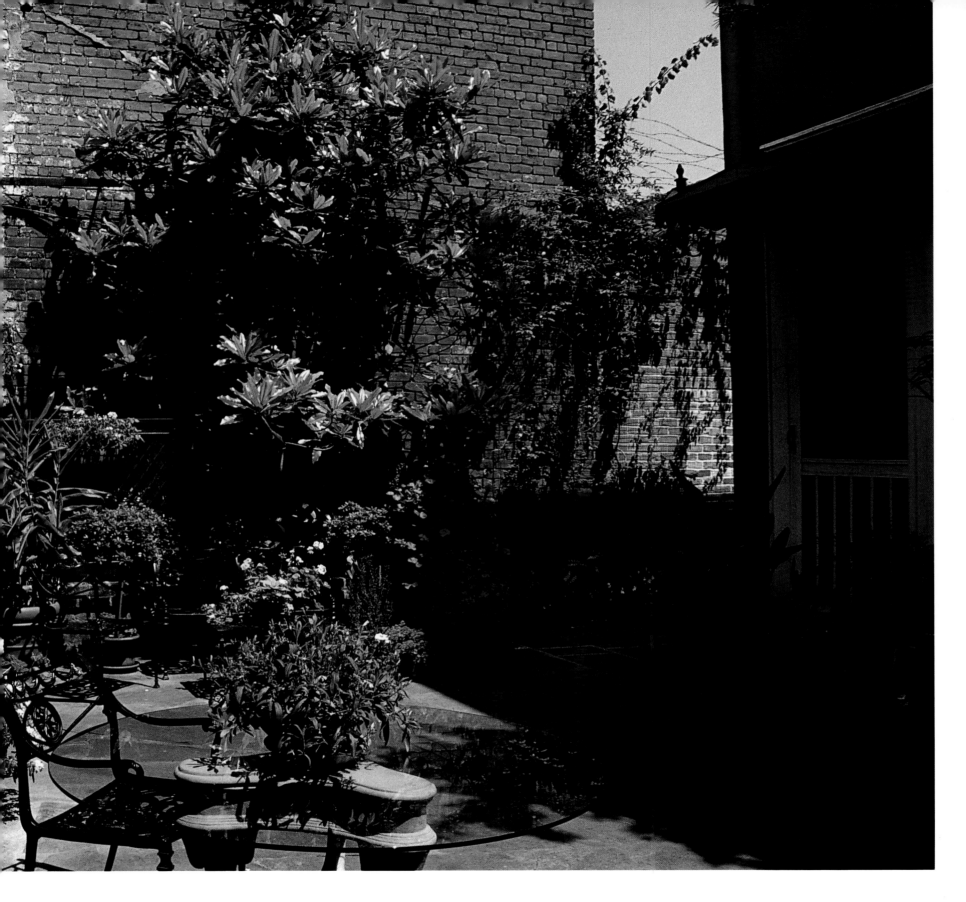

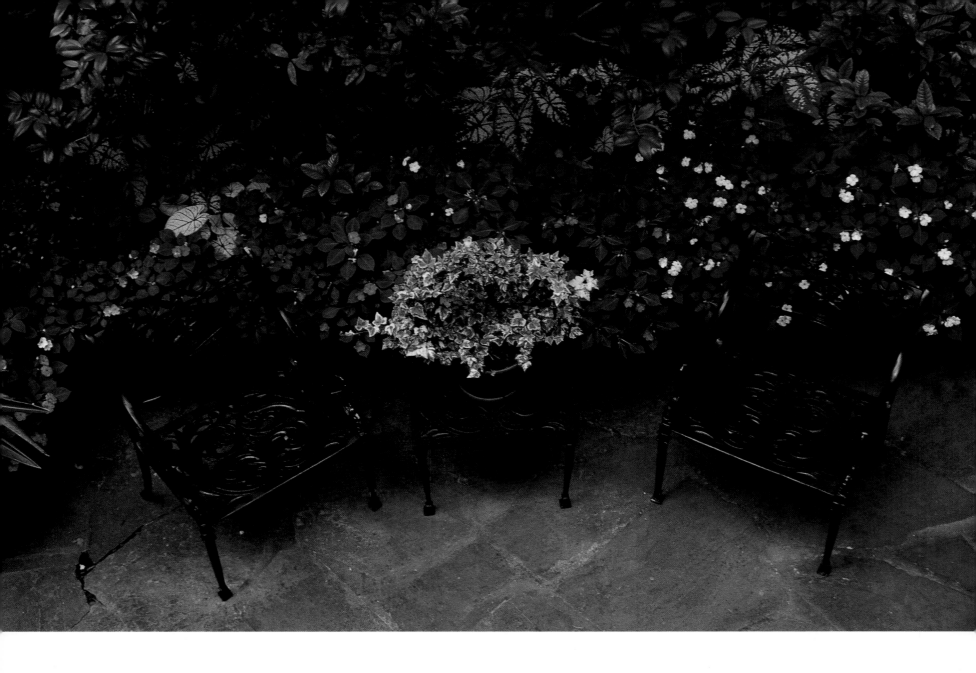

A handsome pair of black cast-iron chairs and a side table, holding a variegated English ivy, provide a shaded place to sit. The half-moon fountain at the side wall is shaded by wall baskets of pink and white impatiens, ferns, and caladiums. A brace of bronze pigeons tarry in the cool timelessness of this place. A stone child playfully pours water from a jar to fill an eternal well, while the dulcet sound of the tinkling water laughs gently in approval.

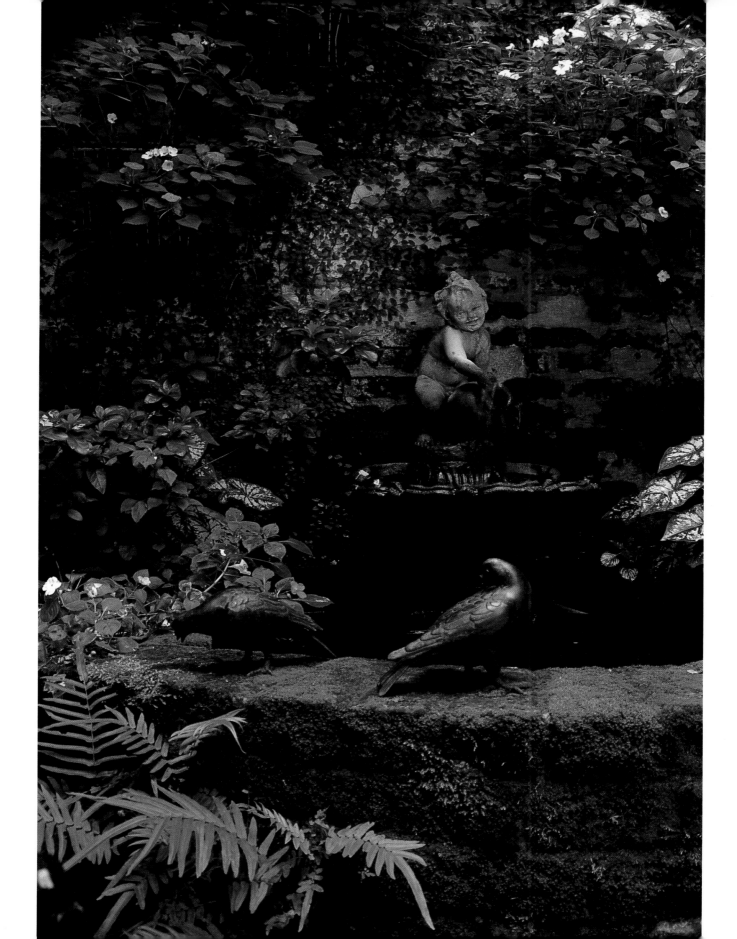

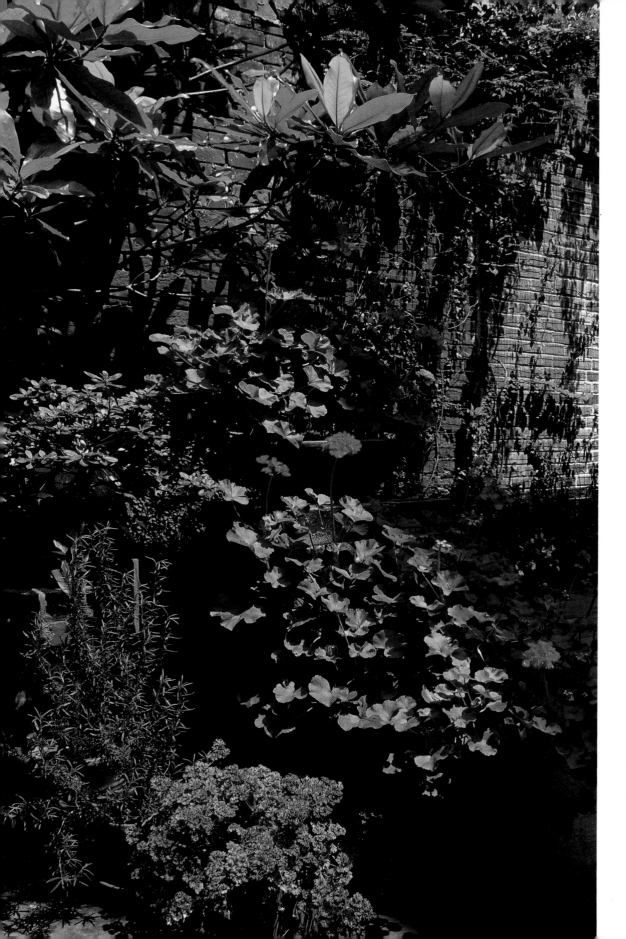

Beneath the magnolia is an arrangement of red geraniums, rosemary, and parsley. The upper balcony railing of the slave quarter provides support for a creeping wisteria vine.

An unusually small door, no more than eight inches square, provides a convenient look-through where two neighbors can gossip about the day's happenings.

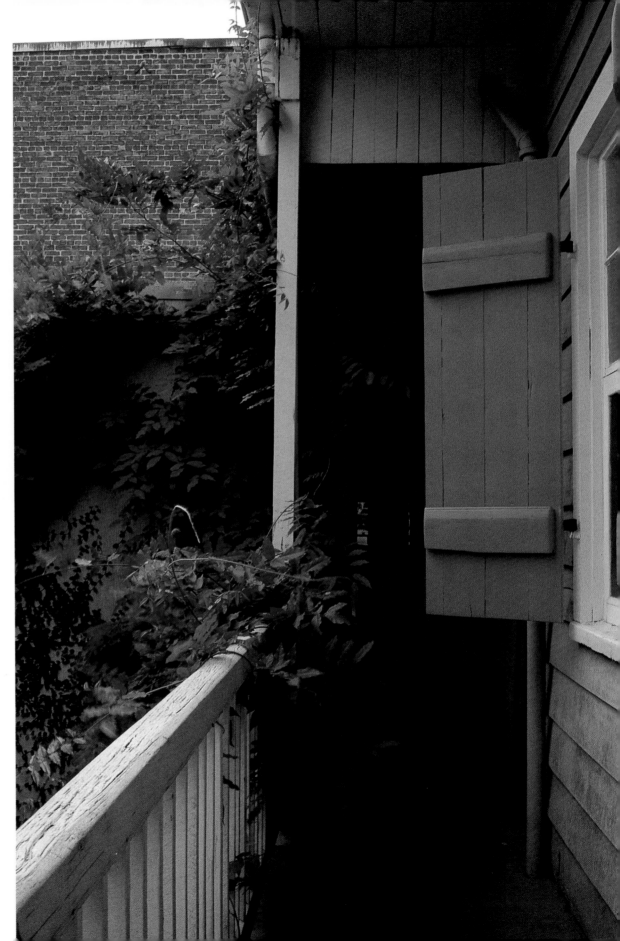

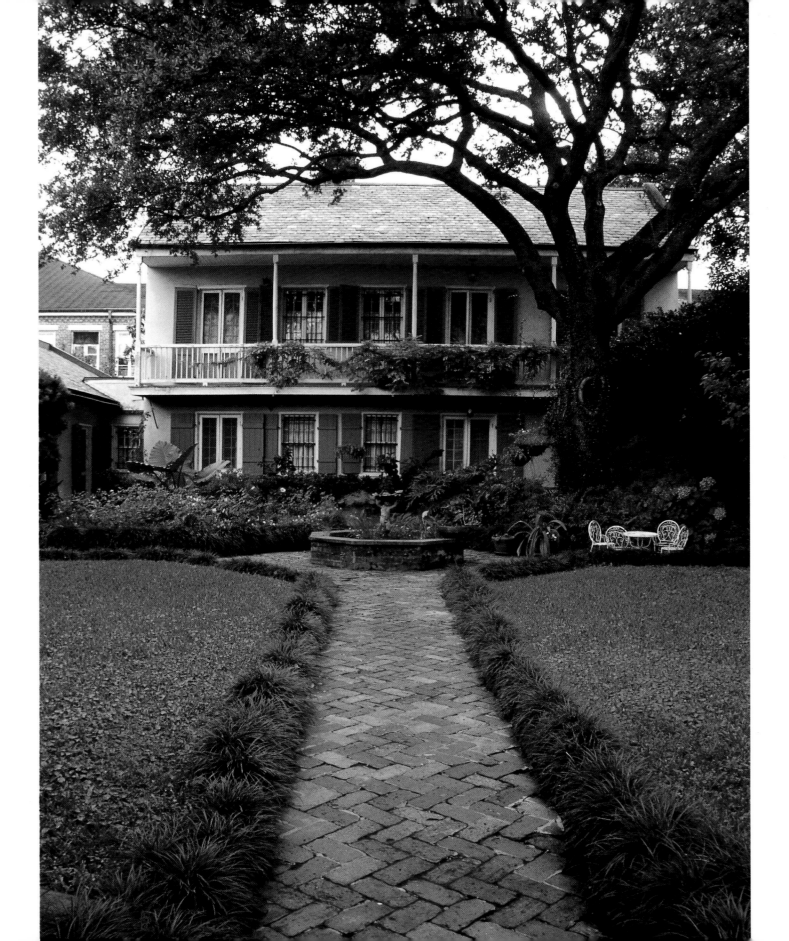

# *Sauvient*

*The complex was originally three lots that were brought together to create the size of this area. This lot was one of the last in the Vieux Carré to be used as an orchard. The garden is in front of the house and walled in from the street side. From the street the privacy of the garden is amplified by the thick pyracantha and wisteria climbing along its crest. The pink flowers of a MANDEVILLA vine peek out over the gate, flanked by a brace of flowering Bradford pear trees. Once inside the gate, the deep attitude of the garden offers a glamorous and dramatic entrance to the estate.*

*Towering oak trees provide shade to the garden generally, yet allow enough sunlight for the growing of many colorful flowers.*

This romantic secret garden illustrates much about New Orleans history, and the buildings that surround it are a stunning example of the West Indies influence on the city's architecture.

Located on the original map of New Orleans of 1722 drawn by the engineer de la Tour, ownership of the property changed several times before it was held by Joseph Sauvient, who built the major buildings circa 1804. Sauvient had come from Santo Domingo as a refugee from the riots there in 1791. The slave revolt drove thousands of whites and free persons of color from their home island to Louisiana.

The original Sauvient buildings consisted of an elegant stone and brick house on the banquette, with stables and a two-story West Indian–style slave quarter in the rear. The property was inherited by Madame Sauvient's daughter Camille, who married Major Theodore Lewis. Major Lewis and Camille had two sons, John B. Lewis and Dr. George W. Lewis. When George was about to wed, his fiancée's parents sent her to Paris, separating the two lovers. They had come upon information leading them to believe that George's grandmother had been a free woman of color. It was felt that this was a socially unacceptable situation for their daughter. Heartbroken, George retreated into his medical practice, never to marry or have children. His death in 1919 followed an unhappy life that was later ruled by despondency, depression, and eventually addiction.

Having no children, he left his property solely to his niece Louise, a daughter of his brother, John. Family members contested Louise's right to inherit the property singularly. All became embroiled in bitter legal disputes for the remainder of their lives.

The elegant front house of the property burned in 1816, leaving the stables, slave quarters, and the unusual large front garden area, which was never rebuilt upon.

A significant legend is connected with the existing slave quarter. Joseph Sauvient was Jean Laffite's lawyer. Jean Laffite was the famous pirate who assisted Andrew Jackson in the defense of New Orleans and contributed heroically to his victory at the Battle of New Orleans in 1814. It is said that Sauvient secreted a portion of Laffite's pirate treasure away within the construction of the building, and it is yet undiscovered. At present, however, the owners are content with creating their own treasure in the beauty of this secret garden.

This is surely one of the most lovely gardens in the Vieux Carré, with its myriad of flowering plantings. There are undoubtedly more flowers in this garden than any other in the French Quarter. The owners take great pride and spend several hours each day caring for this green space.

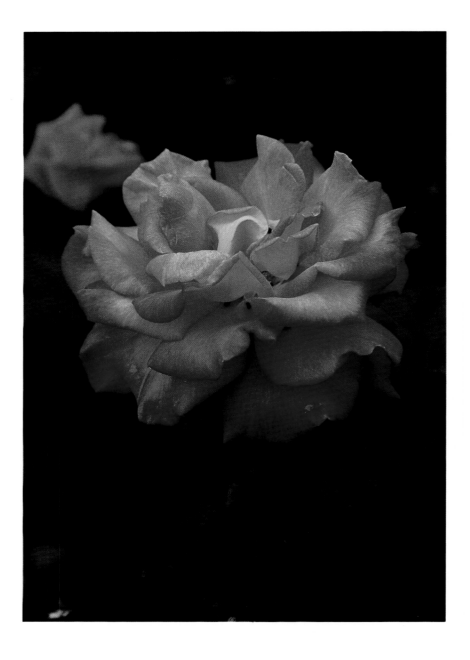

*Entering the garden through the brick wall on the street affords a magnificent view of its splendor. From the street wall to the house, the yard is divided into quadrants, partitioned by a cross of walks and a central fountain. The two forward sections are long and bordered with monkey grass. The center of the garden is designated by a quiet fountain, home to goldfish and water plants including a dwarf* CYPERUS, *or umbrella plant, on the left.*

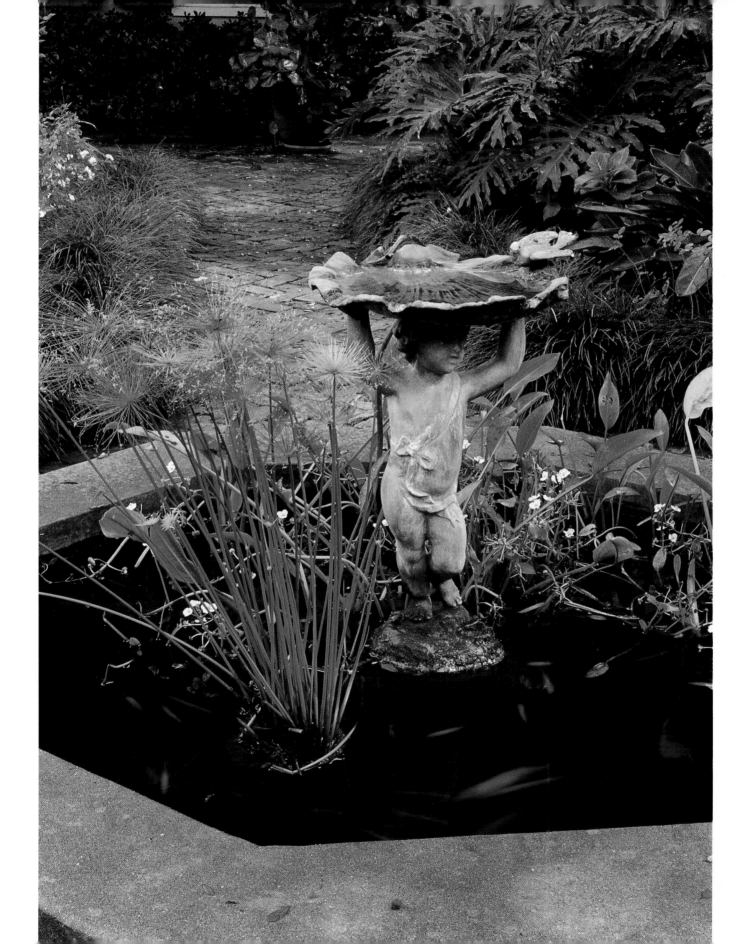

The most magnificent square of the garden provides a bed for roses exclusively, and a plentiful variety. They are carefully tended and produce unusual bursts of color. A hungry black caterpillar enjoys a lunch of orange rose petals.

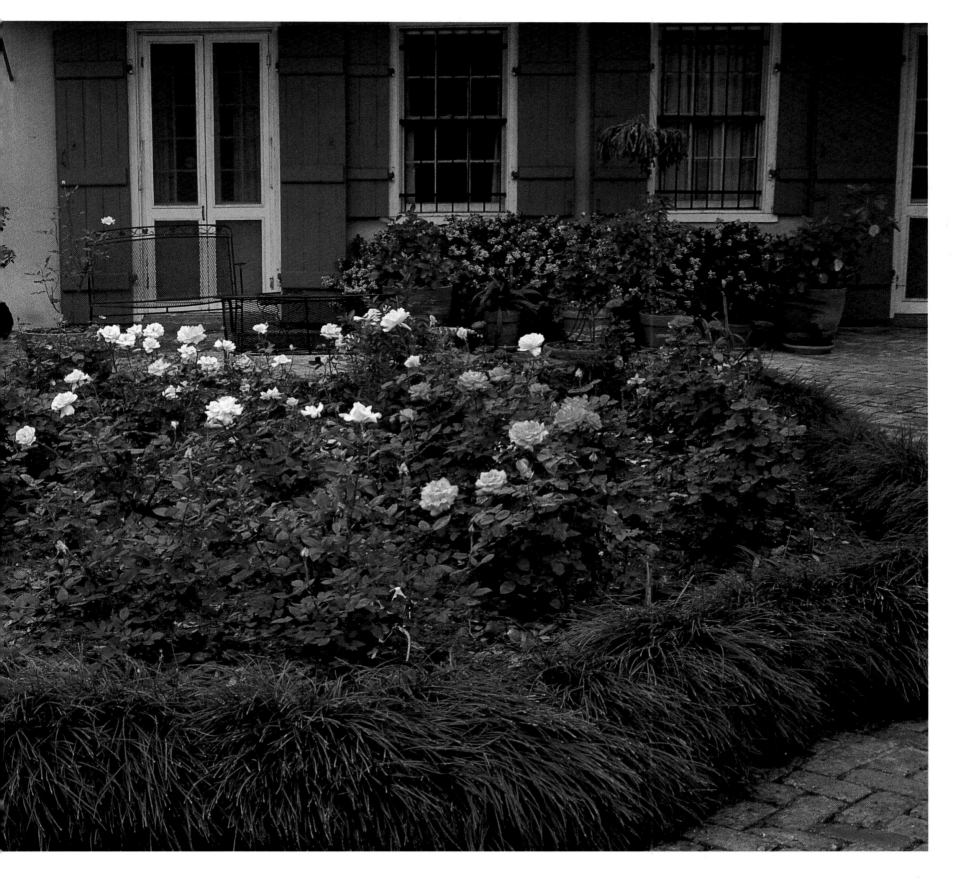

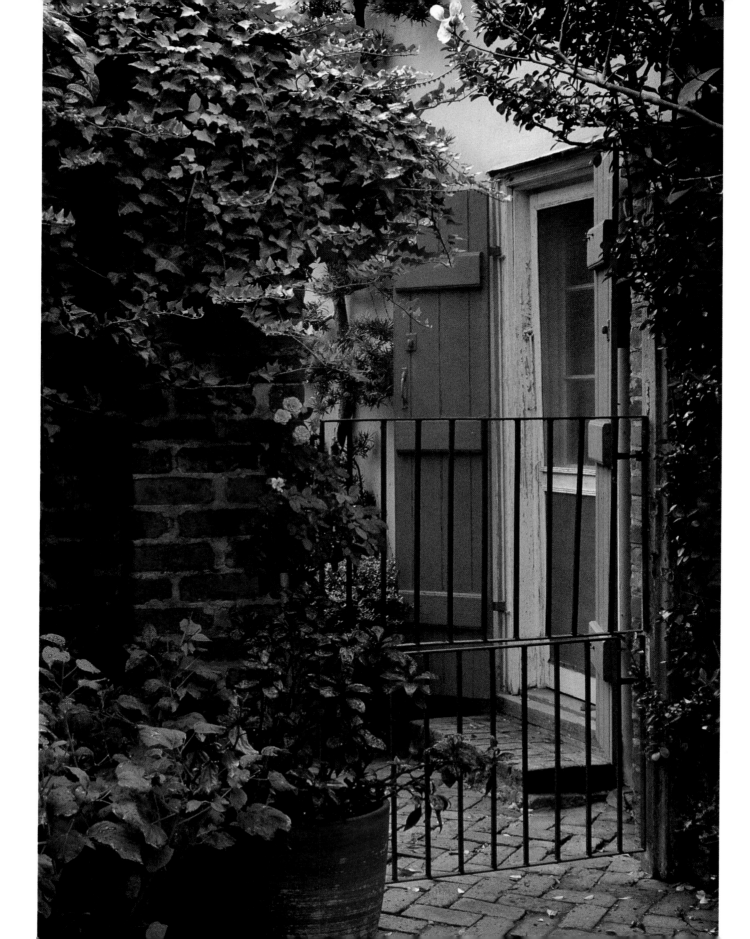

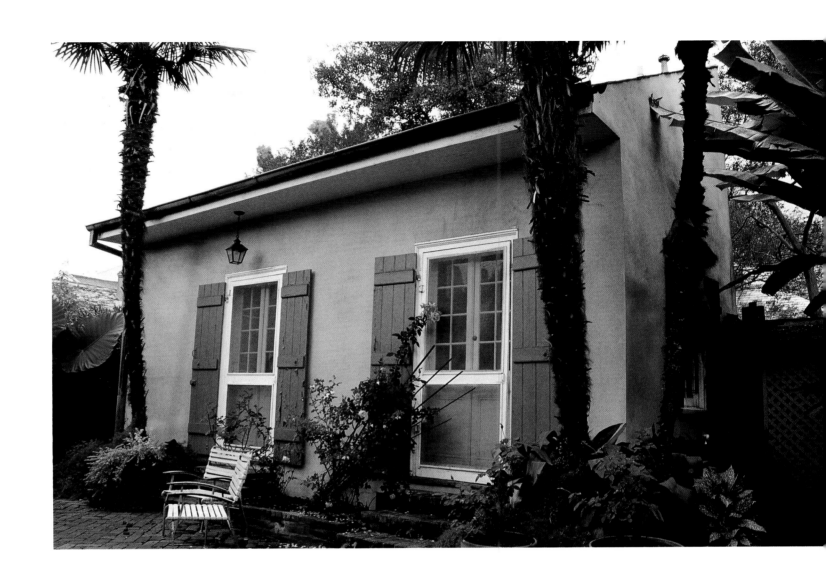

The back walk passes through a brick entryway draped in English ivy. The walk leads to other areas of the complex where a guest cottage, flanked by towering palms, stands in its own private court.

*A show of phlox — red, white, and purple — brightens a shaded corner. The butterfly wings of a pink cyclamen appear to flutter up through the phlox. Batten shutters frame the espaliered Japanese yew, which climbs the wall from a neat growth of rounded boxwood and white and purple petunias.*

Through a wide arch, an open stair inside the building leads up to the second-floor balcony of the main house. The balcony view of the garden is lovely. Looking over the pale green of a wisteria vine into this garden, shaded by the long branches of a great oak, this is easily a place to sit in a rocking chair and pass many an hour in quiet grace.

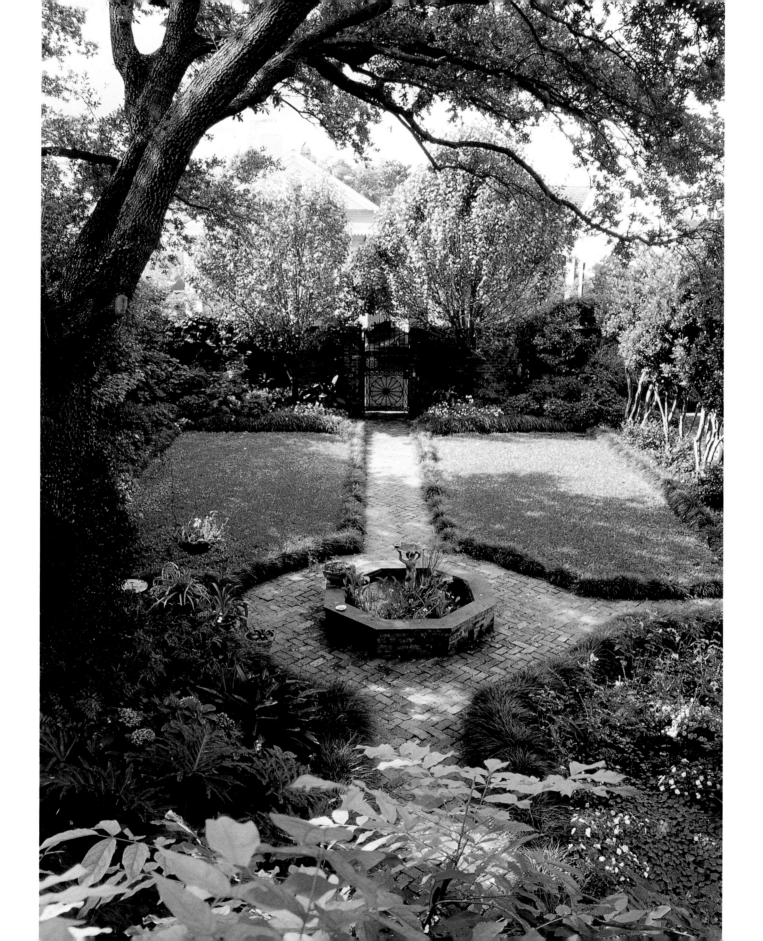

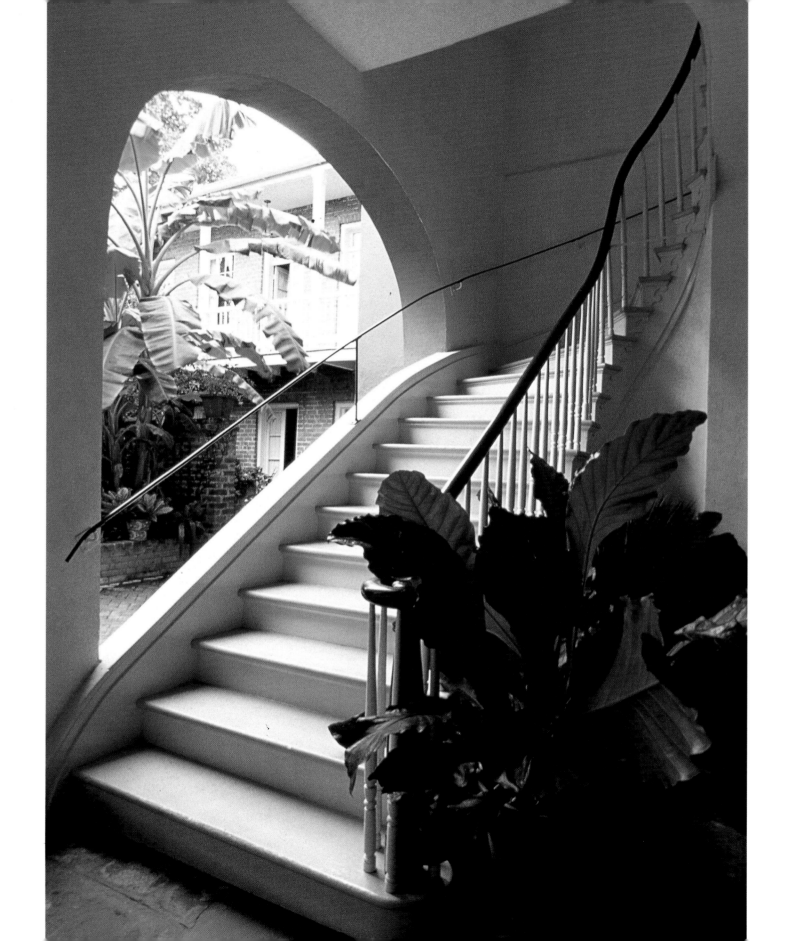

# Soniat

*The Soniat House is now a singularly marvelous small hotel. The walkway through the carriage entrance comes to the high arched openings of the courtyard and to a massive exterior stair that leads up to second-floor guest rooms. A giant anthurium adds a patch of green to the interior of the hallway.*

Passersby may admire this handsome building on Rue Chartres. They may remark on its brass and iron trims or the lace curtains at its windows. Yet until the doorbell is sounded and the door is opened by a gentleman wearing a crisp white jacket and small black bow tie, they will not glimpse the lovely courtyard garden that lies beyond the solid carriageway door.

This once-private house and secret garden were built by Joseph Soniat. His father, Guy Soniat du Fossat, was a Frenchman of some means who came to New Orleans in the late 1700s and developed Tchoupitoulas Plantation, thirteen miles upriver from the city. Son Joseph inherited Tchoupitoulas and lived there with his wife and thirteen children.

The journey from country to city was a tiresome one and kept the Soniats on the muddy river road for the better part of an entire day. After arriving in town and attending the theater, the opera, or a soiree given by a friend or relative, the family preferred to remain overnight in the city. They required accommodations of considerable size, and even relatives were hesitant to offer hospitality to such a brood. So Joseph followed the custom of many wealthy planters in the first half of the nineteenth century by providing a city residence, or town house, for his family and himself. It was completed in 1830.

After Joseph's death during the Civil War, the property passed through many hands, suffering degrees of deterioration. In the twentieth century, Madame Louis Felton came into possession of the Soniat residence and converted it into a guesthouse. Her rooms were simple and honest, and when she sold the property, the old house was fortunate to have been discovered by its present owners.

The courtyard's function changed over the years. In earlier times, the Soniats' horses were harnessed here, then led down the street for stabling while the family was in town. A small carriage remained with a brace of horses at the ready for evening engagements. Parts of the inner courtyard were partitioned off as necessary for daily laundering, cooking, and cleaning. Chickens scratched the soil and pecked at herbs planted in a kitchen garden that was an inevitable part of the era.

Today, muddied carriages no longer rumble through the massive doors, and the carriageway has become a subdued, welcoming entry that sets a mood of peaceful quiet. The expansive courtyard embodies the style, ambience, and *tout ensemble* of gardens that were created when the Vieux Carré was young: gardens that focused on the romantic, sensuous nature of Creoles, the sons, daughters, and latter-day descendants of colonial Louisiana's French and Spanish settlers.

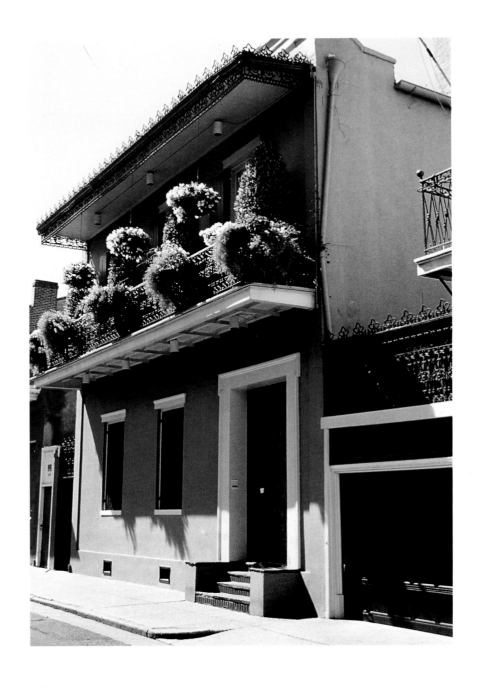

*The bricked court, viewed from the far end of the space, provides a sitting area where guests may take their* PETIT DÉJEUNER *in the mornings, tea in the afternoon, or just sit quietly during their stay in the Vieux Carré.*

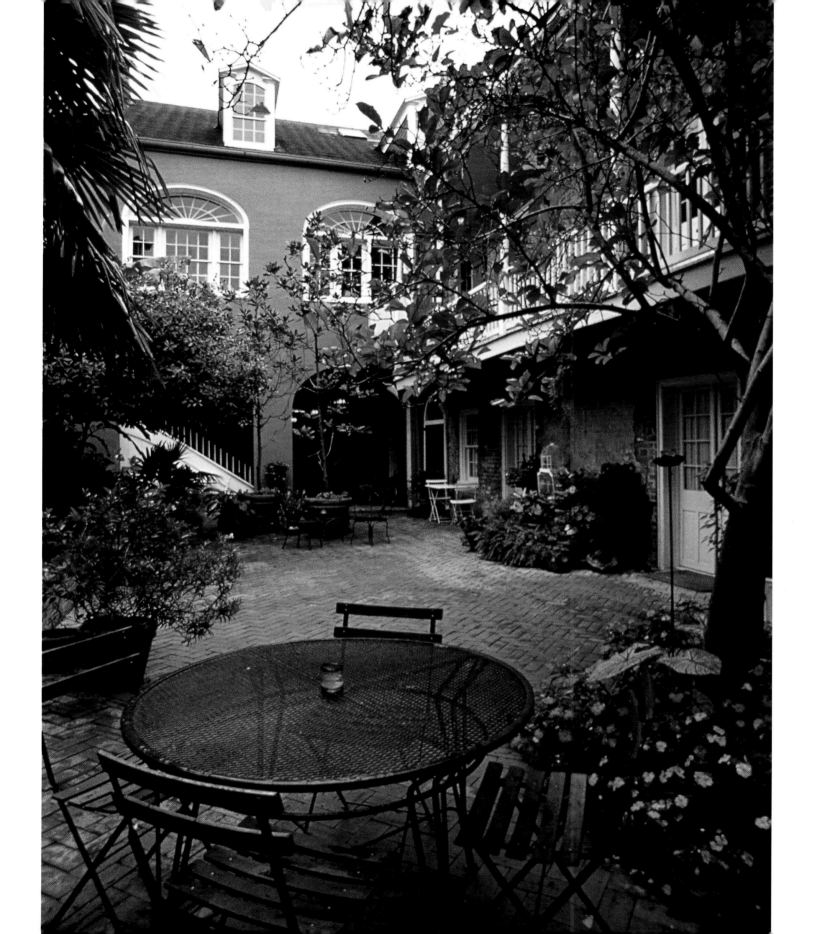

This 1860s Belgian stove of nickel-plated iron is tiled in yellow and blue patterns. The stove is used as a planter for prolific Swedish ivy and a base for the potted COLUMNEA, or goldfish plant, which drapes its fascinating cascade of brilliant slender blooms over the ivy, to spill down the stove's front and sides. A side fountain and small pond add the necessary sounds of trickling water to the court.

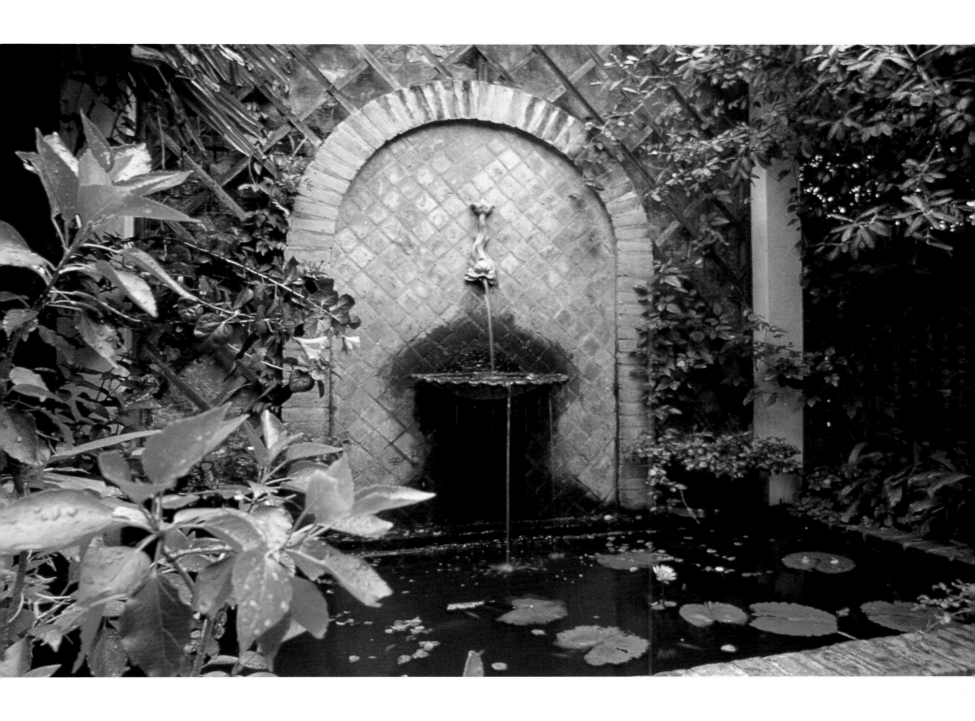

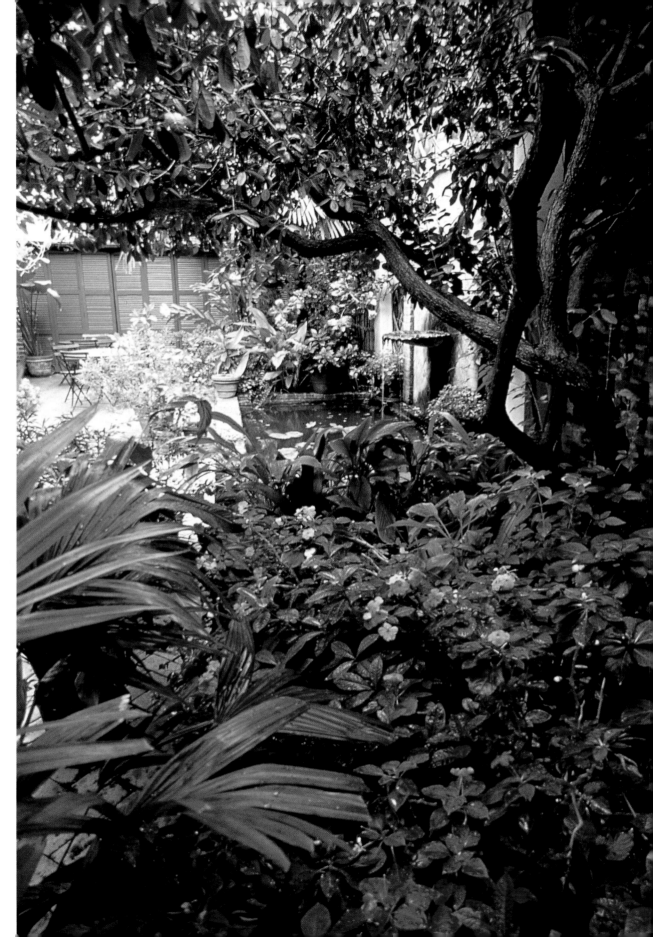

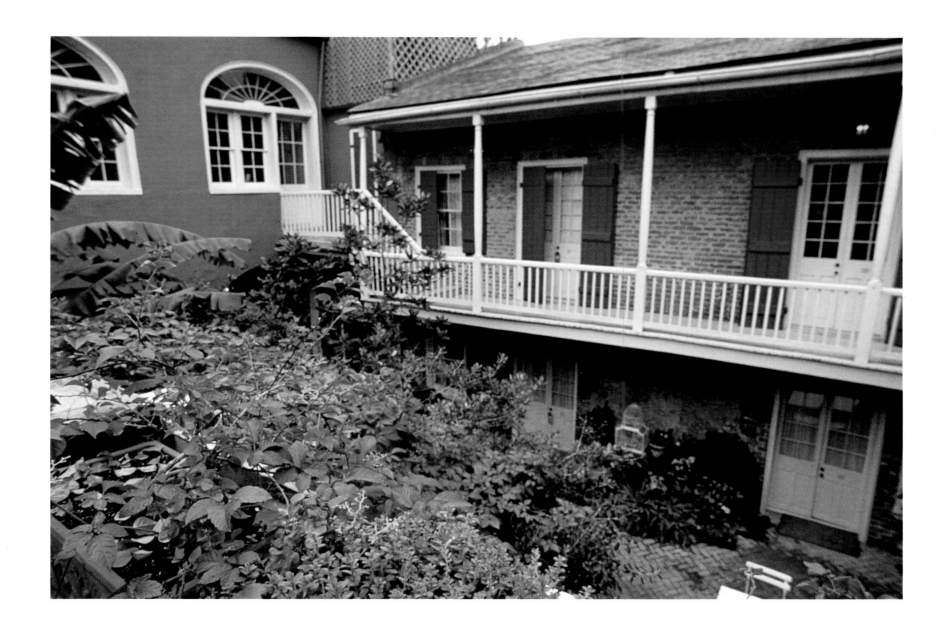

Next to the pond is a dense growth of palmetto, pink impatiens, and the oldest tree in the courtyard, a sweet olive tree — OSMANTHUS FRAGRANS. Nearby, a butterfly ginger flower gives off its sweet gardenia-like fragrance.

From the upper balcony is a view into the court over a bower of magenta bougainvillea . . .

*while in a corner below, a younger bougainvillea
stretches its branches out of an old Spanish olive
oil jar. A parting view through another arch gives
a panorama of the entire courtyard.*

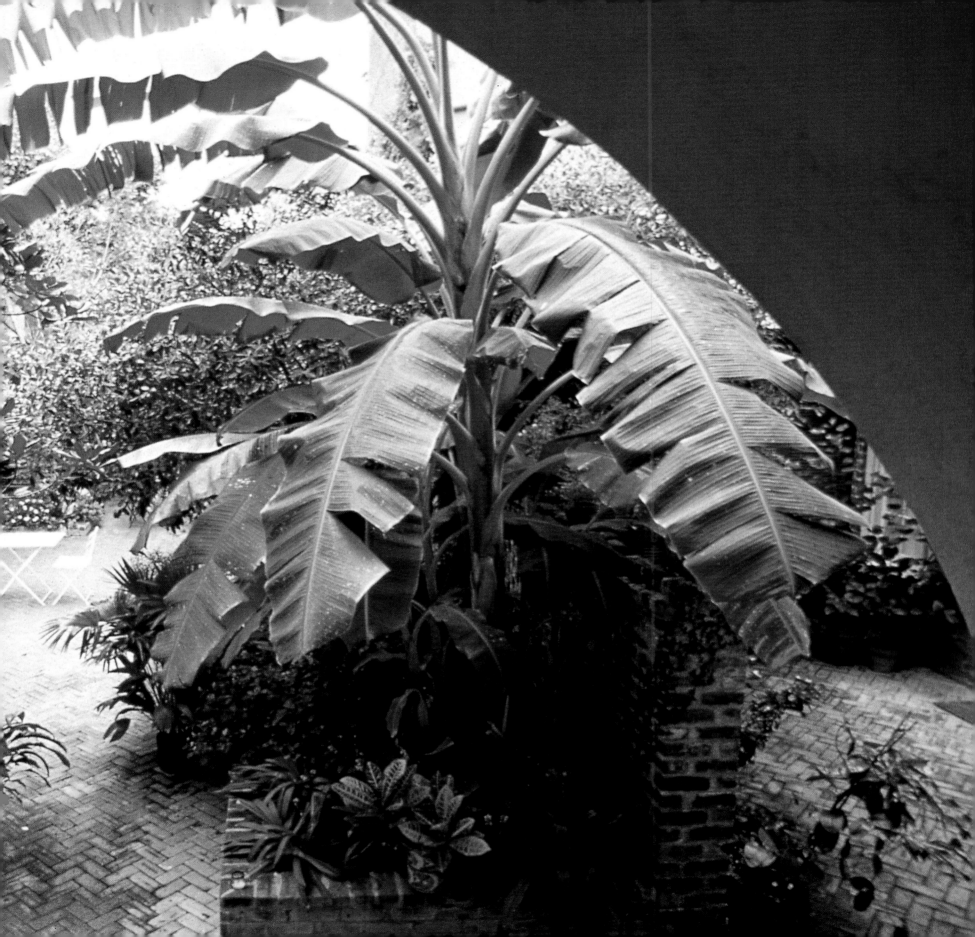

# *Suarez*

The welcoming yellow color of the building's facade, with its deep green shutters, draws us to the building itself. The entrance at the left of the facade opens to a corridor, leading back to the courtyard, slave quarters, and stair leading to the upper living quarters of the front and back building. The coolness of the corridor is striking in contrast to the heat of the street. It causes condensation, which glazes the old slates of the walk with a sheen of reflected light.

*I*n the early softness of an overcast summer's morning, the approach to this home reveals the elegance of this quadrant of the Vieux Carré. The beauty of the edifices in this environ has been maintained by meticulous restoration. This lovely house has a secret garden kept in a pure and authentic manner true to its original design.

The 1832 structure was designed and built by a group of New Orleans architects for an owner who intended to lease it. Abraham Suarez, owner of the newly completed structure, placed an advertisement in the *Courier,* an early New Orleans newspaper, on September 1, 1832, which read as follows:

*TO LEASE*

A two story brick house, situated in Hospital Street between Royal and Bourbon, newly built by the Architects Company, calculated for a genteel family; has good back buildings, and possession will be given on the first day of November next. For terms apply to A. A. SUAREZ OR GORDON, FORSTALL & COMPANY.

Hospital Street was so named for the location of the military hospital down a short way toward the river from this address on what is now Governor Nicholls Street. The street's present appellation comes from an early Louisiana governor. General Francis T. Nicholls, who had already distinguished himself for his bravery in the Civil War, was elected in 1876 as the Louisiana Democratic candidate chosen to redeem the power of the state from the radical carpetbagger regime then in control. Nicholls served as governor from 1877 to 1880 and from 1888 to 1892. Governor Nicholls Street is the location of numerous splendid homes and gardens.

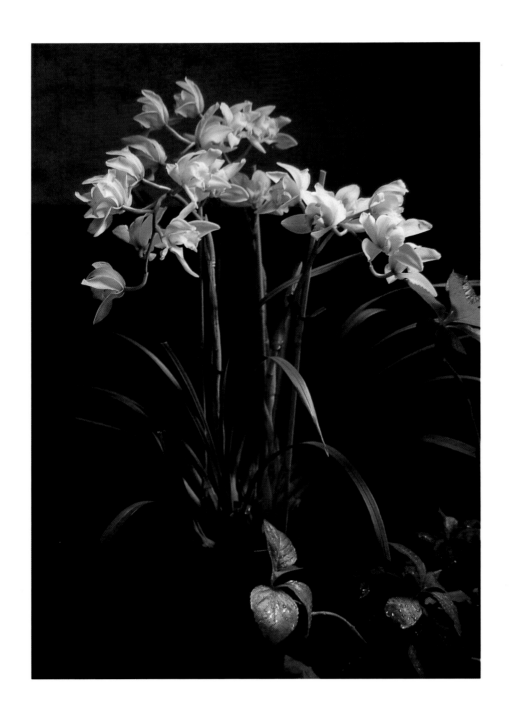

*A pot of yellow cymbidium orchids, with their long graceful leaves, reflects the building's exterior colors and brightens the open arch into the court-yard. The court is sparse, yet each nook is artistically arranged.*

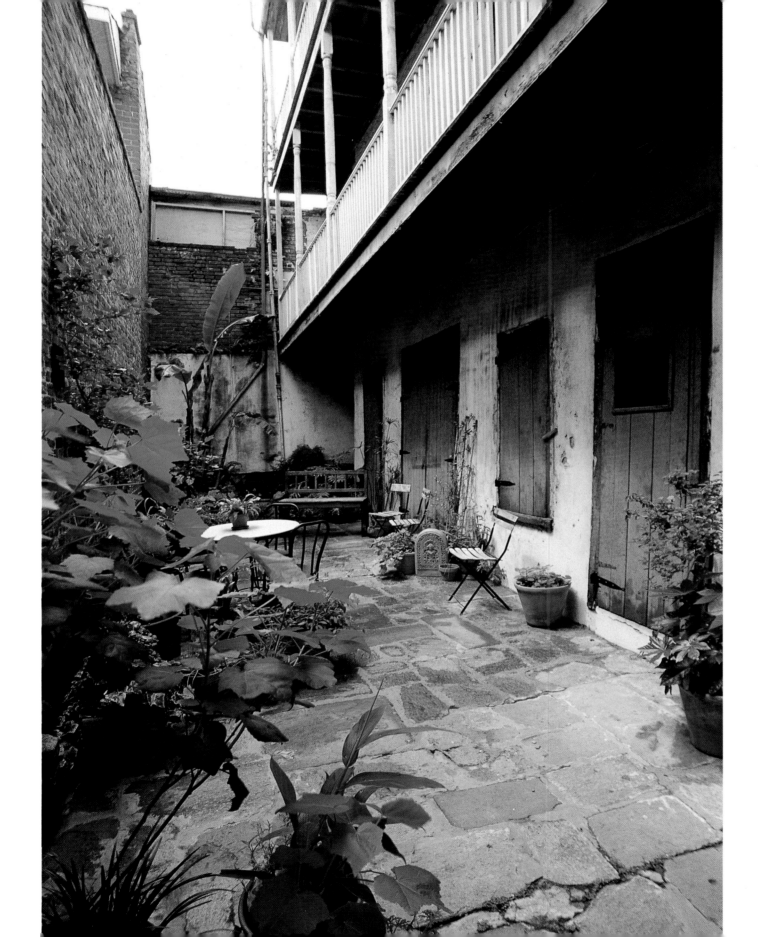

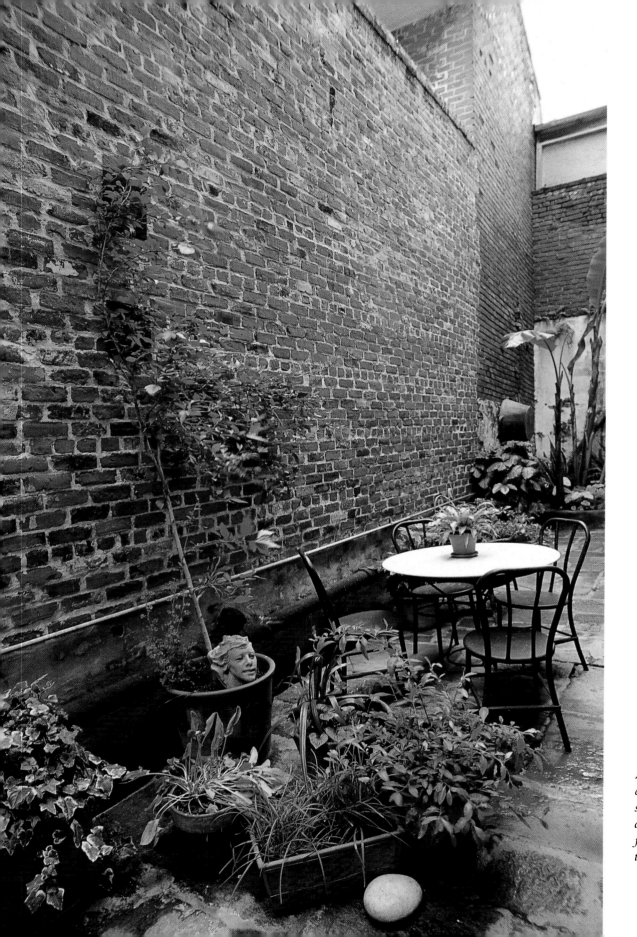

Along the wall there is a cluster of decorative pots containing variegated English ivy, plumbago, and sorrel, flanking a space for comfortable alfresco dining. The face of a garden nymph peeks out from the rim of the larger of the vessels; a contented smile is composed on the face.

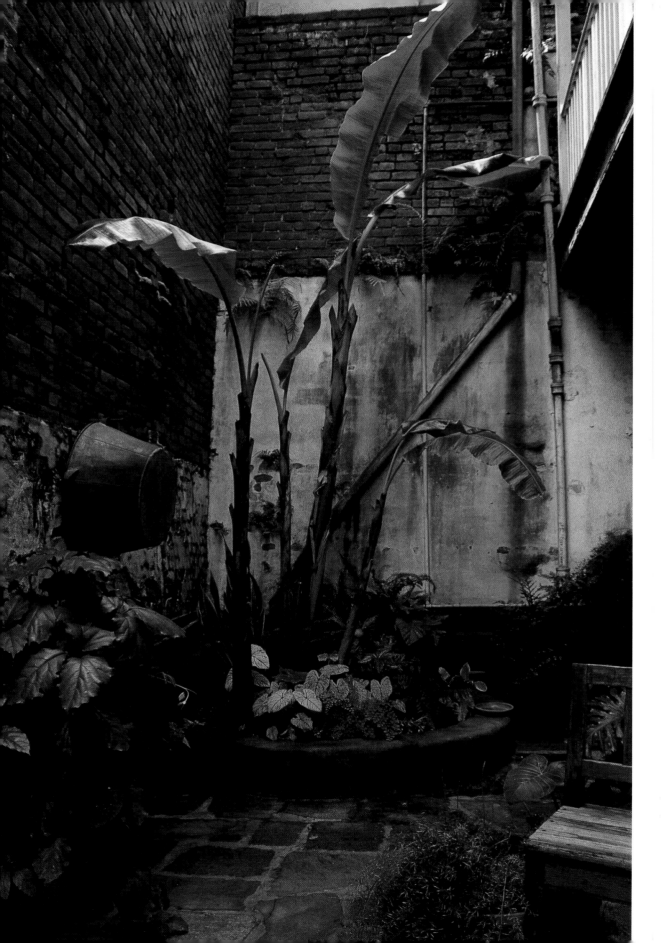

The large tub hanging on the wall was once used for the washing of kitchenware and the blueing of fine white linens and clothing.

The corner bed, where a well or cistern once existed, now makes a home for an early spring growth of bananas and caladiums.

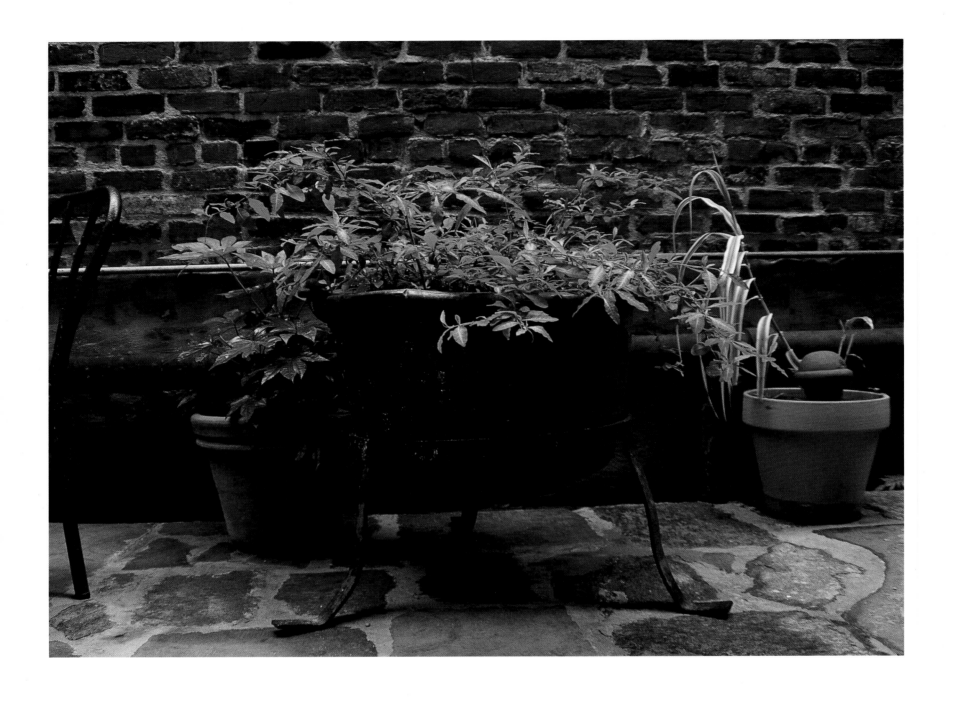

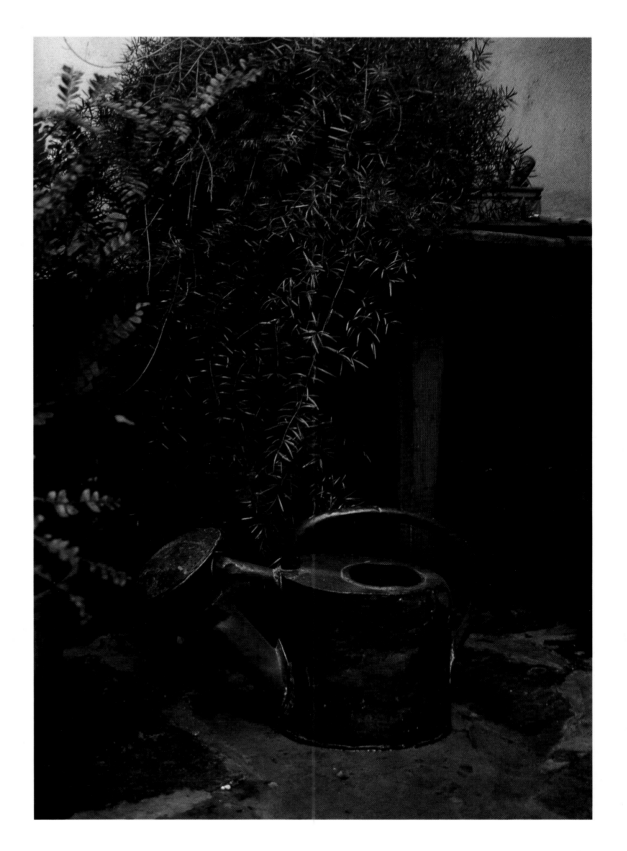

The soap caldron, once present in every courtyard in New Orleans, now stands suspended as a bed for plumbago.

An alcove in the far end of the back building houses a potting area, where a table and garden tools are kept. A large asparagus fern rests on the table, and an antique copper watering can sits on the flagged surface of the ground below.

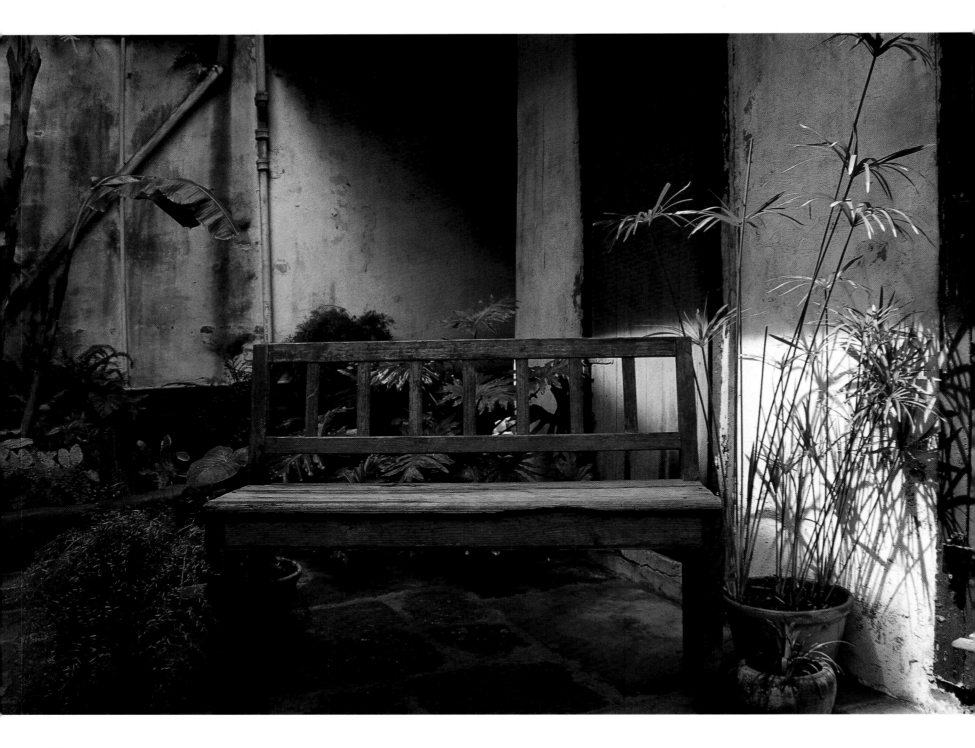

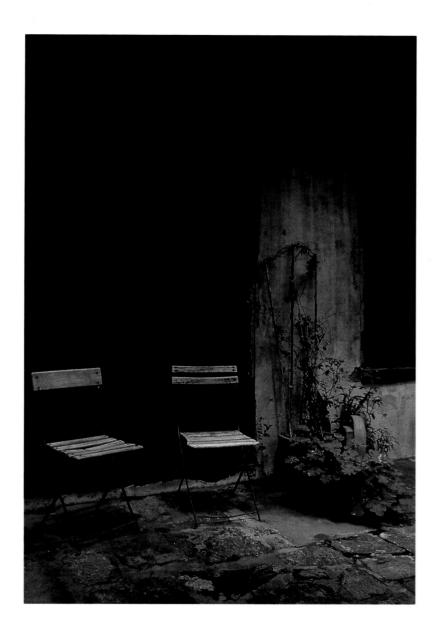

The stones used in surfacing the ground in this courtyard are some of the original ballast stones once carried from France and Spain to weight the empty ships, which would be loaded with sugar, cotton, and indigo on their return.

A unique fireplace grate with a lady's face in the center, fired of terra-cotta, is an elegant piece of artistry.

Serene and quiet, this secret garden is an escape from the outside, a place to sit and enjoy being unnoticed as the bustle of the street passes by.

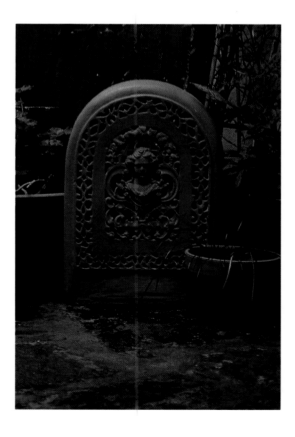

A wooden bench serves as a quiet place for a respite from the day's chores or for a relaxing conversation in the cool of the garden with a visiting friend. A papyrus plant sits beside the bench. Two folding French bistro chairs provide space for more visitors.

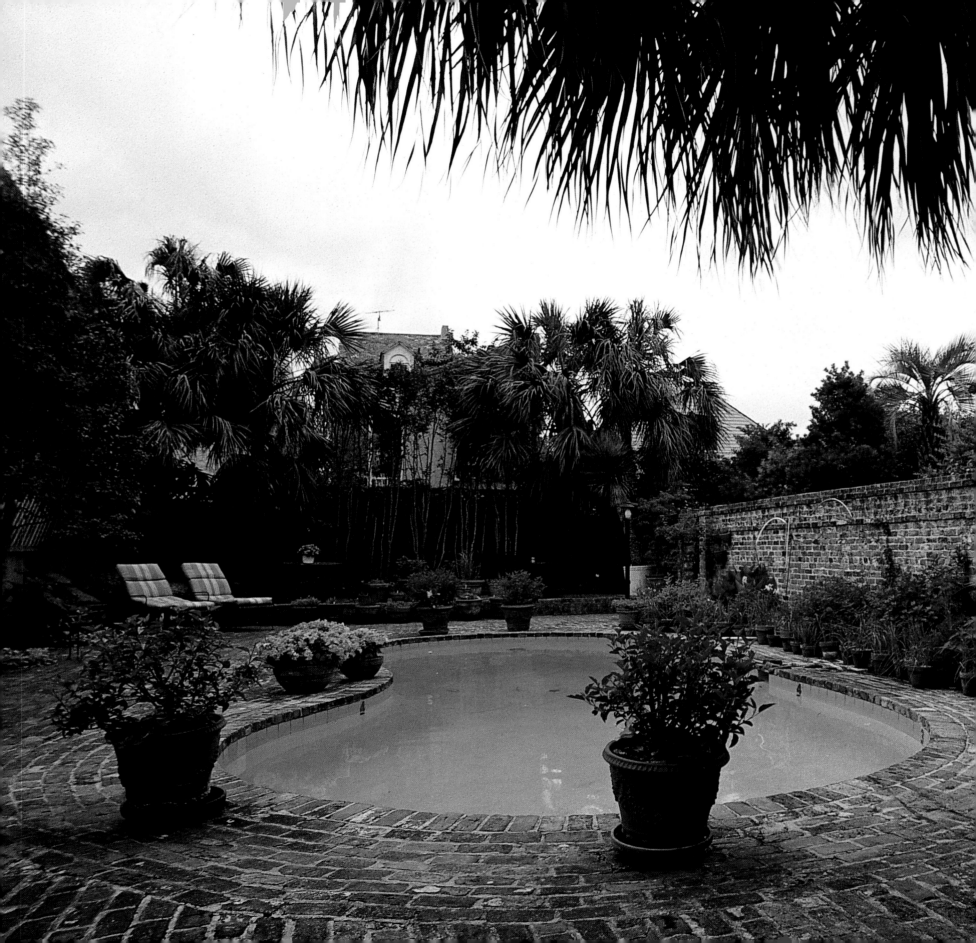

# Tennessee

New Orleans in general, and the French Quarter in particular, have been inspirational to generations of novelists and poets; titles of all genres continue to keep the city's literary tradition alive. Through the years, writers have been drawn to the city, spending time to write their poetry, stories, and novels about New Orleans. It has always been a romantic and economical city for writers to reside in, two elements necessary to most writers for periods of their careers. Most of the writers who are linked through their work to the Crescent City were not born here; many have journeyed here to develop their work.

Mark Twain and George Washington Cable were friends when they were here at the same time. Edna Ferber placed a scene from her *Saratoga Trunk* in the upstairs dining room of a restaurant in the Vieux Carré. Lafcadio Hearn came here as an educated vagabond and became a well-respected newspaper columnist. Lyle Saxon encouraged William Faulkner to live in New Orleans, persuading him to begin writing novels as well as poetry. Faulkner's *Soldier's Pay* was written in a building on Pirate's Alley, which now houses the Faulkner Book Store. And there was Frances Parkinson Keyes, who wrote the famous *Dinner at Antoine's,* and Sherwood Anderson. Kate Chopin, the author of *The Awakening,* moved to New Orleans shortly after her marriage in 1870.

New Orleans is a city that cannot be denied its literary history. More recent authors, such as Truman Capote, have claimed New Orleans as their home, and Anne Rice, who was born here, has recently returned to reside permanently.

If, however, there is a single author who has tied himself to this city through his work, it is Tennessee Williams. Williams's play *A Streetcar Named Desire* is one of the most indelible pieces ever to have been created for, and seemingly

dedicated to, a city. The title came from an actual streetcar line that ran down Desire Street.

For Williams, New Orleans was the place where he could retreat into his personal melancholy, a condition he said resulted from the "foxbite of loneliness." It was in New Orleans that the children of his heart came alive.

In his later years, Tennessee Williams owned a home in the Vieux Carré where he lived during his many visits. He installed a pool in the deep court and spent happier times here.

*Preceding page:*

*The rear court has a kidney-shaped pool that was installed by Tennessee. Old bricks have been attractively arranged in patterns to accentuate the shape of the pool. Large palms grow in the corners of the court. The back wall is planted with a bed of pink impatiens, while tall slender tree branches offer additional privacy to the area.*

*The building and side court are typical Vieux Carré buildings. The flagged surfacing has irregularly sized stones, ballast from empty ships coming to collect trade cargo in the colony, and a large sugar caldron as a planter. Loquat, bamboo, cedar, and Japanese yew surround the court. Hanging baskets of Boston fern help to fill the open space between the building and the trees.*

*New Guinea impatiens, with lovely orange flowers and shiny dark leaves, are scattered about in the beds in contrast to the pink impatiens.*

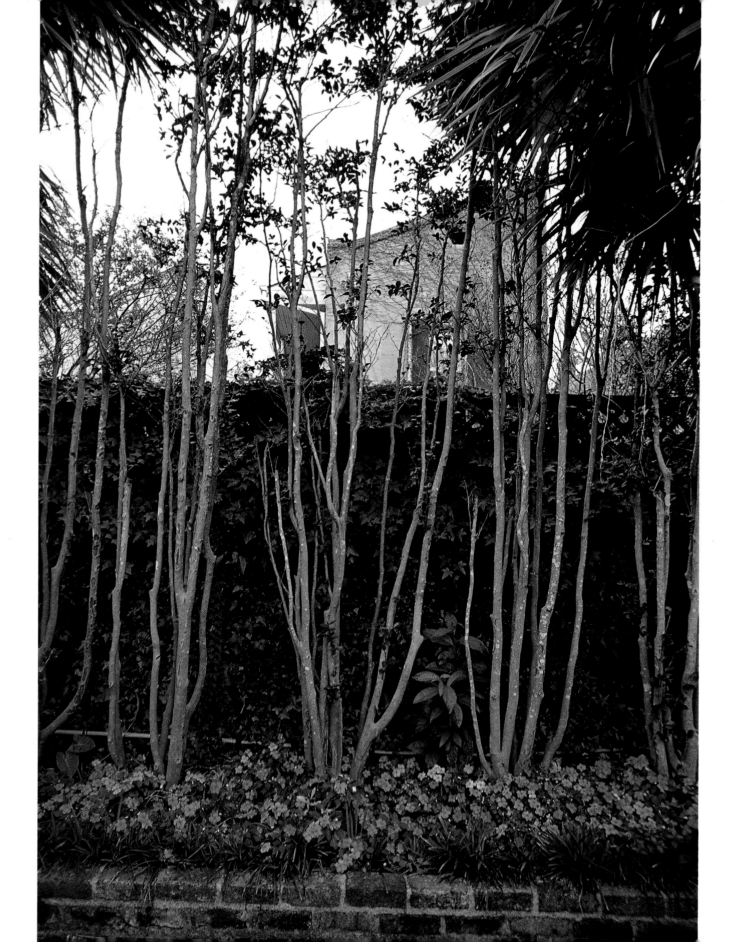

A potted magenta bougainvillea stands aside a gate entering a side yard. The wisteria in this area gives a magnificent display of its draping lavender flowers. These clusters of buds are falling to the ground, painting the brick surface with a coat of lavender.

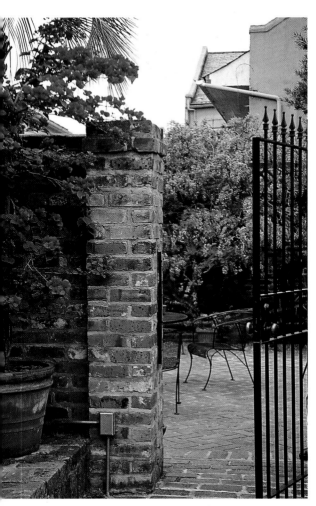

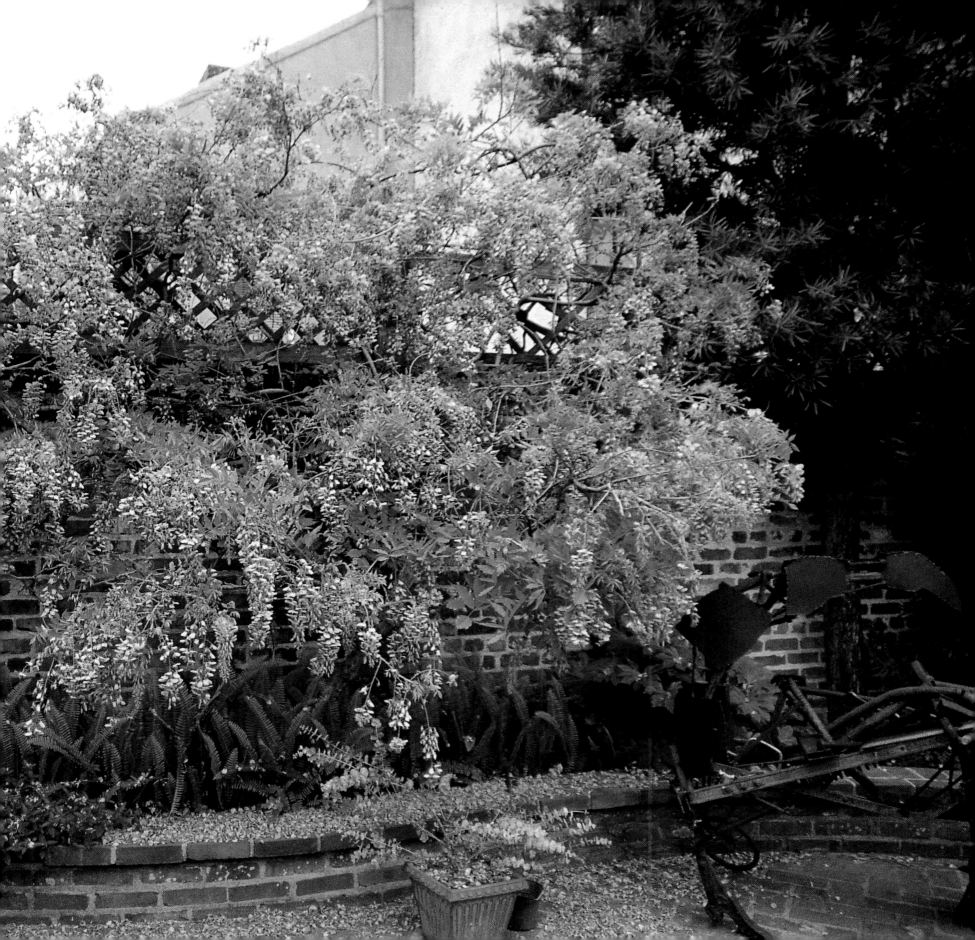

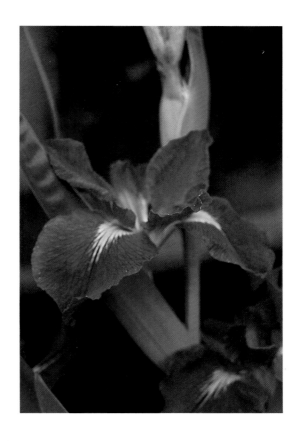

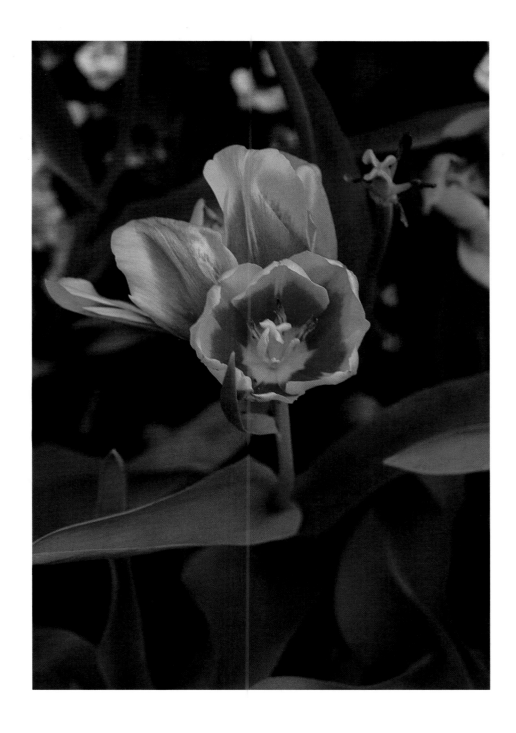

*A small back fountain contains a richly purple iris resembling velvet. Other planters contain varieties of tulips, some yellow and red, others purely red.*

*A turtle, who lives in this garden, languishes in the bed of wisteria petals, waiting for his next meal to appear.*

# Tropical

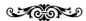

Over the course of the history of New Orleans, as it was passed in ownership and rule from the French to the Spanish, back to the French, and then to the United States, several major conflagrations virtually destroyed most of its original buildings. It is because of this that much of the architectural charm of the French Quarter is actually of Spanish design. Even the French Market is a Spanish building, though the market at that location existed from the founding of the city in 1718 as an Indian trading post.

All of the private residence buildings in the Vieux Carré replace prior dwellings that were destroyed, or torn down, and rebuilt in the architectural style of the day. This small residence, built in 1831, was restored in the 1970s. The deep and narrow courtyard with its lovely garden is an excellent example of how well a narrow space can be horticulturally designed. This is also an excellent example of the exquisite tropical foliage and flora that can grow in a New Orleans garden.

*The peach-and-turquoise color scheme of the structure opens up the space, allowing it to breathe, giving the court the illusion of a much greater space. The Caribbean feeling of these colors is magnified by the choice of equatorial verdure.*

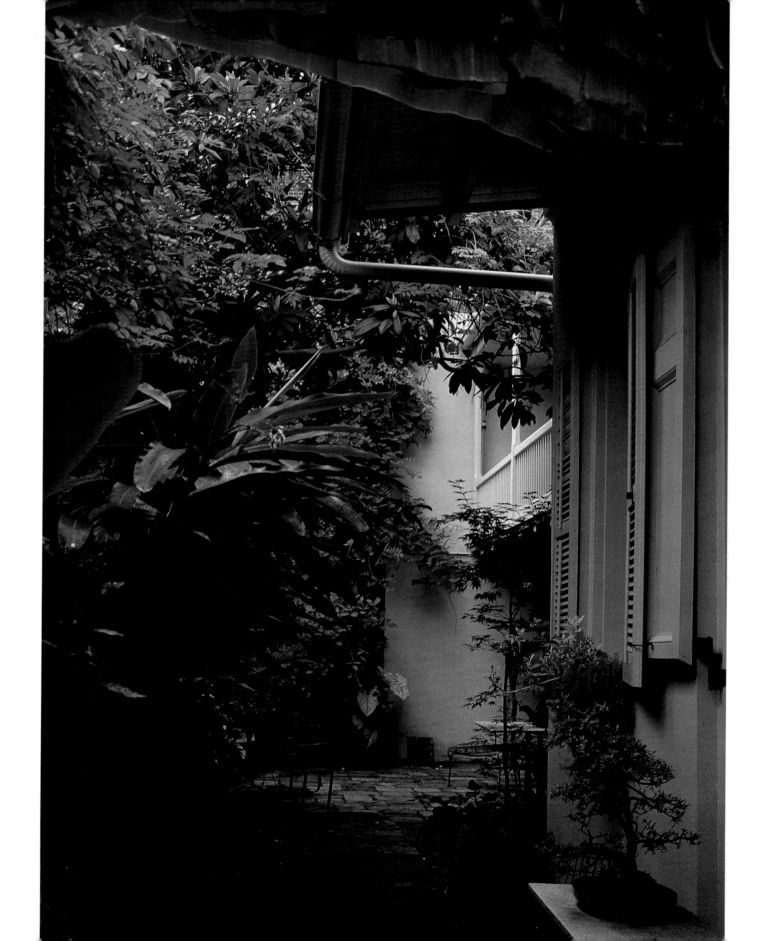

The entire bordering wall to the left of the entry-way has at its base an elongated planter bed that extends to the very rear of the property. The leaves of the bananas lean heavily over and into the walk, upholding a purple heartlike bloom into the sky overhead. These treelike perennials gained popularity in New Orleans during the 1840s and have ever since been an indispensable component of the city's foliage.

Lush leaves of a ginger reach out over the path, as do the bananas, pulling in the sun that slides down into the narrow path. A window box of pink geraniums and dusty miller help break the continuous color flow of the building.

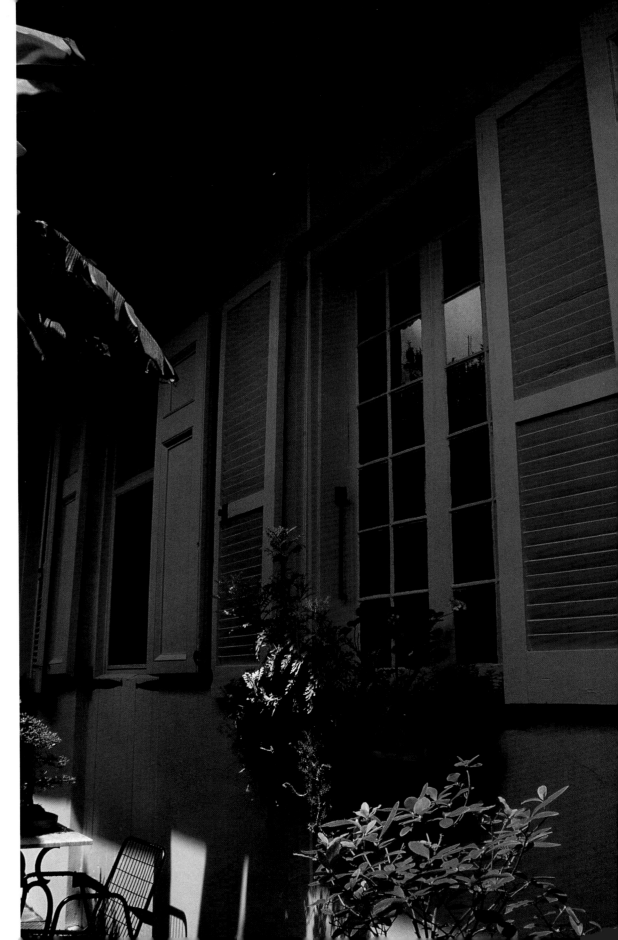

An unexpected bonsai contrasts nicely, not only with the other foliage but also with the backdrop of the partially closed batten shutters.

The back corner of the court is a cascade of greenery. Thick masses of wisteria climb high, while caladiums hug the ground around the fountain.

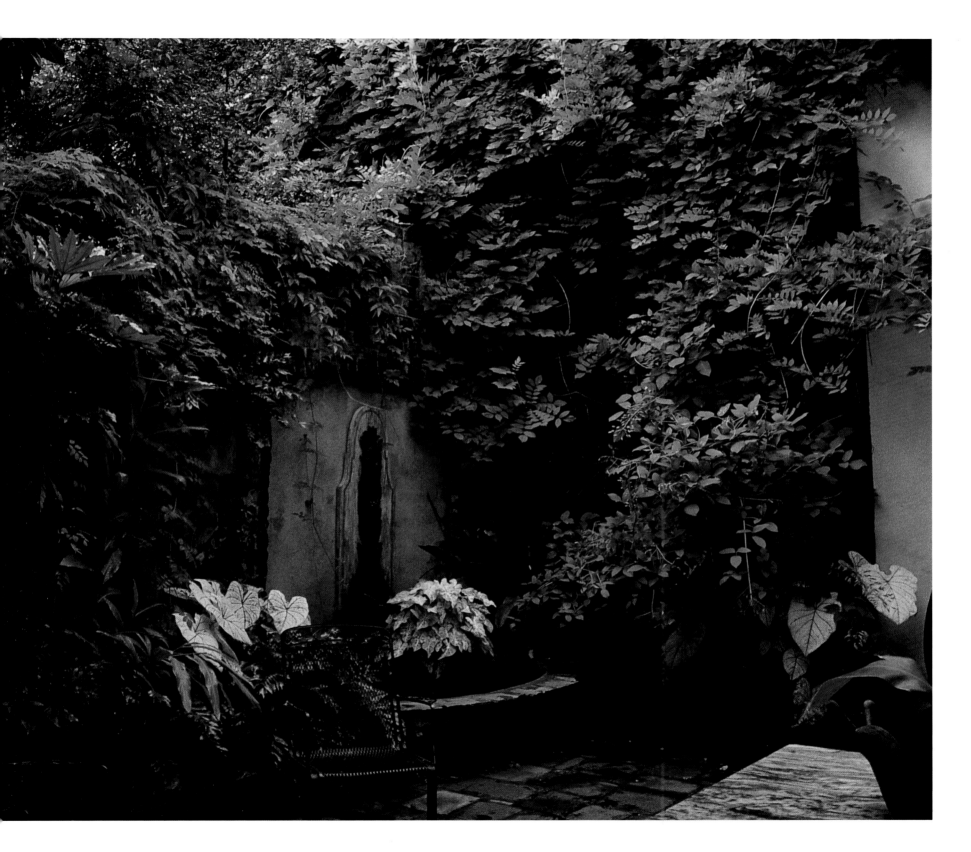

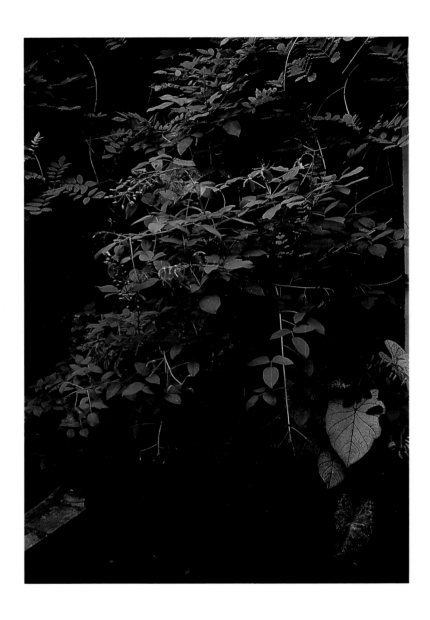

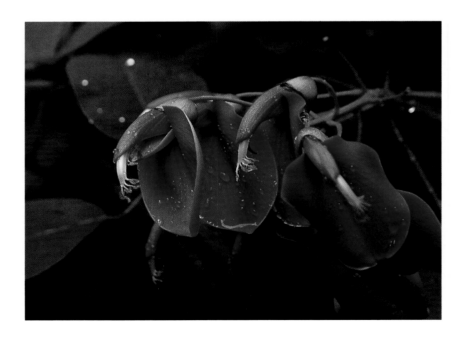

*Orange-red trumpet flowers,* CAMPSIS RADICANS, *suspend behind leaves of a ginger, with a holly fern behind.*

*A small cockspur coral tree,* ERYTHRINA CRISTA-GALLI, *with some of its blooms unfolding, is accompanied underneath by both white and pink caladiums. The scarlet open blooms of the cockspur coral tree are stunning in their exotic beauty.*

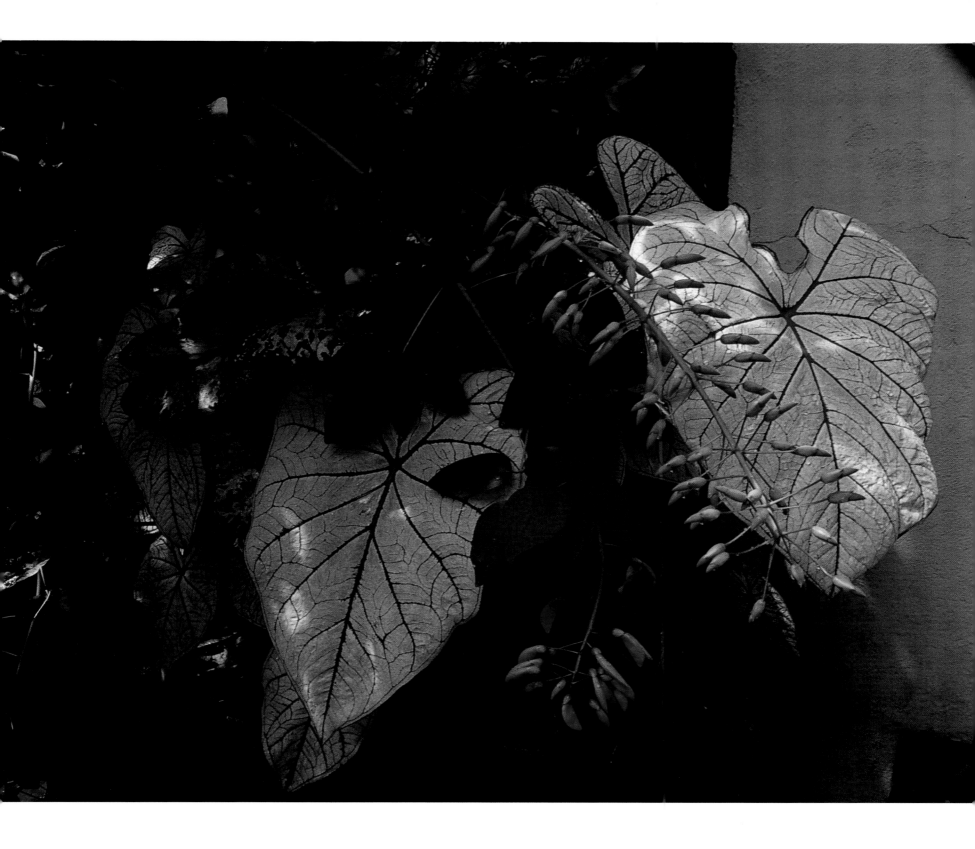

The corner of the wall adjoining the building
houses a rustic wooden bird shelter and feeder.
The shadowed silhouette of leaves dappled against
the shutters asserts the tropical feel of this secret
garden.

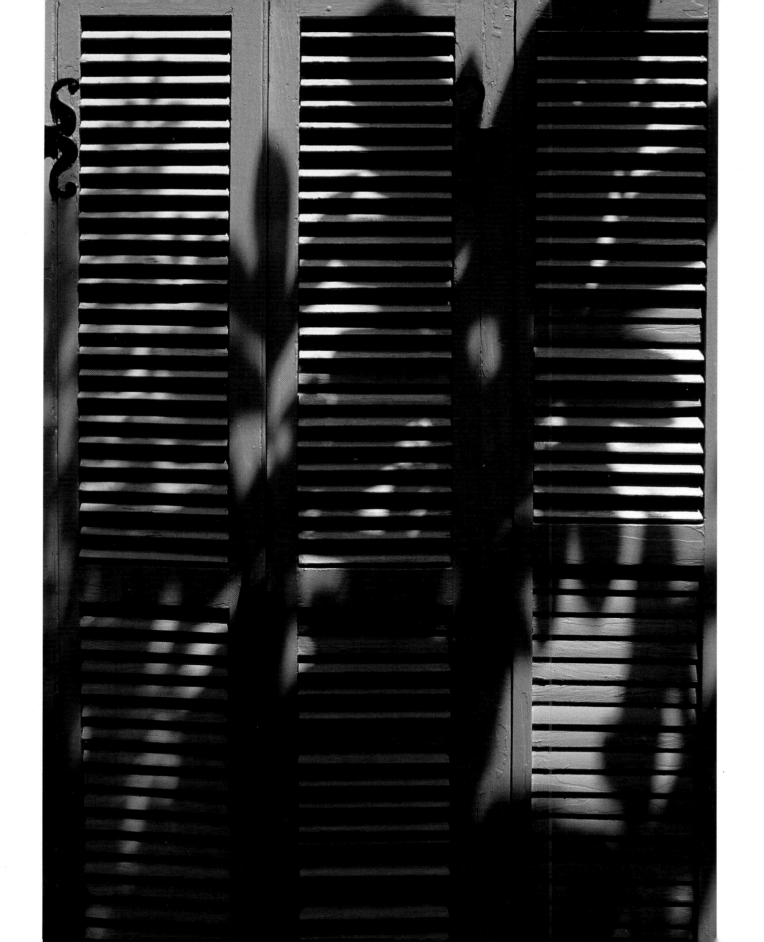

## Photograph Acknowledgments

Transparencies for the pages listed here were taken by
Glade Bilby II. All others were taken by the author,
Roy F. Guste, Jr.

Arsenal: 14, 16
Begue: 32 (top and bottom), 34
Bijou: 38, 43 (right), 47
Conflagration: 78, 80, 87
Heguy: 88, 91, 92, 93
Jalousie: 108 (right), 109, 110, 111
Patti: 139, 140 (right), 141, 142
Soniat: 168, 171, 175, 177
Suarez: 181, 182
Tennessee: 188, 190 (top), 191, 192 (bottom), 193

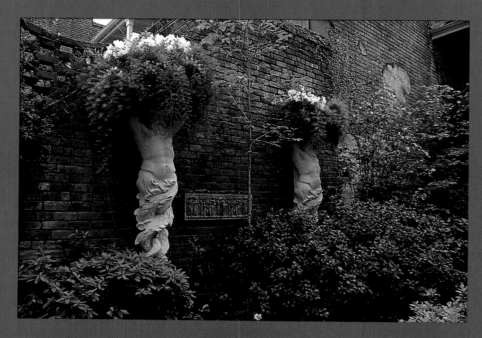
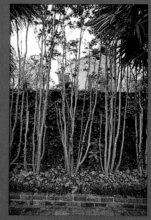
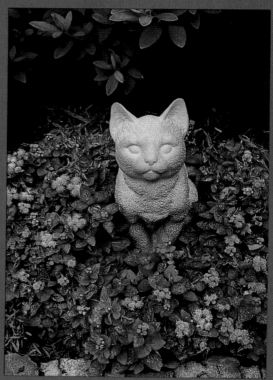

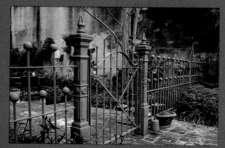

# New Orleans

1878

*For a hundred years and more has New Orleans been drawing hither wandering souls from all the ends of the earth. The natives of India and of Japan have walked upon her pavements; Chinese and swarthy natives of Manila; children of the Antilles and of South America; subjects of the Sultan and sailors of the Ionian Sea have sought homes here. All civilized nations have sent wandering children hither. All cities of the North, East, and West have yielded up some restless souls to the far-off Southern city, whose spell is so mystic, so sweet, so universal. And to these wondering and wandering ones, this sleepy, beautiful, quaint old city murmurs: "Rest with me. I am old; but thou has never met with a younger more beautiful than I. I dwell in eternal summer; I dream in perennial sunshine; I sleep in magical moonlight. My streets are flecked with strange sharp shadows; and sometimes also the Shadow of Death falleth upon them; but if thou wilt not fear, thou art safe. My charms are not the charms of much gold and great riches; but thou mayst feel with me such hope and content as thou hast never felt before. I offer thee eternal summer and a sky divinely blue; sweet breezes and sweet perfumes, bright fruits, and flowers fairer than the rainbow. Rest with me. For if thou leavest me, thou must forever remember me with regret." And assuredly those who wander from her may never cease to behold her in their dreams — quaint, beautiful, and sunny as of old — and to feel at long intervals the return of the first charm — the first delicious fascination of the fairest city of the South.*

Lafcadio Hearn
(1850-1904)

# Part Three

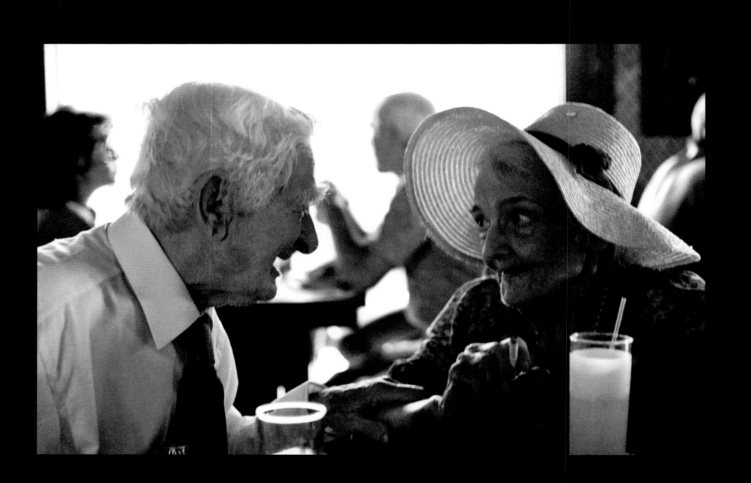

# Orléans Embrace

TJ Fisher

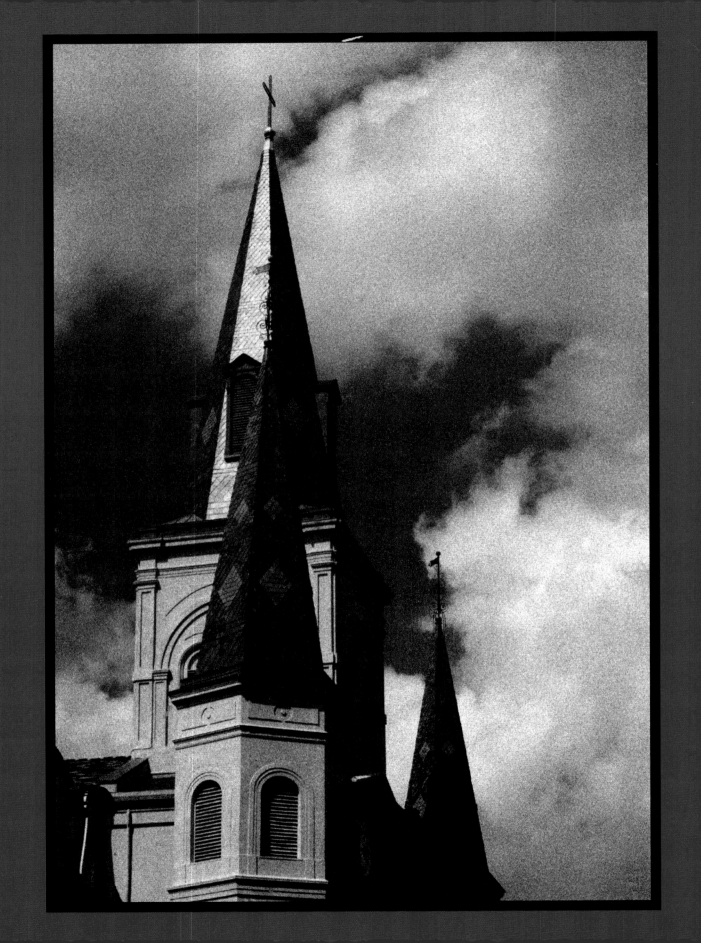

# Saving New Orleans

## L'Histoire

This is a real book with real passion about a real city, her landmarks, customs and people. Triumph over tragedy defines New Orleans. Her big heart and old soul carry timeless traditions. Invariably there are stories behind the story. The Crescent City is a community of neighborhoods, a land of pageantry and spectacles; an impetuous place brimming with colorful scenery and larger-than-life characters. This is where history was made and still lives. Images that touch us prove tough to dislodge, offering a tantalizing window into our own soul; what swells and captures our mind's eye molds and shapes the outcome of our days and nights.

The syrupy, humid air of the Vieux Carré holds dreams of feelings that lie thick upon us. We see the French Quarter's sublime repose, her fierce hauntedness and charm, wordless but intense. Ageless. Other memories become our own like mist seeping upon us; yet, for all, the Vieux Carré remains the historic, architectural, cultural, musical and culinary capital of New Orleans and beyond.

Like a thief, Katrina took from us more than we know; yet our crown-jewel historical district was spared. Her mysteries were not laid to rest or silenced. Her mythical status pulls us to her. Through an aged molding together of diverse cultures, she remains as seductive and unique today as a century ago. The Quarter's illusive, moody gravity grabs us while the nuances of life continue uninterrupted, helping to mitigate the litany of dark days. The Vieux Carré is alive.

From the beginning, New Orleans has differed greatly from the rest of the country in its Old World makeup, cultural legacies and relationships. With a proud and unusual history, spawned and influenced by rich ethnic diversities and spiritual affinities, locals have always possessed a unique outlook on life. The multihued personality of the city derives from centuries of cultural interactions and exchanges, a mixing together of traditions for which there is nothing comparable.

The city that engendered jazz, New Orleans is a parading town, no matter what. In recent years our signature brass marching bands traditionally deliver a soulful serenade and then a boisterous second-line finale to a jazz funeral; the procession of community members and curious spectators, following behind with exuberant dancing as the tempo picks up, assume a new direction in the celebration of triumph over adversity.

The nineteenth-century ceremonial practice of second-lining was the advent of African-American mutual aid and benevolent societies, whose members initiated this expressive tradition of accompanying the dearly departed on the way from the church to the cemetery, giving the deceased a grand send-off.

Since Katrina devastated our homes and city, second-line marches have become more abundant than ever. Hardly a day passes when music is not heard in the streets, sometimes even in the destroyed areas. We New Orleanians have an aversion to letting misery, mistakes and regrets bog us down for too long.

The ancestral lineage of the city has a long interface with dirge music — the sound of struggles, hardships, the ups and downs of life — but then comes the joyous high-spirited part. The great weight of sorrow lifts and we are released, for the moment. Baptized in a salty wave of life's harsh downpours, locals still come forth with an explosion of color, umbrellas, horns, feathers and fancy footwork. Even from afar, the world salutes and identifies with the comeback spirit of our city. We are widely recognized for this inherent trait and temperament. A not-so-secret *joie de vivre* society able to leave worries behind when the spirit hits. After all, it is better to be happy here and now, regardless of circumstances, because there is always the invisible threat — what if tomorrow never comes?

The Quarter remains a rarefied gemstone of wonderment, music and play, a city of jazz, rhythm and blues; the original home of eloquent artwork and graceful architecture. All the best

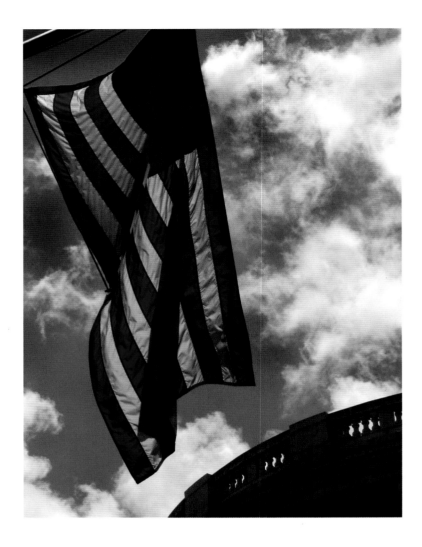

Like the venerable cemeteries of New Orleans, the majestic French Quarter embodies age-old soul set in stone; in today's world, enduring emblems of the lockstep of man and time are strangely comforting to cling to.

The Vieux Carré has always possessed the uncanny power to amplify our life's experiences, opening our eyes to the stunning domains, a legacy that lies just beyond the limits of our unaided senses. We see impressions more than what is actually in front of us. No intuition is needed to peer into the obvious cracks and etchings, the cycles of life, the small slices suspended in time.

In a post-Katrina New Orleans, if you choose to tour the right streets in repopulated areas, you'd think we survived fairly well, with charmingly cracked buildings and mossy oak trees still intact. At least for most portions of Orleans Parish's Commercial Business District, Warehouse District, Garden District, Uptown, Marigny, Bywater and a few other high-and-dry vicinities of town, primarily strips of land located along natural ridges.

You can close your eyes and pretend — but the devastation laps right up to the still-beautiful neighborhoods, weaving a meandering and menacing trail that slices throughout the Queen City of the South. It flanks the edges of everything. The city is down, but not out. Not yet. Though it seems clear to some that without a bold national commitment the rest of the shriveled areas farther out will not come back. Does America care? As they have elsewhere when tragedy struck? We hope so. There is strength in unity, and New Orleans cannot do it alone.

New Orleanians share the common trait of holding fast to courage and resiliency. Life — insistent, unyielding, unstoppable — comes crashing, seeping onto us from all angles and corners, assaulting our senses and sensibilities. This happens whatever self-protective makeshift shield we craft. The fleeting patterns of history, memory and preservation remind us who we are and are not. So many untruths pass for truth. Lyrical fables chronicle and foretell man, mystery, legend and lore. As the days and years pile up and pass over our heads the question remains: how much of the mask becomes the face?

The legacy of the Vieux Carré carries forward. Tomorrow is a prophecy, a vision waiting to materialize. We hear the vibes, not quite audible. We see foreshadows on the horizon, nearly visible. Despite misgivings, the future is coming; sooner rather than later. We can look ahead with a valiant or fearful heart. Capricious nature is both cruel and kind. We know a lifetime

and most flavorful enticements, ingredients and shadows of life and optimism remain here.

With its quaint buildings and carriageways, a bold symbol and spearhead of cultural and musical heritage, the Old Square is an ongoing device of wonder, a long-running allegorical performance. She is music to the eyes and more.

Her faded splendor and vestiges of grandeur, melded together from bygone epochs lost in the brushstrokes of time, await the inevitable return of an international adoring audience. There will always be those drawn to her dreamy texture and sullied twilight beauty, aging in the dingy softness of decline and decay. Incurable romantics long to reach into the past and recapture what was, what is already vanished.

can be made or broken in a moment; that the odyssey of a century can occur in a day. It has already, in New Orleans.

Yet if we lose this crumbling city, then we squander and surrender the best of our spirit, block by block. We hope to survive and recover from the storm surge's floodwater scars.

During this historic plight, all those who are here to aid our town in recovery and rebuilding sift through hundreds of yesterdays worth of rubble and debris, all come to realize that not only do New Orleans' walls and floors need urgent repair — so do human hearts.

Yet many who come to help our city start over actually decide to stay and call this place home. Every day, newcomers choose to lay down new roots and plant fresh dreams in this damp soil, as even in the aftermath of calamitous disaster the city of New Orleans holds fast to a kindred consciousness of family and community; this part of the country has a shared open friendliness and warmth, a mutual zest for life, three centuries in the making that is unmatched in other regions of the world.

Although we love our buildings, trees and traditions, the real greatness of New Orleans is her people.

Katrina was the storm we always feared, the one that brought terror and stunning mass destruction. The calamity will be studied for decades to come. The floodwaters changed the course of our city's history; the daunting side effects still burn the eyes with dampness; still swallow hearts and wrench emotions. So much is gone; it's almost beyond belief. Yet because something dematerializes does not mean it never existed. Only a New Orleanian spirit could survive this. You do not have to be born or drawn to live in this place of deep attachments to possess the fortitude of our forefathers, but you cannot be prone to running away or giving up easily. Similarly, you must believe that what is broken *can* be fixed. This is the basic principle and persuasion upon which our country was founded.

In coping with the ongoing sequel of deluge, our citizens continue to traverse the firm common ground of great generosity and personal sacrifice. Our focus narrows and deepens.

We may need to live with illusion, especially in the Vieux Carré, but here, as firsthand witnesses, we are smart enough not to overlook reality. There are voices to be heard. We ingest and learn from this great American tragedy as we strive to move beyond Katrina. Now as a new era is ushered in with a brutal onrush we chase memories; yet — because we must — we move ahead.

The sun sets on golden eras, fading into the dark. Time betrays all but — you can count on it — the world rotates anew. We see through the prism of time how humankind, cities and civilizations rebound. Light gradually spreads to the dark places. Something new forms in the shadowlands. Admittedly some empires vanish completely, yet we've seen that even the war-ravaged capitals of Europe successfully were rebuilt to reflect and surpass their former heyday. If other shattered landscapes can reemerge as sumptuous jewel-like cities, so can flood-soaked New Orleans.

Although the physical evidence of many memories was spirited away, swallowed by the storm waters and later carted away by demolition teams, still, we remember. Our bond to the past is thicker than floodwater. We do not forget all that came before, including who we are and where we come from, even though we may not entirely know exactly where it is we are now heading.

To survive disaster does not mean we no longer chase and believe in the ornamental dressings of the great American Dream. No, just the opposite. It means we are less likely to be lulled into false impressions of security; the draping of naiveté is gone; *poof*, eyes wide open.

The storm's cresting killed indiscriminately, leaving in its wake hundreds of thousands of people homeless and tens of billions of dollars in damage. Clearly we were woefully ill-prepared. And

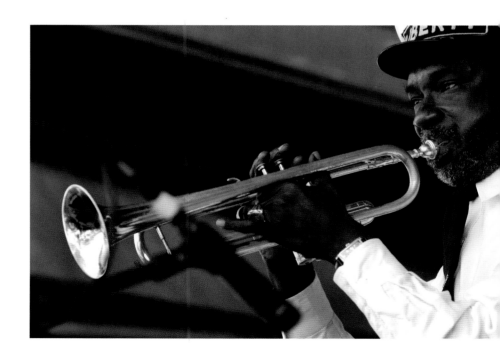

what now? Next in line to the human side of tragedy, saving New Orleans — saving one of America's most prized cities — helps save the nation. It is a test of national character and integrity; what lies within our own soil is worth struggling for.

The allegorical beauty of the Vieux Carré remains indispensable to the rebirth and renewal of New Orleans. Astonishingly the primary colors of our classic, time-warped antique architecture and lyrical cityscape remain intact. The Quarter's resilient strength and beauty flourish as ever; a haven of grace. The divine inspiration she provides is tinged with a

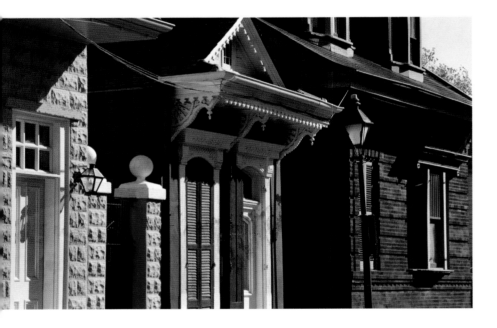

feeling of intrinsic faith. It resembles an eternal conversation. Here, while not forgetting the rest of New Orleans, we come to immerse ourselves in the ongoing beauty, ceremonies, joviality, festivities and festivals; we even come to trust that things will ultimately be all right.

Wishful romantics or not this trust influences us to overcome helplessness, to manage the moment. To submerse in a sea of emotion need not be an impediment to recovery; it is justified to ruminate in recollections and words of wisdom. Consecrations and epiphanies coax us back to life. We celebrate and sop up the living moment. For a time our fears and tears are tempered. We square off against the grim and formidable tasks at hand yet look

to redemption, even bliss, in revitalizing lives and our city. Drawing upon the beauty and power of charging forward, we cast out our weaknesses, demons and doubts, discarding them by the wayside.

Nothing stays the same forever. And sometimes not for a day. Not in New Orleans and not elsewhere. None are immune to the uncertain future. The merciless, unyielding flow of time, restless and relentless, shifts and drifts upon this temporal world, altering the shape of everything we value. Life's impermanence is a bitter burden to accept. Of all the pitfalls that come with being alive, this is the most painful of our accommodations. We all want forever. We pound our chests and demand a world without end. Our wailing falls on deaf ears. This was never promised us. We cannot achieve the everlastingness we crave and we are crushed. Complacency disintegrates. The intrusion of destiny cuts short our quest for evermore and a day, and we do not take kindly to it. We mere mortals never want to let go of people, places and things we have loved. No matter where we live or take shelter, in the end all is pried from us. Even so, we can choose to remember and not forget.

Now the future unfolds with bold visions, with the unresolved past lurking nearby in exile. Currently we toil and breathe smack-dab in the swampland, preoccupied with survival. This is morally fraught terrain. As we sift through wreckage, the permeable boundary between fact and fiction turns more porous. The standing silhouettes, reflections and shadows of the Vieux Carré come to symbolize so much more; the mystique of the Quarter's old soul and spirit give hope and comfort. She sends a strong yet subtle statement. We see the tonality and hear the resonance in this message immemorial, unspoken and timeworn.

In the bleakest of days, disillusionment is sometimes followed by a reawakening as we respond to life's overwhelming challenges. Just when we think we will never laugh again, we do. Our existence is a series of chapters, a continuum, a story and a fabric of life echoed down from our ancestors. There is no happily ever after, only happily here and now.

The Vieux Carré survives as a brush of magic set against an epic swath of catastrophe. A complex, intriguing inner world remains. The Quarter's persona still exists in marked isolation along with a high-ground embankment of other historical areas, dampened but barely scathed. Her survival is spun like the saga of a modern-day fairy tale. She is an institution bigger than the buildings and personalities inhabiting her soil. This is where we leave solitude behind to enjoin history

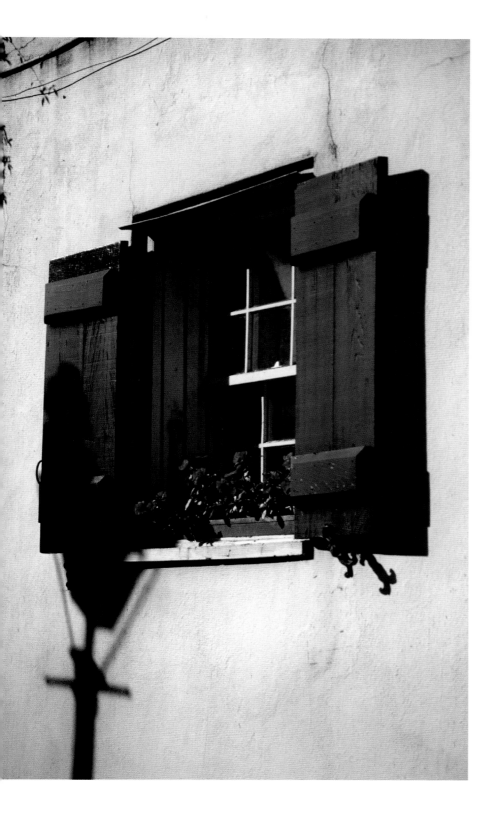

and share more than one lifetime. She remains our earth-bound consolation and constellation.

Deadly Hurricane Katrina and her massive floodwaters mark the costliest storm fury to ever attack U.S. soil, bringing unprecedented torment. So much of New Orleans sank. The hurt is huge. Unforgettable. Yet here a sense of this city — the city that appears now to be sinking in America's memory — lives on. Those who expect the tragic parts of our city to languish unnoticed beneath a mound of ruins and rot are wrong. Louisianians mourn for yesterday and rant and rage at the present yet hold hope for the future. Here in the Crescent City we are grappled to the ground to wrestle life's burdens and more. The cause of so much misery is more complex than most Americans realize. It is a twisted set of circumstances far beyond the dynamics of a hurricane's landfall. Grievances are many. Faced with the monumental task of piecing a city back together we set out to recover our heritage, to make fresh reflections and to rebuild anew.

Once someone survives calamity, the future looks different; suffering takes on a deeper meaning, as does laughter. Torrents of emotions are set loose. We strive to contemplate the imponderable, to speak up more, to live more fully. Our imaginations are coarsened and ripened — it is our ventilation. To keep quiet is impossibility. We are not alone, of course; the world is full of sufferings, questionings, injustices, mistakes, losses — grief — but yet life goes on, as do love and laughter.

Many societies are lucky and unlucky at once; fairness and unfairness all too often are doled out casually while here mimes and muses come and go with regularity.

Beyond the harshness of light, we perhaps fool and master the mind with small details that emerge in the salve of flawed reality, yet sometimes it saves the self, from an overload of life's indignities.

Admittedly this time the storm ushered in an unspeakable season of dark reckoning for the whole city and beyond. Our centering axis has been knocked from its fulcrum, rocking our world. Giant craters, fissures and openings suddenly caved in surfaces previously smooth and solid. What confines and defines us is suddenly a new paradigm as backdrops of dying dreams and ordeals lie behind and ahead of us. A profusion of minstrels, mysteries, miracles and misfortunes appear and melt away with that rolling luck of the dice. All *fait accompli*. Unfazed, we have seen the parade of rainmakers, court jesters, harlequins and charlatans before. They populate the centuries, their singsong and rhetoric invariably the same.

7

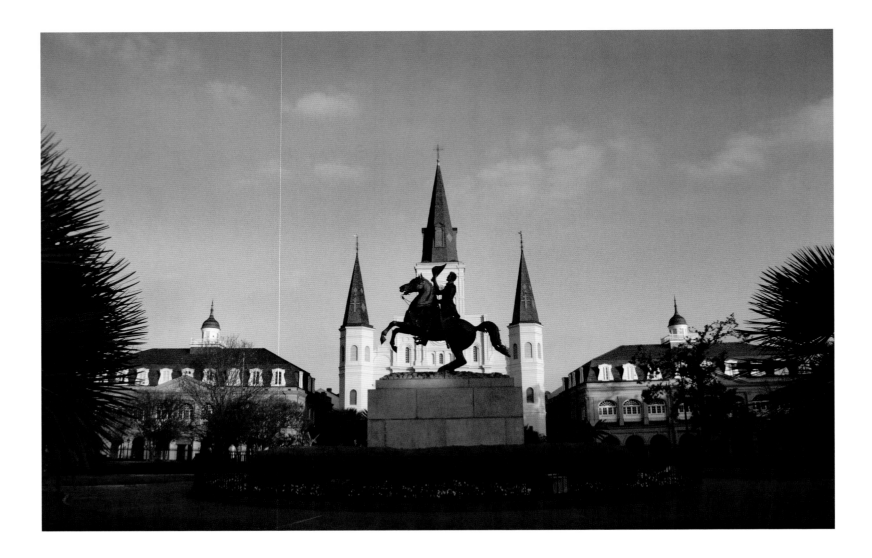

Lost in the walls of our memory are trapped embers of time, ashes caught in shadows helping to heal despair and soften sorrows as we live in the afterglow. Beyond the fossil folds of a past littered with loss, we reinvent the future. More than despair, Americans believe in optimism and cures; though we do not forget what has eroded us and altered the face of our nation. The rhythmic winds of yesterday forever wind and chime through us all, affecting whether or not we salvage or fritter away tomorrow. The decisions we make or ignore will modify this nation's future physical, historical, financial landscape in consequential ways. Our impact is substantial. All of this must be examined closely or else we fail family, country and ourselves.

A ladleful of emotions, remembrances and dreamscapes with no expiration date help renew and regenerate us. We preserve and graft together those memories that dwell within us. This is a time-honored balancing act of growth, glory and success. Those whose hearts contain no regrets and no deep feelings for unbelievable tragedy are without conscience. This is obvious. Yet valor, faith and hope govern the world, not kings or heads of state.

New Orleans remains two cities divided yet united, a cityscape heaped high with unspeakable difficulties and staggering atrocities. Yet amid a juggernaut of scrambled debris left in the wake of horrendous misjudgments, inexcusable lapses, poor preparation and outright falsehoods, people still summon incredible courage and resolve to rise to the occasion.

We are determined to preserve what Katrina left standing in the shadows of upheaval, the historic character that water and wind didn't sweep away.

In the hidden cloak of stilled Vieux Carré courtyards, and the concealment of plant-laden balconies, as breaking dawn colors

and creeps across a half-cast scalloped skyline, quiet shadows flutter across crumbling buildings, water drips from wrought-iron railings and birds slowly flap past, as the Vieux Carré intimates a strange aura, a sensation not found elsewhere. Truly, you feel at the permeable edge of something eternal, as if unseen ancient memories are whispering, sagging and heavy, floating through the air. There is an unreality of reality, an abeyance of time, between what is actual and perceived, and that is one reason we love her so. What seems to exist as a phantom of our imagination is always more intriguing than what's there.

Many have spoken of and attempted to put words to the unexplainable phenomenon and feelings the Quarter emits and evokes, over the course of hundreds of years.

The hub of the Vieux Carré, the areas that fan from Jackson Square and St. Louis Cathedral like powerful spokes of living stories sprung to life, is the site where major buildings have always been erected and significant historical events transpired. This powerful heart of confluence includes not only the Cabildo and Presbytére but also the Pontalba buildings, Pirate's Alley and Le Petit Theatre. Earlier in history, Jackson Square was previously the *Place d'Armes*. Most assuredly one does not have to be psychic to feel the restless hauntings, musings and murmurings of man and history that converge here.

Beyond being a zestful and romantic Louisiana city, drenched in lightheartedness, the French Quarter is a dominion of American lore and folklore, a bastion of the past.

A place that sustains itself on myth and metaphor, this is a town of storytellers. Our extra layers of sorrow and celebration, tragedy and survival, heroism and humor, give our city a bittersweet resonance; the spirit of New Orleans can never be destroyed or removed from this place, it is native to the soil.

Truth seekers, maskers, portraitists and scribes who collect, create and recount stories and folklore of man and mankind are lured to this precarious place, an antiquated and fusty seat of power, settled and tottering at the ripe mouth of the mighty Mississippi. This is the seaport that shaped, founded and fed the soul, culture, development and romance of America's Delta, and beyond.

Cryptic shades of the enchanted characters of history and literature forever waft about mingling with the gusty breezes and vapors that rustle through our courtyards, twinkling a distant wind-chime cadence that echoes the past glory days of the Vieux Carré, casting reflections of the people and days of old

that lay densely imprinted in permanent residence here, filtering and filling into the multilayered thresholds.

The rotating cast of international characters continues, including an unforgettable melting together of sightseers, media, relief workers, construction personnel, *bon vivants*, history buffs, modelesque society refugees and wayward souls, those attracted to seek out the fascinating peculiarities of thirteen-by-six dense blocks of antiquated haunts and bohemian lairs; a curious concentration of mesmeric music, fabulous food, endless eccentricities, fascinating shops; even the well traveled pilgrimage here, since, even after Katrina, there is no place anywhere quite like it. This is where you can lose yourself to recover your true

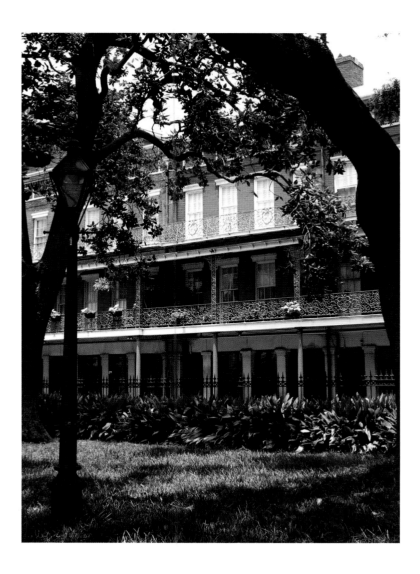

self. Those who come to eat, party, laugh, shop and have fun help our city recover. Tourism makes our city run.

New Orleans gambled against the odds for years and finally lost big with a catastrophic end to its thirty-nine year winning streak. A classical tragedy, it contains all of the big themes that weave through life. Yet the city and her people face down the demon water wreckage with solid determination to reclaim our unique culture. The birthplace of old New Orleans survived, the Vieux Carré carries on. Memory refuses to be buried here.

A flinty sense of purpose, willpower and imagination give New Orleanians the stamina to persevere high-water marks and harbingers of doom. We remain committed to overriding the outrage and carnage of nature and more. Defiance over defeat, the spunk to stay and recover, this is how we lay claim to the future. Only time tells the whole story, unleashing the real truth in the same way that history reveals the ultimate hero and antihero. Oft-times both wear indistinguishable masks until the final unveiling.

For our city to thrive, all socioeconomic classes of New Orleanians need viable housing and income; for economic recovery to happen, New Orleans needs big business, financial investors, employment opportunities, commerce and tourists to return to this place so determined to upright itself. The fate of the region also depends on congressional appropriations.

Uncertainty persists. As do blighted homes waiting to be redeemed or demolished. No one doubts that the Crescent City is forever changed. There is no "normal" anymore. So many flagships of the city floated away. Polices officers, firefighters and city workers and denizens of society, residing in thousands of temporary FEMA trailers, are counted as the lucky ones. Others displaced during the mass exodus from the city remain dispersed in exile with no way home; nothing left to return to. Many are hobbled and hamstrung by endless red tape. The emotional toll is immeasurable. It could always be worse, so some say; but not much.

Yet it does not matter. Our dear gallant New Orleans town, we who have known and cherished your noble colors love you now as we loved you before. No matter where we go, we carry faded pieces of you. We see your beauty always within our sights, somewhere just beyond; over the shoulder. Even crusty cynics concede to the spirit, culture and ballads of a place previously called the "Big Easy." Always a haunting, potent force prepossessing the gracious looks, charm, goodwill and hospitality of another era, New Orleans is a city famed for allowing people

to rummage through bygone moments that evoke a kinder, more forgiving day.

Much has been taken away yet we are hardly in a vacuum. We dwell amid an ever-present cacophony of sights, sounds, smells, feelings, shouts, whispers…. In the bitter outgrowth of cataclysmic force de majeure and the stunning failure of the larger society and bureaucracies, we are left to contend with rebuilding seeds of hope and healing intermingled with the

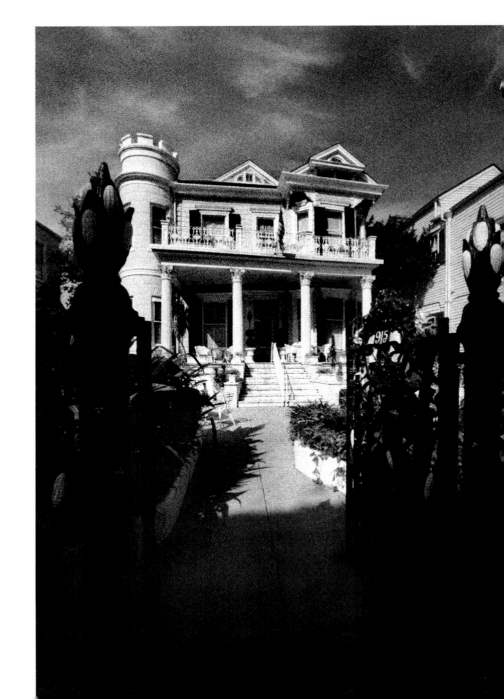

salvo of destruction. Grave peril affects the essentials of what it means to be human. It calls up and commands profiles in courage.

In times of challenge, discouragement, disruption, to go onward we also look rearward; that way we find our roadmap and the inspiration and knowledge to conquer our misfortunes. We tough out the tides ebbing and waning because we have little choice; we refuse to be plowed under.

Where have the buildings and secret gardens of the Vieux Carré gone, you ask? Where are they now? As of the printing of this book they remain softly at rest here where the sodden earth rises just above sea level. Although much dissolved with the wind, rain and flood, the Quarter's uncanny courtyards continue to lie awake and asleep mainly undisturbed as if tethered to this earth and yet somewhat afloat. Herein lies a barrage of history, unfiltered.

Whether the Vieux Carré and the Mississippi River ridge she straddles continue to overcome the haunting reverberations, legacies and betrayals of yesterday and tomorrow is somewhat up to us. If we do not move to save her, we will lose the French Quarter regardless of hurricane strikes.

As we revel in the soft sanctuary of the brick-and-stucco buildings and secret gardens that remain, we find life's footpath traces a curve and we come full circle to where we began. The Vieux Carré is the essence, the soul, the cultural home and spiritual vortex stronghold of old New Orleans. The Quarter, despite its frivolities and oversights, has long been the eyes, ears, tears, cradle and consciousness of our past.

She is a silent yet beseeching seer and sage whose walls have authenticated and recorded the continuous rise and fall of time's gavel. Fluctuations. So many clamors, mutations and changes have passed this way.

The imprints of the centuries are all engraved and storehoused here, embedded thick into the walls and soil. In the French Quarter, the twin faces of happiness and sadness, comedy and tragedy, are clasped in the same hand. It makes a silhouette framed in a grimace and a grin.

In Louisiana, a hideous domino-effect chain reaction of events beyond our control swept us into the unwelcome entwining of yet another new epoch. Without adequate warning or preparedness we were inundated, the effects spilling across all boundaries. Everywhere here unforgettable people are awash in crises, vivid and gripping. We do not particularly like life-changing events or invite the brutal onslaught of sudden wretchedness; yet we barely know what havoc lies hidden ahead just up the serpentine road lurking around the next hairpin curve. Thus we are obligated to confront and tackle whatever life flings our way. No matter how loudly we weep, mourn or rip our clothes we have no choice. Not really.

We are distraught, sad, mad, angry, frightened and vulnerable. We want to know who is accountable? Who is responsible? Who is in charge? Who do we blame? Who is the culprit! How could this happen? And who will help? Who can explain to us so many misfortunes, calamities and misdeeds untold?

Except perhaps for encountering a few knights of chaos who occasionally gallop past, answers from nigh or high rarely come. When they do they hardly ever make sense and we do not want to listen anyway. Nothing makes us feel placated, soothed or avenged. We have been unexpectedly trampled and

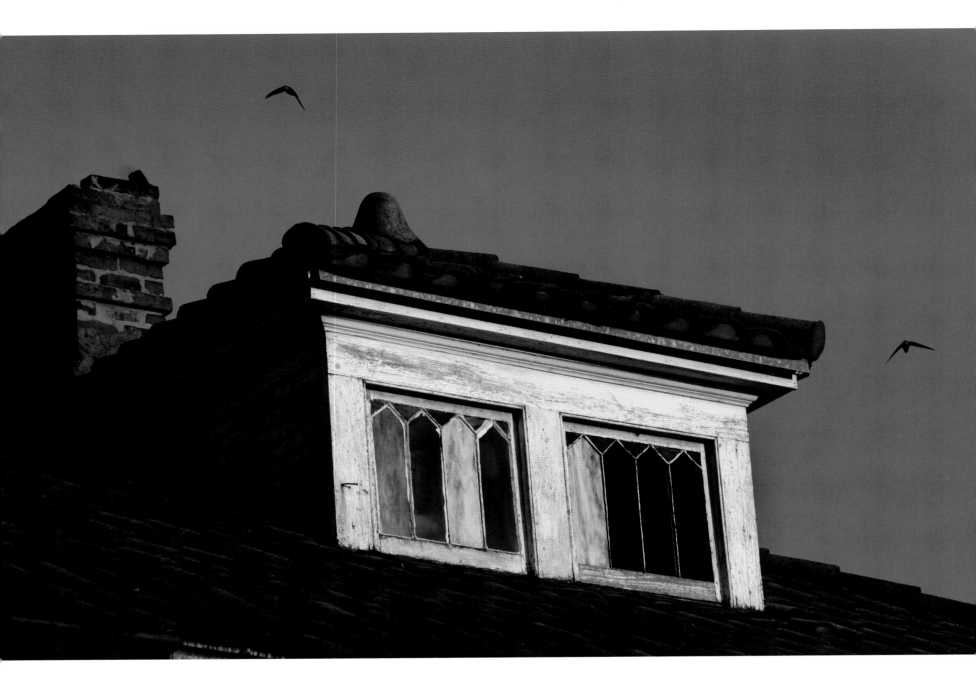

tread upon, plundered and destroyed. No sweet alibis, no bitter lullabies satisfy us. This same unilateral universal principle basically applies to all of us no matter from where our own particular pains and problems stem.

As we have come to know, there lives a well of turmoil and strife concealed just a wee bit underneath the leaky tarpaulins, canopies and presumed safety nets of life. Supposed safety, like bubbles bursting, can evanesce and disappear in a finger snap.

Nothing keeps us dry forever. No situation is without risk. Heartbreak alters everything. If you are alive it is unavoidable to not know sorrow and loss on a first-name basis. These rules of life are written to endure and cannot be blotted out.

Most can relate to the vertigo of having a familiar world snapped in half, spun around and slammed hard upside down. Sooner or later, one way or another, no matter how far or fast we run, it is something quite inescapable. Eventually the

droplets, amulets, sandstorms and deluges of cruel destiny always do seem to track us down and find us. We are snatched from coziness and awakened to starker realities. No pretty cupola weathervane can predict the fancies of fate. At any given time, fickle fortune deals a considerable or meager hand. No one knows when or where the next lightning bolt strikes or when Hades' hounds will come nipping upon our heels. A similar destiny to what has befallen New Orleans can happen to any other city, at any moment in time. All are at risk.

Some threats can never be totally abolished or eradicated. Ever. Unpredictable assailants of destruction appear rampant in the forms of nature and man or the amalgamation of both.

We learn to live with it, as they say, to weather the storm. The debt of being alive is that one day the stars smite us. There is no safe haven, sanctuary or harbor. Period. Not really. No place to hide or shore up our defenses. I call it "life's hometown insecurity." Expect the unexpected. Ashes to ashes, dust to dust. We can refuse to accept this eventuality and pretend we are invincible, for a time at least, but such pretensions do not change a single thing. And to sit on one's hands and not budge does nothing. Neither does moody contemplation. Nobody is immune. We shadow box with the unknown. Tears are equal part vindication and sorrow, so I have heard. We have traveled this rutted road before. Undeterred, we rouse a dream and rise once more.

Some roots run too deep and entangled to be separated or supplanted. There is an unbroken continuum and a strong sense of place here in New Orleans; an impassioned, quirky lineage that the people of this great American city cannot forget or abandon. Here we do not merely leave our cares behind. This town still celebrates a love for life, for beauty barren of finery. We continue to nurse our identity, embrace our culture, honor our heritage, worry about how to protect our future.

The historical French Quarter of New Orleans is a name known on every continent. This chimerical city of dreams and desire has legions of loyal fans and admirers dispersed globally. Strange internal compasses steer people here to this quizzical isle of infatuation and curiosity. It is hoped that the countless tourists who love the Crescent City and have visited often over the years — all those with a special personal connection and attachment to this impossible place — will come forward now and join efforts to look after and preserve the lingering beauty, painstaking craftsmanship, and culture of our city.

Again, thank you for purchasing this commemorative-edition book of a twilight town dimming yet still beautiful, an enchantress of the land and water. It is a telling story of overflowing imagery, a foretaste of the unvarnished coffers that lie in front of and tucked behind bolted doors and padlocked gates. This reflective work is an earnest ode to a tale of survival and endurance that cannot be recounted by mere words alone.

The photographic artistry of Guste and Sahuc that highlight these pages reveal a million pieces of what one already knows, feels and sees deeply. And who can turn away? Few who succumb to the charms of the Vieux Carré can ever disengage themselves from her beauty and tribulations. At this most difficult crossroads, those who immerse themselves in this work will be left with an avowed recommitment and heightened sense of connectedness to the French Quarter, the oldest and most revered part of New Orleans.

The romantic impressionist photography of this book follows on the heels of the great documentarists of time, those who have lovingly brought the French Quarter and her colorations to a world held spellbound.

The unmistakable sight of the Vieux Carré calls out, cleaving to the mind like a magnetic collection of art eliciting an emotional response from all. This work offers a tempting glimpse of why most who visit or live here feel their mood uplifted by her fractured fairy-tale existence. We are bewitched, bothered and bewildered in even measure.

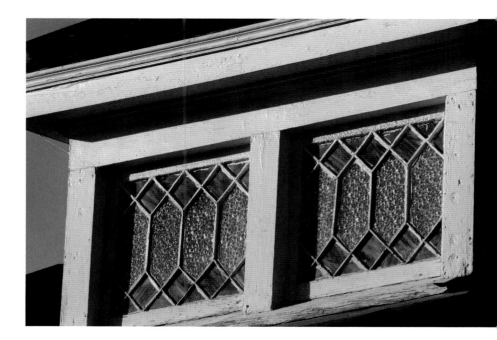

All who experience the Vieux Carré soak up the continuing presence of the past in the present. History resounds on every street corner. A taut ensemble of shadowy characters and images leave their mark on time only to recede, then advance again. Each scene here seems strewn across a theatre stage, interacting yet separate from similar previous sketches of time, every tableau strangely tied to another, half-draped and repeated. You feel that here, perhaps now more than ever; it is impossible to ignore how easily one slips into the bricks and merges with a hazy secret society of shadows.

Everything is recurrent and irregular here. Whether you have been in residence for a day, a week or for decades something takes hold and envelops you and will not let go. It is difficult to ever want to leave and some never do. Uncharacteristic and capricious mysteries baffle, intrigue and entice us, holding our feelings hostage. The fortitude of the crumpled siren called the Vieux Carré touches us deeply.

Those who love and greatly value the Vieux Carré will be inspired to place this trilogy-compilation in as many hands as possible. Once New Orleans haunts the head and hammers the heart, one understands the vital significance of ensuring the continued well-being and longevity of the Quarter, as we know it. Locals and lovers of our city will appreciate savoring a lasting memento of her enchantment.

Whether an entrenched, periodic or occasional "local" by birth, christening, choice, or simply by special kinship with the city, this book is for you. Eyes that love the French Quarter never tire of resting upon dreamily symbolic photos. These visual reminiscences, as with the milieu of the Vieux Carré, transcend temporal and spatial boundaries. We are reminded of something we cannot remember but cannot forget. Please pass this book on to others. Better yet, get them their own copies.

This thought-provoking pictorial of moving photos speaks to our innermost being, mobilizing and mustering the spirit, rallying the heart to respond. In a post-Katrina world, some continue ongoing contributions to hurricane recovery and revitalization efforts. Fundraising activities span smatterings of charitable organizations and goodwill ambassadors rising to meet the need.

It is crucial to keep New Orleans in the foreground of our country's minds and radar screens of what is important and newsworthy. The desperate, widespread need for help here on all levels is mind-bogglingly endless and not likely to subside anytime soon. For the American public, it is difficult to fathom being faced with rebuilding a major metropolitan area. A town ruptured with incomprehensible desecration, saturated with broken lives. To quote what has been repeated and handed down through time: Where there is no vision people perish; where there is vision, people recover.

Once the earth has been dug and spaded, the voice of America speaking up can ensure that the gaping holes are either used to build strong foundations and support for a new beginning or to leave a sure graveyard to bury a dismembered town. Much depends on scruples. The prevalent morals, mores and social conscience of a community and a society heavily come into play. It is up to us to sound the trumpet of triumph or of defeat and disgrace. Every little helpful sliver assists efforts to save New Orleans, and boldness is even better.

Please tell your family, friends, colleagues, congressmen and senators that New Orleans still needs help getting the badly devastated areas of the city back in operation, up and running, as everything is not OK.

Schools, hotels, restaurants and tourist attractions are opening, or at least trying to, but, for this city to survive and recover, the citizens of New Orleans look for more Americans to make their way here, as a testament and encouragement to our rebuilding efforts, either in body or spirit, as everyone can do something, to help.

New Orleanians need the rest of the country to join us in corroborating and ratifying the importance of USA soil.

The nation's reaffirmation and determination to get behind the resuscitation of a ravished American city, along with the revitalization of coastal wetlands and an adequate flood protection system, will help restore our infrastructure and economy.

Confidence attracts citizens, conventions and tourism back to New Orleans. All of this is vital to the American oil and gas industry as well.

Now that the United States has sustained an immense direct blow with unprecedented mass destruction — the cataclysm of bungled federally backed engineering and inadequate levee construction repairs when pitted against the violence of Mother Nature — are we wiser? To ensure the future of our nation, and the safety of its citizens, flood-defense programs must be correctly financed, designed, built and maintained, with proper multijurisdictional policies in place.

Americans relate best to what they know and love, the French Quarter. If the floodwaters had gushed just a few blocks more, the Quarter would be gone as well.

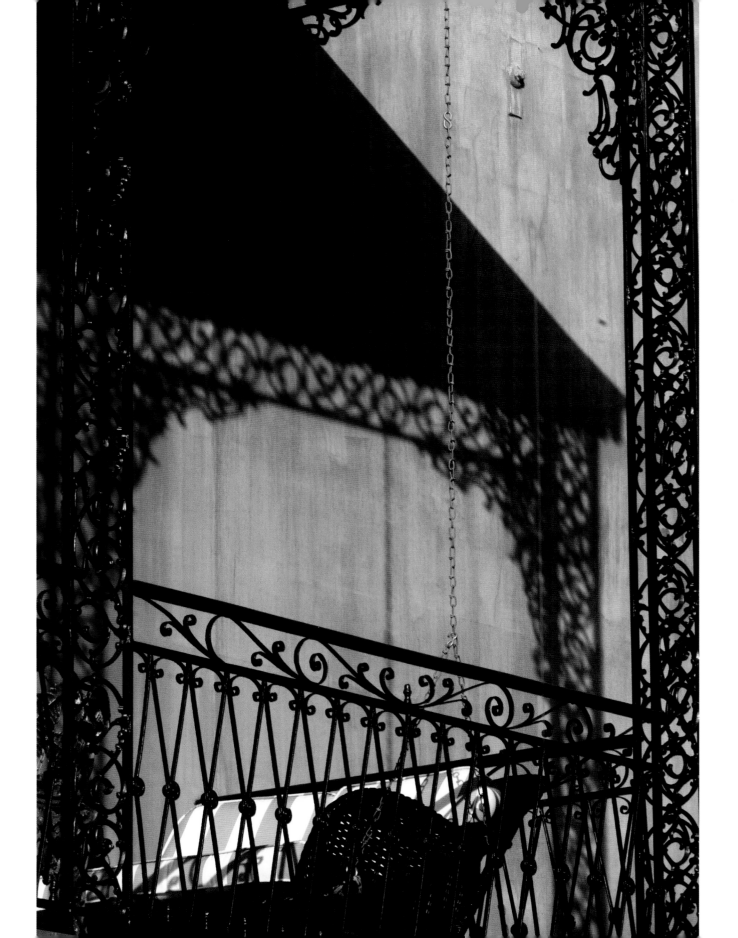

15

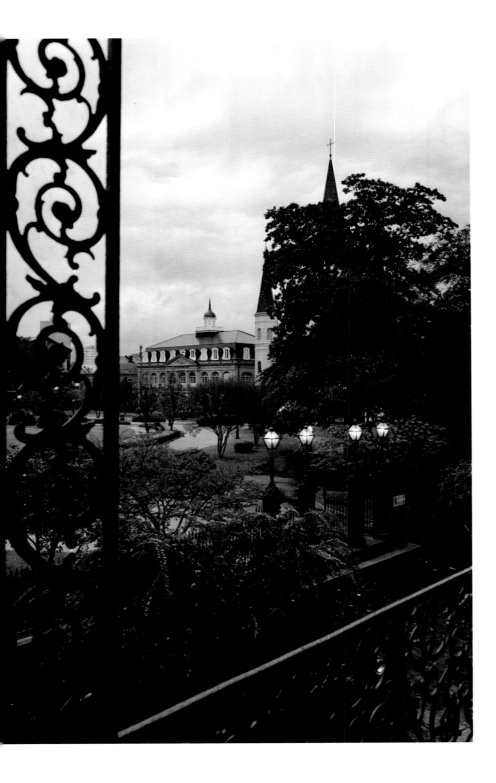

A stout assemblage of churches, temples, civic groups, government agencies, private individuals and community outreach programs continue to aid and abet the stranglehold of Katrina-related causes at hand, one dent at a time. The seriousness of the current situation is that, with regard to recovery, the surface of the hardest hit areas is barely touched, if at all. In a microwave-mentality society prone to a short memory and fleeting attention span, many have forgotten already. Meanwhile the monstrous need seems endless. Unimaginable. The magnitude and misery of this level of devastation is generally only contemplated on foreign soil, primarily war-shredded countries. But this is not someplace else, some other faraway land — it is right here and now, in the United States.

Here in the French Quarter the dark veil covering other vicinities of our hometown is never far from mind. The Vieux Carré uplifts New Orleans toward finding and resurrecting her afterlife. That said, this book project serves to benefit the brick-and-mortar preservation of what remains, the historic French Quarter of New Orleans and the legacy of Americana that resides here. Everyone must pick for oneself a personal mission and a purpose that touches us and speaks for us. Deep in the midst of the monstrosity that blanketed New Orleans, this is our mission; our purpose — while we concentrate on reconstructing and retrieving New Orleans we must pay attention to ensuring vigilance in safeguarding the immemorial French Quarter. Her venerable bellwether buildings stand poised and vulnerable at this frighteningly unsettling fork in time.

Once lost, should it come to that, the Vieux Carré cannot be recaptured; there is no ransom available to repurchase or replace her. She is our yoke of continuity with the common threads and faded fabrics, seamed together as one, of our country's history. The implications are clear. There is only one way to construe it. If it is not up to us to defend the integrity and strength of our American ancestral lineage, then to whom?

This lingering place of confluence that has so impacted and influenced the centuries, this iconoclastic city of seemingly unearthly proportions and essence, extraordinary personality and character, is not merely valued for our own personal enjoyment and fulfillment. She is a place of momentous historical value and wisdom, a special reality to be passed on to the waiting clasp of hands that come after us, the rightful heirs of generations to come.

Not so far removed from the tidewaters of disaster, the French Quarter stands poised along the riverbank's edge. A classic age-old

siren, a muse of unparalleled gravity and presence, she is our role model and soul model — a potpourri of people and culture.

Visually arresting, the Quarter indeed remains a living history museum. Here all that we know and believe of time and the outside world grows dim in our consciousness, fading from sight as we waltz along with history mired in the irresistible pull of a fleetingly real yet false reality. We do not fully see the Quarter until we conceive the beauty beyond. Then we step through the looking glass into another world; we touch and brush against what is tangible but we feel, too, what is intangible.

Before the destruction of New Orleans, before the unforgiving floods obliterated an American city, the Vieux Carré had long ago established itself as the single most renowned and one-of-a-kind precious asset that New Orleans ever possessed. The significance of the Quarter has only grown. Her continued existence assumes an even deeper, more urgent meaning and new level of distinction particularly to those who may not have previously fully grasped or understood how precariously perched is the Vieux Carré.

The lapse into obscurity can come all too quickly, without horns trumpeting. Descending and ascending from the mirage of a vertical horizon an ominous black cloud of collapse and crisis suddenly rides in like a devil plunderer in the night rampaging all that we love. All walls can come tumbling down, without warning. This we have learned.

The more people who lovingly pore over, herald, understand and appreciate the meaning behind the all-important work of love, including the nonpareil *The Secret Gardens* centerpiece work that Guste first brought to the world in 1993, the more conservation monies will be raised for the Vieux Carré. Spreading, sharing and discussing remembrances and images of the real Vieux Carré revealed here helps increase the spotlight of international public awareness, media attention and support for French Quarter stewardship. The issues at hand are many. Newfound public recognition and acceptance of the fragility of what remains will positively impact the ongoing protection of the Vieux Carré.

Again, the Quarter is not really owned or possessed by any of us. No, not at all. She belongs to no one but to herself and history, to her ghosts and secrets. We are merely the caretakers and keepers of her eternal light so that the flame might be passed on to others. Many long before us have fought for, protected and watched over her; one reason she is here today. To stir up

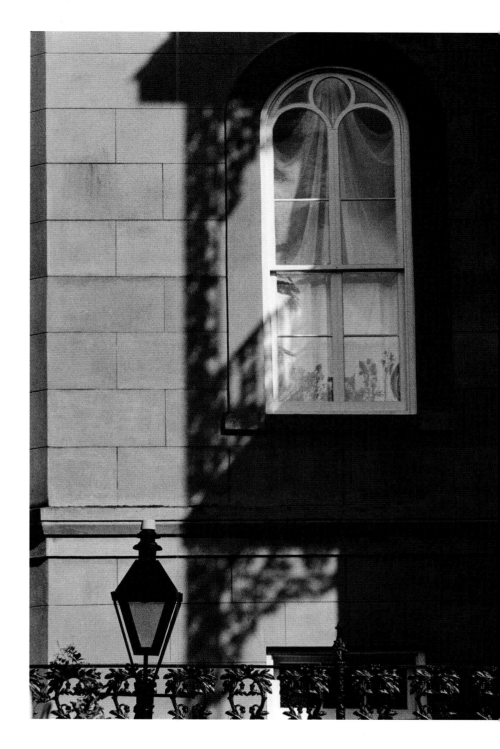

public concern for the safety and well-being of the Vieux Carré is long overdue. Through the rich layers of New Orleans, the domain of this beloved gaslight district remains the archetype of all that our national heritage stands for and represents — a vivid connotation of the sum and substance of this country.

Given the vastness of the tragedy, this post-Katrina compilation work is being introduced as a majestic and meaningful French Quarter keepsake to have and to hold close, a tangible documentation of that irreplaceable past, present and future of the Vieux Carré, something that must not be forgotten, dismissed or lost. Otherwise we are doomed to head down a one-way road to nowhere.

Despite the great epic tragedy that overwhelmed New Orleans and her people, the world continues to celebrate and cherish what Katrina and her floodwaters did not take from us; the ancient heart and soul of New Orleans — the Vieux Carré. Around the world, all know that the French Quarter survived the storm, barely, and follow her tale closely. Walls fell, roofs

blew off and caved in, buildings were damaged by wind and rain; but her principal framework, which suffered the worst of the storm, remains remarkably intact.

When so many have lost everything, people hang on to hope for tomorrow. So many at this difficult hour have long awaited the triumphant return of Guste's treasured title. We clutch tight to what we have left, the Vieux Carré. The timing is right for this three-part symbolic book, so profusely illustrated with eloquent photographs, piercing and poignant. This handbook of time is a living tribute to what we have lost, forever; dedicated to that which can still be saved — the Vieux Carré. That is at least one part of the past that we can and must hold onto.

Locals here struggle daily to keep pain from turning inward and consuming all that we have left. For the most part the grief is turned outward, channeled into the recreation of efforts to protect something magical and healing, the Vieux Carré. Sometimes the sensation of wanting to go moonwalking backward through time consumes us, but nobody successfully escapes

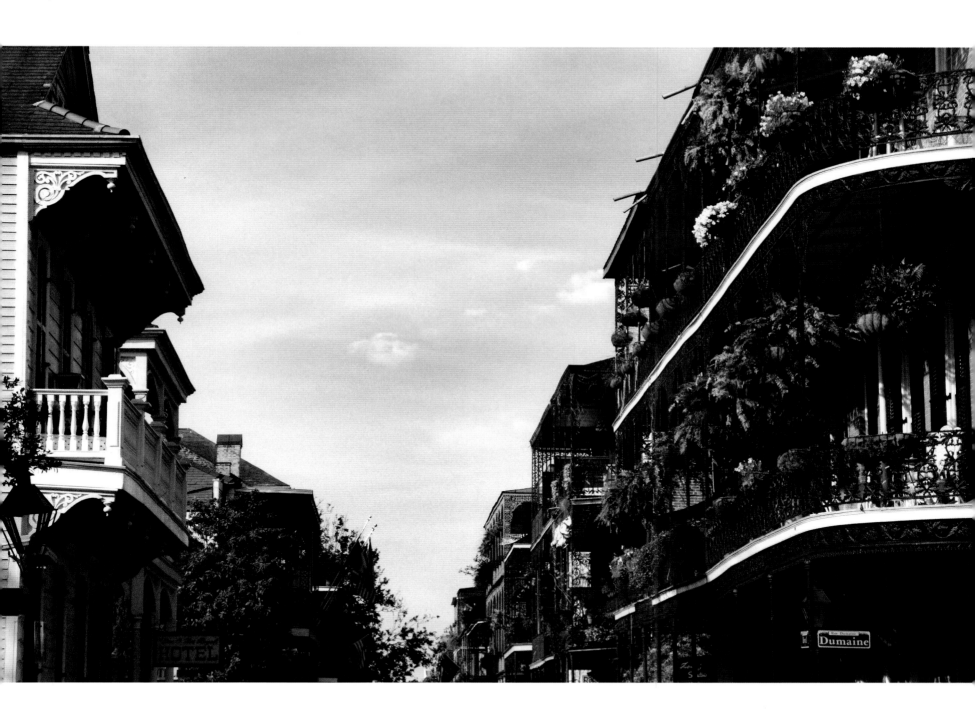

looking only backward. Try as we stubbornly might, arguing with what was does not change it because it cannot be undone, only repeated. At least the Vieux Carré is one remaining place that speaks to an unquenched thirst and yen for the earlier days, set in the shadow of today's unsteady world.

As New Orleans prepares to rebuild and reconstitute itself, the Quarter remains the quintessential site of priceless historic structures. The Vieux Carré preserves and celebrates America's legacy. She is a jubilation of diversity crafted and built by the underpinnings of a foundation constructed upon layers of ethnicities and cultures, lore and mysteries. Her exceptional existence should never be taken for granted. In so many inexplicable ways this highly publicized yet largely unsung place of desire, of days gone by and dreams reborn, remains the polestar of the aged hand that rocks the cradle.

The collaboration of new work combined with the reemergence and reintroduction of *The Secret Gardens,* in its entirely classic and original form, hopefully will encourage enhanced protection of the Vieux Carré that remains, upping her auspices. Perpetual patronage, backing and support remain crucial to establish her continued longevity. It is imperative that the world sees, knows, embraces and remembers the distinctive face of the French Quarter's physical character. Reflections of her scarred, imperfect beauty represent the inward indomitable spirit of the Vieux Carré unbowed.

Unquestionably the Vieux Carré remains a ceaseless torch-lit procession — one of the most consequential historic and unusual urban neighborhoods in the world. The town is a living metaphor plucked from beyond the pages of a paradise lost, but found. All paradises are vulnerable. Peril lurks close by. The omnipresent threat is always there, always here, present in this densely trafficked and internationally-touted city. This town forever battles against the willful or incidental destruction and dismantling of its original structure, character and charm.

The frail and yet pertinacious Quarter has long been known as a socially tolerant locus of inspiration and renaissance. It is the bond that forms a conscious continuity of a marred and yet effectively magical marriage between the past, present and future cohabiting as one. It is a union like none other. The ultimate ambiance of the fabled tree of life and knowledge is rooted here, inextricably so with vibrant leaves that grow strong and reach skyward.

Nowadays, as much as at any previous moment, most all are stirred and spurred by the spirit of the French Quarter. She is

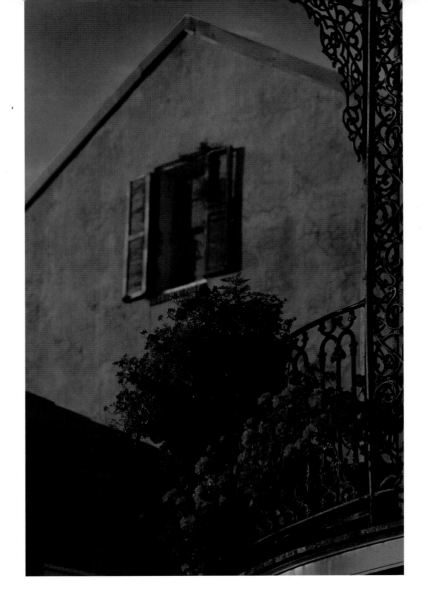

solemn yet carefree. An impassioned city etched deep with old scars and emblems, her embankment totters at the edge of an era. She is a town where sprees of random jubilee still take hold and flourish like magical mist rising from the ground. In life, there will always be moments of merrymaking and joy wrapped in the backwash of all miseries. It proves we are alive.

The celebration and solemnization of the gravity of the human condition does not mean anguish is not observed and beheld. The irregular rhythm of nature's pendulum recurs uninterrupted. The people of the storm feel a thousand years older; that much is true, as if a hundred lifetimes or more removed barreled upon us and flashed before our eyes, pulling us down and engulfing us. We are different now; every one of us.

The torrents that swamped New Orleans have stained all, even the high and dry; the sea of sorrow that submerged our city is a solitary tear shared by all, a tribute to our shared human spirit. No person, no place can stand in the abyss of catastrophe and reappear on the other side unchanged. We look for redemption of our city and ourselves, but, yes, the customs and ceremonies of Mardi Gras and other calendar commemorations always march

again, against all odds. Absolutely. No matter how embattled we are. The tune is the same even if the drummer and the music are changed. Parades roll again and laughter floats through the air. People sing and stomp to the beat. The bombardment and passing of the ages flow unbarred into and through the boundless curved crevasse of an unseen void, unending.

Foolish men pretend they can prevent the clock from ticking, or that they can at least make it pause; wise men know this is not possible. The forward step of man and Father Time cannot be turned back or even halted. Those unable to feel deep sorrow can never feel deep joy. The two are inseparably conjoined and you sense that here. In New Orleans, you come to understand that, no matter what, we shall prevail over ceaseless sorrow.

For the most part, we humans sometimes struggle against the idea that happiness resides in smudgy shadows of sorrow. But here as you survey centuries of alluvial evidence that proves joy is often guarded by the gates of grief, we are somehow better able to pry open and smash through those dark foreboding doorways and pass through into the sunlight. A bold bid for a moment of merriment is rarely wrong.

Not long ago when the oasis of the French Quarter sidewalks were still storm-strewn and littered with endless rows of refrigerators, the scraps and residue of lives smashed, while military Humvees prowled the streets and church chimes rang out, I walked along alone, lost in swarming sadness. Suddenly I noticed a caravan of black cars sidelining the street, and I considered for a split-second that tolling bells foretold of a funeral.

So many untold survivors passed away after the storm. Some died from the darkness of a crumbled heart that would not mend. The vise of sorrow has a strong steady grip, silent and deadly. These fatalities are not counted among Katrina-claimed victims but they should be; they are, in fact, casualties of the storm.

And so, with an edge of tentative, morbid curiosity and fascination I hung back with eyes affixed to the church door to see if I might recognize anyone. Suddenly a whirlwind bride wrapped in a quivering wad of resplendent finery roared out of St. Louis Cathedral, like a white tornado, her procession firmly in tow as she descended the steps with flowery bouquets in hand. My mouth fell agape. I am talking about a time of shortages of basic necessities that make life comfortable, when it was still hard going to find meals, everyday staples and supplies here, much less contemplate a razzle-dazzle wedding. All I can say — I was not unmoved.

At first glance this normally commonplace ceremony looked ridiculously out of place in a post-storm primal and primitive world; I could only stand and stare. I gawked, dumbfounded, at the group in snazzy top hats and formal tails grinning happily as they marched and pranced on down the street, complete with snapping umbrellas held high overhead and protruding into the sky.

I stood and stared at the swooping grace of a fluttering sea of white hankies being flounced and shaken overhead toward the shadowy sun — so wonderfully awkward yet defiant in the midst of such chaotic disaster and detritus. As I eyeballed the second-line band leading the way through Jackson Square and on down the street, for a moment I felt stricken with the harpsichord of something deeper than is explainable or understandable. It is like the urge to cry and laugh aloud simultaneously and yet... you can barely speak. Words do not come. The eyes mist over. Something sticks in your throat and wells in your chest because you are an up-close-and-personal witness to the encircling spiral of life redeemed.

And then you realize that this is how the French Quarter feels — all of the time. I am so glad and grateful to be a part of a place that honors and celebrates the never-ending ceremonies of life. Now I believe it when people say that the journey goes on, come hell or high water. Joy is found and gardens flower again.

The unbroken cycle of creation and destruction, the change of seasons, religious faith, birth ceremonies, death and burial rituals, jubilation and suffering are quietly understood, if not indeed shared, by all humanity. The cycles of destiny come and go irreversibly. We cannot stop the momentum of a universe. The world, as even early mankind knew and respected, moves in a never-ending circle. We all dread the descent and voyage through inevitable dark waters, the umbrage of black clouds, preferring to delay and sidestep the journey as long as possible.

The mythology of the story has been told over and over in endless ways yet it is the same parable. Life spews at us. To survive calamity, downfall and destruction is to be reborn stronger. So they say. I suppose that certain endless universal rules can be deduced from the French Quarter. What is ancient is presumed

wise. Much like a complex labyrinth, the endless cycle of life winds into an elaborate maze, an embellishment within itself. In the Vieux Carré one sees how trodden paths weave back and forth between quadrants, creating mystery within the walk, something pleasantly powerful even to this day.

Here we brush close to the epicenter, sometimes traveling on the outer perimeter before entering the middle ground of yesterday, today and tomorrow. Although this world appears to be crumbling it is difficult to let go of something that seems already gone. Yet this is a town where we do not paint ourselves into a portrait picture and fade away into the night, giving in to powers of destruction that are always there waiting to feed on us. No. We are a community that holds fast to the roots of withering flowers that lie deep within our secret gardens, weathering the elements until they are lovely fragrant blossoms again.

The world rejoices that the Vieux Carré outlasted the wicked wrath of Katrina, her sweeping hellish wall of water and the colossal failure of levee breeches and floodgates fallen; and although the primordial French Quarter did not perish into the ocean of woe that swamped and devastated much of greater New Orleans, the population and caretakers of this most enchanted place are deeply affected by profound personal sorrow. Whether recorded and obvious to the naked eye or not, the losses are extreme.

Of course no one here is untouched by tragedy. So many who make up the stouthearted backbone and peripheral edges of day-to-day life in the French Quarter, those who make up the workforce in all capacities — from laborers and service staff to leaders of the business, entertainment, medical, hospitality and art communities, to longtime custodians of the Quarter who serve in governmental guardianship positions such as police and fire rescue and historic commissions and councils — lost everything in the storm. Some lost their lives, as well. Others remain missing, never to be found. Regardless of where those in exile are now makin' groceries, grocery shopping that is, their hearts remain here in New Orleans firmly planted in this damp earth just beyond and beneath sea level.

This place of ancestral and ancient soil is a curious alchemic mixture of so much more than can be seen or caressed; sometimes only that which can be felt with the head and heart provide the anchor for what refuses to give way and vanish.

Many stayed here in the Vieux Carré during the cataclysmic storm and never left, riding out the pandemonium in the streets; others who did evacuate returned as quickly as possible — with sleeves rolled up to offer aid to survivors and help clean up the backwash of storm-fed stagnant stench and debris littering the streets — in order to bring the Vieux Carré back to life. This happened sooner than anyone could have anticipated. Without divisiveness, all worked together to help feed and house one another. It worked. Life forces here got up and running in record time.

In a post-traumatic New Orleans the will remains strong, stronger than we know. It always has been. Always will be.

Memorable cities and characters thronged in crises continue to capture the world's thoughts, ideas, imaginations and hearts.

The French Quarter has always been known for an extravagance of eccentricity and excess of behavior. A sprinkling of swashbuckling, as well. It is a place with a flair for the arts of living. Although it is an everyman's town, it is not a site relegated to the practice and principles of mediocrity or normal convention. Cracking catastrophe did not rob or deprive the Vieux Carré or extinguish the flame of cultural identity. Here loud laughter, singing aloud and the celebrations of life are never viewed as improper. That which might be maligned as being warped and strange elsewhere is perfectly acceptable here. People are free to be and to reinvent themselves no matter how "artistic." Frivolity, foibles and follies are frequent. Life is not fixed, unyielding, rigid. Serious frills and madcap escapades are as colloquial as they were in colonial times. It is permissible to change your mind, change your way.

Our town is not a sinking showboat that can be moved and replicated, it is the real home, of real people, with real faces. Basically, we remain polite people, a society replete with humility and forgiveness, but some of us have been floodwater-reborn with an uncompromising edge, unbridled emotions and a slight swagger, whereas no answer is no longer an acceptable answer; this is part of survival.

New Orleans has been unmasked, our secrets laid bare. Among other things, our crusty sense of fatalism, risk and the fragility of life are exposed. Yes, perhaps only a true local could understand how and why we return home, as quickly as possible, to stay put, to look beyond the continuity of extreme discontinuity, chaos and disorder. To some, this is peculiar behavior. However, our beliefs and attachments are such that we accept the gloaming of eventide and watch with expectation for morning to come.

As an unadulterated ode to surviving and swimming out of a sea of sorrow, where else but in the Quarter would — not long after massive forces wrecked the Crescent City — an undeterred dinner host prepare a sumptuous 1700s banquet table setting with crystal, china, tall taper candles and real artifacts of shrunken heads adorned with scattered strands of primitive teeth and skulls; and nobody at the spontaneous soiree think it odd? In what other city could you possibly spy a pirate strolling a pet monkey down the street? Here we play chess on the sidewalk. Observe voodoo rituals. Decide to wear a headdress of festive feathers plunked atop your head. Or, for that matter, a decorated

lampshade in order to go out for afternoon tea and cocktails. Such personal indulgence is really quite fine and altogether perfectly acceptable.

Where else, I ask, would you encounter a stunningly glamorous and gloved socialite who drives a Jag and yet enjoys the hurly-burly drama of selling wraparound sarongs in a weekend French Market booth? Name another city where you can gather

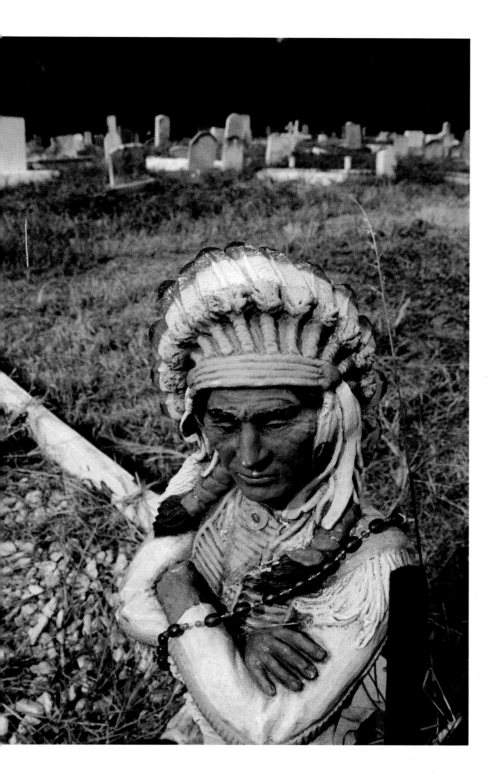

your undestroyed and undeterred surviving posse of pals together for an impromptu parade down the street just because you feel like it? Here, that's where — because you are alive, pulled through the storm and want to whoop it up. Here you find a funky fun friend who drives around with a baby kangaroo stashed in the backseat. Here you can observe cedar-lined closets that contain more costumes than clothes; and find centuries-old homes with bones buried in the walls and attic.

Tell me what other town deems summertime seersucker suits and straw hats de rigueur attire for proper gentlemen… huge hats for ladies…along with the resumption of all-day-long Friday luncheons? No place. That's where. Eccentricity is never a problem here. Camaraderie is always quite in order. Peculiarities are considered normal. The moon has a different opalescence. These things did not wash away. Even the humor of a drink called the Obituary Cocktail is still reveled; more than ever. There is no place else, anywhere, like the Quarter — there never will be again.

As it was in the beginning, the Quarter remains a steadfast guardian angel, golden goose and breadbasket of the surrounding parishes. The Vieux Carré is a lighthouse amid blackness; the quintessence of what a destroyed old New Orleans depends on to give life support and hope to the rebirth of a new New Orleans. This is the mysterious site where the aurora of the ages lingers. The Quarter remains the center of consciousness for the city.

Still, considering the scale of the debacle and ongoing suffering of our neighbors, it is endlessly difficult for all here to grapple with the surrounding soul-slicing devastation of New Orleans. The aftermath takes its toll. Despite the good fortune and survival of the Vieux Carré, nothing assuages the shock and horror of losing so much of Orleans Parish and more. Some who do not reside here have a distorted view of the path of destruction; they do not even begin to fully comprehend how many neighborhoods are truly gone — totally wiped out.

Many proclaim that New Orleans was a city long ago slipping away in a steady, steep decline, which is absolutely true yet untrue at the same time. Prior to the storm-swept destruction of Katrina, the Crescent City was deteriorating but, equally, undergoing a renaissance.

The obliteration is not merely confined to one isolated area or section of town as some are mistakenly led to believe; nor is it restricted to one socioeconomic group.

Things are patchy. Poor, middle class, well-to-do, old, young and all colors, faiths, cultures and backgrounds have been plagued and scourged by the storm's curse. Endless miles of homes and businesses ransacked by raging floodwaters. Some have been luckier than others, but the catacomb trail of destruction intersects, dissects and cuts across all lines. The valor to retrieve and rebuild our city also knows no boundary lines.

One need not travel at times of crisis to Baghdad, Afghanistan, Somalia, Kashmir, Indonesia, typhoon-slashed Thailand or any other nation if one merely wishes to witness the tragedy of a city grappling with the repercussions of nature's consummate carnage. It is here, sadly and shockingly so, on U.S. soil. In New Orleans and the Gulf Coast the angel of death passed over many houses, knocking unexpectedly on a myriad of doors. We cannot brush off the images we witnessed, or that the world watched wide-eyed in the media, of those the storm claimed and took from us. The presence of the victims is marked indelibly in the mindset. The ruin and rampage stretches as far as the eye can see and the heart imagine. Photos and videotape snippets only impart an itsy-bitsy artful sliver of what the smashed site of apocalypse now looks like at the scene.

It is an unthinkable vision barely conceived by those Americans who do not live in these tragic regions. One has to gaze across the blighted horizon of Hades to even begin to fathom the brackish hell on earth, the abyss of misery. Imagine your worst nightmare come true, multiplied and expanded on an immense scale. Only then might you have the slightest inkling of what the demise of a great American city looks like, up close and personal; hardly a make-believe doomsday saga, something Hollywood dreamed up. This is real, real, real. The catastrophic onrush and aftereffects of the killer storm and her waters inflicted an unmerciful, relentless reign of terror and atrocities upon all of New Orleans, leaving behind a morbid, mangled landscape. You have to cast your eyes upon a gutted community at close range to even begin to understand or fathom what is basically inconceivable to the human mind.

Yet, from all walks of life, the courage, conviction, dignity, honor, bravery and gallant resolve of this city continues in ways that this country has seldom, if ever, seen. The greatest acts of grace and giving, grit and guts, brief moments of lingering heroism and selflessness, the things that make us human and connect with our consciousness, are rarely recorded by film, caught on camera or printed in any book. Most profiles in courage are private.

The people here are hearty souls, tenacious and determined, graced with black humor and laughter fashioned in the face of despicable darkness. We do not give up and surrender easily to any Armageddon. However bloodied and blistered, we persevere to bathe in the briny pungent sea of hope and resolve, for locals await a new day and the opportunity to reclaim battered homes and lives. With the right help, that which is critical does not have to be fatal. This is home. New Orleans is home. All seek what is home and the ability to be able to go home. Homecoming is always sweet sorrow.

As large portions of one of the most beloved cities in the world lies in ruin, the hurricane-imposed exile of New Orleanian evacuees from all segments of society is beyond heart-wrenchingly painful. Not only are many storm refugees still stripped and split away from the structure of familial connections and a beloved city, much of their familiar surroundings and hometown city are gone. Period. Most people want to come home, regardless, as soon as possible, no matter what; clearly "home" takes priority and precedence over shelter no matter how lavish the shelter or modest the home. Home is not soon forgotten.

Although scores of New Orleanians remain scattered nationwide, an American Diaspora with no coherent voice in the media, if they could speak as one they would say that New

Orleans is their home, love and life. This fabled city rooted deep in the shade of ancestors, culture and celebrations in places where cement angels and crypts at rest take on a life of their own as an integral part of the family.

Groups such as The National Trust for Historic Preservation and Preservation Resource Center of New Orleans, as well as numerous other unnamed volunteers, are working hard not merely to bring people home but to bring them back to the kind of home and city that they remember: a New Orleans saved and rebuilt. In a modernized world where things old are knocked down and trucked away, where there is no end to brand-new housing developments and suburbs, places like New Orleans and the French Quarter that truly revere and sustain the past are anachronistic. Yet vanishing rarity or not, here is where precious bits and pieces of splendid history are recalled and clung to.

With the help and encouragement of these American heritage groups and others, like-minded people are working hard to maintain and resurrect the matchless fibers of the country's origins that linger here in New Orleans. I am speaking of saving severely damaged homes where ancestral heritage and culture have resided hand-in-hand for generations.

Since our country has been a uniquely blessed, gifted nation, it is sometimes difficult to accept the scope of undiluted, staggering awfulness, as we have never before seen it. Our country has nothing to compare it to. Thus, as noted, without seeing it for yourself it is not possible for anyone to realize or grasp the magnitude of the ruination. You must set your own eyes upon it; on the dreadful enormity of it all. There is no other way to "get it." People need to see and stare at it with open hearts to truly comprehend the desolation. So many here have so many stories to tell, to those who will listen. For those who do not live here, or who have not been here post-Katrina, New Orleanians hope and pray that many of you will take the open invitation to accept the challenge. Come as you are. As soon as possible. We need your presence more than you know.

To journey here is to take an all-important road trip to take stock and pride in the real pulp and original authentic heartland and heritage of America. Please do not waver or wait. It is we the citizens of our country, who have a say and hand in shaping tomorrow, who are charged with safeguarding and valuing our own American heritage. Or the scarcity thereof.

Fortunately and thankfully, countless Americans and Capitol Hill were caring and concerned enough to pilgrimage to see the site where the twin towers fell. Yet many remain reluctant to tour hurricane-torn areas of the Gulf Coast. Why? How come? New Orleans is where an entire U.S.

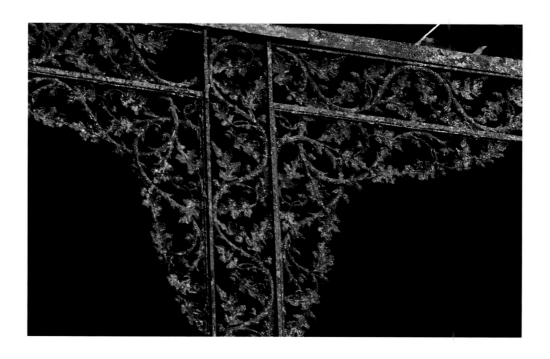

city fell. And more. An entire region. Those who went to survey the infamy of twelve square city blocks of Ground Zero will also be deeply affected by witnessing the horror of hundreds of square miles of City Zero. Take heed. This is a

soil — they wake up to the reality of reliving this horribleness every single day. The victims lost here were not brought home in flag-draped coffins yet they leave a mark; they speak for America and for America's future.

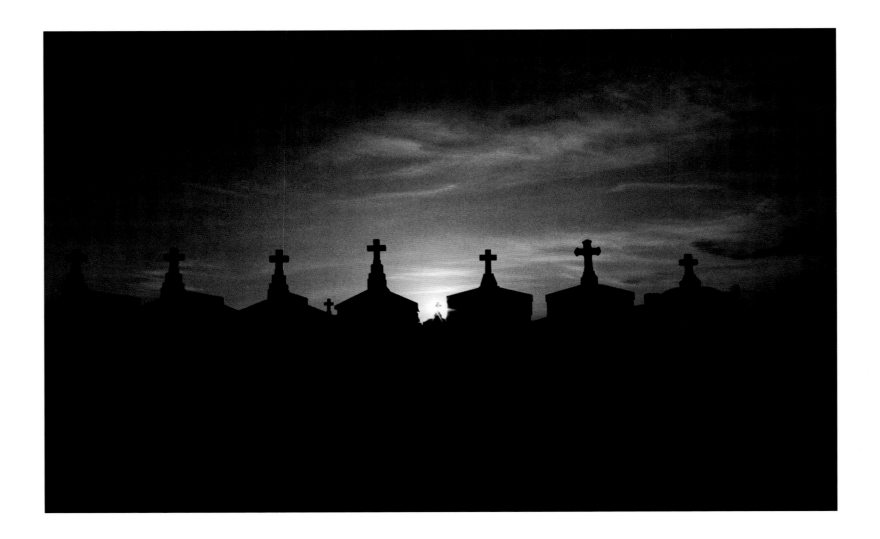

place that will not leave you undisturbed. It will change and shock you, chisel sharp into the core of your conscience with unsettling thoughts, visions, insights and memories you will not soon forget.

The City of New Orleans and her people are unable to flip off the television, bypass the newspaper, pass the bread and block out the tragedy of Americans and the annihilation of American

Should New Orleans be rebuilt, you ask? The sentiment of the question slices and rankles New Orleanians to the bone, as well it should. There simply is *no question* about it; we cannot let such a major city disappear; we cannot in disregard let sink all that New Orleans has been and must continue to be to the nation. The very question — bantered about by primetime pundits, authorities on everything and nothing at

all — unjustly minimizes and leaves one in clear denial of this Great American Tragedy. New Orleans is an important flashpoint of incalculable depth and devotion and emotion deserving more thought and serious attention than reduction to freeze-dried superficial sound bites and conjectures. The darkly emotional disaster and upheaval here, the collateral damage inflicted — and how we react to it — parallel the essentials of being a human being.

All of this outlines the truth of what America is and is not. For those busy maligning this great American city of dignity, grace and substance, here's news. Come lend a helping hand. Get involved. Let the true situation sink in. Secondhand information doesn't even begin to adequately convey the extent of what Katrina did. Only by seeing it in person and on the ground can one truly appreciate what happened. So many other national problems pale in comparison. This city and her people have already suffered, excruciatingly and horrendously, quite enough. No additional harpooning is needed. The recovery and reconstruction of this decimated region sets the prevailing tone of our country and for our nation's future.

Yes, there are personal drawbacks and social responsibilities involved for Americans to step up to the plate and help an American city. Yet the call to action is the founding mortise of our country. Our roots are those of an egalitarian nation. Life is not fair but that does not release us from our responsibility to try and make it so. There is no absolution for Americans who sidestep the human dimension of helping fellow Americans. The Crescent City needs people who care.

Why should New Orleans be rebuilt? Those here at the heart of the disaster, those infrequently afforded the time, venue or opportunity to respond to this much-publicized national remark would no doubt gladly answer with a like question: If New York City were to suddenly vanish from the map, should it be rebuilt? What about Washington, D.C.? Boston? San Francisco? Los Angeles? Chicago? How bleak, ruined and fallen would the world be without the luminous glow of these great and magnificent cities?

Should the displaced population of a demolished cosmopolitan city merely be advised and admonished to migrate *en masse* — like a million-strong nomadic people-of-the-storm tribe on a forced move searching for distant terrain? Every city is vulnerable to an unconditional mega-disaster of some sort. Who picks and chooses which American city is disposable?

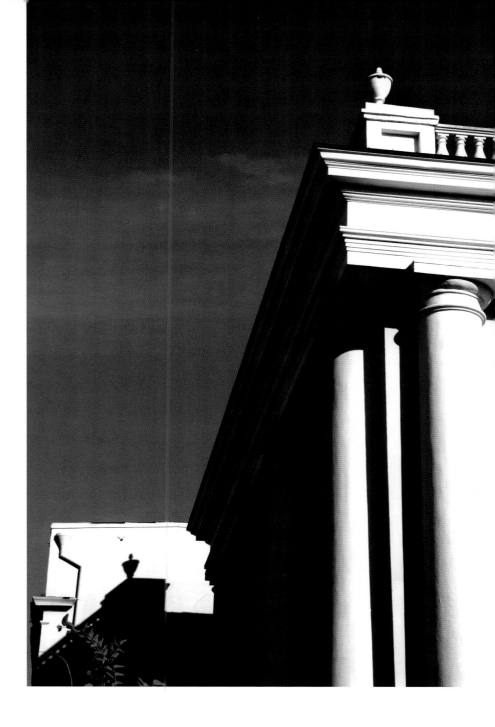

Yes, New Orleans has a long and abundant record of combining a handclasp of the saintly and sinister, grandeur and squalor, revelry and violence, secretiveness and corruption, erudition and illiteracy, but who carries the impunity to cast the first stone? I know of no great city anywhere entirely free of these things. The contrast between sacred and profane is perhaps more pronounced and visible in New Orleans. Always a vivid

place, it is one of the oldest cities in America, and Louisiana is among the earliest territories in the country with a deep, abiding respect for the Constitution of the United States.

Few if any cosmographic cities other than New Orleans have roots that go deeper than any fallen oak or concrete foundation. For the knitted population of an entire American city to be spread out, splintered and assimilated someplace else is unprecedented. If the tides were reversed — and the tides regularly change direction as the earth rotates and spins — I ask, where would you go? What would you do if suddenly, tomorrow morning, your hometown or city collapsed, evaporated, ceased to exist?

What if one day your own homestead, neighborhood, business, church, car, school, stores, neighbors, doctors, friends, family, pets — everything you know, love and depend on — simply disappeared? Who can answer such a question and why should he? It is something so bizarrely hypothetical that no one should ever have to consider it. For those who choose to close their eyes and minds to disaster, thinking it always strikes somebody else, a little reminder: it can and could happen to any of us. There is no high or low road to disaster.

New Orleanians search out and exhume traces of hope on the horizon.

The innocent residents here are blameless and without error for previously feeling as safe as anyone else; the avoidable failures of collapsed floodwalls are not the fault or mistake of the citizens. Guilt and shame belong elsewhere, not here upon the heads of the ordinary man. New Orleanians had faith in the life they led in the city they love; they believed what they and their ancestors were told over the generations. The deep-rooted culture and spirit of New Orleans was founded on this soil long ago, not just recently. Most New Orleanians did not err or make bad choices. No, that is not the case at all. New Orleanians are not suffering the consequences at hand because of any culpability on their part. Most people everywhere realize that the everyday common folk of a country are not necessarily able to effectuate major influence or impact over choices made by leaders and those in power.

As we see in the United States and worldwide the unexpected and uncontrollable rampage of catastrophic forces, whether put into motion by man or by nature, suggest a cruel, cunning, erratic foe often blindly choosing targets. The punch delivered can be a glancing wound or a fatal knockout: a flash fire, earthquake, typhoon, tsunami, tornado or bombing, the string of potential culprits of mass destruction is far too long to even *begin* to list.

Big buildings, tall walls and hilltop fortresses provide no guarantee of safety. We can always take measures to be safer and that is something we absolutely must do; that much we owe ourselves, principally for our own sense of security and peace of mind. Yet clearly there's no guarantee; no true safety, ever. The world is a patchwork of danger zones. No city anywhere is foolproof.

In the blink of an eye, worlds collapse. No matter who you are or where you live. To omit this bothersome truth is to ignore a perilous road. Tellingly, the careless or callow deed of indifference to suffering and misfortune is universally not accepted as just or right. Most who live through and survive nightmares believe it better to stagger beneath a broken heart than to be afflicted with a hardened, hollow chest cavity. To trivialize by ignoring the struggles of fellow Americans only serves to squelch dreams, to stamp down on the backs of already cracked spirits.

In an era often characterized by rampant cynicism, it is better, lacking firsthand knowledge, that we search deep within ourselves for genuine compassion and empathy. For who knows whose

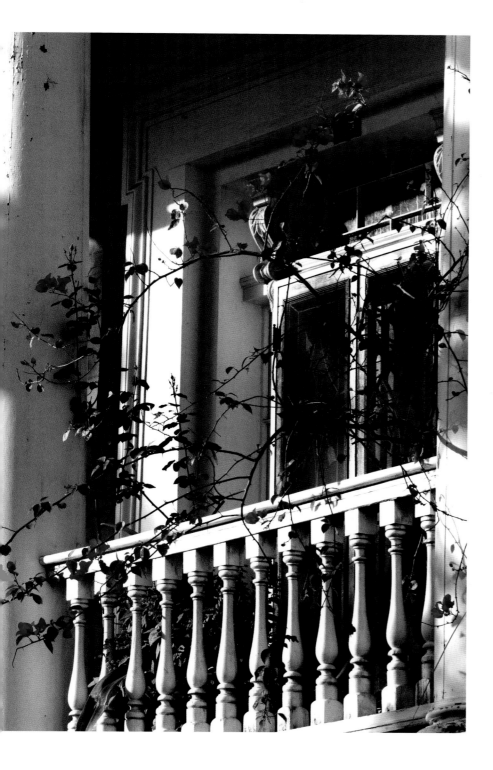

terrain; torment is great. We search for an abridgment across the "no man's land" desert of dissolution where gardens once grew and people lived and laughed and loved; we search so that we may turn blighted soil back into the land of milk and honey. This applies even to places already long ago siphoned of their succulence. It can be done; it has been done before. We all hope and trust that rescuing, healing hands are outstretched when the need is great, when the call goes out for help and guidance. Everyone needs something solid to lean upon to help upright one's bruised and fallen self.

Calamity leaves a hefty fingerprint on shaping the future. Yesterday can eclipse tomorrow. Destruction leads to change. Many things conspire to consume and wreak havoc upon a city; the Vieux Carré a prime example; her scarred appearance contoured and mottled by the ages, by insults of elements and adversities. The Vieux Carré has known "abject misery, crying, sobbing" of the people, words solemnly spoken by the city's Spanish governor in the late 1700s after a catastrophic Good Friday fire transformed the city into smoldering piles of rubble.

Indeed, more than once this old city constructed and sculpted from an island-like swamp wilderness has been raked and ravaged, transformed back into the ashy scrapings of a dismal wasteland. Fires in 1788 and 1794 swept through and leveled the city and forever changed the fundamentals of its architecture. That is why the French Quarter is primarily Spanish-looking, not French Colonial. When *la Nouevelle-Orléans* became *Nuevo Orleans*, after the fires, Spain's overlords mandated that roofing materials made of baked tiles and quarried slates replaced axe-cut cypress shingles on public buildings, homes and businesses. Burned buildings were reconstructed in brick architecture with an altogether different look and actual footprint. Long, narrow lean Spanish-style town homes with steep accents and rear courtyards replaced the previously typical galleried genre of French settlement structures.

Yet regardless of what is foisted upon us, our city emerges from the ashes. Our ancestors understood the promise and the peril in the dream unraveling; the human spirit is willful and resilient when it comes to rising from the engulfing ashes or waters of consummate catastrophe. To love New Orleans means that without her you are lost and incomplete. This is a city espoused to its culture, a place of treasured memories where people go forth again.

Like many here, Guste and Sahuc actually stayed put in the city during the storm and flooding. I did not. I left with my

turn comes next at the wheel? We can only hope it is not us for whom the bell tolls and the dark clouds gather.

Clearly unless one has thirsted, toiled and grieved on site, it is difficult to fathom the cruelties of navigating hardscrabble

family before Katrina's landfall, although not so willingly; it is hard to leave behind the stubborn and stranded, the foolish and infirm. Many from all multigenerational corridors of life had no way out, period; no choice but to stay, batten down the hatches, ride it out and pray for a miracle. Escape was *not* an option for everyone caught in the hellish bull's eye of Katrina's deadly path.

Later, both Guste and Sahuc each eventually made their way out of the city, as most, though not nearly enough, inevitably did. After the levees broke, Sahuc found a way to flee to New York City and stay with friends; however, Guste's getaway took

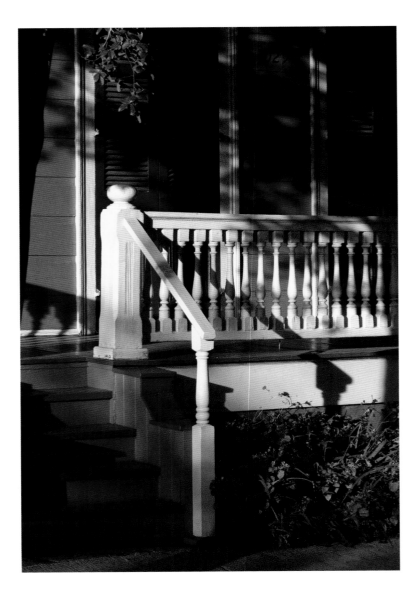

longer. After Guste broke away from a fast-swamping New Orleans, he lived a nomadic gypsy-like odyssey, moving about and staying in a variety of Louisiana settings, later spending several homesick months with kindhearted friends in California, all the while longing for the day he could return.

As with Guste and others, ricocheting around the country has been and still is a way of life for displaced New Orleanians. Yet everyone is profoundly thankful for the outreaching kindness and understanding of friends, relatives and strangers; in time of need and crisis the generosity and caring of well-wishers makes a big difference in countless lives.

Thus many have journeyed on the long harrowing trek from here to there, and back, all the while dreaming of a return to this place they love best.

Guste and Sahuc were each finally able to return, at separate times, back to the one-and-only Vieux Carré where they are both now ensconced in their respective homes. Permanently. Each, as do all survivors, has tales to tell, thoughts to share, deep scars to show.

I shall never forget the last conversation I had with Guste shortly before the phone lines went dead and the hurricane struck. We both knew then that the worst was to unfold, that imminent disaster was bearing down fast. We both realized the Vieux Carré might vanish entirely. Neither of us felt at all sure that the Quarter would be left standing. As well, we were unsure if Guste would be among the survivors. We made a vow to bring the haltingly priceless and haunting *The Secret Gardens* work of beauty back into the hands of the world, despite what or who might end up forever lost.

We fully believed that the pictorial might finally be republished as an historic account and documentation, a tribute to a fallen French Quarter that exists no more. In retrospect our fears were well founded — our worst-case nightmare scenario of losing the Quarter nearly materialized.

The many mesmerizing places so lovingly depicted throughout this book have endured by a slim margin of miracles. The Vieux Carré escaped the debacle of the ages by an angel hair's breadth of separation, something we are soberly reminded of daily. The dateless world captured in Guste's and Sahuc's work is still with us; it has not been forever lost. However, Katrina and her aftershocks are not the be-all or end-all of current and future thunder; and cultural sites always teeter and languish right at the cliff's edge.

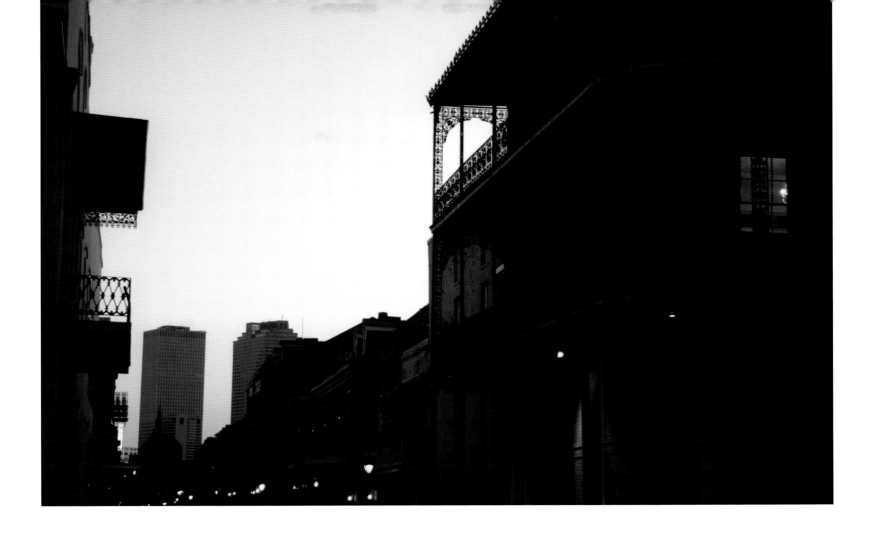

So we fall back into time and embrace the elusive and poetic charms of this fortuitous place of torrid temperatures and inclement weather, transmuted wood and masonry, iron and glass, clouds and mist, light and shadow — all of which together transmit the mysterious force and weight of life, its façade and reality, beyond the turbulence and debris.

The Vieux Carré remains our flambeau in the twilight, casting light upon the darkness. The French Quarter is perhaps the most written-about of all cities. Here we find solace and contemplation. As we study the silent revelry of the Vieux Carré's secret gardens still flowering, we accept, despite all, that the annuals and perennials of life do return, though never again in quite the same way. The French Quarter — which has for centuries remained one of this nation's most important and relevant symbols of survival and steadfast long-lastingness — is a true *tour de force*, prevailing over the toughest calamities, wars, weather-beating and other difficult geographical conditions.

Those who know and understand our basic American beginnings need no reminding of the key role New Orleans and her Mississippi River site played in developing this nation. In fact, the unique role of this city is known around the world. Not so long ago America's fortunes were tied to New Orleans. Now the future of New Orleans is dependent and founded upon the memory and consciousness of America. The unsealed prospect is in our nation's hands. We can either banish her to the graveyard of an abandoned city or be a part of her triumphant resurrection. We can decide to buck cruel contretemps or lie down and surrender.

Although many have forgotten, dismissed and diminished the historical lessons learned, most Americans are personally and profoundly and fantastically grateful that our country's pugnacious founding fathers possessed mettle and reams of valor. Otherwise where would we be and what flag color would we be living under today?

Indeed, the origins and genealogy of our past are densely populated with nervy names of those who had sufficient stamina and conviction to not only settle and develop this great country but to rebuild after calamitous disaster. It is humbling to think about it. If not for these pioneers there would never have been a New Orleans or a French Quarter for the world to know and fall in love with; we would have no legacy and the face of America would look quite different today. Our entire culture and so much that we supposedly hold dear would be altogether different; the carriage and hue of our nation would be greatly diminished.

And for Europe, too. Who can imagine a world in which the great cities of Europe did not exist? London, Paris, Amsterdam, Madrid, Rome.…Yet they would not be there today if, after centuries of wars, hardships and disasters they had simply been discarded. Civilized societies supposedly long ago abandoned the

sentiments of cave dwellers and nomadic early man. Civilized societies build and rebuild cities and value their citizens.

As a nation and as individuals building the nation, courage under adversity is hardly new. The frontier pioneers and settlers forged ahead across corduroy roads of logs layered atop difficult terrains of muck and mud. The steadfast venturers made long, arduous journeys across soft, treacherous marshland; sites where wagon wheels often bogged down, making normal passage impossible. Roads cut across difficult terrain, once settled, were not easily abandoned. Our ancestors did not retreat from adversity. They stood their ground. In olden days our country's leading patriarchs and matriarchs came from morally strong stock, prepossessing characteristics that served them well from adulthood to the tomb. New Orleans does not belong only to people who live and work locally; the city belongs to this country. It is an integral and founding fiber of the fifty stars and thirteen

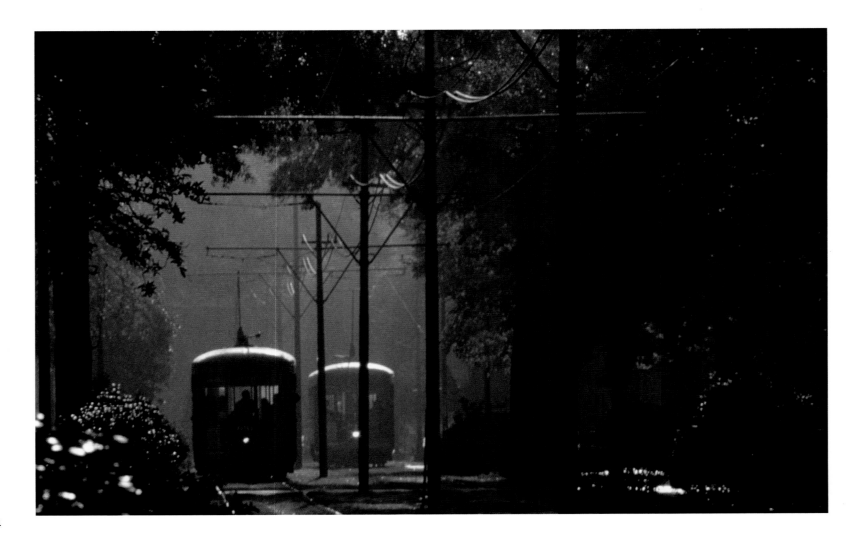

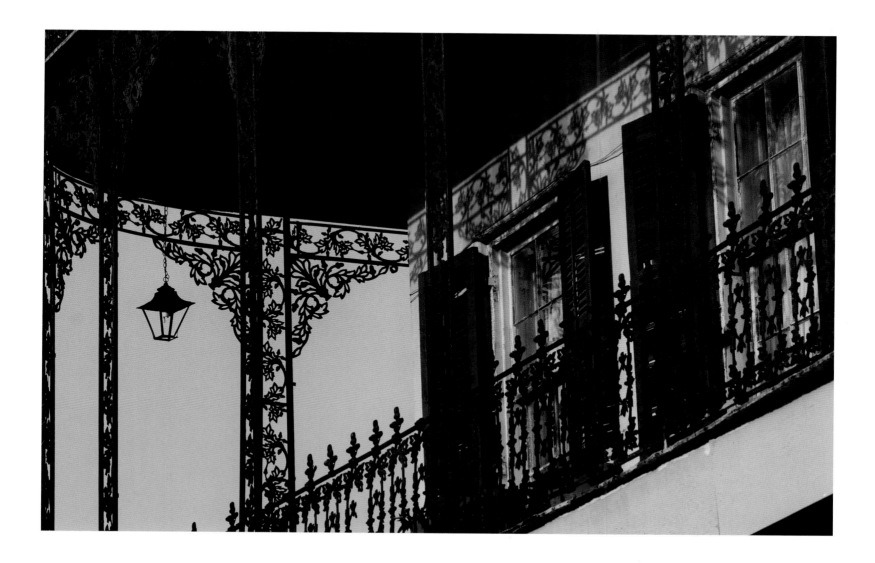

stripes that we so proudly fly on our nation's star-spangled banner. Many New Orleanians have asked themselves — is our country prepared to cut loose, lose and forget a large chunk of our all-important shining stars? To just let it drop off the flag altogether, disintegrate and disappear. Are we really too weak to rebuild? If a thing is broken do we throw it away? Will America jettison an entire inconvenient community?

Those who study the revelations of events know the truth: we cannot fix the future if we cannot cope with the repercussions of the past. We have a choice of allegiance to values. We can look the other way or help one another. When the wounded wail of a neighbor or a relative calls out, we can make believe we do not hear; we can turn a mocking deaf ear into the wind and go on about our own personal business and pleasures — or we can be moved. The decision is ours. Are we prepared to pretend we do not see the political, social, cultural, economic and moral consequences and ramifications of losing an entire city?

An undivided world cried for New Orleans as hordes of television cameras came close into the floodwaters. All were eyewitnesses zooming overhead in helicopters or floating along with news crews through the streets in a flotilla of flat-bottom rescue boats. Even seasoned and hardened journalists cried real tears for New Orleans and her people.

As the days multiply and overwhelming problems persist, New Orleanians now ask, please do not forget or desert the Crescent City or think everything is all right. It is not. Come walk alongside us here on the ground in a place that declared war on horror. I am referring to the terror of possibly losing a singular American city and watching her die. It is an appalling sight. She is not so far gone that she cannot come back from the

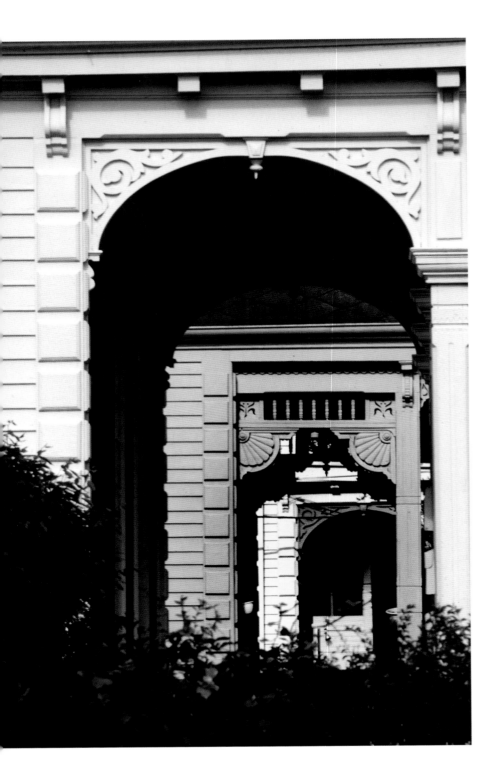

dead, but she cannot and will not come back unless we raise her onto our shoulders and carry her part of the way to recovery.

For New Orleans to even begin to meet the challenge, Americans must rally around her and not turn away. With help and understanding our city can and will be lifted; it will flourish from the fallout of Dante's netherworld like a phoenix ascending from the slimy silt of floodplains. This is the type of a nonpartisan lasting legacy and indelible imprint that serves our decedents and future generations; this is the tone upon which our country was founded. It is the demeanor to show the world. If not, then we have to ask ourselves who and what are we and ask what have we become, really.

All hope that this tragedy will mark the beginning of a new era, a time when concerned citizens of our country will come together to help reestablish New Orleans. The world awaits the renaissance of this majestic American city. We need a compassionate corps of citizens as much as a capable, adequately-funded Army Corps of Engineers. This is where we are able to lay down and plant the grassroots foundations of sharing, caring and learning. Kinships, friendships and alliances can and will form, slicing across the barriers of socioeconomic dividers. Here we may grasp and climb the ever-illusive rainbow that takes us skyward into a rebuilt city of opportunity, a place where we can break the shackles of whatever holds us back. Either we build new millennia or doom ourselves to repeat the mistakes of the past. But we must move now, not later. Later is too late. The more we tarry, the ostensible future will already be long gone along with yesterday and today; it will be all but a haunting shadow viewed with a regretful backward glance. Regrets do us no good. We need not fail our nation nor our nation fail us.

Many Americans are prepared to toil hard to help our own downtrodden, to heal and cleanse our own All-American city called New Orleans. That much I believe. Those who "know what it means to miss New Orleans," to love and lose New Orleans, please come forward from near and far to help rebuild our city. This is a city easy to adopt. If you have not already done so, let New Orleans into your heart, today. Do not wait. Take pride and a stake in America.

The Crescent City is crying out for public-private partnerships, resumption of business and guardian angels. The cultural treasures that remain post-Katrina are threatened; structures and customs that document and illuminate our nation's ancestry are in great jeopardy of being forever lost.

The sentimental city of New Orleans was already financially strapped and teetering on insolvency before the catastrophe. Now the situation is critical. Support through community involvement, sponsorships, charitable donations, advocacy, tourism and private sector investment all help this city recoup. This economy needs to be jump-started. Every aspect of underlying and day-to-day infrastructure and institutions — all that makes a city a viable place to live, work and raise families in — needs serious attention and assistance here. From the revitalization of housing, schools, libraries, health care, roads, refuse removal, public transportation, police, fire and rescue, the arts, and on and on, from the ground up, the list seems endless.

The remaining residents — whether born or settled here by choice, and those anxious to return — hope to be joined by countless others who wish to pay tribute to those who lost their lives; joined by those with a pledge to pitch in and help upraise our city and her citizens and to embrace our culture.

Whether one decides to visit or relocate here for good, the rewards are great. This is where, no matter what, we do not toss our past away. More than the buildings, architecture, trees and notable landscape, more than our secret gardens, the saga of New Orleans is about her people and the spirit that sustains them. Those with a surviving sense of toughness and strength can and will cross and move mountains of debris and destruction to reclaim this crippled city. Here just above and below sea level is where we will redeem and recapture the essence of New Orleans, and what has departed will appear again. Although the passage of time sometimes begrudges the truth and forgets heroes, the record will honor the evolving drama of those helping to overcome the human suffering in New Orleans. Before Katrina and particularly after Katrina, with clarity and good reason, I like many am fiercely proud, honored and grateful to call such a place "home."

As New Orleanians prepare for the first major American city to be rebuilt in the twenty-first century, this pivotal point in our nation's timeline is easily understood. All ask, where do we go from here? How do we get there? What is our footpath? We do not always know the way. Of all American cities, the Vieux Carré exemplifies the nexus of a place that has already gallantly battled and overcome a long and beleaguered colorful past. The Quarter's own deep travesties and setbacks match most anyplace else on U.S. soil. As few American cities can claim, our town is no stranger to military occupation. Long before the Louisiana

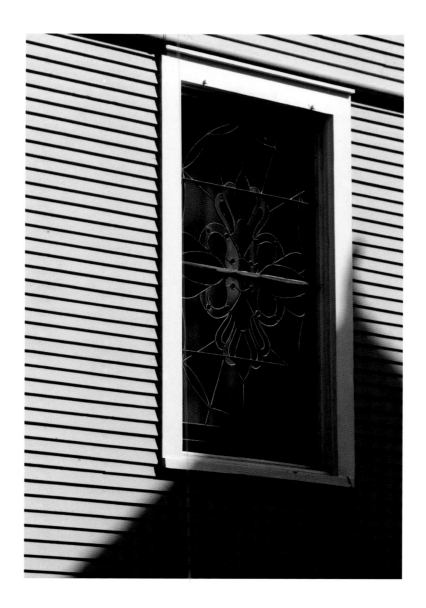

Purchase the Quarter was already known as a war-torn, diverse, contentious and conflicted city ravaged by change and upheaval during many perilous periods, and yet she withstood repeated onslaughts. Homes and buildings were rebuilt and gardens sprouted up again.

Generation after generation has enjoyed the old flavor of this area with its wealth of eighteenth- and nineteenth-century edifices. Admittedly it never has been easy to watch over and care for this aging place. It takes unflagging dedication to preserve and maintain its treasures. But nothing valuable or worthwhile

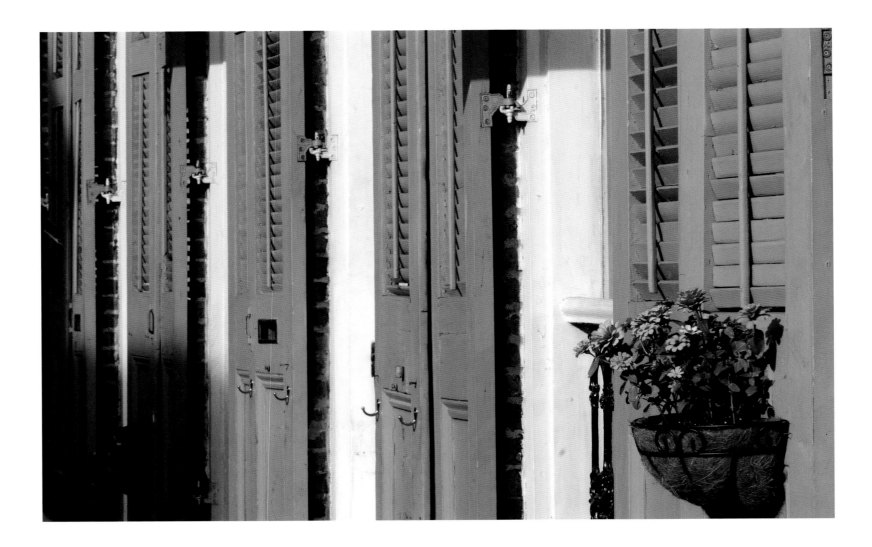

This is a land unwilling to purposefully forfeit and ransom what lies buried within the psyche. It is a place with deep-seated feelings for memories and objects both priceless and plain. The revelations, art and artifacts of culture and antiquity are deemed valuable. We are endeared to these secrets and stories.

ever comes easy. The world is not fair and never will be, but we are not absolved of our obligation to try to reach out and make a difference.

Our country is far too young to have a lapse of memory. Most remember and honor our ancestral past, things rooted in all that we are. Only destruction comes swiftly. No great city is

built in a day, and no great city is rebuilt in a day. Great love and great achievement require great risk and commitment. The following excerpts are from a personal journal Guste kept while in exile from New Orleans. His thoughts reflect the absolute gravity pull of New Orleans for those who love her. Guste's words eloquently reveal the potent and valorous passion, purpose and identity of those who share a common love of this great city.

On September 11, 2005, Guste explained:

*I lived the hurricane in New Orleans. I remained in the French Quarter and waited it out. Most people, unless you are a New Orleanian, would not understand this. Is it possible for outsiders to understand that there are many of us who feel so closely tied to who and what we are in New Orleans that death is simply a circumstance of remaining true to one's self. A circumstance that we accept as a real possibility. We take the gamble. Some of us lost and died. Others of us, like me, did not win....We survived.*

*My first Louisiana ancestors, the Roy family, my namesake, arrived with Bienville, founder of New Orleans in 1698. My great, great grandfather Antoine Alciatore, founder of Antoine's Restaurant on Saint Louis Street in the French Quarter, arrived in 1840. I have roots here that are as deep as the grandest oak. If I am felled from my roots, like the great oaks in Jackson Square were in the hurricane, I would simply die. There would be no recognizable cause for my death. It would be heartbreak, or simply that there was no longer a life-force to draw from the earth, the swamp, the air that is New Orleans.*

*I have become a reed that bends in the wind and can survive even the most cruel hurricane force when other, seemingly stronger trees crack at the ground and fall.*

*And what of the gardens in the Vieux Carré, the French Quarter? They are devastated. But only for now. They will revive and be revived. They will flourish as our city grows again from the watery hell in which it now exists.*

*'The Secret Gardens of the Vieux Carré' was an exercise in love when I first published it in 1993. Now it is a piece of history, history that will be restored to its highest place.*

*The good people in the city of New Orleans will shine, while the bad will darken. I can see the hurricane as a great cleansing effort that will give the good souls of this city the opportunity to show their true colors. All the great peoples here will work together to rebuild a city and a culture that is more rich and diverse than any in this country.*

*We are, after all, New Orleanians. We are bound to our city as our city is bound to its people. There are no lines of separation. We are one*

*living vital organism that will combat the destruction and become, again, one of the great cities of the United States, one of the great cities of the world. And I, for one, look forward to the effort.*

— *Roy F. Guste, Jr.*

In the outstretched and all-consuming aftermath of the worst U.S. disaster our country has seen or confronted, those who love this city work hard to salvage the leftover pieces of our own hemorrhaging hearts; pieces that have laid drowning, sinking beneath a bottomless river of sorrow alongside what remains of the shattered remnants of an ancient siren at the bend of the river known as New Orleans. Yet the staunch

undercurrent of endurance that this legendary city possesses survived. It did not erode or wear away. That which is inside us surges to the surface, trumping sadness and reviving us.

We who are irrepressibly in love with New Orleans cannot recess or rest until our city is restored and rebuilt. We are deeply committed and serious. There is no concentration of historic structures in this nation, let alone the world, comparable to New

Orleans. Here everywhere you go history touches you. Layers and legacies of tradition, architecture, music, art, food and festivals contribute to this strong sense of place. Help now, not later, is needed to bring back our town and reconstruct neighborhoods, to regain people's pride and sense of community. The culture of New Orleans must be maintained, nourished and enhanced.

Throughout the centuries, the French Quarter's distinctive stamp of character and memorable streetscapes light a preeminent cornerstone of time. This is true today. This city is a converging point for those who prepare for the restoration, rebirth and renaissance of New Orleans. The telegenic and photogenic Vieux Carré is a staging area, a focus point for emerging endeavors to recall the heritage and pride of battered neighborhoods sunken. The Quarter is the backdrop where New Orleanians and the nation confirm the resolution of so many to retrieve this beloved city.

Pre-Katrina, the National Register of Historic Places listed 37,000 such significant New Orleanian structures within 20 different neighborhoods, surpassing any other city per capita.

And so, with firm resolve we affix ourselves to the extraordinary all-encompassing urgent needs of the resurrection of Greater New Orleans. However, along with our quest to recover, restore and rebuild, locals and those who descend here to help and assist must not slight or lose sight of the Quarter, not for a minute.

Those who love New Orleans practice prudence in heeding the call of not trampling upon what remains intact — the rather decrepit and altogether glorious Vieux Carré. To accidentally become slothful, craven, unvigilant or inattentive in our efforts to shield this district from harm threatens its very survival, irreparably so.

The French Quarter is a National Landmark to be championed, respected and properly looked after to ensure that the historic integrity and majestic beauty of the Old Square endures another centennial birthday. It is an irreplaceable treasure that has already survived the wrap of centuries; not a throwaway object to be squandered or sacrificed. This tiny thimble city within a city has always understood, bolstered and protected the economic, cultural and aesthetic importance of Greater New Orleans.

Within the few blocks of the Vieux Carré there is an abiding mass and maze of divergent tastes, habits, consciences, manners, and morals of citizens and visitors alike. This has been the case during the French Quarter's many incarnations. Always set amid a crush of humanity, this place has often been caught in the crosshairs of famous and infamous frays. The stormy passages this coveted city has taken veered between being a fashionable, revered and sought after golden-days town, then slummy, followed by an about-face metamorphosis back into a prized place again. Along the way, notable skirmishes and heated eye-to-eye debates have occurred over collective and individual rights and interests of residents, businesses, developers and preservationists.

Through the decades, many a paramour of the Quarter devoted an entire lifetime to diligently safeguarding structures in this old section, the only intact Spanish and French Colonial settlement in this nation.

In the late 1800s the once proud and stylish Creole crown-jewel city turned adrift, seemingly with no one at the helm. Following the Civil War and Reconstruction period, many of the founding families scattered from the Quarter into other areas of New Orleans, and the Old Square became home to a

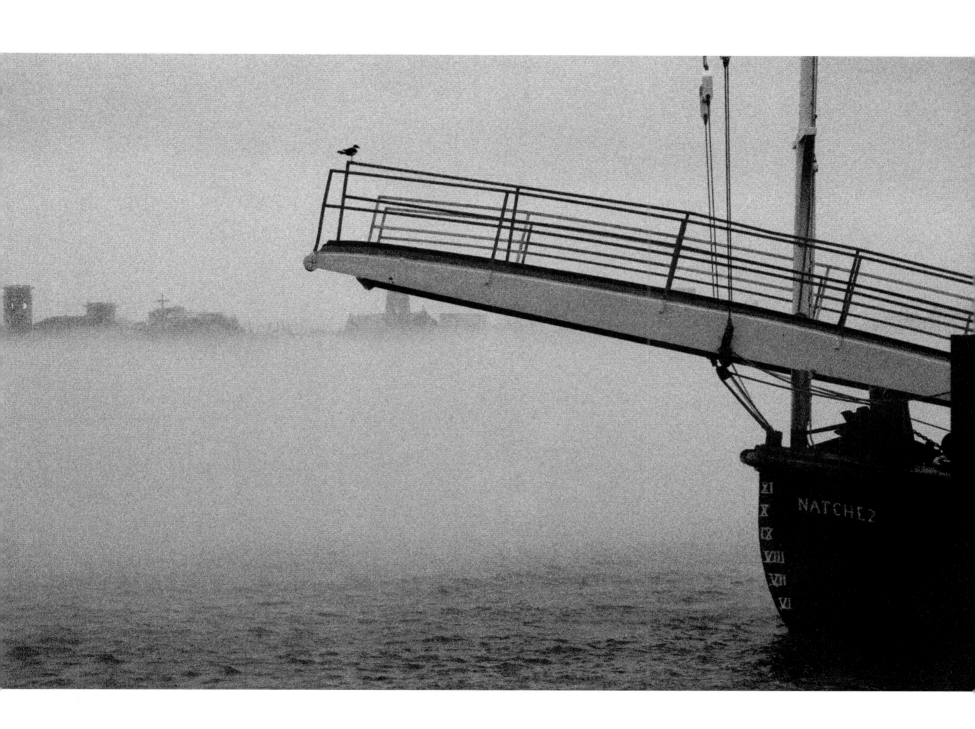

new wave of turn-of-the-century immigrants. With a super-abundance of families crowded into any and all available living spaces, the complexion of the Quarter changed. The area languished, deteriorating into squalor and disrepair. A veil of poverty, a pall of decay crept in and hung heavy over the self-contained Vieux Carré. A stranglehold net of apathy encircled the city.

Amid this period of cultural indifference, more than one prominent New Orleanian suggested demolishing the French Quarter entirely. By today's standards, the utterances of 1915 seem staggeringly shortsighted, prejudicial and inflammatory, at best. One such reputed commentary about the Vieux Carré read: "The section is gone completely. It has no future as a business district and as a residential district; it is undesirable except for the habitation of the Italian immigrants. A good conflagration, such as destroyed this section in its infancy, would be the best solution."

Today such appallingly mindless remarks appear myopic and ludicrous. But then again I suppose some of the recent remarks bandied nationwide about New Orleans will sound equally absurd a hundred years from now. It is frightening to realize how flawed reasoning of the early 1900s, if left unchallenged, could easily have led to the obliteration of today's most hallowed surviving district of living-legacy landmark structures.

During the cultural renaissance of the early Depression years, the local battle to preserve the Quarter first sprang to life spearheaded by the era's leading preservationists and socialites. This group openly opposed those intent on destroying the Quarter. Civic-minded individuals who set about rescuing the Quarter from being dismantled and torn down were aided and abetted by the constituency of artists, writers and intellectuals who had settled here in the 1920s seeking refuge and creative freedom. Those who formed this vibrant artistic core "colony" community within the Quarter were particularly instrumental in helping save the Vieux Carré. This composition of people brought to the world many of the legendarily colorful and persuasive ideas, ideals and images of the Vieux Carré that we still carry around with us, to this day, carved into our consciousness.

Once a wartime national campaign spotlighting public awareness on the issue of American heritage spread across the nation, the mission to defend the Quarter gained added fuel and supporters. Bohemians and the fashionable alike continued to rediscover and unearth the eternal charm of the Quarter and another round of important restorations and repairs began in earnest.

Concentrated efforts to form a preserving mandate for the area by this small but vocal and tenacious coterie of Louisiana's early preservationists finally gained solid footing and momentum in this century's third decade. This early mission was fraught with roadblocks and false starts, finally culminating in the creation of the permanent state-sanctioned Vieux Carré Commission in

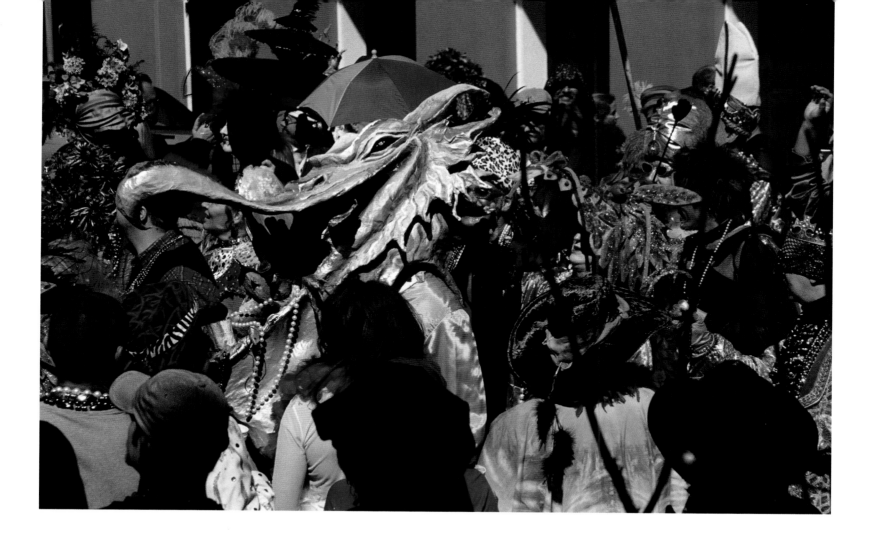

the 1930s. Shortly thereafter, this group pressured residents to landscape the walled courtyards now known as the secret gardens of the Vieux Carré. Since its inception, this prominent organization has been charged and entrusted with safeguarding and safekeeping the quaint architectural marrow of the Vieux Carré, the nation's second oldest historic preservation district.

The untiring dedication and efforts of so many French Quarter crusaders throughout the last century is the overriding reason why all has not been lost, why the uniqueness of the neighborhood — the diverse stratum of architectural framework that has defined the city for hundreds of years — continues to flourish.

The VCC is empowered with the purpose of protecting a national treasure of architectural and cultural importance. Despite far-reaching broad powers to protect and regulate the conservation of this irreplaceable city, over the years, they have also at times lost the battle to preserve what should not vanish.

During the past century, many buildings were tragically lost and razed to rubble by the wrecking ball and the capricious whims of a willful mankind bulldozing what is inadequately respected and protected. Likewise, since the VCC's formation many highly valued walls and buildings have also been summarily claimed by fire, other natural disasters, and outright demolition by neglect.

Over time so much has been ripped down, destroyed, wasted, taken away and irrevocably mutated. The damage is permanent. What has been lost is irretrievable. Comparing "then" and "now" photographs is breathtaking. Sad as it seems, the advice, authority, counsel and creed of the commission is not always heeded or followed by the "powers that be" of the era. Similarly, there is more often than not a dire shortage of sufficient manpower and necessary funding to implement and support code administration and preservation manifestos.

The threat of Mother Nature's fury always lurks nearby. The constant encroachment is relentless. The Quarter, never out of harm's way, is always in danger of disappearing. It's no surprise that The National Trust for Historic Preservation believes the French Quarter is one of the country's most critically endangered historical places.

Overall, notwithstanding fraying pieces of the Quarter's original fabric and character that continue to be lost each year through detrimental erosion, elements and surrender to unscrupulous purposeful destruction, it is remarkable that the Vieux Carré remains as it is.

The VCC does its utmost to closely govern and monitor literally everything pertaining to the old buildings here,

regarding the comprehensive protection and planning of this inimitable neighborhood.

The commission keeps a tight rein on all proposed revisions, restorations and remodeling of the district's structures. All work undertaken on the exterior of any building in the Vieux Carré, new or old, whether visible from the street or not, requires permits from the commission. The "exterior" of buildings that fall under

VCC jurisdiction is classified as all elements exposed to the weather. This definition takes in front, side and back walls, patios, courtyards, walls, galleries, balconies, fences, signs, exterior stairs, passageways, carriageways and sidewalks. If it touches air, it comes under the watchful eye of the VCC. When repairing or rebuilding an exposed historic brick wall, for instance, owners must use authentic reclaimed historic local brick, indigenous to this area. The emergence of modern-day construction is also regulated. New construction exteriors must visually blend in and conform to the buildings of yesteryear.

Working hand-in-hand with the director of the VCC, the core nucleus of the commission consists of nine volunteer appointees who sit on various committees. This dedicated group includes architects, preservationists, and involved locals. Even at the best of times pre-Katrina, the VCC, with precious few salaried employees, always operated on a shoestring budget.

Today the situation is more extreme and urgent than ever. Only a skeletal staff continues now, with available resources slashed to the bare-bone. Proper policing of rules and laws is extremely difficult and near impossible with little to no budgeted funds. And with people revamping and rehabbing landmark structures by their own unregulated devices, the exposure of losing such valued Vieux Carré structures that survived the storm is at an all-time high. A long-running battle continues in earnest to prevent damaging changes to French Quarter buildings and unauthorized commercial use of the buildings. Without this type of ongoing commitment, living history will be forever lost and the Quarter will look like Anywhere, USA.

To help protect the Quarter, a little known offshoot group of the commission, The Friends of the Vieux Carré, includes volunteers strictly consigned to be on the lookout for flagrant or clandestine code and building violations. I am talking about the continued undoing and alteration of historic structures. This group is always in need of committed volunteers willing to help out and make a difference.

In the sequence of a disaster's many trials and tribulations, government, non-government and private interest groups all have a special time and place to come together and contribute to the community, through the recognition of kindness, generosity and public-spiritedness.

Most property owners, whether homeowners or business owners, are especially proud and respectful of the rigors of maintaining these cultural properties; but not always. Either for

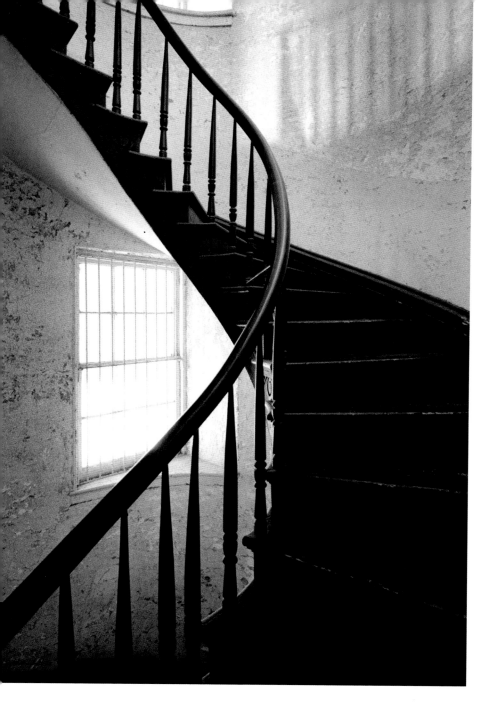

The insidious neglect and disregard that has infested the Old Square — buildings of uncustomary sumptuousness and splendor abandoned to the elements and allowed to rot away — is one of the most serious transgressions threatening the Vieux Carré today; a suffocating chokehold on the Quarter's very existence. You have to wonder why this appalling travesty is allowed to continue in plain view without intervention and an immediate plan of action.

To cry and grieve over the demise of such fallen buildings splintered into dust is too late. Once America's irreplaceable treasures are looted, stripped apart, crushed and dissipated the rich tradition is wiped out, forever.

Another extremely active and popular local nonprofit organization that came into organized existence in the late 1930s is the Vieux Carré Property Owners, Residents and Associates; a force to be reckoned with, it is a powerful and dedicated advocate, defender, protector and staunch supporter of the Quarter.

The VCC and VCPORA, though not interconnected, share the same matter-of-fact goals and philosophies of preserving this living, breathing age-old district. The VCPORA mantra remains faithful to the "preservation, restoration, beautification and general betterment of the Vieux Carré." The Quarter espouses more than one alliance of actively involved citizens who care deeply for their city.

French Quarter Citizens for Preservation is yet another longstanding neighborhood action group concerned with serious issues that threaten to irreversibly alter the special integrity and ambiance of this neighborhood, notably with respect to zoning ordinances and related matters.

Residents struggle daily to maintain the idiosyncratic disposition and original architecture that make our old city unique. Sadly, not everyone respects the Quarter. The pressures and strains upon a small aged neighborhood that graciously hosts and welcomes millions of annual visitors are enormous.

The Vieux Carré is a designated Landmark National Treasure. Our hallowed Old Square illustrates, interprets and imparts the heritage of America.

The city commemorates and tells important stories of the United States and more. The Vieux Carré is a living world-class memorial worth saving.

Yet when it comes to ensuring protection of the Quarter, sometimes there are clashes, controversies, dissention and valid differences of opinion within the ranks of the loyalist devotees

financial gain or savings, depending on how you equate it, many attempt to clandestinely slash down and tear away the original nature and texture of these buildings if one feels he or she can succeed undetected and without consequence. Others unwittingly destroy their properties by neglect. This happens when gracious old buildings fail to receive basic maintenance or repair until reaching a dangerous, unsound, collapsible or irreparable point of no return.

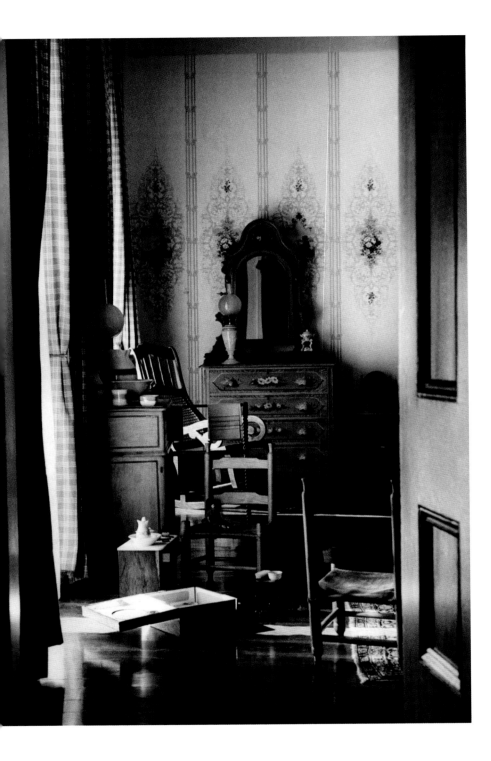

of the Quarter, people whose hearts are predominantly in the right place with respect to what is deemed right or wrong for this designated district. Nobody agrees in tandem on everything all the time. This sometimes leads to minor frictions. It is impossible for all to perpetually share the same point of view. However, among all, the continuance of the Quarter as a historical gem and livable neighborhood remains the ultimate priority.

When the chips are down, such as when the Vieux Carré is openly threatened by destructive forces, in the end, after the vicissitudes, reversals and waverings play out, locals generally put their differences aside to work together for the overall good and betterment of life here in the Vieux Carré.

Without the unfailing selfless work and tireless efforts of people who appreciate the distinctive constitution and significance of the Vieux Carré, the Quarter could quickly take on the homogenized complexion, feel and facade of a humdrum *any-place* and *everyplace* nondescript town center.

The Vieux Carré is the largest, most densely packed and uniquely individual single historic area in America. People here are passionately and fiercely loyal and committed to the Quarter, because we believe in it. That is why, despite all, many continue to forge ahead with collaborative and joint-venture efforts with a devout input of time, talent, resources, blood, sweat and tears, seeking to preserve the Vieux Carré.

For those who reside here, maintain and care for the Vieux Carré it is an intense labor of love. This antiquated lady is a living cultural treasure, deeply rooted in obsolescence and olden days. With inspiration at every turn, she captures our affections and affects our insights. The Quarter still exudes a secret ingredient of eccentricity and magic that no box contains. Unlike most places preserved in shadings of yesteryear for visiting tourists, where costumed people perform reenactments of the way of life, here in the Vieux Carré we do not merely tiptoe and observe American history as a gateway to the past from afar; we are immersed in it daily. Set in the surroundings and panorama of events is a thriving self-contained community where people live, work, vacation, rest and play; and, yes, end their days.

A living montage imbued with a highly concentrated concoction of realism, impressionism and symbolism, the Vieux Carré attracts millions of visitors from throughout the world, from all walks of life; yet she is atypically non-mainstream. Her gamut of charms is great, as is her long list of peculiarities; there is no place quite like the Quarter.

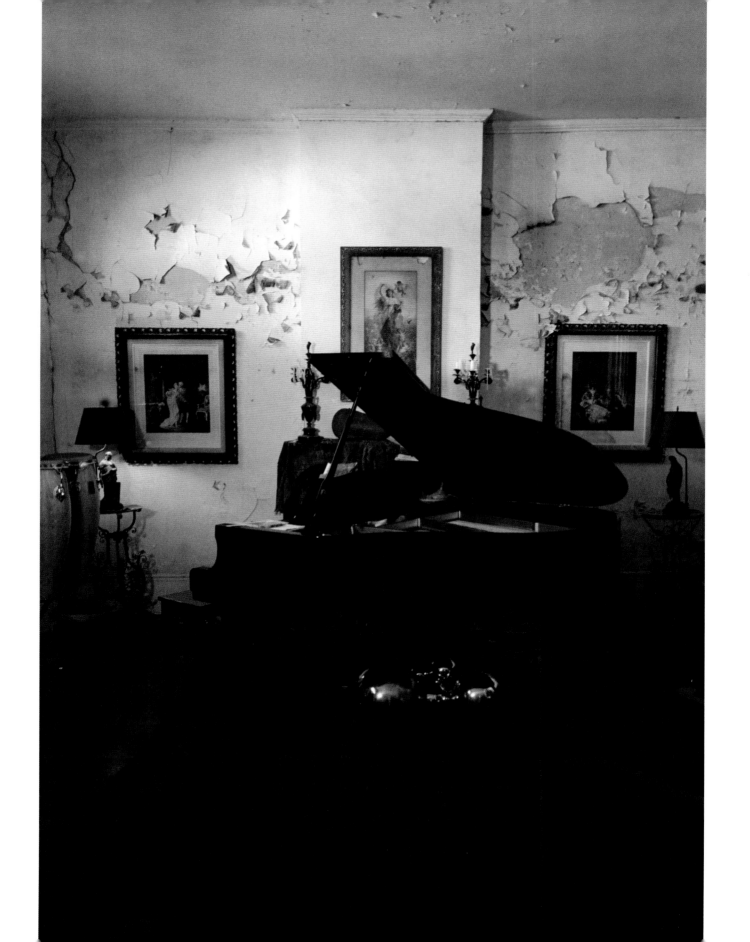

Over the years there has been a trumpeting of public support and surging interest in helping to preserve the Quarter; yet memories lapse and people forget. There have been too many dreary days already where the original integrity and fiber of eroding and long-suffering structures has been lost abruptly, or gradually through a slow drubbing and bleeding away. Whatever the cause, the end result is often the same. Vanquishment. Blue ruin.

Open appeals have been made to ardent preservationists, historians, philanthropists, benefactors and antiquarians who have worked diligently to lend a vital helping hand and resources to restore and maintain some of the world's most esteemed and cherished treasures, places such as the Palace Versailles and the Venice Opera House; we hope there will be renewed national interest in preserving the heritage and integrity of America's French Quarter. Direct attention focused on confronting severe issues that threaten the imminent demise of the Vieux Carré is urgently needed, particularly in these dark days for New Orleans. The publication of this *première-édition* book is one step forward.

All New Orleanians and French Quarterites, regardless of personal storm-sapped casualties and private despair, have been severely affected and damaged more than can be uttered or recounted. Yet we soldier on. No doubt many of my own feelings and portrayals are a shared mirror image of what others also feel and think; undoubtedly I am not alone in my thoughts.

The heart is hard to rule and govern; but when broken and dipped in sorrow and anguish it gains unflinching fortitude. I, like most New Orleanians, shall never forget the things I have learned from this epic tragedy. Many brave souls I have been blessed to call a "friend" have taught me an unforgettable lesson in fearlessness, fortitude, dignity, helping others and being able to accept and come to terms with what's ahead, with what's inevitable. Their strong words of positive promise and encouragement reverberate in my ears wherever I go, whatever web of chaos or labyrinth garden path I am destined to walk through.

I say, we all say, in one collective voice, all we have known and loved in New Orleans shall be with us always, alive and well and dancing in our mind's eye; we shall never truly say farewell even if we are never again graced with the opportunity to cast eyes upon all that we have known and loved. I can never forget what I have known and seen, the people, places and things that are no more. New Orleans cannot and will never forget the

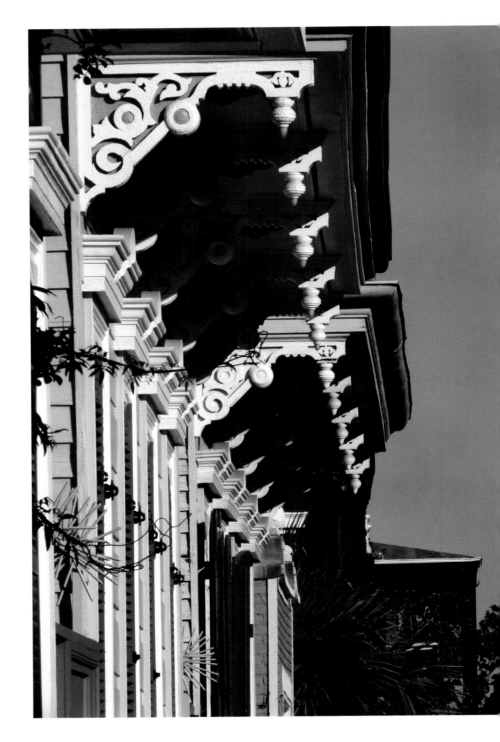

names, faces, images and stories of those who perished in the storm and her outcome. No. I cannot. We cannot. New Orleans has been the cradle, crib and tomb of so much, yet it will not be vanquished. We cannot and will not forget all that has passed away and been taken from us. Those forever will be our people, friends, loves and families. To lose all that you love and know as "home" is devastating beyond belief. Inherited keepsakes and photographs document who we are, who our families were, and with whom we shared our past lives; it is a record of our existence. Our prized so-called "things" are important to us as human beings and we mistakenly like to believe that our surrounding objects keep us safe. Yet no matter how much we mourn our losses, the pain and agony of losing a lifetime of memories and belongings is nothing compared to the loss of family and friends.

For many who found a way out, most remain haunted and tormented by the watery grave that engulfed all that was known and loved best. For these people, there is no peace until the day they find a way to return to New Orleans and retrieve the remnants and relics, the broken pieces of love and trust. Until then, the possessed and dispossessed all shall dream of special moments sealed in time, and a hometown city still out of reach. I am serious. We are all serious, about truths that need to be said. For even magicians cannot hide or make the truth disappear, forever; it always resurfaces, eventually, in one incantation or another.

More than a footnote in time, this sodden city manifests the legacy of our ancestor's hopes, dreams, beliefs and aspirations, all that we hold dear. So if you walk through the parts of New Orleans obliterated, you are forced to face down the debris left behind by Katrina as it overwhelmed and submerged a most storied and original American city.

Once you try to make terms with a macabre, somber and mangled landscape, you will taste and swallow the utter agony of New Orleans in shambles, of lives wrecked; a vista of perdition in full view. The truth reveals and fillets our deepest innermost selves exposed raw yet redeemed. You cannot turn away; you cannot pretend you do not see the gaping ruin; nor will you ever forget the obscene lurid jigsaw puzzle of things slit apart; the cruelly mocking pieces of fuller, more coherent lives: a rocker here, a shoe there, a baby carriage crushed. In forlorn neighborhoods barren and empty, you scuffle with sorrow and wonder where everything has gone.

You tell yourself, "I want them all back. I want them laughing, smiling, singling, alive and vibrant." But they are not

there. The snow cone carts and children's kites sailing overhead silhouetted against the sunlight have gone away. All that is left are endless piles of ruined refuse and rubbish. The remaining objects of a life left behind are never pretty. A stark reminder that the earth rips away and retakes all, devouring all we have loved. And as the eye continues to search the brackish landscape, of what is no more, you see the tattered pieces of people's lives lying scattered along the roadside.

As images of what was, what existed, what was loved, swarm upon us, our mind swims and another part of us withers and shivers inside. We want to crumble, collapse, scream, cry, run away as fast as we can and not return to confront this cruel, maimed landscape.

And then we come upon and return to the indomitable French Quarter, the ancient oasis of thirteen-by-six blocks prevailing since 1718, sitting like a wonder of the world smack-dab in the middle of the outskirts of an otherworld. And we ask ourselves, is it our role to pick up the shattered ruins? Are

we supposed to be torchbearers, the leaders of a new day? A world of new potential and possibilities? Or do we slip away and go quietly unnoticed into the night? No, we know we cannot leave her side, ever. At least not for long. This is where we belong, the place we long to be. She attracts us like the mesmeric arc of a faint rainbow.

Unlike Guste and Sahuc, but like many, I was not born here. I was drawn here, I came here, and I shall stay here. For me, and others, this is home. The Vieux Carré is something so lasting it cannot be denied. She has laid claim to us, a bond that cannot be broken, for she will never let go.

Amid the desolation that New Orleanians have faced, and are facing, lay the bittersweet sea of oblivion; a cruel dark place that pulls us under to drown in the abyss or to be born against the current and emerge reborn. I believe what they say is true. If you bring forth what is in you it will save you; if you do not bring forth what is in you it will destroy you. The strength and spirit of New Orleans is in all of us who so love this city, and we will bring her forth again.

The sights and sounds of New Orleans, this beguiling old seductress so scarred and fascinatingly imperfect, shall forever dwell within the souls of all who have known and loved her. Slumbering deep within our heads, her beauty lingers somewhere in the twilight. We can never close our eyes to what we have seen and loved. Those who love New Orleans already know that once she has nestled you in her cradle with lullabies she will never set you free from the rising tides and pull of her ancient charms. Thus my heart forever belongs to New Orleans, to her people and to my beloved French Quarter, the Vieux Carré.

For many who feel as I do, now as in years gone by, in the final hours even when we come to face our regrets and glories and arrive at the last shore on the edge of Hades and Paradise, it is the streets of the Vieux Carré that we shall remember always; the love and laughter we have known and shared here in the finish of our days and nights. Here just above sea level is the indomitable home of our hearts, whether our pulse continues to beat or not; a memory that will be with us to the end.

Within the enchanted secret gardens of the Vieux Carré forever abloom, you will find the places where triumph overshadows sorrow, where a new day transcends and transforms the face of tragedy, and we celebrate the fleeting moment.

In an ever-changing world of choice where we may seize the opportunity to be the architect of our own lives, we need to question where we are going, who we are and where we belong. Do you know what it means to miss New Orleans? Do you long to come back and recapture the wonders here, those memories that never fade, that beckon all? The future unfolds: we wait for New Orleans to be lifted from watery ash and come into its own again. Tomorrow is an unfinished tale of dreams and stories yet to be told. The ending is never written.

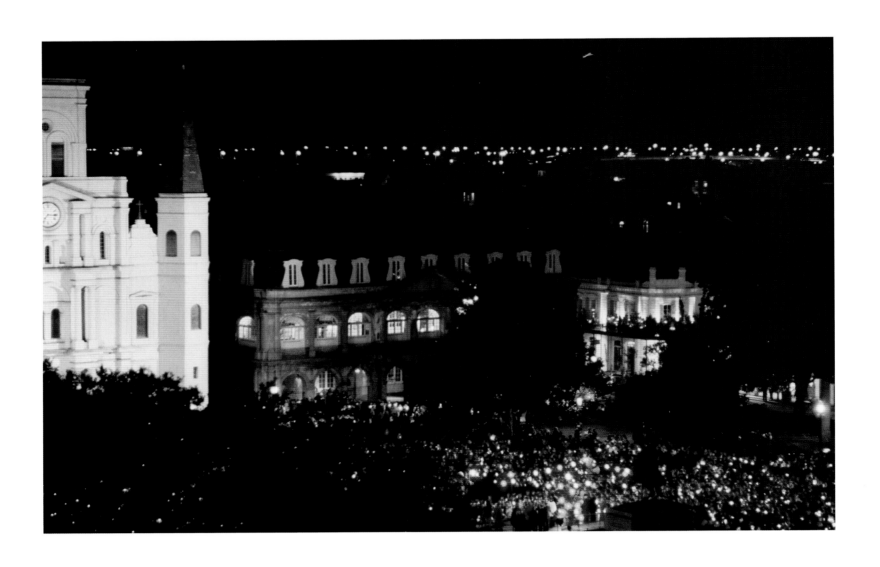

# *Orléans Embrace* Louis Sahuc Photo Works captions by TJ Fisher

## *Secret Gardens* Prelude

*Silent stories untold:* deep within the secret gardens of the Vieux Carré, this courtyard statue quietly echoes the triumphs and trials, galas and griefs of New Orleans.

*The curve of fate:* an appealing wrap of ironwork sweeps with dramatic flourish across the square corner of this French Quarter brick building. The heavily detailed railing features the centering focal point of an eight-sided ornament, giving the illusion of the magical turn of a wheel or compass.

## Introductory Material

ii     *A ray of light and dreamy days of languor:* French Quarter eternal sky haloed in a majestic swirl of magical clouds aglow.

iv     *An artful showplace of aging, decay and elegance:* the layers of years back, of lives spent and myths created, are in evidence at the threshold of each French Quarter doorway. The fringe of delicate wrought iron, thick and multilayered millwork door moldings, detailed with rosettes, all are clues to this building's biography. One easily imagines the colorful characters floating in and out of — and the scenes that transpired within — the slightly visible, darkened recesses of this home's interior.

xi     *Memories of Margi and Joe:* remembrances of people, places and things we have loved forever burn brightly in our memory, as evidenced by a couple, paramours rejoined at Napoleon House in the French Quarter to share ageless stories and enchantment of old flames. A rear wing of this structure was constructed just after the Great Fire of 1794.

## Part Three

2     *Trilogy of years:* slate-covered triple towers and spires of iconic St. Louis Cathedral hold staunch against a dark backdrop of ominous clouds. A minor basilica established as a parish in 1720, it is the oldest Catholic church in America. Made of wood and stucco instead of stone, the *église paroissiale* is the third church of St. Louis to sit on the square since 1727. The original French structure stood for six decades, until the Great Fire of 1788; a second cathedral was erected in 1794. Church bells and a tower clock were added in 1819; however, that church collapsed during 1849 renovations. The present-day cathedral was dedicated in 1851.

4     *Intrepid star-spangled banner:* American flag waves gently in the breeze, against an opulent French Quarter sky, flying alongside the courthouse's circular rooftop Beaux Arts balustrade.

5     *We are one:* a trumpeter evokes the collective face, voice, vision and heritage of New Orleans.

6     *Preserved and prettified:* a French Quarter row of cottages reflects the unique personality and diversity of architecture, culture, heritage, colors and styles found within the thirteen-by-six-block Old Square. The French Quarter sets an unusual rhythm and rhyme to the peculiar harmony and symmetry found in disharmony and asymmetry. The Vieux Carré is poetry in suspended

motion, standing still. Center cottage gives an elemental slice and winsome glimpse of charming Eastlake-style architecture, with quintessential 1880s Victorian character and accoutrements.

7    *A window of long-ago:* thick board-and-batten shutters, trimmed by an inset window box of delicate flowers, give this Vieux Carré home a distinctively European appeal and charm.

8    *Blue skies smiling upon a masterpiece manual of time:* in the heart of the Vieux Carré sit Jackson Square, St. Louis Cathedral, the Cabildo and the Presbytére. Previously called *Place d'Armes* by the French and *Plaza de Armas* by the Spanish, militia drills and citizen meetings were held here, as were public hangings and beheadings. Historically, the large open common was also military parade grounds, plus a place to train and drill troops. Equally, it served as a central area to pronounce decrees of law and treaties. Renamed in the 1850s after Maj. Gen. Andrew Jackson, victorious American leader at the Battle of New Orleans in the War of 1812, the park is landscaped in a sun pattern.

9    *The days and nights of Pontalba:* two sets of handsome red-brick buildings, set opposite one another across Jackson Square, were built in the late 1840s by native New Orleanian Micaela Almonester, Baroness de Pontalba, a lady of great wealth and stature, one of the first to introduce cast iron to French Quarter structures.

10    *Stalking mansions of memories:* the Southern mansion at 915 Royal Street *(Rue Royale)* known as the Cornstalk House and Hotel is actually an original brick townhouse structure (c. 1850-60), later — following a 1900 fire that damaged the original building — dressed up and overlaid in an eclectic Queen Anne style with asymmetrical massing. The famed "cornstalk" cast-iron fence was crafted 165 years ago.

11    *Timeless New Orleans:* reflections of the past are felt and seen in the present, joyous and somber, as the French Quarter remains a journey of enchantment.

12    *A matter of style:* the firmament of an overhead blue sky and birds in flight frame the faded splendor of this tile-roofed, early twentieth-century New Orleans home.

13    *A cusp of the ages:* dormer glimpse of a vernacular cottage at 631 Barracks Street *(Rue du Quartier),* (c. 1910-15) Edwardian bungalow with Colonial Revival detailing.

15    *Colorful days and shadows of old:* a gallery setting drips with an intricate measure of mystery, acquired from the varicolored age-old stains, weather and iron, coupled with deep shadows, all Old Square-style enrichments, an authentic patina that cannot be purchased or replicated.

16    *Scalloped shadings of now and then:* elemental crown jewels of the Vieux Carré, sketches of ironwork, Jackson Square and the Cabildo, with a sliver of St. Louis Cathedral steeple as observed from an ever-aristocratic Pontalba gallery.

17    *Espoused to a street-light town:* another enduring building of historic style and grace, with artisan-inspired scored stucco, arched window and shaded with the imagery of things unseen.

18    *Harmony of history:* in an archaic building that bears walls from c. 1750, the Preservation Hall sign shadows the essential sanctuary of New Orleans jazz.

19     *Nothing is black and white:* Royal Street *(Rue Royale)* storyland streetscape illustrates vintage ambiance and nostalgia of another period as vestiges of grandeur remain.

20     *A many-splendored story:* where Ursulines *(Rue des Ursulines)* and Dauphine *(Rue Dauphine)* streets cross is where this old gable roof, weatherworn window, hanging flower baskets and tendrils of ironwork can be found.

21     *Components of a starry emblem:* U.S. flag adhered to the side of a brick-and-iron residence in the French Quarter, a locale where many of the buildings are older than most of the states represented by the flag's symbolic stripes. The French Quarter is the soul of this great American city called New Orleans, her history, passions, customs and culture.

22     *Behind every story:* the ornamental curves and details of the little-noticed, tucked-away rear of St. Louis Cathedral, abutting St. Anthony's Garden, offer a hidden treasure of architectural grace. The site, between Pere Antoine and Pirates' alleys, also fronts Royal Street *(Rue Royale)*. The Presbytére cupola is in the background; the original lasted sixty years until a Category Four hurricane destroyed it September 29, 1915. Nearly a hundred years later, the missing and long-absent cupola was finally restored to the Presbytére, shortly before Katrina made landfall, August 29, 2005.

23     *The fortresses of history:* a thick and heavy ornamental gate at the corner of Chartres and St. Ann streets *(Rue de Chartres and Rue St. Ann)* paints a filigree iron picture-portrait of the painstaking craftsmanship of another era.

24     *Where ladies wear hats:* the beautifully mysterious city of New Orleans remains a place of charm, customs and traditions. Elegant woman seated at Galatoire's, established 1905.

25     *Journey beyond wooden Indians:* a lone Native American statue stands vigil over a grave at Holt Cemetery, New Orleans' only below-ground burial site, established in 1879. The poorest of the city's cemeteries, in direct contrast to elaborate Cities of the Dead, the graveyard, with homespun tombs and hand-lettered wood markers, is decorated with a unique array of personalized objects left in impermanent moving tribute and memorial.

26     *Energy in erosion:* over the years the elements have weathered and decayed these structures, bittersweet beauties with stories to tell of that which is authentic and original, not replica shabby-chic, webbed in rust and abandon.

27     *Shapers of style:* the idiosyncratic color of varying ages has worn and corroded this artful ironwork support column, a redolent relic of refinement, irrevocably entwined with the past.

28     *The signs of the crosses cast against the sunset:* a row of tombs silhouetted in the veil of sundown captures the substance of a town that peeks through once again in the dim of twilight, Greenwood Cemetery, established in 1852. New Orleans prefers to bury its dead above ground because of the high water table of the sodden earth.

29     *Pillars preserved:* an art statement of architecture, this c. 1826 building at 334 Royal Street *(Rue Royale)* at the corner of Conti Street *(Rue Conti)* is a monumental structure, in Roman classical design. Nowadays it is home to the French Quarter 8th District Police Station and the Vieux Carré Commission.

30     *For aficionados of simple yet complex pleasures:* a fern pierces the foreground focus of a blurred Cabildo, as if pointing the way to swirling stories and secrets that transpired there.

31     *Aging columns:* the Ronstrom–Weysham Mansion at 524 Esplanade Avenue is a c. 1845 pre-Civil War property with projecting portico and balustrade railing, round columns, Greek Revival entrance with cornices and entwined vines.

32     *Step this way:* inviting front porch offers a passage into the glory days of yesteryear, with wooden newel post, turned pieces and balusters, all exuding hometown appeal and personality.

33     *Intimate details in the shadows of high-rises:* dusk settles over the Vieux Carré, as Central Business District towers loom in the distance. The Quarter is an open-ended drama, a historic city with a style of life unique in the world, still evident in the arts, culture, and architecture.

34     *Misty mornings:* streetcars roll down the avenue of dreams, St. Charles Avenue, New Orleans; green streetcars represent and recollect the oldest continuously operational line in New Orleans, in operation since 1893, a landmark.

35     *Elegance personified:* an enticing wrap of florid ornamental ironwork for which the French Quarter's galleries are so famed, close-up, adorned with tall and regal shutter-trimmed windows.

36     *Celebration of Hometown, USA:* colorful Victorian Eastlake decorative front porches line this picturesque sweep of an uptown New Orleans street, a community of neighbors.

37     *The house next door:* the ornamental finish of a stained glass window highlights the individuality of this Crescent City home. Wooden siding from the olden days reflects ruminations of the adjacent structure.

38     *Expect the unexpected:* colorful aqua-louvered shutters lend an air of originality and attention-grabbing street presence to this row of French Quarter businesses; housed in two c. 1870, four-bay, one-story and gable-ended exposed brick Creole cottages, located in the 800 block of Royal Street *(Rue Royale).*

39     *A doorway of mystique:* this faded green door in the French Quarter, not far from the Ursuline Convent along Ursulines Street *(Rue des Ursulines),* exudes the allure of the centuries.

40     *Guardian angels:* A pair of iron angels watch over an ancient and decaying tomb, St. Louis No. 1. The novel appearance of this unique cemetery's vibrant cultural landscape is reminiscent of the diversity, tradition, legacy, history and people of New Orleans; tomb tablets tell the story of generations of families. The aged burial tombs are primarily made of local "river" or "lake" brick and high content lime mortar, covered with stucco. In olden days, the tombs were lime-washed in earthen yellows, blues and reds, colorations that have mainly long-since faded away. The cemetery is identified as one of *Save America's Treasures,* enduring symbols that define the nation, but which are deteriorating and in danger of being forever lost.

41     *Solitary seagull:* a small bird, perched on the gangplank railing of a sailing schooner, finds solitude as a foghorn-thick coating of dense mist closes in upon the Mississippi River and the Vieux Carré.

42     *Interpretations of a strangely familiar essence:* example of the stylistic ironwork galleries and steep vernacular ascent construction prevalent in the Vieux Carré. A decisive sentry, this ornamental and yet menacing fan-shaped barrier called a *garde de frise* (guard screen) can be spotted at the 600 block of Royal Street *(Rue Royale),* a picturesque streetscape of an adjoining row of post-colonial c. 1830 and 1831 classic Creole townhouse dwellings. These three-story brick-and-stucco structures are

representative of typical Creole architecture of the prosperous 1830s, as is this elemental blockade with cathedral-shaped tips; this type of obstruction was frequently placed in between adjacent French Quarter balconies and galleries, similar to a wrought-iron fence with spearhead points.

43     *The tale of what began on the Twelfth Night:* Mardis Gras revelers celebrate the merriment of Fat Tuesday, until St. Louis Cathedral's bells ring out the passing of midnight, the beginning of Lent. New Orleans' rich cultural flowering of three centuries remains evident in the arts, culture, architecture and lifestyle.

44     *Reflections of Paris:* even in the shadow of dark days and troubled times, the epicurean pleasures of fine dining, fun and entertainment, enhanced by good friends and lively conversation — an ingrained tradition carried forward from the eighteenth century — clearly exemplify the French Quarter.

45     *Sweep of centuries:* "dancing winders" suspended and self-supporting staircase leads into a Pontalba apartment; for those who will listen, sounds of the past can be heard echoing upon these stairs. This stair design, inherent to New Orleans, was often built by French-speaking Creole artisans and African-heritage free persons of color, *hommes de couleur libre.*

46     *Elegance preserved:* step deep into events at Gallier House, a lovely c. 1857 Victorian mansion at 1132 Royal Street *(Rue Royale)*, a museum of antiquity. This honored landmark, open to the public, offers impeccable and accurate historic restoration. The opulent home and elegant furnishings reflect the taste and lifestyle of the mid-nineteenth century French Quarter.

47     *As time goes by:* impressions and hues of earlier days radiating from this atmospheric and richly patinaed Vieux Carré home call to and capture the imagination, with vivid envisionings of enticing French Quarter characters and stories of old.

48     *Now and then:* this row of jewel-like early twentieth-century cottages in the 600 block of Barracks Street *(Rue du Quartier)* exhibit beautiful Abat-vents, roof overhangs that provide shade from the sun and protection from the rain.

49     *Fancies and flights:* the Victorian charm and romance of whimsical iron birds, wings spread and partaking from a cornucopia of fruit, festoon an aged gate in the Old Square, along Royal Street *(Rue Royale.)*

51     *Ancient bricks and blue skies:* mementos with integrity. Marred and weathered buildings stave off the signs of aging as historic ornamented chimney pots strike a pretty silhouette along the roofline.

52     *Annual candlelight Christmas caroling at Jackson Square:* festive celebrations and traditions are deeply entrenched in New Orleans, a city settled and built around stately St. Louis Cathedral. October 2, 2005, marked the cathedral's first post-Katrina mass. For many, an epic return to this monumental cathedral symbolizes all homecomings — sharing, generosity, faith, gratitude and the sense of family and community are the ties that bind Americans together. Thousands gather annually in Jackson Square each holiday season to joyously sing carols and share the spirit of Christmas. St. Louis Cathedral and the adjacent Presbytére are brightly lit and readily visible in the photo; the far-right building is also shown on Page 53 of Part One; the band of lights spread out toward the darkened horizon are all lights that Katrina later extinguished. In the wake of Katrina, the greatest disaster to ever decimate U.S. soil, the 59th annual holiday tradition of caroling in Jackson Square was held on December 18, 2005 — clear testament to the endurance and resiliency of the people of New Orleans.

58     *The art of revelry and reverie:* Bourbon Street *(Rue Bourbon)* is like no other street in the world.

58    *In close proximity:* interwoven cultures and traditions create a fascinating open-ended drama, where intimate details unfold and simple images contain multiple layers of meaning; the French Quarter is a dense web of contrasts, cloaked in the atmosphere of times of yore.

59    *Exquisite impressions of New Orleans:* the St. Anthony's Garden side of St. Louis Cathedral portrays a beautifully mysterious and enchanting scene, flecked with idiosyncratic imagery and symbolism; the bell and clock were added in 1819. The iconic marble statue of Christ lost a thumb and forefinger to Katrina's fierce winds, which toppled nearby oak trees and dislodged iron fencing.

60    *A haunting memoir of days and dreams bygone:* the c. 1836 Mittenberger Mansion at the intersection of Royal *(Rue Royale)* and Dauphine *(Rue Dauphine)* streets is among the most distinguished and celebrated structures in the Vieux Carré. Elaborate ironwork galleries swirl and wrap around the corner, giving a sense of motion, and the elegant building is adorned with cast-iron moldings, railings, pilasters, borders and brackets, done up in an oak leaf and acorn pattern motif — opulent symbols of food and shelter, health and hospitality.

61    *Footsteps of yesterday:* this courtyard staircase found deep in the secret heart of Pedesclaux-Lemonnier House, situated at the French Quarter cross streets of Royal *(Rue Royale)* and St. Peter *(Rue St. Pierre)* adorns one of the most important landmark buildings from New Orleans' Spanish Colonial period. Construction of this famed, oft-photographed building began after the fire of 1794 but was not completed until 1811. Already a notably tall building in its day, shortly after the Civil War, with the addition of a fourth floor atop the original three-story entresol house (a quintessential and enigmatic type of Creole townhouse), the structure then became known as the Vieux Carre's first so-called "skyscraper." Steeped in tradition and myth, the building is closely linked with George Washington Cable's short story "Sieur George." To this day, Sieur George's house is one of several names by which it is known. Legend has it that Lafcadio Hearn also spent time here. (Pages 62-65 are also Louis Sahuc photos.)

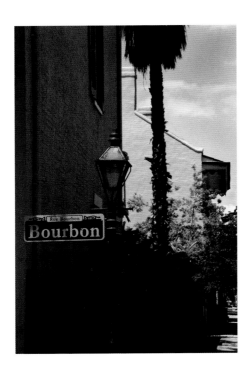

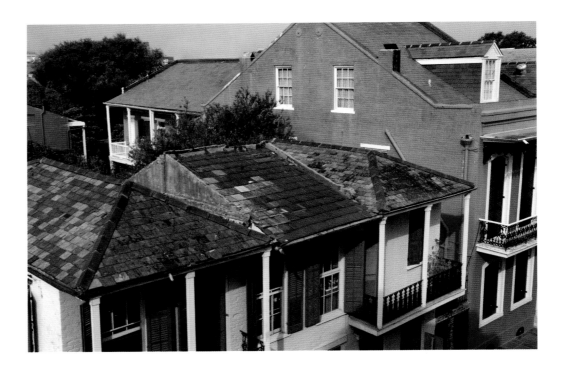

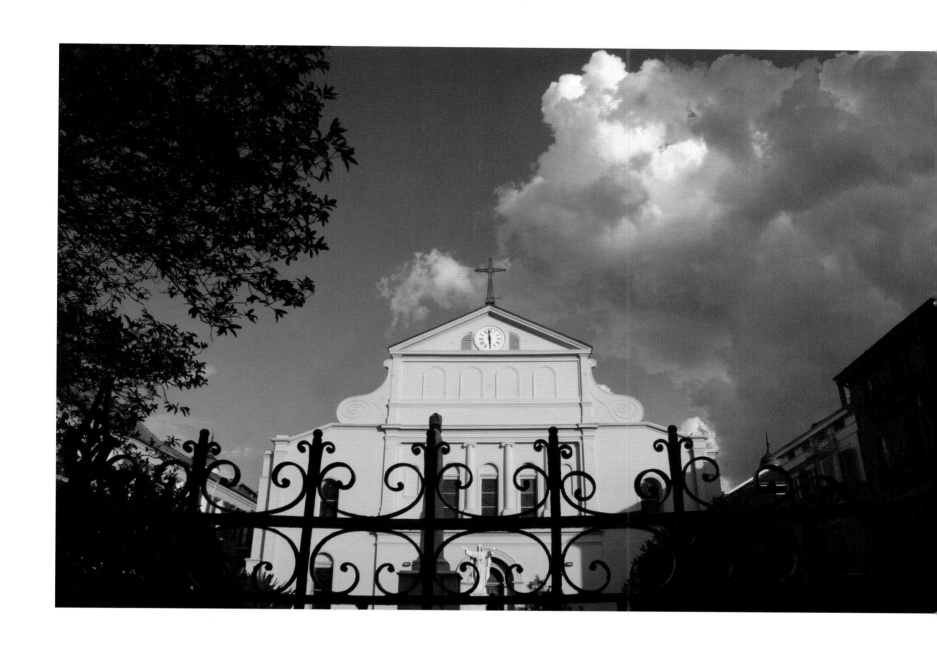

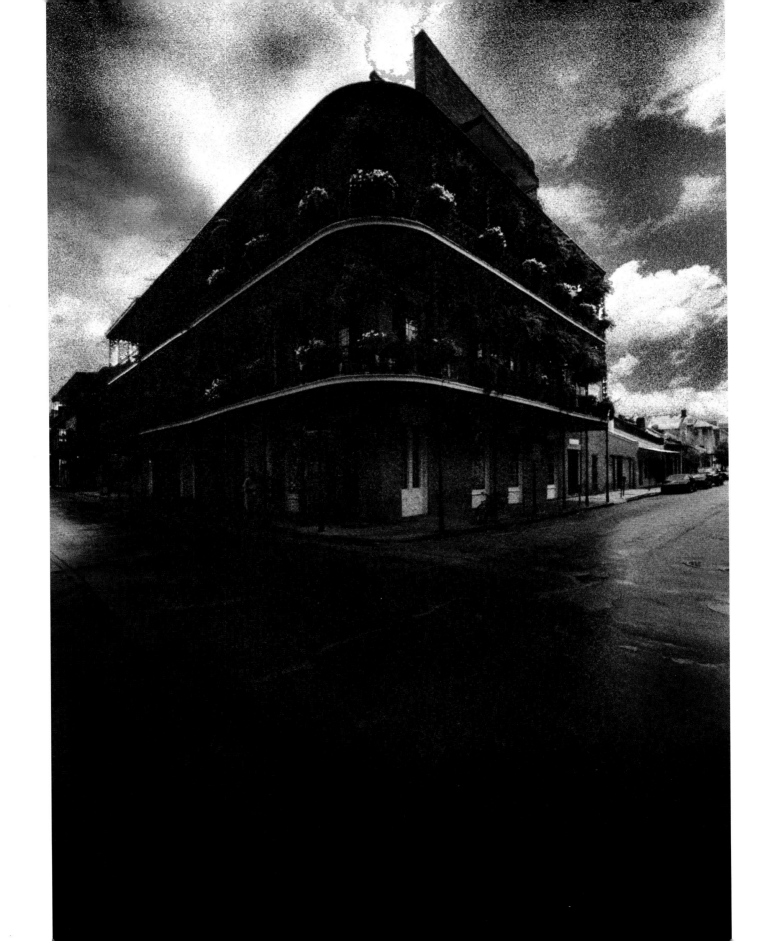

# Publisher's Note

Thank you to *The Times-Picayune* newspaper and affiliated *Nola.com* website for being the hometown Louisianian lifeline that united a broken community in its darkest hours — by providing breaking news, forums and blogs that saved countless lives, uplifted spirits and gave hope. In addition to the newspaper's passionate and dedicated staff of reporters, editors and photographers, who received two Pulitzer Prizes for heroic and comprehensive coverage of Hurricane Katrina and its aftermath, New Orleanians also applaud the local piquant columnists who represent everyman's ubiquitous voice and consciousness of what it feels like to live in and love a place called New Orleans.

Additional recommended reading
for those who love New Orleans:

*1 Dead in Attic*
by Chris Rose

*The Great Deluge:*
*Hurricane Katrina, New Orleans, and the Mississippi Gulf Coast*
by Douglas Brinkley

*My New Orleans:*
*Ballads to the Big Easy by Her Sons, Daughters, and Lovers*
by Rosemary James (editor)

*Why New Orleans Matters*
by Tom Piazza

*New Orleans, Mon Amour:*
*Twenty Years of Writings From the City*
by Andrei Codrescu

*Breach of Faith:*
*Hurricane Katrina and the Near Death*
*of a Great American City*
by Jed Horne

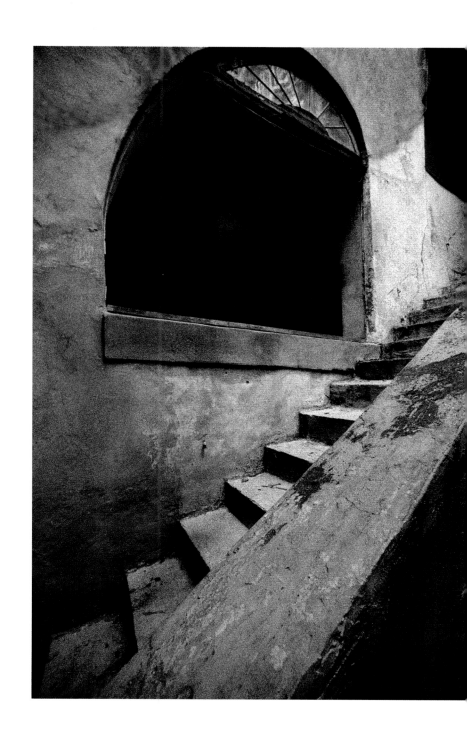

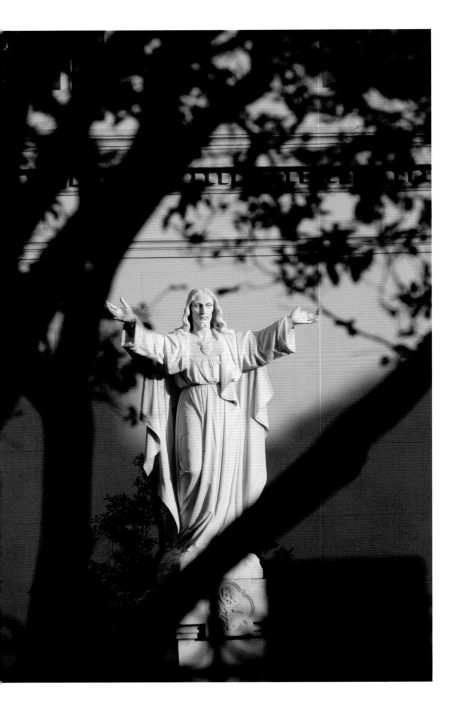

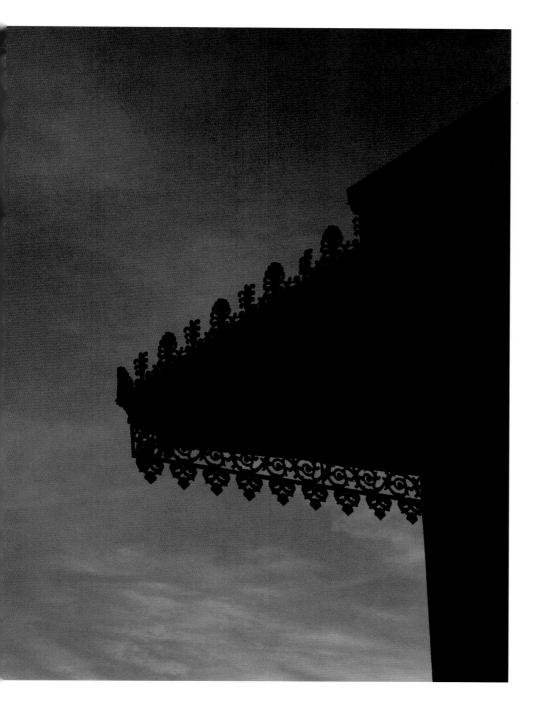

## *Orléans Embrace*

New Orleans remains a city of magical thinking, looking to upright, reclaim and recover the broken parts of itself upon the wings of hope. We believe in tomorrow, yesterday and today; may our faith and fate collide and dovetail as one. We shall remember always. Beauty here is born of three hundred years of wisdom and experience, collapse and revival, laughter and grief. No matter how unforgiving the wilderness, or deep the well of darkness, New Orleanians, like those who came before, now persevere and look for the eternal light, rebirth and renaissance of the city we love.

TJ Fisher

# Authors' Page

**Roy F. Guste, Jr.,** the past fifth-generation proprietor of New Orleans' world-renowned Antoine's Restaurant, is a Vieux Carré resident and the author of nine books on Creole cuisine. First published in 1993, Guste's well-received *The Secret Gardens of the Vieux Carré: the Historic French Quarter of New Orleans* earned him an extra measure of fame and a loyal following. His classic *Antoine's Restaurant Cookbook* has been returned to print. Post-Katrina, he continues his involvement with cooking and writing about the cuisine and stories of his native city, and is also active in the local real estate industry.

**TJ Fisher** has been enamored with Louisiana's colorful culture, characters and customs since childhood, finding creative inspiration in all things New Orleanian. A compelling writer, thespian and documentary filmmaker, Fisher has a passion for towns and people with vivid stories to tell. She is a member of Writers Guild of America, Directors Guild of America, Producers Guild of America, Dramatists Guild, Academy of Television and Arts and Sciences, Screen Actors Guild and Actors' Equity Association. Fisher is equally recognized for her dramatic interior design themes and restoration of historic properties. A lover of legacies and memorabilia, she shares her home with American icon Howdy Doody (Photo Doody), one of the three original 1940s marionettes, and drives a 1959 pink Caddy convertible. Fisher divides her time between the Vieux Carré and South Florida; post-Katrina, she remains immersed in ongoing literary and film works projects and the preservation/rebuilding of her adopted hometown, New Orleans.

**Louis Sahuc** is a lifelong New Orleanian, French Quarter resident, local photographic gallery owner and award-winning photographer whose work is collected by celebrities, corporations and individuals worldwide. He is currently featured in the recently published *Galatoire's Cookbook*. Sahuc has spent much of his storied career capturing what is unique about his hometown — the architecture, misty mornings and people. Lauded as a master of romantic impressionist photography, Sahuc, post-Katrina, continues assembling an ongoing collection of images of the New Orleans he loves.

66

(388 total pages)